Latina Teens, Migration, and Popular Culture

Intersections
in Communications
and Culture

Global Approaches and Transdisciplinary
Perspectives

Cameron McCarthy and Angharad N. Valdivia
General Editors

Vol. 19

PETER LANG
New York • Washington, D.C./Baltimore • Bern
Frankfurt am Main • Berlin • Brussels • Vienna • Oxford

Lucila Vargas

Latina Teens, Migration, and Popular Culture

PETER LANG
New York • Washington, D.C./Baltimore • Bern
Frankfurt am Main • Berlin • Brussels • Vienna • Oxford

Library of Congress Cataloging-in-Publication Data

Vargas, Lucila.
Latina teens, migration, and popular culture / Lucila Vargas.
p. cm. — (Intersections in communications and culture:
global approaches and transdisciplinary perspectives; v. 19)
Includes bibliographical references and index.
1. Hispanic American teenage girls—Social conditions.
2. Hispanic American teenage girls—Economic conditions.
3. Children of immigrants—United States—Social conditions.
4. Hispanic Americans—Ethnic identity. 5. Transnationalism—Case studies.
6. Sex role—United States—Case studies. 7. Working class—
United States—Case studies. 8. Consumption (Economics)—United States—
Case studies. 9. Popular culture—United States.
10. Hispanic Americans in mass media. I. Title.
E184.S75V37 305.235089'68073—dc22 2008036032
ISBN 978-1-4331-0752-8 (hardcover)
ISBN 978-0-8204-8845-5 (paperback)
ISSN 1528-610X

Bibliographic information published by **Die Deutsche Bibliothek**.
Die Deutsche Bibliothek lists this publication in the "Deutsche
Nationalbibliografie"; detailed bibliographic data is available
on the Internet at http://dnb.ddb.de/.

Front cover art by Galileo Velarde Vargas

The paper in this book meets the guidelines for permanence and durability
of the Committee on Production Guidelines for Book Longevity
of the Council of Library Resources.

© 2009 Peter Lang Publishing, Inc., New York
29 Broadway, 18th floor, New York, NY 10006
www.peterlang.com

Printed in the United States of America

Para mi querido hijo Galileo

Table OF Contents

Tables

Figures

Acknowledgments

A few years ago, my friend and colleague Jane Brown convened a group of faculty and graduate students who were interested in research involving girls. We received a small grant, became institutionalized, and called ourselves the Girls Working Group. My project was incubated in the warm space created by the Group. I wish to thank the Group members for sharing insights from their own research. I especially wish to thank Jane for her leadership and her relentless urging to "get this work out," and Wendy Lutrell for inspiring me to incorporate collage-making into my research and for persuading me to "write myself" into the book. In addition to the Group, many other people deserve recognition. Among them are Vicki Mayer and John Downing, who agreed to read the long manuscript and to write endorsements for the book. Several colleagues and anonymous reviewers of earlier versions of some chapters helped me to develop ideas and approaches. I am particularly grateful to Angharad Valdivia for offering me incisive criticism and timely updates on the literature in Latina/o studies. My thanks also go to my editor Mary Savigar from Peter Lang; to my research assistants, Kelly Toon and Michael Fuhlhage; to my data analysis software Guru, Paul Mihas and to those who copyedited my work: Jennifer Drolet and Janet Mittman. My dearest son, Galileo Velarde Vargas, designed the book's cover and transcribed many of the tapes. *Gracias hijo.*

My research was supported by a Chapman Family Fellowship granted by the Institute for the Arts and Humanities, and by a semester leave as well as grants

from the School of Journalism and Mass Communication, both institutions of the University of North Carolina at Chapel Hill. The Odum Institute, also at the University of North Carolina, funded the Girls Working Group. I appreciate the assistance provided by these institutions.

Parts of the book appeared in earlier versions in journals and anthologies. The core of Chapter Five was published as "Transnational media literacy: Analytic reflections on a program with Latina teens," in the *Hispanic Journal of Behavioral Sciences* 28(2), pp. 267–285. Most of Chapter Six appeared as "Transnational media use and ambiguous loss: A qualitative study with Latina teens," in *Popular Communication: An International Journal of Media and Culture* 6(1), pp. 37–52. Most of Chapter Seven was published as "Media practices and gendered identity among Latina teens" in *Latina/o Communication Studies Today*, an anthology edited by Angharad Valdivia (Peter Lang, 2008, pp. 187–218), and parts of Chapter Eight appeared as "Media and racialization among working-class Latina immigrant young women" in *The American South in a Global World*, edited by James Peacock and J. H. Watson (University of North Carolina Press, 2005, pp. 39–58). I thank these publishers for their permissions to reprint.

Despite all the support from institutions, colleagues, friends, and family that I received to carry out my project, I certainly could not have done it without the participation of Latina teens. I own a huge debt of gratitude to the wonderful teens who shared their memories and desires with me. Likewise, I am grateful for the access to Latina/o youth that two non-profit organizations facilitated for me.

Memory AND Desire

2/23

(1-3)

Memory fuels desire: the past as imagined from a Latino perspective awakens an anticipatory sense of what is, or might be, in store.

Juan Flores (1997, p. 184)

Diasporas bring the force of the imagination, as both memory and desire.

Arjun Appadurai (1996, p. 6)

Memory and desire are salient motifs in the literary writings of exiles, refugees, sojourners, and other migrants. They are also recurrent themes in migration scholarship and in discussions about cultural identity and transnational subjectivity. As well, memory and desire are the two dimensions of what Juan Flores rightly calls "the Latino imaginary," the cultural ethos of Latina/os. The symbolic significance of memory and desire may come from the elusive meanings that they evoke, as well as from their metaphoric association to past and future, origin and destination. Expressions of memory are as profuse as expressions of desire in the narratives of self that a small group of teens composed for the project that led to this book. And memory and desire are often inextricably linked in such narratives, as feelings and manifestations of longing.

Memory and desire, thus, became convenient heuristics for exploring the relationship among migrancy, subjectivity, and popular culture that I wanted to illuminate. In this book, I approach the ambitious task of casting light on such relationships at the level of everyday practices. I examine how a small group of

working-class, transnational Latina teens talk about their "selfs" in relation to their popular culture consumption practices. I attempt to explain how transnational Latina teens' subjectivities are constituted *in* and *through* their verbal and visual "talk" about popular culture. In other words, in order to elucidate how they "deploy their imaginations" (Appadurai, 1996, p. 4) to talk about their popular culture practices while simultaneously producing an identity, I show how they remember, crave, yearn, wish, and long for texts such as films, and artifacts such as toys. Among the various methods that I employed in my study, there is one called the "who I am" collage method, through which I was successful in collecting visual narratives of self composed by the teens. Figure 1 shows the collage made by one of the most perceptive teens, Paty. Much of the interpretation presented in the book hinges on these visual narratives.

This book lies at the intersection of two subfields, Latina/o Communication Studies and International/Global Communication. It is a qualitative case study (Stake, 1995) of working-class, first- and second-immigrant generation Latina teens who live in the "New Latino South," one of the areas of the United States where Latina/o settlement is very recent. This group is a segment of the broad and diverse social formation that the term "Latina/o youth" includes. The label "Latina/o" comes with many perils because it renders invisible some crucial intra-group differences (Oboler, 1995). As an all-inclusive category, it identifies the roughly 45.5 million residents of the United States (15.1 percent of the total population) who trace our origin or descent to Latin America and the Caribbean. Nearly 34 percent of all Latina/os are under age 18, compared with 25 percent of the total U.S. population. Thus, despite large internal differences, 15.5 million Latina/o children and adolescents are tied together by similar cultural memories, similar experiences of racialization, similar exclusion from key institutions of U.S. society, and similar prospects for the future (U.S. Census Bureau, May 1, 2008). But how similar or how different are their patterns of consumption and use of media and popular culture? This question is not as trivial and inconsequential as the preference for a certain recording artist over another appears to be. As Raymond Rocco rightly asserts, Latina/o cultural practices are thoroughly implicated in power relations at the macro level:

> We have a history of having limited access to political rights, to decision-making institutions, and opportunities for economic and social mobility. Because of the centrality of cultural differences in this history, certain Latino cultural practices have been interpreted as undermining U.S. culture. Despite the fact that these critiques are made within a cultural discourse, they are in fact political claims being made about "appropriate" national boundaries and about what the conditions are for attaining and enjoying full citizenship. Thus

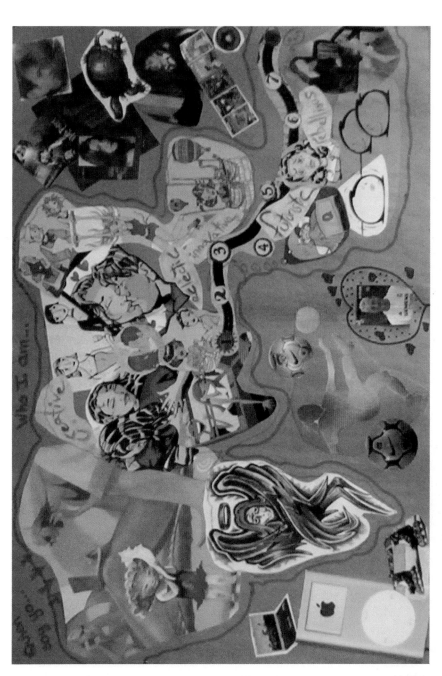

Figure 1. Collage by Paty (age 15)

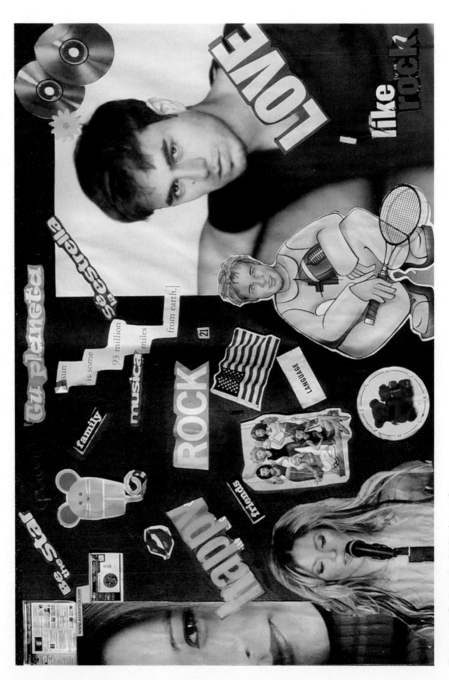

Figure 2. Collage by Lidia (age 14)

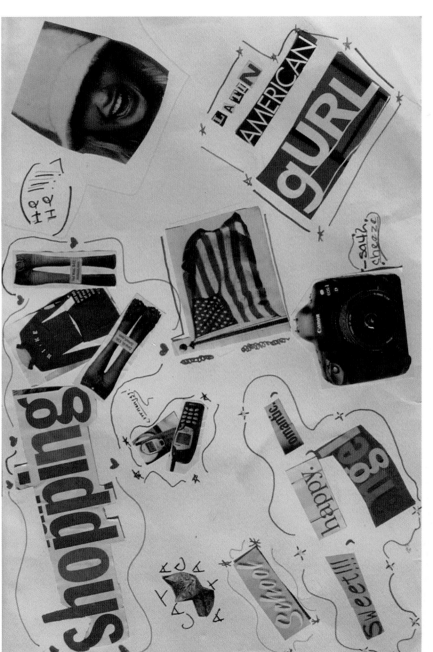

Figure 3. Collage by Stephany (age 14)

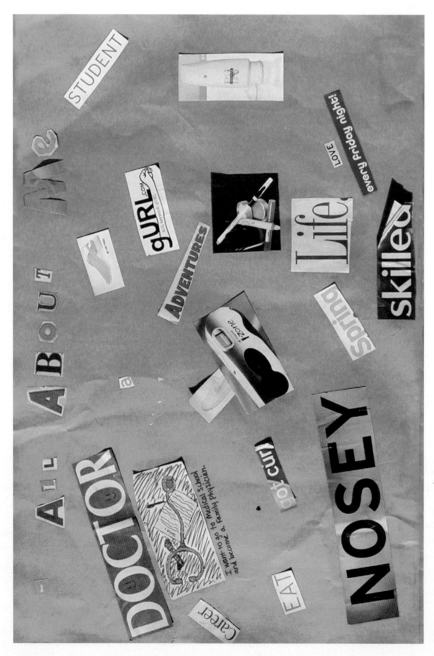

Figure 4. Collage by Sabrina (age 15)

it is possible to look at cultural practices of Latinos as representing, among other things, the means by which communities have both reproduced and resisted, accommodated and challenged, the relations of power and domination. (Rocco, 1997, p. 114)

Because the cultural practices of Latina/o youth are deeply implicated in the reproduction of, and resistance to, systems of inequality, they carry considerable importance for the collective future of Latina/os. Regrettably, this youth is an understudied population (Montero-Sieburth & Villarruel, 2000), and we are only beginning to tackle the intricate questions raised by their cultural practices. Vicki Mayer's (2003a; 2003b) ethnographic work on Mexican Americans in San Antonio, Texas, is the most substantive contribution to the mapping of the variegated media and popular culture experience of Latina/o youth, and other welcome contributions are starting to appear (Bejarano, 2005; González Hernández, 2008; Moran, 2003; Valdivia & Bettivia, 1999). However, in this nascent scholarship, as well as in most of the scholarship on Latina/o audiences, the migration experience has not received its due attention. I hope to demonstrate in the book that the consumption and use of popular culture by the children of migrant Latina/o families are shot through by the life-changing encounter with unrootedness. Their practices as users of popular culture commodities cannot ignore individual and family history. While we should not disregard the performative and thus creative and shifting aspect of identity, we must also bear in mind that past trajectories shape both individual and collective identities. Cultural identity, states Stuart Hall, "belongs to the future as well as to the past. It is not something which already exists, transcending place, time, history and culture. Cultural identities come from somewhere, have histories. But, like everything which is historical, they undergo constant transformations" (Hall & du Gay, 1996, p. 225).

The book focuses an analytic lens on the experience of migration. International migration is a major occurrence in the lives of people because it is not a single event but a lengthy process. Migrant families spend years planning their departure and then years establishing themselves in the new country of settlement (Fernandez-Kelly & Schauffer, 1996; Portes and Rumbaut, 1996; Rumbaut, 1997). Then, in late modernity, things, people, and places are no longer "left behind" like in previous generations; the social, economic, and political ties with "home" are profoundly different and at times even stronger, because even after decades of living in other countries, migrants often fantasize about going back home. Therefore, migration has a steady presence in many aspects of our everyday lives, including, naturally, the way we incorporate popular culture into our mundane deeds and pursuits.

Issues of consumption, taste, and media/popular culture have been central to the study of audiences. Although I draw from numerous sources, my understanding of these issues relies heavily on Pierre Bourdieu (1984). His theory of social reproduction highlights cultural capital, without disregarding the importance of economic and social capital. In addition to existing in institutionalized forms (e.g., educational titles), and in material culture, according to Bourdieu cultural capital resides in the *habitus*. As a set of durable, embodied dispositions, the *habitus* is generative of practices. It is a sort of *langue* that makes possible individual utterances of practice; an internalized code that manifests itself as style. Because each class and class fraction has a corresponding unique *habitus*, which is based on specific conditions of existence, taste fulfills a central legitimating function in social reproduction. For Bourdieu, the aesthetic sense is the sense of social distinction, and taste is a classification system that serves not only to categorize artifacts, but also to assign people into social classes: "taste classifies, and it classifies the classifier. Social subjects, classified by their classifications, distinguish themselves by the distinctions they make between the beautiful and the ugly, the distinguished and the vulgar, in which their position in the objective classifications is expressed or betrayed" (Bourdieu, 1984, p. 6).

The book's working concept of popular culture is merely descriptive: sets of texts like television programs, and artifacts like compact disks.[1] The practices that I discuss throughout the book demand attention to what Jesús Martín Barbero (1987) calls "mediations," that wide array of institutions, subjects, processes, and cultural matrices that exists between mass media and audiences, between production and consumption. Scholars conducting qualitative audience research with transnational populations have dealt with the broader questions of mobility and ritualistic uses of media and popular culture that concern me in this book. Especially germane is the body of literature on the *domestication of technologies theory* (Silverstone & Hirsch, 1992) and on the production of *locality*, the process whereby we construct a sense of belonging (Geourgio, 2006; Tufte, 2001). While numerous qualitative studies have shown that people use popular culture artifacts to produce and express their identities, especially their gendered identities, the scholarship on how transnational youth use popular culture is still in its infancy. The foundational ethnography of Marie Gillespie (1995) on the use of television among teens of Punjabi descent living in London initiated an approach that I find to be the most appropriate for my work. Drawing on Paul Gilroy's (1993) idea of the "Black Atlantic," which posits that the framework for the study of black culture is the black diaspora, Gillespie argues that British Asian cultures should be investigated not as ethnic cultures bounded by local limits, but as cultures that are part of transnational social formations. Accordingly, her study looks at how adolescents, as part of the British Punjabi diaspora, use media to deal with issues of cultural

identity and negotiate intergenerational conflict. Like Gillespie, I think of the teens who participated in my project as part of a transnational formation.

As a theoretical model, transnationalism conceptualizes the social, cultural, economic, and political practices of today's migrants as networks and flows that crisscross national borders, and that are qualitatively different from the practices that emerged within previous migratory movements. In other words, the assumption is that the identities, social networks, economic interests, and civic and political memberships of today's international migrants have an unprecedented nature (Appadurai, 1996; Croucher, 2004; Vertovec, 1999). Marcelo M. Suárez-Orozco and Mariela M. Páez stress the tactical aspect of such practices by stating that transnationalism refers to "economic, political, and cultural strategies articulated by diasporic peoples across national spaces" (2002, p. 6). The model has been used to investigate diasporic media and the way everyday media reception practices help bring about what Hall (1988) and other cultural studies theorists have called "new ethnicities," a term that refers to the cultural identities developed by postcolonial immigrants.

The analysis of the consumption and use of media and popular culture by transnational Latina/o youth requires that we examine these phenomena at the very local level, which is what I do in this book through a qualitative case study (Stake, 1995). I posit that the processes of identity construction that I try to sort out are but a particular case of analogous uses by subaltern, postcolonial diasporic youth around the globe. By the expression *transnational Latina teens* I refer to young first- and second-generation immigrant women of Caribbean and Latin American origin or descent who reside in the United States.[2] I employ the term "transnational" to stress that the milieu in which they relate to popular culture crisscrosses national borders. Crossing borders back and forth, or *circular migration* (Rouse, 1995), is nearly as common in their social networks as is code-switching between linguistic and popular culture codes. As I show throughout the book, the deterritorialized practices of transnational Latina teens break traditional boundaries among culture industries and communication technologies.

Any discussion of belonging and attachment in late modernity has to engage with the contested notions of place and citizenship. No doubt, globalization has been reconfiguring citizenship practices, and the meaning of citizenship is currently the topic of much debate among scholars and policy makers. As a form of belonging to a political formation, citizenship has been traditionally understood as membership in a polis. It has implied a tie to a state that carries rights and obligations. The shrinking of the power of the nation-state, however, has diminished the hitherto crucial importance of this traditional form of citizenship. Sheila L. Croucher points out that the cases of dual citizenship and supranational citizenship demonstrate that citizenship is currently being disconnected from the

nation-state. She maintains that we need to think of citizenship as malleable and to recognize alternative formations of political belonging (2004, pp. 80–81).

A related notion to which I return again and again, is Renato Rosaldo's idea of cultural citizenship. The notion adds a fourth category of rights—cultural rights—to the classic typology of citizenship rights proposed by T. H. Marshall (1950), which identified civil, political, and social rights. Cultural citizenship "refers to the right to be different (in terms of race, ethnicity, or native language) with respect to the norms of the dominant community, without compromising one's right to belong, in the sense of participating in these nation-state democratic processes" (Rosaldo & Flores, 1997, p. 57). The notion also goes beyond the legal dichotomous distinction (i.e., either one is a citizen or not) to point out that citizenship practices at the grass-roots level presume degrees of belonging and entitlement.

Regarding place, Doreen Massey (1993) offers a useful conceptualization of place as social relations. Traditionally, the concept of place has involved space and boundaries; it has been seen as a portion of space, often bounded for political or administrative purposes. Yet, in mathematics, place is a relation and in certain common uses the word "place" refers to a relative position, such as in the expression "her place in society." Massey argues that places are relational, unbounded, and fluid; they are unique points of intersection on the continuously changing constellation of social relations: "Instead, then, of thinking of places as areas with boundaries around, they can be imagined as articulated moments in networks of social relations and understandings" (Massey, 1993, p. 66). Asking the reader to imagine seeing the earth from a satellite, crisscrossed by the moving lines of social relations, Massey says that the point where two or more of these paths cross each other constitutes a unique "place" (Massey, 1993, p. 66).

As place and citizenship, identity and subjectivity are complicated matters. Hence, after a brief description of the project that yielded the material for the book, I summarize the philosophical tenets underneath my understanding of these notions. Then, to begin setting the stage for what follows, I describe the broader and specific settings of my project. Next, I offer an overarching view of the teens' popular culture landscape, followed by a review of the notions of the borderlands/*la frontera*, hybridity, counterpoint, and *contrapunteo*. I conclude by outlining the subsequent chapters of the book.

AN ACTION-RESEARCH PROJECT

The book is based on material that I gathered through an action-research project that included two after-school programs on critical media literacy. Action research

is a process-oriented methodology that pursues understanding as well as social jus-
tice. As "interventions," the after-school programs sought to empower small groups
of transnational Latina teens to understand how media texts work. As the main
"sites" for my fieldwork, they were set to facilitate participant observation and in-
depth interviewing. I further describe the project and its methodology in Chapter
Two, where I explain that the project was predicated in Freirean pedagogy, which
has at its core the transformation of the self. Drawing on Albert Memmi, Erich
Fromm, Frantz Fanon, and others who have theorized on the subjective aspects of
(post)colonization, Paulo Freire highlights the psychological wounds inflicted by
oppression. He highlights intersubjectivity and thus he assumes that human beings
are formed in social relationships and that the identity of the oppressed has been
constituted by the Hegelian master–slave relationship (Freire, 1999, pp. 44–45).

 Also in Chapter Four I point out that the project was inspired by Paul Willis's
concern with the relationship between identity and subordination. Intrigued by
the role of cultural practices in social reproduction, Willis demonstrates the power
of class culture on the development of subjectivity. "The difficult thing to explain
about how middle class kids get middle class jobs is why others let them," says
Willis. "The difficult thing to explain about how working class kids get working
class jobs is why they let themselves" (Willis, 1981, p. 1). In his investigation with
working-class English adolescent boys, Willis powerfully shows that youth
resistance cultures can be self-defeating. His theory relies on the concepts of
penetration, limitation, and *partial penetration.* Penetration refers to a social
formation's impulses toward grasping the conditions of its existence and its position
in the larger society. Limitations are forces or ideological effects holding these
impulses back. Partial penetrations are the result of the interplay between
penetrations and limitations. Willis argues that "it is this specific combination of
cultural 'insight' and partiality which gives the mediated strength of personal
validation and identity to individual behaviour which leads in the end to
entrapment" (1981, pp. 119–120). Like Willis, I am concerned with the part that
public identity and subjectivity play in processes of social reproduction, including
processes that assure the generational replacement of labor power. Yet, like Freire,
I am also concerned with the emancipatory potential of critical literacy.

 Among the seventeen teens that took part in my project there were twelve foreign
born, four native-born children of foreign-born parents, and one who had been born
in the U.S. Commonwealth of Puerto Rico. Their places of origin or descent includ-
ed Colombia, Honduras, El Salvador, Mexico, Puerto Rico, and Venezuela. Apart
from two, the teens came from working-class families. Their tastes and dispositions,
or *habitus* (Bourdieu, 1984), matched the general *habitus* of the urban working class-
es of the Caribbean and Latin America. Their bodies reflected the variety of pheno-
types typical of the region, but the teens did not see themselves as belonging to

indigenous groups such as the Mayan. With the exception of one, they saw themselves as *mestizas,* that is, as the descendants of both the native peoples of the Americas and the Spanish colonizers. Many lived in modest neighborhoods, but some lived in the improvised dwellings made of prefabricated houses that have sprung up in the New Latino South. Most of their parents worked in the lower rungs of the service industry. In the case of teens from two-parent families, the father came first and the family tagged along later. However, more than half of the teens lived in households headed by single mothers, a "new transnational family form" that, according to Pierrette Hondagneu-Sotelo has become more common (2002b, p. 259).

IDENTITY AND SUBJECTIVITY

Because identity and subjectivity are vague concepts that we bring into play to contemplate interrelated aspects of the self, some authors use the terms "identity" and "subjectivity" interchangeably. Other authors make a clear distinction and use the latter to refer to our interiority, and the former to talk about the social categories to which we are assigned by others. Linda Martín Alcoff offers a clear definition, which I follow in the book:

> By the term identity, one mainly thinks about how we are socially located in public, what is on our identification papers, how we must identify ourselves on Census and application forms and in the everyday interpolation of social interaction. This *public identity* is our socially perceived self within the systems of perception and classification and the networks of community in which we live. But there is also a *lived subjectivity*… By the term subjectivity, then, I mean to refer to who *we* understand ourselves to be, how we experience being ourselves, and the range of reflective and other activities that can be included under the rubric of our "agency." (Martín Alcoff, 2006, pp. 92–93, italics in original)

According to Martín Alcoff, however, the distinction between identity and subjectivity is "never pure." Even though social identity and subjectivity may not be aligned with each other, as the literature on *passing* superbly illustrates (Larsen, 1929), Martín Alcoff rightly argues that "this neat separation doesn't quite apply to any post-Hegelian social understanding of the formation of the subject in which social interaction plays the constitutive role" (2006, p. 78). Upholding Hegel's belief that the self's interrelationships with other selves are necessary for its development because they are the soil in which the self grows, Martín Alcoff highlights the power of the Other to shape our subjectivity. She stresses that "one cannot have a subjectivity that can transcend the effects of public identification." In other words, our sense of who we are cannot but depend on the public identity

that is assigned to us. For her, our subjectivity is especially dependent on our gendered and raced identities. I will say more about Martín Alcoff's argument regarding the salience of sex/gender and race/ethnicity for identity and subjectivity, but before doing that, I introduce another of the fundamental notions that I use in the book, Judith Butler's notion of *performativity*.

Blending ideas coming from feminist, post-structuralist, and psychoanalytic theories, Butler has delved into the problems related to the constitution of the subject, the emergence of subjectivity, and the formation of gendered and sexed identities. Important for this book, is, first, Butler's understanding of identity as signification, constructed in and through language and discourse, and thus fluid and in need of constant reproduction; and, second, her Foucauldian claim that sex and gender are the effects (rather than the cause, as essentialist theories assume) of institutions, discourses, and practices. In *Gender Trouble*, Butler (1990) conducts a genealogical analysis of the notion of identity. She begins with Simone de Beauvoir, one of the existentialist philosophers who posited that the self is a becoming and that it is constituted through its deeds. De Beauvoir (1968) encapsulated her ideas of gendered identity in her legendary claim that "one is not born a woman, but rather becomes one." Her view of gendered identity laid the foundation for feminist challenges to essentialist notions of gender as something stable and existing prior to culture. Yet Butler goes beyond existentialist claims:

> My argument is that there need not be a "doer behind the deed," but that the "doer" is variably constructed in and through the deed. This is not a return to an existential theory of the self as constituted through its acts, for the existential theory maintains a prediscursive structure for both the self and its acts. It is precisely the discursively variable construction of each in and through the other that has interested me here. (Butler, 1990, p. 181)

What Butler argues is that nothing exists outside of discourse because "doer" and "deed" constitute each other within discourse and by means of signification. There is no actor prior to the performance, as the metaphor of gender as theater suggests. Butler's concept of gender as *performativity* builds on Jacques Derrida's critique and elaboration of John Langshaw Austin's speech act theory. In *How to Do Things with Words* (1975), Austin distinguished between statements that are merely descriptive such as "this ship is the *Queen Elizabeth*," and utterances that actually do what they talk about. Austin argued that utterances like "I name this ship the *Queen Elizabeth*" or "I promise," actually enact the actions that they talk about. He called these statements *performative utterances* and maintained that their constitutive power depends on the speaker's intention ("serious" speech) and the conditions under which they were spoken (uttered in a public and ritualized mannered, in the presence of an

authority, etc.). Derrida (1982) pointed out that the performative power of a sign relies on *iterability* and *citationality* rather than on the speaker's intention because performatives are always a repetition of highly conventional practices. The speaker is therefore citing norms, regulations, and authorities. He argued that any sign/utterance can be lifted from its context, "put between quotation marks," and repeated again, even with totally different intentions, breaking, in this way, the connection between the sign and its referent, and opening up the possibility for inauthentic (not "serious") repetitions. Using this reasoning to question essentialist notions of identity, Butler puts forward that gendered identity is "done" or constituted through the iterative citation of conventions in everyday practices.

Embracing Monique Wittig's critique of the distinction between sex and gender, which maintains that gendered identity is constructed in culture and discourse, but sex is a biological given, Butler posits that both sexed and gendered identities are discursively produced, that they are "done" by signifying practices. In *Bodies That Matter* (1993), Butler argues that individuals are "sexed" when they are interpellated (in the Althusserian sense of "hailing") as either a "she" or a "he." Butler talks about the first moment in which an infant is "girled" by someone who declares that the infant—who up until that point was an "it"—is a "girl." By means of the statement "it is a girl," the previously unsexed infant is thus allocated into a category based on gender. This "sexing" of the infant, points out Butler, would be reinforced, or contested, by various authorities throughout her life (Butler, 1993, pp. 7–8).

Butler views sex and gender as hierarchical systems created by society to group individuals into political categories. "Man" and "woman" are political terms because whether one is classified as one or the other determines the claims to power that one can make. Sexed and gendered categories are "in fact the effects of institutions, practices, discourses with multiple and diffused points of origin," claims Butler (1990). Here she both relies and elaborates on Michel Foucault's (1978; 1980) analysis of power/knowledge, which contends that power is not only repressive, but also productive. Foucault reasons that, in addition to repressing individuals by prohibiting, limiting, and regulating their actions, juridical systems of power also define who is under their control and, by so doing, these institutions actually constitute the subjects that they claim to regulate (i.e., one becomes a "criminal" or a "law-abiding citizen"). According to Foucault, the subject is an effect of institutions, constituted in and by their discursive structures.

Butler's assertion that gender is a "repeated stylization of the body, a set of repeated acts within a highly rigid regulatory frame" (Butler, 1990, p. 44) seemingly implies that her theory of gender as *performativity* leaves little room for individual agency. Nonetheless, Butler makes an argument against gender determination based on three points. First, given that identity is a signifying practice that requires repetition, it is likely that variation, and indeed failure, on that repetition would

occur. Second, because the rules governing signification are not only restrictive mechanisms, but also enabling tools for creating novel meanings, it is possible for some individuals to perform modalities of gender that, as Butler says, "contest the rigid signs of hierarchical binarisms" (1990, p. 185). And third, because individuals have to "cite," all at once, the different rules and conventions that regulate each of their various roles, there is a "possibility of a complex reconfiguration and redeployment" of gender. The last two points present an opening for incorporating race/ethnicity and other differences that the theory of performativity ignores into the framework that I employ to make sense of the ethnographic material that I collected. As insightful as Butler's theorizing is, it is insufficient to make sense of popular culture practices because it fails to account for the intersectionality of multiple axes of identity. Feminists of color have pointed out that race, class, and nation play central roles in the particular way in which a woman experiences herself. Indeed, this blindness has been the focus of harsh criticisms to Butler's work (see Salih, 2002). In what follows, I introduce Martín Alcoff's argument that the category of race is as crucial a category for the constitution of the subject as the category of gender.

RACE AND THE "LATINO/A PARTICULARITY"

Martín Alcoff combines insights from the hermeneutic tradition (especially Merleau-Ponty's) with post-Husserlian phenomenology to make a forceful argument about the significance of the body for exploring the *problematique* of identity and subjectivity. A full-fledged account of the formation of the subject, she argues, needs to consider the mighty role that bodily markers play in the historical construction of social identity categories, as well as in the specific way in which we experience our interior life. She reasons that the social category of race/ethnicity is as salient for the self as is the category of sex/gender. Like gender, the category of race is linked to visible physiological features, and notwithstanding its culturally-bounded and changeable nature, such linking makes the category of race appear as natural and immutable as the category of gender seems to be. In fact, Martín Alcoff goes further to claim that the bodily markers of race and gender are inseparable from the social identities associated with them:

> The social identities of race and gender operate ineluctably through their bodily markers; they do not transcend their physical manifestations because they *are* their physical manifestation, despite the fact that the same features can support variable identities depending on how the system of markings works in a given culture. (Martín Alcoff, 2006, p. 102, italics in original)

Martín Alcoff recognizes that while the same bodily mark, say a slightly dark skin, may signify adscription to different racial categories in different contexts, she argues that, because those gender and racial features are inborn aspects of one's body, they are fundamental to one's social identity and subjectivity (Martín Alcoff, 2006, p. 86). She is not claiming that culture, history, and location do not matter. On the contrary, she underscores the significance of context for the analysis of identity and subjectivity, and she makes a strong case against theories of subject formation and identity construction that explain these processes as universal. One of her strongest points refers to the tremendous importance of context and history for understanding identity: "We cannot assume that the process of constructing 'whiteness,' for example, which has involved strict border patrols, illusions of purity, and a binary opposition to nonwhiteness, is analogous to all other processes of identity formation. Identities must be contextualized and processes of identity formation need to be historicized" (Martín Alcoff, 2006, p. 85).

Her intervention into the current philosophical critique of identity and subjectivity is quite useful for my work because she is especially concerned with the "Latino/a particularity." Martín Alcoff maintains that Latinas and Latinos in the United States do not have an ethnic identity, but rather a racial identity. In her view, the efforts to change the meaning of "Latina/o" from a racial to an ethnic category, in the same way that the Jews and the Irish were able to deracialize their public identities, are likely to fail. The United States' colonial relationship with Latin American and Caribbean countries, she says, complicates the possible deracialization of Latina/os because it would require a profound re-examination of foundational narratives of the country, like "manifest destiny," that legitimated subjugation of peoples and annexation of lands, and that continues to legitimate exploitation of labor and natural resources as well as unequal international relations. Moreover, she argues that unlike race, ethnicity does not work through bodily markers, and therefore ethnic categories are not connected to visible signs that may be used to differentiate people:

> In popular consciousness and in the implicit perceptual practices we use in everyday life to discern how to relate to each other, ethnicity does not "replace" race. When ethnic identities are used instead of racial ones, the perceptual practices of visual demarcation by which we slot people into racial categories continue to operate because ethnic categories offer no substituting perceptual practice. (Martín Alcoff, 2006, p. 242)

The deracialization of Latina/os, therefore, would require changing long-established "ways of seeing" (Berger, 1972) as well as overcoming the need to differentiate people in our everyday encounters. Given such daunting obstacles, Martín Alcoff suggests that it would be better, for both political and analytical purposes, to recognize the enduring racialization of most Latina/os as an

historical fact. Such recognition may enable us to develop more effective political strategies and to transform the meaning of racial categories. "It may be easier to help 'race' slowly evolve by engaging with it in new ways rather than trying to evade it," she says (Martín Alcoff, 2006, p. 245). In accord with her argument, I deem that the prevalent categories of race in both the United States and Latin America and the Caribbean are greatly relevant for transnational Latina/o selves. However, Martín Alcoff also argues that racial categories are more powerful than categories based on class (and nationality) because class only becomes apparent in behavior (2006, p. 86). In my view, the power of race to organize the social order in Latin America and the Caribbean derives from its disguise as class; therefore, the analysis of race has to simultaneously consider class categories. In the everyday interactions among Latina/os, as well as among Latin Americans and Caribbeans, class distinctions are paramount. During the European colonization of the region, class became conflated with race. The cultural dynamics that emerged during colonial times are constitutive elements of the "Latina/o particularity."

BORDERLANDS/*LA FRONTERA,* HYBRIDITY, AND *CONTRAPUNTEO*

Syncretism and *mestizaje* (literally, mixing) have been pivotal ideas in Latin American and Caribbean thought (see Zea, 1990). Again and again, we return to them to theorize on the region's uneven modernities, on its cultural production, and on its peoples' identities. Néstor García Canclini introduced the notion of hybridity as an alternative approach to the study of the popular-national in Latin America and the Caribbean. He argued that the term hybridity is more useful to address questions of *cultura popular* in contemporary Latin America than either *mestizaje*, a term generally used to refer to miscegenation, or syncretism, a term mostly used to refer to religious fusions (1989, p. 15). The *clases populares* are largely comprised of indigenous, mestizo, and mulatto populations who, until the 1950s, resided mostly in rural areas. Thus the term *cultura popular* is still used to talk about the so-called "traditional cultures" of the peasantry and the region's indigenous peoples.[3] State modernization efforts encouraged the diffusion of mass media and put in motion large domestic migrations that resulted in heavily populated cities. García Canclini explains that the new cultural expressions of the *clases populares* exceeded the established meanings of *cultura popular,* and scholars began to use the term *cultura urbana.* The conventional official and disciplinary distinction among *lo culto, lo masivo,* and *lo popular,*[4] says García Canclini, obscures the social and cultural processes that both occur and constitute Latin American (post)modernity (García Canclini, 1995, p. 15). He points out that while the distinction was always arbitrary (because both the elites and the subaltern have

borrowed and appropriated the cultural expressions of each other), with modern-
ization the mixing intensified and incorporated a new element: the products of the
culture industries. Therefore, argues García Canclini, term *culturas híbridas* best
captures the complicated cultural dynamics of Latin America's uneven modernity
(García Canclini, 1995, p. xxviii).

The trope of hybridity has been frequently invoked to theorized the cultures
and cultural identities of Latinas and Latinos, but the master trope in Latina/o
Studies has been poet Gloria Anzaldúa's borderlands/*la frontera*. Calling attention
to what happens on the threshold of cultures, Anzaldúa talks about the borderlands
as a "juncture," a space "where phenomena tend to collide," and "where the possibil-
ity of uniting all that is separate occurs." Implying a process view of subjectivity,
she posits that a qualitatively different self emerges from the collision of different
cultures. "This assembly is not one where severed or separated pieces merely come
together. Nor is [it] a balancing of opposite powers. In attempting to work out a
synthesis, the self has added a third element which is greater than the sum of all its
severed parts. The third element is a new consciousness—a *mestiza* consciousness"
(Anzaldúa, 1987/1999, p. 103). Such new consciousness constitutes the grounds for
opposition and resistance. The contestatory potential of cultural mixings has inter-
ested authors like Mikhail M. Bakhtin (Bakhtin, Morris, Voloshinov, & Medvedev,
1994), who reflects on the "intentional hybrid" as a kind of dialogic hybridity that
produces contestation.[5] It is in this latter sense that the trope of hybridity has been
used in postcolonial theorizing about identity (De Santis, 2001).[6]

As early as 1940, Cuban anthropologist Fernando Ortíz put forward the
Cuban contrapunteo (counterpoint), another trope that has been deployed to explain
processes of cultural mixings in Latin America and the Caribbean. I return to
Ortíz's *contrapunteo* after the next few paragraphs, but first it is necessary to
explain a recent use in media communication studies of a very similar notion:
Edward Said's counterpoint. In *Culture and Imperialism,* Said (1994) suggests the
counterpoint as a metaphor for theorizing intercultural encounters. A musical
notion, counterpoint is the art or technique of bringing independent melodic lines
together to produce both musical tension and musical repose. It is also defined as
a polyphonic quality of sound, or texture, in Western music. For Said's purposes,
the important element is that two or more melodic lines, each with its own rhythm
and pitch, play simultaneously "against" one another. In the field of international
communication, Marwan M. Kraidy's (2005) *Hybridity, or the Cultural Logic of
Globalization* stands out as a comprehensive discussion of the use of the tropes of
hybridity and counterpoint. Kraidy briefly mentions Ortíz's *contrapunteo* (2005),
but he states that he draws on Said: "My modus operandis is contrapuntal, an
approach that I adapt from Western classical music by way of Edward Said"
(Kraidy, 2005, p. 113). Similarly, Roger Silverstone (2007) has turned to Said to

claim that the contrapuntal approach avoids the pitfalls of hybridity theory, which ends up essentializing cultural difference by suggesting that a new cultural entity emerges from the fusion of "elements of previously discrete cultural identities" (Silverstone, 2007, p. 89). Silverstone also highlights the epistemological aspect of Said's insight, insisting that, for Said, the contrapuntal is a method, a political approach to reading literature, history, and culture. "The contrapuntal," notes Silverstone, "speaks to the inevitable, continuous and significant juxtaposition of elements and threads in a life, a text, a history, and to the necessity for an analytic which confronts that juxtaposition and deconstructs it" (Silverstone, 2007, p. 85). Both Kraidy and Silverstone quote the same brief passage in which Said explains his approach. It is worth repeating this illuminating passage:

> As we look back to the cultural archive, we begin to reread it not univocally, but *contrapuntally,* with a simultaneous awareness both of the metropolitan history that is narrated and of those histories against which (and altogether with which) the dominating discourse acts. In the counterpoint of Western classical music, various themes play off one another, with only a provisional privilege being given to any particular one; yet in the resulting polyphony there is concert and order, an organized interplay that derives from the themes, not from a rigorous melodic or formal principle outside the work. In the same way we can read and interpret English novels, for example, whose engagement (usually suppressed for the most part) with the West Indies or India, say, is shaped and perhaps even determined by the specific history of colonial resistance, and finally native nationalism. At this point alternative or new narratives emerge, and they become institutionalized or discursively stable entities. (Said, 1994, p. 59)

There are two elements in the passage that are crucial to my study. One is Said's description of the counterpoint. The second is the method proposed by Said to read the historical record, a method that evokes Ortiz's approach to reading Cuban history. Kraidy's (2005) research with young Maronites in Lebanon exemplifies the use of the contrapuntal approach to investigate media reception. He found that they talked about themselves by bringing into play two competing discourses, "the West" and "the Arabs." Kraidy suggests that these discourses "functioned not as a dichotomy, but rather as dialogical counterpoints, a notion…[that refers] to discursive variations that create a space where the central theme is elaborated" (Kraidy, 2005, p. 127). This argument resonates with Gillespie's (1995) contention that young Punjabi Londoners participate in both their families' local ethnic minority culture and the "Western" youth majority culture.

Said's and Ortiz's notions are deceptively similar, but I would argue that Ortiz's metaphor is more a verb than a noun. The Spanish term *contrapunteo* that Ortíz deployed comes from the musical genre *punto,* which is a musical *controversia*

or a poetic debate between singers who improvise rhymed *décimas* (ten-line stanzas) in response to each other. *Contrapuntear* is a quick improvised singing of *décimas*. Rooted in African rhythms and Spain's Andalusian music (via the Canary Islands), *punto* is a characteristic genre of the peasantry, but it gained great popularity among urban populations during the 1940s, precisely at the time when Ortiz was theorizing about Cuban culture. Ortiz's *Contrapunteo cubano del tabaco y del azúcar* (1963) is an attempt to make sense of the rich culture of Cuba by staging a *contrapunteo* between *Don Tabaco* and *Doña Azúcar* (Don Tobacco and Doña Sugar). Deploying the main crops of colonial Cuba as allegories for African and Spanish cultures, Ortíz posits that Cuban culture emerged from the tension between the two.

Another important concept introduced by Ortiz is *transculturation.* Even though anthropologist Franz Boas (1940) argued that cultural exchanges are always mutual as early as the late 1880s, the term "acculturation" came to be used as synonymous with assimilation of minorities or immigrants into the hegemonic culture. By the late 1930s, when Ortiz was developing his ideas, the term "acculturation" was already in use in Anglo anthropological circles and Ortiz was trying to debunk the increasingly common use of the term as assimilation. In Ortiz's view, "acculturation" stresses processes of acquisition and realignment but fails to properly acknowledge, first, that there is always a mutual exchange in intercultural encounters, and second, that unrooting from native lands and partially losing one's vernacular culture can be profoundly disruptive. For Ortiz, *transculturation* entails processes of *aculturación* (acculturation) and *desculturación* or *exculturación* (deculturation or exculturation), and *neoculturación* (neoculturation):

> We understand that the term *transculturation* better expresses the different phases of the transitive process [of moving] from one culture to another, because this process consists not only of acquiring a different culture, which is what strictly implies the Anglo-American expression *acculturation*, but it also necessarily implies the loss of, or the unrooting from, a preceding culture, which might be called a partial *deculturation*, and, in addition, it means the ensuing creation of new cultural phenomena that might be called *neoculturation*. (Ortiz, 1963, my translation)

While his book is a historical interpretation of the particular mixings that occurred in Cuba, Ortíz implies that his theory is generalizable to other intercultural encounters. In the introduction that Bronislaw Malinowski wrote for the book, he recommends the use of Ortiz's neologism, "transculturation," instead of "acculturation," to avoid the unfortunate moral, normative, and value judgments implicit in the latter. Malinowski argues that "acculturation is an ethnocentric

term: those who are expected to acculturate to the 'Great Western Culture' are the immigrants, the indigenous peoples, the barbarians, the infidels" (Malinowski, 1963, p. xii, my translation). Against his own advice, however, Malinowski did not use Ortiz's term, and consequently the theory of transculturation did not receive due attention beyond Latin America until recently, and the term "acculturation" is still widely used. The language, genre, and form of argumentation that Ortíz employs in his book may have also contributed to its lack of recognition among Anglo scholars. The book parodies another parody *El Libro del Buen Amor* *(The Book of Good Love)* by Juan Ruíz, Arciprestre de Hita (ca. 1283–1350), which is a milestone of Spanish literature.

The problematic aspects of Ortiz's theory have been pointed out by scholars such as Antonio Cornejo Polar (1996) and Silvia Spitta (1997). Theorizing on the migration experience of the millions of people who have been unrooted by processes of urbanization in Latin America (specifically in Peru), Cornejo Polar argues against categories that imply a dialectic and its resulting synthesis:

> My primary hypothesis has to do with the assumption that the migrant discourse is radically decentered, since it is constructed around several asymmetric axes, in some way incompatible and contradictory in a *non* dialectical way. It accommodates no fewer than two lived experiences that migration, against what it is assumed in the use of the category of mestizaje, and in a certain way in the concept of transculturation, does not intend to synthesize in a space of harmonic resolution. (Cornejo Polar, 1996, pp. 842–843, my translation).

Thus, in Cornejo Polar's account, by implying a dialectic logic and its concurrent synthetic resolution, *mestizaje* essentializes or reifies processes. As I mentioned above, Silverstone (2007) raises a similar criticism of the notion of hybridity. Although Cornejo Polar includes transculturation in the above passage, he is less categorical about the concept's limitations. Spitta (1997) raises another critical point, by showing that *contrapunteo* implies a naïve view of power relations. Ortiz deploys the already gendered meanings of the crops (in Spanish *azúcar* is feminine and *tabaco* is masculine) to do a gendered reading of intercultural encounters that invokes relations between the sexes and the patriarchal family as allegories to grasp the nature of intercultural relations. As Spitta contends, the allegories are inappropriate because, by ignoring the historical oppression of women, Ortiz assumes that there are no power differentials between man and woman, father and mother. A second, related point made by Spitta is that *contrapunteo* implies that the relations between Africans and Europeans in Cuba were on nearly equal terms, minimizing the fact that Europeans brought Africans to Cuba as slaves. This weakness in the theory of transculturation has been pointed out before by Mary Louise Pratt (1992).

Despite her incisive critique, drawing on Stuart Hall's articulation of Africa as a subtext in Caribbean cultural life, Spitta suggests that Ortiz's theory can be useful if *contrapunteo* is understood as "subtextual tension": "The 'counterpoint' then does not actually allude to the 'note against note' structure of contrapuntal musical compositions, but rather to an African subtext and rhythm in a more general contrapuntal relationship to all of western music and culture. In the end, it is this expanded, transcultural notion of 'counterpoint' that operates in Ortiz's texts" (Spitta, 1997, p. 163). The gender bias and the lack of precision of Ortiz's work notwithstanding, his ideas have been suggestive enough to provoke further elaboration, most notably by Uruguayan writer and literary critic Angel Rama (1985), and a recent renewed interest in his theory by Latina/o and Latin American Cultural Studies scholars (e.g., Moreiras, 2001). I find that Ortiz's theory is a convenient heuristic to make sense of various aspects of transnational youth's consumption of popular culture because it refers to an art of improvisation. I elaborate this argument in the concluding chapter of the book, where I offer a critique of notions of hybridity, counterpoint, and *contrapunteo*. Because these metaphors are deployed to grasp the meanings of the migration experience, which always occurs in a unique context, at this point I turn to describe, first, the national context of the teens' lives, and then I move to the local context of their distinctive migration experience.

THE NATIONAL SCENE AND LATINA/O COLLECTIVE IDENTITIES

On June 18, 2003, about the time I was beginning to recruit teens for my project, the U.S. Census Bureau issued a press release titled "Hispanic population reaches all-time high of 38.8 million" (U.S. Census Bureau, June 18, 2003). With the release of the findings of the 2000 census, it was already official that the Latina/o share of the U.S. total population (12.5 percent) had exceeded the African American share, hitherto the largest minority group in the United States. As of this writing, the Bureau has issued another release stating that there are now roughly 45.5 million Latinas and Latinos in the United States (15.1 percent of the total population) and that most of the increase of the last few years is not due to immigration, as it was in the 1990s, but to birth. The young people who came looking for economic opportunity or escaping political repression in the 1990s, have been having children (U.S. Census Bureau, May 1, 2008).

The relation between the United States and Latin America and the Caribbean has been a determining factor in the growth of the Latina/o population. In the mid-1880s, the United States annexed half of the Mexican territory. In some of these areas, like California, Texas, and New Mexico, Spanish and Mexican settlement preceded the arrival of Anglos. Thus, with the re-drawing of the border

between Mexico and the United States, many Mexicans became U.S. residents. Another case in point is the 1919 annexation of Puerto Rico. When Puerto Ricans became U.S. citizens (and thus Latina/os) they began migrating to the New York area; during the immediate post-World War II period this migration increased. By 1960 Puerto Ricans were the second-largest Latina/o group after Mexican Americans. Likewise, the Cuban Revolution brought asylum seekers to Florida after 1959. Driven by international competition and technological innovation, the U.S. labor market started to change and by 1960 it developed a great need for "labor made cheap."[7] Consequently, the Immigration and Naturalization Act of 1965 was passed to enable large-scale legal immigration from Mexico through the *Bracero* program. Then, by the early 1980s, unprecedented numbers of Dominicans as well as Central (especially Salvadorans, Guatemalans, Hondurans, and Nicaraguans) and South Americans (especially Argentineans and Chileans) from war-torn areas joined the exodus to *El norte* (the north). In an effort to meet the challenges of this migration, in 1986 the Simpson-Mazzoli Act (Immigration Reform and Control Act of 1986) granted amnesty to large numbers of undocumented individuals, but also criminalized employers who knowingly hired undocumented workers. In the 1990s, the economic changes brought by the North American Free Trade Agreement (NAFTA) on both sides of the U.S.–Mexican border further encouraged international migration.

By 1990, Latinas and Latinos were concentrated in the states close to the U.S.–Mexican border (Arizona, California, Colorado, Nevada, New Mexico, and Texas), and in certain areas of Florida, Illinois, New Jersey, New York, and the District of Columbia. A decade later, however, we were living in places with little or no previous history of Latina/o settlement: the Northwest, the Midwest, and the Southeast (Suárez-Orozco & Páez, 2002). Global macroeconomic processes merged with processes at both the domestic and the local levels to create the conditions for the transformation of traditional migration patterns. Areas that have received relatively large numbers of international migrants, like southern California, experienced a saturation of the local job market and a surge of anti-immigrant sentiment. At the same time, economic restructuring in the U.S. South required an infusion of new labor power, and the federal government was not prepared to enforce immigration and naturalization laws in the region (Massey, Durand, & Malone, 2000).

In the next section, I describe the local scene of the case, but first it is necessary to discuss the constructions of *panlatinidad,* understood here as constructions of collective social identity for all Latinas and Latinos at the national level, disregarding intragroup differences. Manuel Castells (2004) provides a useful framework for exploring these issues. He differentiates among legitimizing, resistance, and project identities. Whereas legitimizing identity originates in the Anglo hegemonic society, resistance and project identities are produced by social

actors in response to the legitimizing identity imposed on them. He defines the three types of identity as follows:

> Legitimizing identity: introduced by the dominant institutions of society to extend and rationalize their domination *vis-à-vis* social actors …
>
> Resistance identity: generated by those actors that are in positions/conditions devalued and/or stigmatized by the logic of domination, thus building trenches of resistance and survival on the basis on principles different from, or opposed to, those permeating the institutions of society …
>
> Project identity: when social actors, on the basis of whichever cultural materials are available to them, build a new identity that redefines their positions in society and, by so doing, seek to transform the overall social structure. (Castells, 2004, p. 8)

The legitimizing identity of Latina/os has been a racialized construction of the hegemonic society, which has refused to see us, especially those of Mexican, Puerto Rican, and most recently Dominican descent, as "white." A fundamental element of this legitimizing identity has been the refusal, on the part of the institutions of the Anglo society, to view us as "real Americans." Such refusal has manifested itself in numerous ways, but for the purpose of this book, it is important to look at the way in which we have been excluded from institutions key to the building of a sense of nation, such as the mass media and national museums. I discuss at length the exclusion and stereotyping of Latina/os in the Anglo media in Chapter Three. Here I wish to direct attention to a revealing event: the creation of the Smithsonian Center for Latino Initiatives, which took place about 150 years after the creation of the Smithsonian Institution. The report of the Smithsonian Institution Task Force on Latino Issues concluded in 1994:

> The Smithsonian Institution, the largest museum complex in the world, displays a pattern of willful neglect towards the estimated 25 million Latinos in the United States. Because of both indigenous roots and Spanish heritage, Latinos predate the British in the Americas. They have contributed significantly to every phase and aspect of American history and culture. Yet the Institution almost entirely excludes and ignores Latinos in nearly every aspect of its operations… Many Smithsonian officials project the impression that Latino history and culture are somehow not a legitimate part of the American experience. It is difficult for the Task Force to understand how such a consistent pattern of Latino exclusion from the work of the Smithsonian could have occurred by chance. (Task Force on Latino Issues, 1994)

Given that the collections of tangible artifacts kept by national museums create and sustain intangible notions and feelings of nationhood, the systematic

exclusion of Latina/os from this pre-eminent collection reveals an important way in which institutions of the dominant society have produced a legitimizing identity for us as permanent foreigners or as denizens. But the creation of the Center for Latino Initiatives also reveals the high degree of present contestation to such legitimizing identity and the emergence of a project identity that includes all Latinas and Latinos. The collection is one of the sites in which the Latina/o project identity redefines us as "Americans." The Center was the result of intense political lobbying by Latina/o organizations (especially the National Council of La Raza) and their allies. The collective struggle for inclusion in the national imaginary[8] has gained momentum as of this writing. After a five-year crusade, on May 2008 Congressman Xavier Becerra succeeded in passing legislation that takes the first step for the creation of a future National Museum of the American Latino (*La Prensa*, 2008).

Benedict Anderson suggested that the map, the museum, and the census are institutions that reveal the grammar in which state ideologies and policies are deployed (Anderson, 1983, pp. 163–164). Along with the Smithsonian, the U.S. census brings into view the way the state has, in Anderson's terms, imagined the nature of *Latinidad*. Until 2000, the census classified Latina/os as a race. Thus our legitimizing identity has been a racialized identity, implying that there are inherent differences in worth between us and the dominant group; yet the identities generated by ourselves most often have imagined this social formation as an ethnic rather than as a racial group. Changing the classification system of the U.S. Census Bureau has been one of goals of the Latina/o political struggle. The Bureau now classifies Latina/os as an ethnic rather than as a racial group ("Hispanic origin") clarifying that "Hispanics can be of any race" (Schmidley, 2001, p. 24). Racialization and "de"-racialization (removing the stigma of race) have been at the center of the construction of Latina/o identities because, as Stephen Cornell and Douglas Hartmann assert, "designating a group of people as a distinct race has been sufficient in the United States to mark them off as more profoundly and distinctively 'other'—more radically different from 'us'—than those ethnic groups who have not had to carry the burden of racial distinction" (Cornell & Hartmann, 1998, pp. 25–26).

The Latina/o struggle to advance a project identity has also included both reactive and proactive efforts aiming to de-racialize the Anglo media construction of *Latinidad* that I discuss in Chapter Three. In 1999, for example, the National Hispanic Media Coalition called for the first week-long boycott, or "brownout," of Anglo television networks as a protest against the lack of Latinos and Latinas in the Anglo industry. On the proactive side, Chicano cinema has been one of the most prolific sites of the symbolic production of a Latina/o project identity. In addition to numerous films, this cinematic tradition has produced a television

drama featuring a Mexican American family, which aired on the Public Broadcasting Service in 2002–2004. The creators' intention to de-racialize *Latinidad* is clear: the series is titled *An American Family*. At the same time that, at the national level we have become more vocal in our claims for full citizenship, we have been relocating to areas of the United States that hitherto have not had sizable Latina/o populations. One such area is the New Latino South.

THE LOCAL SCENE: THE NEW LATINO SOUTH

Rapid Latina/o population growth occurred within similar local contexts in the states of Arkansas, Alabama, Georgia, Tennessee, and the Carolinas, an area that scholars from the Pew Hispanic Center call the New Latino South (Kochhar, Suro, & Tafoya, 2005; Suro, 2005). The 1990s migration to new settlement areas of the U.S. Southeast is a new social phenomenon with very specific characteristics. To begin with, the Latina/o population growth rate in these states surpasses the same rate in other regions; for example, in Georgia the rate was 300 percent, while in traditional settlement states like California and Illinois the rate was 43 percent and 69 percent, respectively. Second, although their growth rate was not as dramatic as in the case of Latina/os, white and black settlements in Arkansas, Alabama, Georgia, Tennessee, and the Carolinas also increased beyond previous rates; they added 5.2 million residents, but Latina/os were only 900,000 of them (Kochhar et al., 2005, p. 6). Third, the 1990s Latina/o population in the region had "all the characteristics of a labor migration in its early stages" (Kochhar et al., 2005, p. 1). Therefore, it had larger proportions of males, immigrants, and young people than the overall national Latina/o population. And last but not least, this dramatic population increase occurred against the backdrop of the region's extraordinary economic restructuring, largely driven by global forces, and vigorous economic growth. During the 1990s, the economy of the New Latino South "created jobs for an additional 410,000 Hispanic workers and 1.9 million non-Hispanic workers" (Kochhar et al., 2005, p. iii). However, as Sandy Smith-Nonini points out, "even as the South becomes more urbanized with an influx of high-tech industry and tourism, a wider gap has emerged between cities and rural areas where social programs and public infrastructure remain greatly unfunded. Further, labor-intensive industries have moved abroad since the North American Free Trade Agreement (NAFTA), leaving a wave of unemployment behind that disproportionately affects rural areas" (Smith-Nonini, 2005). While old labor-intensive industries moved abroad, new labor-intensive industries were being established. But many of these industries, such as poultry

and hog processing, sought what employers call the "Latino work ethic," a euphemism to refer to the relatively low expectations of foreign workers along with the typical vulnerability of the undocumented workforce (Johnson-Webb, 2002). Because many of the newcomers had relatively low levels of education, and even many educated migrants were employed in low-paying occupations, the poverty rate for Latina/os *increased* by almost 5 percent, while the region's overall poverty rate dropped by 7 percent (Kochhar et al., 2005, p. iv).

The settings of my project, Durham and Carrboro, are located in North Carolina, the state that enjoyed the highest rate of Latina/o population growth in the nation (394 percent) during the 1990s. The relatively large number of Latina/os who came to the state was unprecedented (U.S. Census Bureau, 2000). About the time of my fieldwork (2002–2003), the government estimated that there were 378,963 people of Hispanic origin residing in North Carolina (4.7 percent of the state's total population) (U.S. Census Bureau, 2000). Local service providers estimated that as many as 549,000 Latina/os resided in North Carolina (El Pueblo Inc., 2003). By 2006, according to the U.S Census Bureau, we constituted 6.7 percent of the state's population (U.S. Census Bureau, 2008b). Whereas at the national level 45 percent of all Latina/os are foreign born and only 32 percent are not legal citizens, it is estimated that in North Carolina, 64 percent are foreign born and 58 percent are not legal citizens. In terms of national origin or descent, 71 percent of all North Carolina Latina/o residents are of Mexican origin or descent, 10 percent come from Puerto Rico, and about 19 percent come from other parts of Latin America and the Caribbean (Holtzman, 2002, p. 6).

Latina/o settlement represents North Carolina's most significant local population change in a century (Johnson-Webb & Johnson, 1996), and it has provoked a rapid re-accommodation of social and racial categories at the local level. The U.S. South is characterized by relative poverty, and North Carolina is no exception. In 2004 the nation's average household income was $44,334; for North Carolina, it was only $40,863 (U.S. Census Bureau, 2008b). Being part of the Confederacy of Southern states that resisted the abolition of slavery in the early 1860s, North Carolina has a social stratification closely linked to race (Wimberley & Morris, 1997). The poverty rate for Anglos is 8.5 percent, 12.2 percent for Asian Americans, 25.5 percent for Native Americans, 25 percent for African Americans and 27.4 percent for Latina/os (Holtzman, 2002, pp. 7–8). Because international migrant families tend to experience higher levels of poverty than other families and because a sizable share of North Carolina Latina/os are international migrants, it is not surprising that, although many of us work in the military, construction, social services, and other occupations that pay moderate

wages, we are overrepresented in low-wage occupations. With respect to gender, because most of the early Latina/o migrants to the state were young men seeking jobs, still nearly 60 percent of North Carolina's Latina/o population is male. Yet, many young women coming to the United States either on their own or to join their partners, are changing the 1990s pattern of labor migration. Not unlike the overall U.S. Latina/o population, in North Carolina we are a very youthful group. The national median age for the overall population is 36.6 years, but for us is just 27.6 years (U.S. Census Bureau, May 1, 2008); in North Carolina the median age for Latina/os is even younger: 24 years. By 2003, roughly one in every five Latina/os living in North Carolina was under the age of 10 years (North Carolina Institute of Medicine, 2003, p. 68). Because many Latina/os are of reproductive age, the rising numbers are due not only to migration but also to birth. In the New Latino South, we have changed more than just workplaces. I came to North Carolina in the early 1990s, and have witnessed how our families have also remade neighborhoods and even entire small cities, reinvigorating many of them. I have also witnessed how our children have transformed the local scene of many schools, hospitals, shopping centers, parks, and other places for sports and recreation. The settings of my fieldwork, Durham and Carrboro, had higher proportions of Latina/os than North Carolina as a whole, which reflects the great county variations that exist in the New Latino South. Before our arrival, the residents of Durham (pop. 187,035) were equally divided between blacks and whites. By the time of my fieldwork, Latina/os made up 8.6 percent of the population (blacks were 43.8 percent and whites were 45.5 percent). In Carrboro (pop. 16,784), most residents were white (72.7 percent), but Latina/os made up 12.3 percent of the town's population, similar to the proportion of blacks (13.5 percent) (U.S. Census Bureau, 2000). Although not as dramatically as some small rural towns in the New Latino South, Durham and Carrboro have been transformed.

As compared to most other states, North Carolina has very large black and Native American populations, and race relations in the region have been entrenched in historical prejudice and discrimination. Being part of the larger U.S. South, the New Latino South shares a history of white supremacy and racial prejudice unrivaled by other regions of the country. Our new visibility, thus, has not always been welcomed by the natives. Blatant expressions of anti-Latina/o sentiment have been common in the local media (Paulin, 2007; Vargas, 2000), especially in the opinion pages of community newspapers (Szarek, 2008).[9] Along with the historical legacy of slavery, which continues to find blatant expressions in the prejudice and discrimination that exist against blacks and Native Americans, old white supremacist fears have been revitalized by Latina/o migration.

THE TEENS' MEDIA AND POPULAR CULTURE LANDSCAPE

Along with national origin or descent, language usage has been the prevailing factor employed to investigate media use among Latinas and Latinos; for example, television viewing is usually divided into two categories: Spanish-language television versus English-language television. Despite the efforts of some within the media industry, like AIM TV Group (AIM TV Group, 2008), to change the way Nielsen Media Research measures Latina/o television viewing, Nielsen continues to use a language-based methodology. Rather than illuminate, this language-based approach obscures the media experience of transnational Latina/o youth. The teens' popular culture landscape was a "polyglot situation" (Bakhtin et al., 1994) in which four different streams of cultural texts and artifacts run through.

Segregationist policies and practices in many areas of social and economic life encouraged the development, alongside the hegemonic Anglo tradition, of other unique popular culture traditions. Relevant for the teens were the black and the U.S. Latina/o traditions. I use the term "tradition" to indicate, first, that like an artistic style each of the four traditions obeys its distinct logic and establishes its own standard ways of doing things; that is, it has its own mode(s) of production; second, that a tradition is akin to a regime of representation with its own grammar, vocabulary, and aesthetic conventions; third, that a tradition becomes a regime of power/knowledge (Foucault, 1980) that positions what it represents in particular ways; fourth, that the social processes involved in, as well as the artifacts created within, a tradition, are structured by its overall logic; and fifth, that a tradition is capable of enforcing its own rules, not only in the production but also in the consumption of its products, subjecting consumers to the regime's knowledge "not only as a matter of imposed will and domination, but by the power of inner compulsion and subjective conformation to the norm" (Hall, 1990, p. 226). Each tradition generates a particular way of seeing (Berger, 1972). Ways of seeing are historical and learned; they demand a certain cultural competence and a given aesthetic disposition (Bourdieu, 1984). Of course, I do not mean to say that these traditions are pure, stable, and neatly separated. Like languages or artistic styles, traditions of media and popular culture are constantly evolving, interacting with, responding to, and borrowing from each other. There are differing degrees of intertextuality in each of the traditions, but the products/texts of each one are "polyphonic" (Bakhtin et al., 1994). Drawing on Antonio Gramsci's (1994) hegemony theory, I assume that several ideologies about *Latinidad* and Latina womanhood compete to establish themselves as the hegemonic one within each of the traditions. For instance, within the U.S. Latina/o tradition one can distinguish between mainstream texts or genres produced by, say Univisión, and alternative texts produced by activist videographers.

To make sense of the mind-boggling variety of media and popular culture that the teens consumed, I suggest a cultural matrix with four categories. The first category corresponds to the hegemonic or Anglo tradition from which most major television networks and Hollywood films draw. The second category corresponds to the black tradition, for example, the texts of Black Entertainment Television and rap music by artists like Ja Rule. The third category corresponds to the U.S. Latina/o tradition; this caters to what marketers call the U.S. domestic "Hispanic market," and includes Spanish-language, English-language, and bilingual texts. And the fourth category corresponds to the global Spanish-language tradition, which originates in places like Miami, Caracas, and Mexico City, and targets the entire Spanish geolinguistic market (e.g., *telenovelas*, magazines like *Vanidades* and *People en Español,* and artists such as Shakira and Ricky Martin). Although the last two traditions are intertwined, for analytical purposes it is better to distinguish between the texts of the Latina/o and the global traditions.

It has been more fruitful for my purposes to think in terms of texts and genres rather than in terms of media (e.g., television) or media systems (e.g., English-language television[10]). Therefore, instead of talking about "Spanish-language television," I talk, for example, about *telenovelas* (soap operas) or about Chicano films. Texts from each of the traditions speak to Latina teens with distinct voices, interpellate or hail them as different kinds of subjects, either as foreigners or as legitimate members of the U.S. polity, for example. In the same act of interpellation, specific texts constitute Latina teens as different kinds of subjects, say, as drop-outs or as successful students. Of course there are many texts that address transnational Latina teens in ambiguous or contradictory ways. The analytical template that I suggest in the concluding chapter, however, helps to make sense of a media and popular culture landscape that is astoundingly complex and rapidly changing.

THE FOLLOWING CHAPTERS

After telling the story of the project in Chapter Two, in Chapter Three I explain the prominent features of the public identity that is assigned to transnational Latina teens by media and popular culture institutions. I examine the representation of both *Latinidad* and Latina womanhood in each of the four traditions of popular culture. Then, in Chapter Four I offer a detailed description of the teens' media and popular culture practices. Because practices are always situated and constantly changing, the minutiae that I describe are likely to have changed. For example, the teens' use of the Internet was limited at the time of my fieldwork, but my recent observations of similar teens reveal that they use the Internet intensively, especially for social networking (e.g., My Space). In this regard, then, those

seeking information for the purpose of designing effective messages are likely to be disappointed. The purpose of the ethnographic description offered throughout the book is different. This book presents a case study and therefore the purpose of such description is to cast light into how "the more general process under discussion works" (Feagin, Orum, & Sjoberg, 1991). Chapter Four is followed by my analytical reflections on the teaching–learning processes and outcomes of the first after-school program that I implemented. The "lessons learned" in the second program were similar to those of the first, thus Chapter Five limits itself to the second one.

The remaining chapters deal with what I found to be the central *problematique* of the relationship among the self, migrancy, and popular culture. In Chapter Six, I tackle the migration experience by analyzing the media and popular culture rituals that the teens performed to cope with *ambiguous loss*. According to Pauline Boss (1993; 1999; 2006), the term refers to a distinct type of loss that defies closure, such as the feelings of the family of a missing person. Each of the subsequent three chapters is about one major axis of identity: gender, race, and nation.[11] Isolating each of these axes allows me to examine in depth particular aspects of the teens' practices in relation to a single form of identity. On the one hand, this approach is analytically effective, but on the other hand it risks obscuring the fundamental fact that different forms of identity do not exist in isolation from each other. Gender, race, and nation do not merely intersect in one's identity and subjectivity but are mutually constitutive. My hope is that, in its entirety, the book will offer the reader a feel for the whole that may constitute a transnational Latina teen's subjectivity.

In Chapter Seven, I look at how the teens used popular culture to produce a gendered self in the narratives that they relayed me. I analyze three individual cases that illustrate unique gender configurations; such cases exemplify various degrees of defiance and accommodation to the conflicting regulatory frameworks that govern the transnational Latina/o milieu. In Chapter Eight, I focus on racialization and its cousin, *colorism*, because for transnational Latinas and Latinos, the reconstitution of identities and subjectivities that occurs during migration has often involved racialization—the process, as defined by Stephen Cornell and Douglas Hartmann, "by which certain bodily features or assumed biological characteristics are used systematically to mark certain persons for differential status or treatment" (Cornell & Hartmann, 1998, p. 33). In Chapter Nine I attempt to sort out thorny questions related to national and cultural identity by relying on the *politics of belonging*, an analytical concept proposed by Sheila L. Croucher (2004), who argues against essentialized notions of citizenship and belonging, instead drawing attention to the ongoing constructedness of belonging. While her theory highlights the agency of individuals, groups, and polities to

claim membership in social and political formations, it also recognizes that such claims can only be made within the limits that context and conditions put on the options that they have available. I conclude the book with a chapter about the possibilities and limitations of counterpoint and *contrapunteo* as metaphors to begin to understand the meanings of the popular culture consumption practices of working-class transnational Latina teens.

The book has a signifying absence and a huge void that are important to mention at the onset. The absence is religion and the void is sexuality. I fear that I did not pay due attention to the cues about the possible saliency of religion in the teens' lives. In Chapter Six I present one teen's fascinating story of religious syncretism and horror media. In addition, one of the visual narratives that the teens composed about their selves has a prominent sign of religion, but this teen did not expand on the meaning of the sign. Thus, except for one teen, religion did not seem to be salient for the teens. Nonetheless, the absence of religion in my work may signify more my own irritation about research that assumes that the lives of Latinas are totally dominated by religion, than the actual saliency of religion in the teens' lives. Then there is the bigger void. Despite the overt and covert expressions of homoerotic desire that are found in the material that I collected, I chose not to explore issues of sexuality in the book because, had I done so, I would have given information about the teens that I believe they were not willing to see in print, probably not even willing to admit to themselves. This methodological choice, of course, hinders my analysis, especially the analysis of the teens' gendered identities and subjectivities that I present in Chapter Seven. In our societies, sexuality and especially alternative sexualities are touchy topics. Although (as the AIDS epidemic painfully exposed), many men and women engage in alternative sexual practices, homophobia is rampant in our communities (Espin, 1997; Mirandé, 1997). Indeed, Gloria Anzaldúa's work is so daring because it not only denounces racism, sexism, and Mexican and Chicano nationalism but also homophobia. Ian Barnard maintains that Anzaldúa's work "centralize[s] queers of color by interpelating Latino queerness from coloredness in a context that explicitly politicizes queerness as an anti-imperialist and anti-racist (anti-)identity" (Barnard, 1997, p. 38). Anzaldúa, thus, challenges us to engage with queerness and sexuality issues that are, undeniably, of central importance for Latina/o Communication Studies. Because I rely heavily on Butler (1990), who argues that gender and sexuality must be dealt with together, the challenge has been even more difficult in this project. Yet, it is precisely a feminist epistemological stance that prevents me from taking up such challenge.

The Story OF THE Project

From a Latino perspective, analysis is guided above all by lived experience and historical memory, factors which tend to be relegated by the dominant approach as either inaccessible or inconsequential.

Juan Flores (1997, p. 187)

On Thursday, September 26, 2002, at about 6:00 p.m. twelve Latina teens, Kellie, (my research assistant) and I are getting seated around a large table in the conference room of a community organization in downtown Durham. Equipped with a blackboard and a television and video-cassette player, the room resembles the seminar classrooms where I regularly teach at the university, but this room is more messy and it is a much more open space because it has a large display window to the street. We are returning to our class after the break. Kellie is giving the last sandwich to Stephany and setting up the tape recorder, I am walking around distributing worksheets for an exploration of advertising, Leticia is talking with her sister at the door, Isabel and Rossana are waving to a group of teens passing by the window outside, and Carla, Carmen, and Lidia are enthralled with a photo album of Daniela's recent *Quinceañera*. Trying to get the teens' attention, I ask Daniela to do a "show and tell" of the celebration of her *Quinceañera*, or fifteenth birthday. Also, I ask the other teens to think in which ways media are implicated in the most significant celebration among Latina girls. The *Quinceañera* is a rite of passage into womanhood, marked by a religious celebration and a lavish party.

Soon the group is bombarding Daniela with all kinds of questions about her dress, the music that was played, and the dances that were performed. Carla says that she wanted to videotape the event, but that she was not able to do it. Carmen mentions that she read an article in *Latina Magazine* about *Quinceañeras*. And Susana points out that the album is a form of media. When I ask the group how advertising is implicated in the quintessential celebration of Latina womanhood, they are perplexed. We end up spending much of the remaining 45 minutes of the class talking about the commodification of Latina/o celebrations.

This session was, as Doreen Massey would put it, a place, an "articulated moment of social relations and understandings" (Massey, 1993, p. 66). It was in this particular place that the material that I gathered was co-constructed. My project was conceived as an action-research effort. Action-research is a host of qualitative research methodologies influenced by the thought of Orlando Fals-Borda, Paulo Freire, and other critical writers. I borrowed from several approaches to action research (Mills, 2000; Stringer, 1999), but mostly I relied on the Southern Cross University approach (Dick, 2002) because it offers guidance while leaving room for designing creative strategies. Importantly, I also followed this approach because when working with teens in long-term projects, it is difficult to get them to act as co-researchers. As opposed to other approaches, the Southern Cross University approach allows the extent of participation to range from participants being co-researchers to only actively participating as informants (Dick, 2002).

Action research's major tenets hold that any investigation is a spiral, iterative, and emergent process. It calls for the researcher to keep "refining methods, data and interpretation in the light of the understanding developed in earlier cycles" (Southern Cross University, 2001). Its tenets differ little from the principles of grounded theory, and I used many of this approach's techniques for gathering and analyzing materials (Strauss & Corbin, 1998).

THE TRANSNATIONAL LATINA TEENS

My main initial concern was investigating the relationship between media use and transnational femininity and gendered expressions of cultural citizenship. That is why I chose to work with young Latinas. In addition, it is easier for me, as a woman, to work with young women versus young men, and my focus was on intragroup differences rather than differences between the sexes. The seventeen teens were between the ages of twelve and twenty. Table 1 summarizes the teens' characteristics; all names are pseudonyms. Beatriz and Gabriela had just graduated from high school, and the others were attending grades 6 through 12. Twelve were foreign born (seven Mexicans, two Salvadorans, one Venezuelan,

one Honduran, and one Colombian); four were the U.S.-born children of Salvadoran immigrants; and one was born in Puerto Rico. The foreign-born teens had lived in the United States for periods of a few months to 11 years. The immigrant experience and residency status of both the teens and their families were key factors that shaped their ongoing identity (re)construction projects.

Table 1. The Project's Participants

	Age	*Grade*	*Country of Origin/ Ancestry*	*Years in U.S.*	*Language Dominant*	*Place of Residency*	*Family*[a]
Anabel	12	6	El Salvador	3	Bilingual	Carrboro	M, SF, B
Carla	13	7	Mexico	7	Bilingual	Durham	M
Leticia	13	7	Puerto Rico	6	Spanish	Durham	M, S, B
Alex	14	9	U.S. and El Salvador	4	English	Carrboro	M, F, S
Stephany	14	9	U.S. and El Salvador	U.S.-born	English	Durham	M, S, B
Jennifer	14	9	U.S. and El Salvador	U.S.-born	English	Durham	M, S, B
Lidia	14	10	Mexico	3	Spanish	Durham	M, S
Paty	15	9	Mexico	<1	Spanish	Carrboro	S, BL
Daniela	15	10	U.S. and El Salvador	U.S.-born	Bilingual	Durham	M, B
Sabrina	15	10	U.S. and El Salvador	U.S.-born	English	Durham	M, S, B
Susana	16	12	Honduras	3	Spanish	Durham	M, S
Yvet	16	11	Mexico	9	Bilingual	Carrboro	M, F, B
Natalia	17	11	Colombia	2.5	Spanish	Durham	M
Carmen	17	11	Mexico	11	Bilingual	Durham	M, F, S, B
Beatriz	18	High school graduate	Mexico	<1	Spanish	Carrboro	M, F, B
Gabriela	18	High school graduate	Venezuela	3	Spanish	Durham	M, F, S
Isabel	20	12	Mexico	4	Spanish	Durham	FM

a Family: M = mother, FM = foster mother, F = father, SF = stepfather, S = sister(s), B = brother(s), BL = brother-in-law.

In Pierre Bourdieu's (1984) terms, most of the teens had a working-class *habitus;* their tastes and dispositions corresponded to those of the urban working poor of the Caribbean and Latin America. Most of their parents had left their home countries in search of economic opportunity, and most held service jobs in the United States. Most teens were typical examples of Latina/o transnational youth, a population with some of the highest poverty rates in the country. They were expected to help at home with cleaning, cooking, and caring for their siblings. Some had used these skills to earn cash in the local informal service labor market. The exceptions were Gabriela and Paty, who had been middle-class in their home countries. Apart from Paty, who was living with her older sister and her husband, most of the Carrboro teens were living in two-parent households. But in contrast to the dominant narrative of the Latina/o family, most of the Durham teens were not. Seven were living with their mothers and siblings, two with their mothers, and one with a foster family. These teens were the children of "new *braceras,*" a term used by Pierrette Hondagneu-Sotelo (2002) to refer to the increasing number of single women who migrate alone or with their children.

The teens were intensely experiencing the effects of racialization. Their bodies mirrored the diversity of U.S. Latinas and many had Indian and/or black features, but they saw themselves either as "Latin American white" (of European origin but different from Anglos) or as *mestizas.* Literally, the term *"mestiza/o"* refers to the offspring of Spaniards and Latin American indigenous peoples, but it is also used to talk about the syncretism that characterizes the cultures of countries such as Peru and Mexico. The term also has a class connotation, linking *mestiza/o* to the cultural production of peasants and the urban poor. Except for Gabriela, they did not seem to recognize the likely African root of their families. They talked about themselves as different from black, Anglo, and Asian American youth. Sometimes they used the terms "Latina and Hispanic" to identify themselves, but even U.S.-born teens talked about themselves by referring to their country of origin or ancestry as well. The Durham teens were attending public schools located in a district where 56.3 percent of the students were classified as "African American," 29.2 percent as *white,* 8.9 percent as "Hispanic," 2.9 percent as *multiracial,* 2.4 percent as *Asian,* and 0.3 percent as "Native American" (Durham Public Schools, 2002) The public schools attended by the Carrboro teens were in a much more affluent district where 71 percent of the students were classified as *white* and 6 percent as "Asian; African American" students were only 16 percent and *Hispanic* students were only 6 percent. The proportion of "Native American" students was similar to that of the Durham district (1 percent) (Public School Review, 2008).

MY OWN MIGRANT MEMORIES AND DESIRES

My biography and membership in the local Latina/o community is, of course, a double-edged sword. On one hand, it enabled me to grasp the story of the teens' transnational media experience from an insider's or *emic* perspective. On the other hand, however, it burdened my interpretation with the weight of my own memories of migration and with my aspirations for Latina/o youth. I came to the New Latino South in 1994, when the growing number of Latinos and Latinas started to be noticed. Soon after, I began to volunteer for grass-roots organizations serving low-income migrants. My years of volunteer work greatly informed my project. Especially informative was my work with a nonprofit organization that now produces a radio show by and for Latina/o teens. My years of volunteering also helped me to somewhat close the class gap that existed between the teens and myself. However, although I grew up poor in Mexico and my parents had little formal education, my mother's definitely middle-class disposition made a deep mark on my own *habitus*. As an upwardly mobile migrant, I did not have a neutral, but rather an uneasy, relationship with many of the media texts to which the teens attended. Surely sometimes it was hard for me to "bracket" my own middle-class aesthetic judgment when analyzing the teens' talk about such texts, and the astute reader will be able to see the class bias of my interpretations. On the other hand, my working-class upbringing and my experience as a Latina transnational migrant helped me to read meanings that may be hidden to researchers with other backgrounds.

What was most difficult to bracket were my migrant motherhood memories. My son came with me from Mexico to Texas when he was an 8-year-old and lived between two countries for many years. The stories of separation and yearning told by the teens, their resistance to being racialized, and their transnational adolescent struggles resonated very deeply with me. They brought about memories that inevitably colored the account that I have written. I have been careful not to project my own experience into their stories. Still, how can I tell that I did not read, for example, my own nostalgia when hearing their stories of separation from family, place, and culture?

ROLES AND RELATIONSHIPS

To promote active participation by the teens in the project, I relied on Paulo Freire's (1999) pedagogy, which advocates a problem-posing method in which students take a much more active role than in traditional educational methods. I explain Freire's pedagogy in Chapter Five; at this point it suffices to say that

because it is based on dialogue and centers on students' experiential knowledge, it made it possible for the teens to shape the actual implementation of the project. In addition, I sought input on the project's design from teens who were participating in the youth venture of the Durham nonprofit, from which I recruited several students. I incorporated most of their suggestions in my initial design. For example, I adopted their idea that teaching–learning materials should be in English, so the class would be an opportunity to learn English.

The dual agendas of action-research projects pose methodological as well as ethical dilemmas. My interactions as a teacher were colored by concerns about issues of reactivity and the validity of the data that I was gathering. Constantly, I had to balance the pedagogical needs of the class with my data-gathering demands. There were many occasions when I would have acted differently as a researcher if I did not have a second agenda as a teacher and vice versa. For example, when the teens insisted on venting their frustrations with their mothers, I acted as a teacher and let the conversation move away from my research goals.[1] Most of the time, our explicit roles were those of students and teacher, but the subject matter of the class and its Freirean pedagogical approach made possible less authoritarian relationships than those that typically develop in classrooms.

All of the teens, except for Leticia, had a pre-existing relationship with at least another student in their group, and Sabrina, Jennifer, and Stephany were sisters. I first met some of the teens when I was recruiting them, but I had met others before, while doing volunteer work. My positionality as a "concerned" professional Latina and the experience of migration that I share with them undoubtedly helped me to create a space where most teens felt safe to engage in intimate self-disclosure. From time to time, I had to remind them that I was recording what they said; on several occasions I turned off the recorder or redirected the conversation when I felt that—despite my efforts—some teens were revealing too much of themselves. Then, language usage was crucial for bonding. For example, Susana said she really liked the class "because I was able to express myself better." We constantly code-switched between English and Spanish, and on more than one occasion, they corrected my English pronunciation. Despite the important class differences between most of the teens and myself, their narratives sound very familiar to me. To use Gloria Anzaldúa's phrase, I share a "state of soul" with the teens that enabled me to bond with many of them (Anzaldúa, 1987/1999, p. 84).

PROGRAMS IN TRANSNATIONAL CRITICAL MEDIA LITERACY

For the Durham program, I had prepared curricula in advance (largely responding to the demands of my university's Institutional Review Board), but my aim was to set

up a Freirean *culture circle*, which is a space for students and teacher to discover *generative themes* that have deep meaning in the students' lives (Freire, 1994b). Generative themes are topics that embody major contradictions faced by the students in their everyday lives. I designed each class session around the generative themes that emerged from the preliminary analyses of the material that I had collected so far, and often I responded to specific requests of the teens. In the Carrboro program, I led activities that had proved to be effective with the Durham teens. In both programs, we met at the community organizations' facilities once a week for two hours, but the class itself lasted about an hour and a half. In Durham, we held twelve sessions and in Carrboro, five sessions. In addition, I met individually with nine Durham teens and with all five Carrboro teens. I audio-recorded the seventeen group sessions as well as the fourteen, 30- to 45-minute individual interviews. The field notes that I wrote during the Durham program recorded many thoughts that emerged in conversations with Kellie Toon, who acted as my teacher's aide/research assistant. She helped me to become reflexively conscious of phenomena that, to me, seemed trivial and self-evident, such as the code-switching that characterized class talk.

Typically, I would have the audio tape recorder running the entire session, and many times the teens helped me to change the cassette. My idea was to simulate a seminar classroom setting, but in a space that would feel safer for the teens than their schools. In what turned out to be a mixed blessing, the informal atmosphere of the youth programs from which I recruited participants was transferred to the class and shaped the teens' behavior. While the settings allowed me to develop good trust and rapport with most of the teens, it also presented methodological challenges. First, I had to work within the inherent limitations of after-school programs (e.g., participant self-selection). Second, to attend the class, the teens had to overcome a number of obstacles, the greatest of which was their dependence on family or friends for transportation. For the Durham teens, keeping their commitment to the class was especially difficult. The place where we held the class is in downtown, a location far from the students' neighborhoods and not particularly safe for young women. And third, most teens were involved in other extracurricular activities (most notably, dance lessons) and, as the semester progressed, they expressed concerns about conflicting schedules and lack of time to do homework for the class.

Rather than implementing the project through the public school system, I worked with nonprofit organizations because in the New Latino South, schools are settings where Latina/o teens are racialized and often ostracized (Palmer Unger, 2003; Wortham, Murillo, & Hamann, 2001). Also, critical media literacy has great potential for the citizenship and social justice efforts of organizations serving working-class migrants. In Durham, I worked with the youth venture of a large community organization, but my project's association with it came with some perils. A difficult challenge was that, because the nonprofit's own youth

program accepted almost any teen, it became difficult for me to screen out teens who did not match my ideal as potential participants. I was successful in screening out young men, but I had to accept young women from an age range wider than the 14- to 18-year-old range that I had planned. In addition, at least two of the students had special learning needs. Although this is not the place to talk about issues related to special learning needs, I should mention that anyone planning to carry out a media literacy program with a Latina/o community organization—and probably with any community organizations—should be prepared to deal with the challenges involved in managing a classroom with some students who have special learning needs. In the end, I was not able to balance the needs of students from different developmental stages, and Daniela and Gabriela, who were two of the most mature students, quit the class after the midterm. In Carrboro, I was faced with a similar situation; the oldest participant of this group, Beatriz, had poor attendance and acted uninterested in the class.

In action research, as with other naturalistic methods, the investigator has relatively little control over the direction of the study. In my project this translated into problems of attrition and absenteeism. These problems limited the amount of material that I gathered and it skewed the data set in favor of foreign-born teens. Nonetheless, my programs' attrition and absenteeism rates are not abnormal for programs in which attendance is not mandatory (Cooper, Charlton, Valentine, & Muhlenbruck, 2000), but they represent a methodological limitation of the project. In Durham, six teens attended between eight and eleven sessions, and the other six attended only about half of the program's class time. In Carrboro, three teens attended four or five sessions, but the remaining two attended only three sessions. As Paty later told the director of the nonprofit: *"El problema con esa clase es que fue muy corta"* (the problem with that class is that it was too short). I should note, however, that my analysis and interpretation draw heavily on my five years of volunteering with the Carrboro non-profit. My work with this organization has given me the opportunity to observe many Latina/o teens while they work and play in various settings, including while they produce and air a youth show at a local micro radio station.

GATHERING MATERIALS

The qualitative case study method encourages gathering materials through different means (Stake, 1995). I used field methods, especially participant observation and in-depth interviewing (Emerson, Fretz, & Shaw, 1995; Rubin & Rubin, 1979; 2004; Spradley, 1980). The bulk of the "media and popular culture talk" that I cite in the book comes from my field notes and from the transcripts of the seventeen class sessions and the fourteen individual interviews. Other material

that I gathered includes teens' class work and homework (e.g., media diaries and worksheets on media availability), and media artifacts that they brought to the class (e.g., CDs, advertisements, and magazines). Especially rich is the material gathered through two methods for eliciting *media narratives of self* that I developed borrowing from methods used in anthropology and sociology. They are the *media life calendar* and the *"who I am" collage.*

"Who I Am" Collage

The *"who I am" collage* method was inspired by my colleague Wendy Lutrell's (2003) anthropological study with pregnant teens.[2] The method is particularly useful for research with adolescents because, by encouraging them to produce a visual narrative of self, it enables them to articulate feelings and ideas that they might not have been able to put into words. Through collage-making, it was easier for the teens to compose rich narratives that took visual and subsequently verbal forms because they presented their work to the class in a sort of "show and tell" exercise. Each of the collages tells a unique story of subjectivity and belonging (see Figures 2 and 3). As a reflexive tool, the collage method almost compels participants to carefully think about the way they experience themselves as being, and to literally compose a visual representation of their belonging. Given that they actually produce the identity that they claim to represent, the making and public presentation of a *"who I am"* collage can be seen as constitutive acts.

In the first or second class, I asked teens to make collages about themselves. I gave them construction paper and asked them to cut and paste images from the media that they had at home. I chose not to provide materials such as magazines because I wanted to use the collages also as a means to learn how much print media were available to them. The idea proved fruitful. To construct their collages, only one of the most intellectually mature teens used a newspaper; most teens used both English and Spanish-language magazines, but the three English-dominant teens used only English-language magazines. Teens also used media that I had not considered. Some pasted images from direct-mail ads; three pasted photographs of themselves and significant others; some downloaded images from the Internet; most resorted to drawing their own images to express important aspects of their selves; and, most importantly, two pasted writings, written by someone else, that describe them. These writings demonstrate the importance that public identification plays in subjectivity (Martín Alcoff, 2006). Their choice of media sheds light on interrelations among their identities and their media and popular culture practices. For instance, Daniela, the teen who used the newspaper, was the most politically active of the group, and Leticia, one of the teens who used direct-mail

ads was one of the few fans of celebrities Mary Kate and Ashley Olsen, who are icons of middle-class, white girlhood (see Chapter Four).

To instruct teens about collage-making, I first had a class exercise in which teens looked at art books with reproductions of collages. Then Kellie or I demonstrated how we would do a collage about ourselves by pointing to images and words from magazines, and saying that we would use them in our collage because "all of these things represent some part of me." The teens followed our instructions closely; one of them even cut and pasted the word "represents." Yet, the demonstration was very interactive, and the teens' questions and comments influenced the resulting collages as well. Carmen's comment seemed to have the greatest impact in the Durham group. She said that the collage should express "who you *would like* to be." The *"who I am" collages* are profusely illustrated with images of these young women's desires. Sabrina, for example, went to great lengths to express her desire to become a physician; she cut and pasted the words "doctor" and "career," drew a stethoscope, and wrote underneath it: "I want to go to Medical School and become a family physician" (see Figure 4).

Even though we did not say much about media in the specific directions we gave, the teens clearly understood that we wanted to learn about the role of media in the building of their identities. Most collages contain codes of media. To my comment that her collage had as many as ten codes of media (see Figure 2), Lidia replied with some annoyance: "This is a class about media." Clearly, the determining factor was not so much the specific instructions that we gave for collage making, but the overall terms for structuring roles and relationships in the project. In the chapters that follow, I fully discuss the collages, yet I make few comments on the numerous images of cameras they contain because I told the teens that they were going to receive disposable cameras as part of the course's materials. Hence, they were highly primed to include such images.

With the exception of Carla, all teens created collages and fifteen presented them to the class. The sixteenth teen, Leticia, declined to do a presentation, but she explained it to me in private.

Media Life Calendars

To grasp the role of media in the multiple transitions that the teens were undergoing, I needed to gain a sense of their media practices throughout time. Thus I adapted a life calendar that has been used by sociologists to elicit people's narratives about specific aspects of their lives, for example, their occupational trajectories.[3] The instrument is a matrix with several columns, one for each of the categories of information sought, and usually dozens of rows, one for each year of the informant's life. Each completed media life calendar consists of several pages.

I wanted to gain a historically situated sense of the teens' media and popular culture practices. In other words, I wanted to elicit narratives describing these practices throughout their lives and in the context of memories of significant life events that the teens were willing to share with me. I therefore created the following categories for the matrix: year, age, place of residence, important family events, closest relationship, year in school, top leisure activity, work/home chores, favorite toy, favorite television show, favorite music, favorite reading, and extracurricular or church activities; for the program with the Carrboro group, I added the category "favorite movie" and made the matrix more user-friendly. The core categories sought information about media practices and turned out to be effective means for information gathering. I consider "favorite toy" a media and popular culture category because toys are texts that (re)produce cultural discourses, and media technologies can be seen as toys; for instance, in the column for favorite toy, Gabriela wrote "computer" and Carmen drew a tiny telephone. Further, current marketing strategies such as merchandising (which connects products with media, especially characters) make it difficult to separate toys from media. Sabrina, for example, noted in her calendar that, at age fifteen, her favorite toys were "TV toys," meaning figures of television cartoon characters. This category also elicited information that shed light onto the way the teens experienced their media and popular culture practices as interconnected. The remaining categories can be called "contextual," because the desired information is about the social and cultural context in which media activities occur. Some of the information gathered through contextual categories became the key to understanding practices and preferences. For example, for the category of family events, Natalia wrote "illness" in the cells for ages five to thirteen, and "dead" for age fourteen. Further, the only extracurricular activity that she noted was "altar girl" at ages eleven and twelve. When I asked her to elaborate on these answers, she told me a story of a childhood dominated by health concerns, spiritual healers, and Catholic rites. Her story illuminated her fascination with media content related to the occult, death, and the supernatural. It also illuminated her most recent interest in medical information.

We gave blank copies of the matrix to the teens, explained how to fill them in, and asked them to complete them as homework. All seventeen teens returned their completed matrixes, and I scheduled individual interviews with each of them. I told them that I wanted them to elaborate on their calendars and collages and that I would audio tape the interviews. In part because of logistical problems, I ended up meeting only with fourteen teens. Yet, I believe that one of the teens avoided the meeting because she did not trust me enough to tell me her life story. These methods ask for an unusual degree of self-disclosure that some participants may find objectionable. In my previous use of the method in the study of a network

of radio stations (Vargas, 1995), one of the employees asked me to fill up my own life calendar for him as a condition for his participation. He said that it was not fair to ask him to disclose personal information to me, if I was not willing to reciprocate the action. I did it and he agreed to participate. The teens did not ask me to do a calendar for them, but they did ask many questions, which I tried to answer truthfully, about my life, my previous books, and my interest in working with them. We held the interviews throughout the semester and by the time I sat with each of the teens to talk about her calendar, I had developed good rapport with them, and most of the gatherings were very intimate. Most turned out to be very emotional for them and for me. The calendar triggered painful memories that would have been difficult to elicit by other methods.

Challenge of Using the Collage and the Calendar Methods

The collage and the calendar methods brought many benefits to my project, but the use of these two methods pose major challenges for media communication researchers. One such challenge is related to general concerns about the validity of the data gathered. I tried to minimize such concerns by designing a project that allowed for triangulation; thus I was able to cross-check the narratives produced through collages and calendars with material that I collected through other field-work methods. While the calendar and collage methods tap both conscious and unconscious traits, the high degree of self-disclosure that they demand from participants requires a previous development of solid rapport and trust. Anticipating this problem, I designed after-school programs that would allow me to spend time with the teens in a setting familiar to them. Importantly, I chose to implement the project through nonprofit organizations rather than through the school system because the research on Latina/o schooling in the New Latino South shows that transnational teens do not experience schools as safe spaces (Palmer Unger, 2003). Moreover, I chose to work with a group with whom I have many things in common, such as gender, ethnicity, language, and migration experience. Nonetheless, the extremely short time of the Carrboro program was insufficient to meet this challenge, and I ended up with narratives that had many blanks, such as Beatriz's.

A further challenge had to do with analysis and interpretation of the narratives elicited through these methods. Some narratives, especially those in visual form, can be ambiguous or even cryptic. It is easy to read our own meanings, rather than the meanings that the participants encoded, into them. I asked the teens to help me make sense of their collages and calendars and thus the teens composed verbal narratives that were both more elaborate and less cryptic. Nonetheless, I do feel that I have not been able to tap into the most profound meanings encoded in these

narratives. The unconscious plays a significant part in the construction of narratives of self, and attempting to interpret them without the proper training is a risky endeavor. I have dealt with this issue by being vigilant against the temptation to interpret ambiguous signs. Finally, again because these methods tap into unconscious feelings, the teens' narratives express parts of their lives and selves that, years later, they may regret having shared with me. I rely on a feminist epistemological stance, which requires care and respect for the participants and ethical use of the data collected. That is why I keep confidential any information that may hurt them, such as comments about sexuality.

INTERPRETING AND WRITING

Excluding the field notes written by Kellie and by me, the materials are self-reports on media preferences and behavior gathered within the context of media literacy programs. I use grounded theory's technique of *constant comparison* of data (Strauss & Corbin, 1998) and I interpret all materials in light of its context of production. More than anything, I have tried to avoid taking data at face value. I see the collage-making and the teens' talk as *performative*. As signifying practices, collage-making and media and popular culture talk are means through which the teens "did," as Butler would put it, gender, race, class, and nationality for their peers and for me, in the particular, structuring framework of my project. Given that an essential feature of such performances was their distinct speech, I quote excerpts as they were uttered, oftentimes in Spanish, sometimes in English, and sometimes combining both languages. Also, I keep the original excerpts for bilingual readers, so they can further ascertain the soundness of my interpretations. All translations are my own and they are likely to reveal that Spanish is my native tongue.

On more than one occasion, it became clear that the teens were responding to my inquiries as students trying to give the "correct" answer to a teacher rather than responding as participants engaging in a genuine exploration of their actual practices. I believe that I was fairly able to discriminate between comments that were socially desirable within the framework of the class, and more spontaneous comments (Strauss & Corbin, 1998). For example, Isabel and Lidia wrote on their television worksheets that they "never" watch television, but later, when we held a group discussion about *telenovelas*, they had this exchange:

Natalia: *¿Cúal es el nombre de la telenovela que están pasando ahora?*
Lidia: *¿Juego de la Vida?*
Natalia: *Sí.*

Lidia: *Y eso que yo no veo la televisión (se ríe).*

Isabel: *¿Qué es lo que no ves?*

Lidia: *Que no veo la televisión pero me lo sé todo.*

Isabel: *Yo también.*

Natalia: What's the name of the *telenovela* that is showing now?

Lidia: *Juego de la Vida?*

Natalia: Yes

Lidia: And this is that I don't watch TV (laughs).

Isabel: What don't you watch?

Lidia: That I don't watch TV, but I know everything.

Isabel: Me too.

The exchange shows that Isabel and Lidia recognized the contradiction between their previous assertions about not watching television, and the fact that they knew which *telenovelas* were showing at the time. They also knew the plots and characters, which obviously meant that they were watching television and that the answers that they had written in their worksheets were the "correct" answers and not the truthful answers. The teens mentioned, repeatedly, that their teachers at school did not think very highly of television watching. An important way in which I tested my evolving explanations was that, when doing the fieldwork, and especially when analyzing materials, I reflected on my own assumptions about the teens' media practices, and I sought disconfirming evidence. The most obvious example is that I expected that they would be avid magazine readers, but I found plenty of evidence disproving this expectation and frustrating my plan to produce a homemade magazine with the Durham teens.

Interpreting the collages was not easy. I draw on feminist scholarship (Jones, 2003) and other literature on visual culture and representation (Pieterse, 1992; Sturken & Cartwright, 2001), and on the use of images in qualitative research (Prosser, 1998; G. Rose, 2001). But most of all, my interpretations hinge on the constant comparison of the teens' explanations of their own work with other material that informed my research. Naturally, it is up to the reader to judge the merit of my interpretations.

Exploring the role of media and popular culture in the teens' processes of subject formation requires a previous analysis of the public identity that such media assigns to Latinas. In late modernity, the mass media have become, arguably, the major site for the production and reproduction of public identities. They are one of the sites where the social construction of Latina/o public identities is mystified, and where outlandish stereotypes are naturalized. Therefore, before describing the

teens' media and popular culture practices, in the next chapter I examine the representations of *Latinidad* and Latina womanhood that populate the teens' popular culture landscape. The metaphors, language, and imagery deployed by the four traditions that traverse this landscape are essential symbolic resources for transnational teens who are developing adult U.S. Latina subjectivities.

Representations OF *Latinidad* AND Latina Womanhood

The public identity of the teens was largely shaped by the meanings of *Latinidad* in general, and of Latina womanhood in particular, that circulate in the four popular culture traditions that saturate their quotidian experiences. In turn, the teens' emerging subjectivities as Latina young women were being developed against the backdrop of these mediated constructions. Thus, in this chapter, I summarize the major features of mass mediated representations of *Latinidad* and Latina womanhood in each of the traditions. As I describe below, different constructions play against each other in the teens' popular culture landscape in a way evocative of Edward Said's (1994) use of the counterpoint metaphor. Roger Silverstone's clarification of what it means to understand the diasporic media landscape as contrapuntal is useful here. He says that such understanding "involves hearing, rather than seeing, the various manifestations and expressions of different cultures as intermingled and intertwined, as both present and absent, and as constantly shifting in their relations of domination and subordination" (Silverstone, 2007, p. 82). I begin the chapter by talking about the representation of *Latinidad* and Latina womanhood in the Anglo hegemonic tradition. Then I move on to discuss the representation of Latina womanhood in both the Latina/o and the global Spanish-language traditions. Given the scarcity of research on the representation of *Latinidad* in the black tradition, I leave this topic for the last part of the chapter.

HEGEMONIC REPRESENTATIONS

Despite the plethora of other cultural resources available to Latina/o transnational youth, the Anglo media and popular culture are key providers of imagery and meanings for Latina teens. Language was not a barrier for accessing English-language media for the majority of the teens. In Chapter Four I fully describe that they listened to popular Anglo artists, such as Eminem and the Backstreet Boys, and most of their favorite films were Hollywood productions. Representations of white womanhood were certainly relevant for teens like Stephany and Susana. Although this is not the place to review the extensive scholarship on the topic, I must point out that, despite the major shortcoming of such representations, white women have been portrayed in much more variegated ways than Latinas. From Bette Davis's strong female roles to *Xena: Warrior Princess,* the representation of white womanhood has included powerful images. However, the identification of Latinas with white womanhood is not always easy. At this juncture my own migrant viewer experience may shed light into the troubled relationship that some Latinas have with representations of white womanhood in the Anglo tradition. As girls growing up in Mexico in the 1960s, my sister and I worshiped the images of *Gatubela* (Catwoman) and *la Mujer Maravilla* (Wonder Woman), and other commanding female figures that we found in comic books. My identification with white womanhood, however, was painfully interrupted after my migration. For example, a few years ago I enjoyed watching *Oh Baby,* a sitcom that ran on the Lifetime cable channel. It is about a single, middle-aged, working woman who chooses to have artificial insemination to have a baby. Many situations in the show reminded me that it was a show about white, not Latina women, but such awareness did not keep me from enjoying the sitcom and often identifying with the protagonist. But when her mother's Latina maid was introduced, I could not keep watching anymore. The fact that a Puerto Rican maid was the show's only Latina character abruptly interrupted my pleasure and made me angry. The character forced me to read the sitcom contrapuntally; it became impossible to not read the history of Puerto Ricans's subordination along with the sitcom's pun lines. Because, almost invariably, in Anglo texts *Latinidad* is represented as the Other, it was very difficult for the teens not to experience themselves as Others. Stuart Hall articulates this point much better than I can:

> Not only in Said's "orientalist" sense were we constructed as different and Other within the categories of knowledge of the West by those regimes. They have the power to make us see and experience *ourselves* as "Other." Every regime of representation is a regime of power formed, as Foucault reminds us, by the fatal couple "power/knowledge." It is one thing to position a subject or set of peoples as the Other of a dominant discourse. It is quite another

thing to subject them to that "knowledge," not only as a matter of imposed will or domination, but by the power of inner compulsion and subjective conformation to the norm. (Hall, 1990, pp. 226–227)

The regime of representation of the Anglo tradition of media and popular culture positions Latinos and Latinas as Other, but it makes important racial distinctions. This tradition has (re)produced the ambiguous dual classification system that governs everyday interactions. While in general, light-skinned, upper-class individuals with European features have been accorded some sort of honorary white status (like for example, *I Love Lucy's* Ricky Ricardo), the vast majority of Latina/os have been constructed as denizens, racialized subaltern subjects. Historically, the two most consistent findings in the research on the Anglo tradition are that we have been nearly invisible, and that when we have been included in news or entertainment content, the portrayal has been packed with stereotypes. The representational patterns of the Hollywood construction of *Latinidad* are the pillars of subsequent representations on television and other visual media. Charles Ramírez-Berg identified six enduring cinematic images of Latinas and Latinos: the Bandito, the Half-breed Harlot, the Male Buffoon, the Female Clown, the Latin Lover, and the Dark Lady. Ramírez-Berg argues that "by and large, Hispanic stereotypes, and the traits that define them, essentially have not changed over the decades. Rather, they exist as repetitive variations played upon too-familiar themes" (Ramírez-Berg, 1997, pp. 116–117). These stereotypes are directly tied to race and class. In general, while light-skinned Latinas have played variations of the upper-class Dark Lady, the staple of dark-skinned Latinas has been the role of a working-class, hypersexualized woman, often a prostitute, maintains Carlos E. Cortés. According to him, the most obvious trait of the cinematic portrayal of Latinas has been sexualization. The Chicana prostitute, says Cortés, is "a regular feature of the American Western" (Cortés, 1997, p. 131). Carmen Huaco Nuzum (1996) argues that, by erasing the cultural specificity of national groups, sexualization and racialization have rendered all Latinas into the "sexually provocative generic Latina" epitomized by the spitfire. Certainly a prevalent stereotype, the spitfire was established by Lupe Vélez, "the Mexican spitfire," who starred in blockbusters of the late 1930s and early 1940s. "The image of Vélez as an 'exotic' object of desire is exemplary of Hollywood's depiction of the Latina as an exotic commodity," states Huaco Nuzum (1996, p. 263). In contemporary cinema, many actors are cast in roles that, although more complicated, are clearly reminiscent of old stereotypes; this trend is illustrated, for example, by Puerto Rican Rosie Perez's frequent role as a spitfire (Valdivia, 1998).

Frances R. Aparicio notes that "*Latinidad* has been partially defined as the ways in which the entertainment industry, mainstream journalism, and Hollywood have homogenized all Latina/os into one undifferentiated group, thus erasing our

historical, national, racial, class, and gender subjectivities" (Aparicio, 2003, p. 91). The metaphoric identification of Latin America and the Caribbean with the tropics has been a central source of meaning for *Latinidad* (Aparicio & Chávez-Silverman, 1997). The Hollywood figure who established this cinematic representation in the 1940s was Brazilian star Carmen Miranda. On describing Miranda, Ana López points out the deployment of excess to depict "Latiness." She notes that Miranda's performance was based on a rhetoric of both aural and visual excess and that through her films Hollywood inscribed "Latin Americaness as tropicality" (López, 1991, p. 416).

Not less than Anglo popular culture, Anglo journalism has represented *Latinidad* in a similar way in which Egyptology represented Egypt "as if there were no modern Egyptians but only European spectators" (Said, 1994, pp. 117–118). By and large, Anglo journalism represents *Latinidad* as if there were not millions of Latina/o spectators in the United States, plus hundreds of millions of Latin American and Caribbean spectators beyond the country's physical borders. A growing body of scholarship supports my claim (see Navarrete & Kamasaki, 1994), but a telling study, released one year before the time of my fieldwork in Durham, investigated the inclusion of Latina/os in major network television. It found that only 42 of the sample's 1,477 characters were Latina/os, and that only eight played primary characters. Only 18 characters (1 percent) were Latina/os, and two-thirds of them were nonrecurring characters. The secondary status of Latina/os was also indicated by the low-status occupations held by the majority of these characters. Most Latina characters were cast as nurses or maids, or as criminals or victims of crime (Children Now; National Hispanic Foundation for the Arts, 2001, pp. 2–7). In my own research on the coverage of Latino news by the major newspaper in North Carolina, I found that the coverage genders Latino news as womanish and (re)produces the stereotype of Latina/os as an underclass (Vargas, 2000). By and large, more recent studies confirm old familiar findings. For example, a study on the news coverage of Latina/os in 2005 found that only 18 stories, or 1.2 percent of the total 1,547 stories, were predominantly about Latina/os (Gabrilos, 2006, p. 3). Concurrent to this invisibility, nativist discourses targeting Latina/os have become much more transparent in the Anglo tradition. They are a commonplace of conservative radio and white supremacist Web sites, but one can find evidence of nativism even in so-called "liberal" media such as CNN. Most notably, every weeknight, pundit Lou Dobbs has been tracing the roots of numerous social and economic problems that besiege the United States to the country's "broken borders." This scapegoating has brought to the forefront the despicable representations of Latina/o immigrants that previously were somewhat covert in the Anglo tradition's imaginary. In his brilliant discourse analysis of *The Los Angeles Times*, Otto Santa Ana (2002) convincingly argues that, in U.S. public discourse, the dominant metaphors for both immigration and immigrants

are "immigration as dangerous waters" and "immigrant as animal." The extremely negative connotations of such metaphors are evident in the images that recurrent phrases like "the relentless flow of immigrants" invoke, as well as in press coverage that describes the informal labor market as "employers hungering for really cheap labor hunt out the foreign worker" (Santa Ana, 2002, p. 84). Another metaphor that, according to Santa Ana is widely used in the public discourse on immigration, is disease. One of my students found these familiar metaphors in North Carolina community newspapers:

> Opinion pieces in *The Mint Hill Times* further dehumanized undocumented immigrants by referring to them as animals or carriers of disease. Carmine Croce used words like "flocking," "droves," and "track them" to describe immigrants, the same words that might be used among hunters during pheasant season. Marty Pearsall's use of the word "swarming" conveys insect imagery, and he highlighted the "burden" of "unvaccinated children" carrying "whooping cough, measles and mumps, and other diseases." (Szarek, 2008)

The metaphor of Latina/o immigration as disease has been widely circulated in entertainment media. For instance, Maria V. Ruiz (2002) argues that the Anglo tradition constructs the immigrant body as "diseased, contaminated, rapidly multiplying, and otherwise disorderly." A telling example that she offers is the construction of Latina and Latino migrants in the film *Men in Black*. The film opens with a scene in which:

> an alien from another planet travels literally inside the body of a Latino illegal alien in order to cross the border from Mexico into the United States. He is intercepted and shot down by the "Men in Black," a "special division of the INS" whose decontamination team is then called in to torch the area...[the film] symbolically positions Latinos—the quintessential border-crossers—as foreign and as the objects of global (in this case, intergalactic) policing. (Ruiz, 2002, pp. 42–43)

In this film, thus, the depiction of the Latina/o body as undisciplined, and of *Latinidad* as a menace that must be controlled, reaches intergalactic proportions. The popularity of such extreme cultural expressions of the impulse to control Latinas and Latinos speaks of the intensity of the fears and apprehensions regarding the demographic growth and our rising political and economic power.

Representations of Latina/o Youth

With few exceptions, Latina/o youth have been represented in hideous ways in the Anglo tradition. Yosso quotes a transnational young Latina as saying about this

representation: "I never really thought that we were being portrayed in a good way…basically a lot of Latinos being portrayed as gang members or drop-outs, getting pregnant, for girls, at a young age, and for guys just going out there and joining a gang…I think that's most of the things that I saw on TV" (Yosso, 2002). Her comment resonates with research findings on the topic. The Latino gang film is emblematic of Hollywood's tradition of portraying Latina/os as aggressive and hot-tempered, and it also illustrates the role of the Anglo media in the dominant society's efforts to render void the resistance identities generated by Latina/o youth formations. Early films about Puerto Ricans, such as *The Young Savages* (1961), established a genre characterized by the demonization of Latina/o inner-city gangs, a representation that becomes even more salient against the backdrop of the otherwise near invisibility of Latina/o youth in the hegemonic public discourse. Cortés (1997) argues that the genre contributes to the cinematic tradition that equates Latina/os with violent behavior. Numerous authors have written about the criminalization of youth of color and the racialization of youth violence in the United States (Cross, 1993; Giroux, 1995). Analyses of youth subcultures of the *barrio* stress that the media have played an instrumental role in shaping public opinion, as well as in legitimizing the heavy-handed policing approach toward Latina/o youth. The most remarkable example of the representation of youth subcultures of the *barrio* as evil is the coverage of the so-called "Zoot Suit Riots." Historical analyses of the tragic events that took place in Los Angeles, California, in 1943, have shown that the media demonized *pachucos* and twisted the facts to create a story of the incidents that fit such demonization (Escobedo, 2007; McWilliams, 1949; Obregón Pagán, 2003). The *pachuco* identity was, in Manuel Castells' (2004) categories that I discuss in Chapter One, the first project identity articulated by Latina/o youth. In an excellent essay on the young women of this formation, Elizabeth Escobedo points out that "by subverting mainstream consumer culture and visibly expressing discontent with the dominant society, *pachucas* created a racialized collective identity that helped many Mexican American women to escape their feelings as outsiders in the United States by claiming an identity *as* outsiders in the United States" (Escobedo, 2007, p. 150).

The stereotypical representation of Latina/o youth has also been documented in analyses of later formations, such as California's low riders, the Chicano teen movement, and the Young Lords Organization of Puerto Rican street gangs (Brake, 1985, pp. 129–132), not to mention the most recent decontextualization and subsequent demonization of homegirls and homeboys (Moore, 1991). Scholars like Raúl D. Tovares (2002) underscore that in the Anglo media, while the organized and systematic violent behavior of white, middle-class youth groups, such as college fraternities, is never labeled as "gang activity," the illegal behavior of minority youth formations is almost invariably demonized. On his detailed study

of the "gang discourse" of local television news coverage of Mexican American youth, he concludes that "the Mexican American youth problem as it appears on local television news is a myth... reports about a growing gang problem and increasingly violent gang members speak more to the fears of suburban middle-class citizens, about the growing number of minority youth in large metropolitan centers, than to any documented evidence about qualitative changes in inner-city minority youths" (Tovares, 2002, p. 163).

Of course, Tovares is not arguing that there are no organized groups of Mexican American youth who engage in violent and illegal behavior in Austin, Texas, which was the setting of his study. What he argues is that the television news narrative on this youth is grounded more on historical hegemonic popular culture narratives about Mexican Americans as a threat, than on what, according to the local police officers that he interviewed, actually happens in Austin. The gang narrative, Tovares explains, soothes the apprehensions of the white, middle-class viewers that television stations sell to their advertisers (2002, pp. 163–168). The gang narrative has been widely used in the most recent moral panic about Latina/o youth: the infamous transnational gang Mara Salvatrucha. As Narváez Gutiérrez (2007) fully documents, the transnationalization of the Mara is an unintended consequence of failed U.S. policies. Rather than addressing the root causes of the Mara's formation, such as discrimination, unfunded schools, and lack of economic opportunity, the state decided to deport rebellious young people who have been raised in Los Angeles to El Salvador, their country of birth. Feeling completely out of place in El Salvador, they resorted to any means possible to return to the place where they were raised: Los Angeles. Rather than contributing to the public understanding of these young people and their actions, notes Narváez Gutiérrez, the press has contributed to mystifying the forces and conditions that originated the problem.

In an essay on the shameful representation of public schools and teens of color in a series of Hollywood films of the late 1990s, Henry A. Giroux reviews *187,* a film set in a Los Angeles high school where most teens are Latinos and Latinas. He says that films like *187* "carry the logic of racial stereotyping to a new level" by presenting denigrating images of Latina/o youth and inner-city schools while ignoring the political and economic factors that bring forth the social maladies portrayed. "Decontextualized and depoliticized, Hollywood portrays public schools as not only dysfunctional, but also as an imminent threat to the dominant society. Teens represent a criminalized underclass that must be watched and contained through the heavy-handed use of high-tech monitoring systems and military-style authority" (Giroux, 2000, p. 77). In a similar vein, in a study of the representation of youth gangs in Santa Cruz, California, Tim Lucas quotes from a local teen publication that sharply commented on the stereotypes of Latina/o

youth circulated in the local media: "They are everywhere: hanging out in front of coffee shops on Pacific Avenue, violating city law by sitting on curbs, smoking cigarettes around the corner, having unprotected premarital sex, spraying graffiti all over the place, and pretty much heading for a quick trip to nowhere. Nowhere, that is, if you look at them through a lens of mainstream media negativity" (Lucas, 1998, p. 145).

Lucas points out that the demonization of Latina/o youth subculture at the local level is achieved by associating them with issues that are already problematized at the national level: "drugs, gun violence, graffiti, and gangsta culture," and one should add "teen pregnancy." Rosa Linda Fregoso (1995) argues that, in line with the gender bias of most research in youth subcultures, *pachucas* and *cholas* have been largely neglected in the research on Latina/o youth subcultures. Scholars in fields other than media communication studies are also voicing concern about the historical representational patterns of Latina teens in scholarly writing. Jill Denner and Bianca L. Guzmán edited *Latina Girls* with the purpose of challenging the hegemonic representation of "the troubled Latina girl" in research. As they correctly observe, "most research still focuses on the risks in Latina girls' lives, not on the ways these girls are succeeding." In an effort to correct this bias, the anthology compiles "social science research that focuses on the positive aspects of Latina girls' lives" (Denner & Guzmán, 2006, p. 10).

Contemporary Challenges to Hegemonic Representations of Latinidad

Along with the demographic growth of the Latina/o population, our growing political, social, economic, and cultural power has been upsetting the traditional politics of representation in the Anglo tradition. One such fundamental challenge has been the emergence of the construction of Latina/os as the "Hispanic market." For marketing and advertising purposes, by the early 1980s the Latina/o population came to be seen as a niche market with three regional segments (Mexicans, Cubans, and Puerto Ricans). But by the early 1990s, advertising agencies and Univisión advanced the notion of a national, more or less homogeneous "pan-Hispanic market" (Rodríguez, 1999). Hence, against the enduring, depressing representations of Latina/o youth that I discussed above, marketers have been advancing the notion of the "youth Hispanic market" or "generation ñ." Since the mid-1980s, the importance of teens as a market in the United States—regardless of race and ethnicity—has been growing as their buying power increases. Many U.S. teens have large disposable incomes and also play a significant role in their families' decisions about purchases (La Ferle, Li, & Edwards, 2001, p. 7). Marketers such as the Ruido Group, a Latina/o youth-focused public relations and advertising agency, have underscored the purchasing power of this youth

(Project 2050, 2008). Marketing gurus like Betty Ann and Felipe Korzenny (2005) stress that Latina/o youth influence the spending of their households to a higher degree than youth from other demographic groups. Naturally, marketers are interested in constructing Latina/o teens as consumers rather than as citizens, and their conceptualization of Latina/os as one single market erases differences among various national groups, yet the "youth Hispanic market" marketing concept requires favorable representations of Latina/o youth.

A second challenge to the Anglo politics of representation has been posed by organized Latina/os working in the media and popular culture industries, who have become more and more vocal in their demands for both fairer representations and larger inclusion of Latina/o talent in these industries. They have joined forces with other Latina/o advocacy organizations that recognize the crucial role that representation plays in the larger struggle for social and economic justice. A major concern of these organizations is the detrimental effect that negative representations can have on Latina/o youth. The National Hispanic Media Coalition, for example, seeks to change the hegemonic representation of Latinos and Latinas because "unless we end this [media] bias against Latinos, the present generation of Latino youth will grow up viewing largely negative images of themselves and they will develop poor self-esteem" (National Hispanic Media Coalition, 2008).

A third, more ambiguous, challenge to the familiar patterns of near-invisibility and criminalization has been the success of crossover artists like Shakira and Ricky Martin, two of the teens' favorite performers. The Anglo tradition seems to be having a contradictory relationship with *Latinidad*. Hegemonic constructions of *Latinidad* have been complicated by the aggressive commodification and subsequent popularity of Latina/o and Latin American artists and performers among non-Latina/o audiences. As Beltrán argues, while representations of crossover performing artists "can involve elements of commodification, such media representations also always contain the potential to upset the primacy of whiteness inherent in the Hollywood star system" (Beltrán, 2002, p. 80).

Frances Aparicio notes that "the term *Latin music boom* deflects the social, demographic, and cultural realities of everyday life among U.S. Latinos and replaces what is socially real Latino with historically familiar, acceptable, and contained images of Latinos that the U.S. can integrate into its own logic" (Aparicio, 2003, p. 92). The success of Jennifer López (or J Lo) is a case in point. Since López was launched into stardom playing Selena in the biographical film *Selena* about the Queen of Tejano music, the two performers at times acted as the same sign of Latina womanhood. Angharad Valdivia examines competing constructions of Latina womanhood through a comparative analysis of López and another celebrity with an opposing signification, Penélope Cruz. López is of Puerto Rican descent and was born in New York; Cruz is a Spaniard. According

to Valdivia, while the representation of Jennifer has focused on her curvaceous body, especially on her "butt," the representation of Penélope has been much more complex. While these representational practices, argues Valdivia, associate López with nature, sexuality, the lower classes, and the racialized Other, they link Cruz with culture, the upper classes, and a much less sexualized and racialized Other (Valdivia, 2007). With her "incorrect" Spanish, her hypersexualized body, and her Puerto Rican heritage, López embodies the U.S. historical fears of miscegenation as well as the hypersexuality attributed to women of color in the Western represen-tational tradition (Pieterse, 1992). In Chapter Eight I explain that teens like Natalia invoked the hypersexuality embodied by Jennifer López, yet in the material that I gathered, there is no mention of Penélope Cruz. Such absence suggests that the image of upper-class Penélope had little relevance for them.

All of this notwithstanding, authors like Beltrán argue that Jennifer López cannot simply be considered simply a Hottentot Venus. López's star image is evidence of her "role and social power as an active agent in the star-making process and most importantly of changing cultural standards within the mainstream media as a whole" (Beltrán, 2002, p. 83). As Beltrán argues, in the contemporary moment the representation of *Latinidad* may not be as containable as it was before. Along the historical patterns of limited and stereotypical images, when Latina/o bodies take central stage and Latina/o performers display their creativity and agency, the imaginary of the Anglo tradition is fractured and atypical constructions of *Latinidad* infiltrate and gain ground. An outstanding example of transformative representations of Latina womanhood in Anglo media and popular culture is the global success of actor and producer Salma Hayek and her 2000 film *Frida,* which narrates Mexican painter Frida Kahlo's life. Kahlo's queer, feminist, and Marxist politics, as well as her unique art and the eccentric public persona that she created for herself, personify a radical nontraditional femininity. In her analysis of the popular discourses about *Frida,* Hayek, and Kahlo, Isabel Molina argues that such discourses "disrupt some of Hollywood's symbolic boundaries surrounding ethnic-ity, race, gender, nation, and sexuality" (Molina Guzmán, 2007, p. 125). Texts like *Frida* are inherently hybrid, not quite the products of the Anglo tradition yet neither the products of the Latina/o or the global Spanish-language tradition. Their hybridity itself signals the transformation of hegemonic notions of Latina womanhood. *Frida* was released at the time of my fieldwork in Durham, and several teens said that they wanted to see the film. However, they did not talk about having actually seen the film, and I failed to follow up. The film is rated for adults only, and thus it is unlikely that any of them were able to watch it before its release on video.

The last challenge is the Latina/o-themed television programming catering to general audiences that began to appear in the year 2000. Most notably, the cable

children's network Nickelodeon began to air the family sitcom *The Brothers García* and the hugely successful animated series *Dora the Explorer*; cable network Showtime started to air the drama series *Resurrection Boulevard*. Also unprecedented was ABC's launching of the sitcom *George López* in 2002. When Showtime was reconsidering *Resurrection Boulevard*, a broad national campaign to save the show was organized by, among others, the major Latina/o advocacy organizations, The National Council of La Raza. Its president, Raúl Yzaguirre, said about the significance of the show:

> Showtime's "Resurrection Boulevard" is a show about a family living in East Los Angeles, California. There is nothing extraordinary about this family; they are loving, decent, and hard-working. But "Resurrection Boulevard" is far from ordinary. It is historic—it is the first-ever drama series focusing on a Latino family on primetime television. It is unique—it is currently the only drama series about Latinos on television. (Yzaguirre, 2002)

Yzaguirre's compelling statement gives a sense of the weight that the symbolic construction of *Latinidad* carries for the broader Latina/o struggle for social and economic justice. Having a Latina/o family appear on cable television was a historic event because, as opposed to the cable networks, the Anglo broadcast national television networks and Hollywood still consider it too risky to cast Latina/os in primary roles. Sadly, despite the campaign, *Resurrection Boulevard* was canceled (Wible, 2004). Almost two years after I concluded my fieldwork, the ABC network launched its phenomenally successful *Ugly Betty,* a dramedy that features América Ferrara as the main character. Ferrara's Betty is an aberration in the casting of main characters in Anglo media. Notably, Betty's Mexican American family is central to the plot, including her father who is an undocumented immigrant. Media critics have rushed to say that the series opens a new era in Anglo television for "first-generation Americans who can see themselves in Betty because of their similar struggle to fit into American culture" (Barney, 2007). The effect that the series, as well as the increasing number of Latina and Latino actors in other shows, might have in the hegemonic representation of *Latinidad* in the Anglo tradition remains to be seen. Despite its success, in 2007 ABC recently canceled the *The George López Show,* and CBS canceled its first-ever Latina/o-centered drama *Cane* after one season.

Then again, it would be erroneous to argue that the hegemonic construction of *Latinidad* has not become a contested terrain. One can now see, for example, extremely articulate Latina/os like Ray Suárez hosting the prestigious evening newscast of the Public Service Broadcasting *(The News Hour with Jim Lehrer).* Also, there is some evidence that we are othered less often in the news today. For example, the news magazine study that I quoted above also found that

nearly 14 percent of the total coverage "mentioned (or referenced) at least one Latino," without stressing their ethnicity, in other words, these Latinos and Latinas were represented as regular members of the U.S. polity (Gabrilos, 2006, p. 6).

LATINA WOMANHOOD IN THE GLOBAL
SPANISH-LANGUAGE TRADITION

Given that they live in a country with one of the highest rates of media availability in the word, Latina teens are constantly exposed to cultural commodities produced for the global Spanish-language market. These commodities are available through both U.S. Spanish-language media and other outlets, such as television via satellite, and music and video recordings produced in Latin America and the Spanish Caribbean that are available at local *tiendas* and even at big chain stores like Walmart. Because media reaching the Spanish geolinguistic market are often intertwined with the U.S. Latina/o media, it is difficult to distinguish between the two traditions and their corresponding imaginaries, but the global tradition's artifacts and texts have their own characteristics, many of which respond to the producers' need to cater to supranational audiences. Spanish-language media in the United States have often carried content produced in Latin America (e.g., Mexico, Colombia, and Venezuela), but a whole new transcontinental system began to emerge by the mid-1980s, due in part to state implementation of the deregulatory, neoliberal policies known as Reaganism and Thatcherism, and the subsequent processes of integration of the global economy. These processes facilitated the conglomeration and concentration of media ownership and smoothed the path for mergers of, and joint ventures by, companies from two or more countries, such as Mexico's Televisa and Murdoch's News Corp (Paxman & Saragoza, 2001), As Vincent Mosco and Dan Schiller indicate, "new patterns of economic practice throughout the culture and communication sector" operate in the Americas since the 1993 North American Trade Agreement (Mosco & Schiller, 2001, p. 40). It was also due to the advent of new communication technologies, especially the convergence of digital and satellite technologies, that made possible marketing and selling the same commodities to an entire geolinguistic market. Finally, global Spanish-language media and popular culture were encouraged by new lifestyle consumer constituencies, whose emergence is due, in part, to the same media and popular culture.

The global Spanish-language tradition interpellates working-class transnational Latina teens in complicated ways. As opposed to the Anglo tradition, the former

offers them powerful representations of *Latinidad*. Yet global Spanish-language tradition is a product of post-colonial societies, and therefore its imaginary holds dear ideas and beliefs about white supremacy (see Chapter Eight). In accord with the colorism that regulates social life in the region, the media and popular culture depict dominant *Latinidad* most often by light-skinned bodies, while subaltern *Latinidad* is nearly always embodied by dark-skinned bodies—unless, of course, the poor protagonist happens to actually be the child of a wealthy character.

In accord with the region's rigid patriarchal regime, the denigration of women, especially of dark-skinned women, is common in the global tradition. With respect to the most significant medium for the teens, music, although some popular women artists have introduced feminist themes into their lyrics, there is a strong tendency in the bulk of the music production to denigrate womanhood. In her study of the representation of women in Mexican Tejano border songs and Trinidarian *calypsos*, Zena Moore found that women "are depicted as tenuous sources of love and happiness. At best, they are objects of pleasure to be exploited, or animals without souls to be brutalized and beaten into submission" (Moore, 1999, p. 230). Her findings reflect the violent control of women encouraged by contemporary compositions catering to working-class audiences. In 2007, several U.S. television shows refused to play a music video by the popular Mexican band Montéz de Durango because of its demeaning treatment of women and its naturalization of domestic violence (EFE, 2007). The video has been playing in Mexican television with no major objections.

One of the global media offerings most attractive for the teens in my project were *telenovelas*. In fact, in the material that I gathered, *telenovelas* are the topic most frequently mentioned. Thus, here I concentrate on these texts, which are the staple of the two U.S. national Spanish-language networks, Univisión and Telemundo. The economic, social, and cultural weight of *telenovelas* is huge and global, and they are a major cultural export of countries like Brazil and Mexico. About the time of my fieldwork, the global media conglomerate Televisa had 10.9 percent stake in Univisión, and it was the main supplier of *telenovelas* for Univisión. According to Clemens, "Televisa provided 34 percent of Univisión's programming and close to 80 percent of its prime-time lineup in 2003" (Clemens, 2005).

Telenovelas are melodramatic serials somewhat similar to U.S. soap operas, but they end after 120 to 200 episodes and are not limited to daytime television. Most often, *telenovelas* are woman-centered stories, and they are seen as television for women and the uneducated *clases populares*. *Telenovelas* aired during primetime often get the highest ratings. Scholars distinguish between the traditional *telenovela* and the *telenovela de ruptura*. While the former is a conventional rags-to-riches story of heterosexual love in a Manichean world where good fights evil

(Martín Barbero, 1987), the latter addresses social and political issues. It breaks the Manichean arrangement of the traditional *telenovela* and features "complex characters that are both ambiguous and unpredictable" (Acosta-Alzuru, 2003, p. 194). Although *telenovelas de ruptura* deal with thorny issues, such as domestic violence, abortion, and even homosexuality (Acosta-Alzuru, 2003), the vast majority of *telenovelas* (re)produce Latin American hegemonic class and racial systems of inequality, and celebrate patriarchal values and heterosexual sexuality. The representation of womanhood in the traditional *telenovela* reflects the genre's Manichean oppositions. Julee Tate describes the two models of womanhood that *telenovelas* offer: "The good woman is self-sacrificing, decent, and sexually pure, or at least monogamous. Meanwhile, the bad woman is just the opposite; she is ambitious, indecent, and sexually promiscuous" (Tate, 2007, p. 97). Tate argues that a "simple maternity test" tells the two kinds apart, because while the good woman is maternal above all, the "bad woman does not see motherhood as an essential element of her identity. In fact, in most instances she views having children as an impediment to her own goals and self-actualization" (Tate, 2007, p. 97). The audience uses of *telenovelas* have intrigued numerous scholars (González, 1994; McAnany & LaPastina, 1994; Orozco, 1996). Especially intriguing has been the question of the exceptional appeal that these patriarchal texts have enjoyed for generations among women of all ages. I chiefly draw on the research on U.S. audiences to interpret the teens' talk about these serials that I present in other chapters.

LATINA WOMANHOOD IN THE LATINA/O TRADITION OF MEDIA AND POPULAR CULTURE

The Latina/o tradition is entangled with, but different from, the global Spanish-language culture. The Latina/o tradition is bilingual and bicultural; part of its production is in Spanish, part is in English, and, increasingly, another part code-switches between the two languages, mimicking the speech of most Latina/os. In contrast to the traditions of Latin America and the Caribbean, the Latina/o tradition borrows heavily from black (Flores, 2000) and Anglo cultural expressions (Rodríguez, 1999). Its specificity is rooted in the history of Latino media, which goes back to the newspaper *El Misisípi* in 1808 (Wilson et al., 2003). The growth of the Latina/o population has stimulated a concurrent growth and diversification of the Latina/o-oriented media industry. According to Federico Suberví Vélez, there are dozens of cable channels and two national networks, Univisión and Telemundo. The print media include about twenty daily newspapers, dozens of magazines, and over three hundred weeklies/biweeklies.

Radio, which is our favorite medium, includes over three hundred stations. And the number of Web sites has been growing steadily (Subervi Vélez, 2006). At the same time, new music production enterprises have been springing up. But it is important to keep in mind that such impressive growth has been accompanied by concentration of ownership as well as vertical and horizontal integration of these industries.

The specificity of the Latina/o tradition is rooted in the failed record of incorporation of Latinas and Latinos into the cultural institutions of the dominant society. Its distinctive features are most evident in alternative texts that represent us as complex, powerful people, for example in Chicano film and in grassroots Latin music. Latina/o alternative texts have stressed the particularities of given subgroups and, as opposed to the homogenizing tendency of the tradition's mainstream, alternative texts, highlight the specificity of local or regional cultural production. Mainstream texts are produced by large companies and corporations like Univisión that are intertwined with global Spanish-language corporations like Televisa. These media distribute both global Spanish-language productions and U.S. productions, and their dual distribution system makes it difficult to distinguish between, for example, *El Show de Cristina*, and a *telenovela* produced by Venezuela's Venevisión or by Mexico's Televisa. But there are crucial differences between the two. Texts produced in the United States, such as *Latina Magazine*, speak directly to the experience of Latinas and Latinos and are regulated by U.S. institutions, not least of which is the legal system. For example, in her pioneering analysis of the production of *Noticiero Univisión*, América Rodríguez (1996) found that the professional values of U.S. journalism as well as the newscast's imagined Latina/o audience largely shaped the newscast. The Latina/o tradition is part of the broader cultural expression of Latina/os. Juan Flores maintains that, like Latina/o social consciousness, the Latina/o cultural expression:

> burst out in the late 1960s. Inspired by the Civil Rights movement and the Cuban Revolution, countless movements, causes, and organizations rallied thousands of Mexicans and Puerto Ricans to the cries of "Viva la Raza" and "Despierta Boricua!" The political momentum of the Latino imaginary was set in those spirited movements, and found vibrant artistic expression in such diverse forms as wall murals, bilingual poetry and street theater, and hybrid music and dance styles like Salsa and Latin soul, Joe Bataan, and Santana. *Talleres* and *conjuntos* and readings and *actos* proliferated, lending voice and vision to the fervent political struggles of Latino and Latin American peoples. (Flores, 1997, p. 184)

Like poems, murals, and street performances, the alternative texts of the Latina/o tradition "lend voice and vision" to our political struggle, and they offer

vital cultural resources to transnational Latina/o youth. The tradition's mainstream texts, however, often co-op and commodify such voice and vision, losing, to a great extent, their contestatory potential. Likewise, the construction of Latina womanhood in the Latina/o tradition is problematic, to say the least. Truly alternative constructions of Latina womanhood, such as the one embodied by the character of Esperanza in the film *Salt of the Earth* (1954), are hard to come by in the tradition. Fregoso (1993) points out that oppositional films made by Chicanos, like *American Me* (directed by distinguished Chicano actor, director, and activist Edward James Olmos) (re)produce patriarchal ideology. She contends that Hollywood Chicano filmmaking has marginalized women and has reproduced conservative mythologies, such as the motif of the mother. In her thoughtful essay "Homegirls, *cholas,* and *pachucas* in cinema," Fregoso (1995) argues that, constrained by patriarchal ideologies, Chicano filmmakers have mirrored the virgin/whore dichotomy and have cast young women as either homegirls or *cholas* and *pachucas.* Chicano cinema, says Fregoso, has failed to represent young women's resisting identities:

> The inability of masculine cultural discourses thus far to portray Chicanas in their urban identities rather than restricting them to the narrow private sphere of the home, derives, in my view, to the threat to Chicano "family romance" that the *pachuca* represents. Her comportment signals the outer boundaries of Chicana femininity; her body marks the limits of *la familia;* her cosmetic and clothing masquerade accentuates her deviance from the culture's normative domestic place for women. And perhaps, the production of *pachuca, chola,* homegirl urban identities has not been celebrated by many of us precisely because her body defies, provokes, and challenges the traditional basis of our representation and formulation of the Chicano nation. (Fregoso, 1995, p. 327)

Representing Latina resisting identities, thus, has been dangerous not only to the Anglo tradition but also to the Latina/o (or at least to the Chicano) tradition because the project identity of the group has been predicated on patriarchal mythology. Equally detrimental to marginalization is the notorious oversexualization of Latinas in other Latina/o cultural works such as Univisión's talk shows. Talking about how Spanish-language television reinforces the subordination and racialization of Latinas by naturalizing racial and classed hierarchies, Arlene Dávila draws on Squire's (1997) critique of the genre of talk shows to point out that these texts "display race and ethnicity through behavior and deviance." In this genre, Dávila points out, "Whiteness is a symbolic reference point: Irrespective of their background, people may appear as 'symbolically white' or as 'others' to the extent that they distance themselves from the latter by their dress and demeanor or, in the case of the Spanish networks, by their correct use of Spanish" (Dávila, 2002, p. 169). In the same vein, Viviana Rojas notes the conflation of race and

class in Spanish-language talk shows: "usually, working-class and uneducated Latinas are seen as abnormal, dangerous, and polluting. Race and skin color are used as a class marker in the shows" (Rojas, 2004, p. 138).

As Dávila and Rojas underline, the major distinction in the representation of Latinas in Spanish-language television has to do with skin color as a signifier of both race and class. Typically, dark-skinned Latinas tend to be oversexualized and portrayed as morally lacking. Such racialization parallels the colorism that, as I maintain in Chapter Eight, saturates the media and popular culture production of Latin America. On the other hand, even as the mainstream texts of the Latina/o tradition tend to follow the Spanish-language global tradition's representational regime, they also disrupt it. For example, in their analysis of skin color in magazines targeting Latinas, Melissa Johnson and her colleagues found that "bilingual and English-language magazines originated in the United States featured more darker-skinned women than Spanish-language titles published in Miami, Mexico, or Spain" (Johnson, David, & Huey, 2003, p. 165). In my categorization, the former magazines are Latina/o magazines and the latter are global Spanish-language texts.

Latina Magazine was often brought out by the teens. Katynka Zazueta Martínez suggests that this magazine challenges stereotypes, asserts the place of Latinas and Latinos in U.S. history, and offers Latina readers a "self-validating gaze." By so doing, the author maintains that *Latina* articles "act as tools that facilitate the emergence of cultural citizenship" (Zazueta Martínez, 2004, p. 165). Yet, like other texts of the Latina/o tradition, *Latina* reproduces consumerist and patriarchal imperatives. Because it depends heavily on advertising, *Latina* commodifies Latina readers and, as Zazueta Martínez notes, "the magazine sometimes falls into the heterosexist trap of promoting normative ideas of family and gender roles that were the cornerstone of early patriarchal Latino social movements" (Zazueta Martínez, 2004, p. 168).

The recognition by major advertisers and media entrepreneurs of the potential of the Hispanic market has brought new opportunities for media companies trying to produce and distribute English-language and bilingual content that speak to our experience in the United States. For example, Telemundo, the second-largest Latina/o television network, has experimented with this type of programming. Although the teens in my project did not talk much about the new offerings that specifically target Latina/o youth, I discuss them briefly because their increasing importance makes it necessary to mention them. In 1997, SíTV was launched as a production company aiming to cater to the growing English-language Latina/o market. In 2004 it became a network that describes itself as follows:

SíTV is a fresh, irreverent, English-language Latino cable network that connects with young viewers through vibrant and relevant programming made

just for them. Our 24-hour network delivers a mix of original and acquired programming including the latest in entertainment, lifestyle, talk, standup comedy, classic series and feature films, as well as irreverent reality programming that pushes the boundaries of the genre. SíTV goes beyond tradition by catering to today's English-speaking Latinos who consume English media, but still want shows that speak to their Latino roots. (SiTV, 2008)

By 2007, SíTV was reaching 13 million households nationwide and increasing its on-line presence with two new blogs, one dedicated to music and other to a mix of news and entertainment (SíTV, 2007). Its success speaks to the rise of the "Hispanic youth market" as well as to the growing importance of Latina/o media and popular culture for transnational Latina/o teens. The "fresh, irreverent," boundary-pushing style that SíTV claims to offer has also been sought diligently by Univisión, which has been trying to attract Latina/o youth through its cable network, Galavisión. In the year 2000, Galavisión launched five youth programs targeting bilingual and bicultural urban youth: *Galascene, Con Cierta Intimidad, VideoMix, Al Desnudo,* and *¡Qué Locos!* These shows, characterized by constant code-switching, feature many young Latina/o actors, comedians, and musicians with Indian phenotypes (González McPerson, 2001, p. 34). These texts offer transnational Latina/o youth a large symbolic repertoire for the construction of clearly delineated U.S. identities and subjectivities.

Alongside changes in mainstream productions of the Latina/o tradition, more subversive artists have been crafting counter-images that contest, appropriate, and/or re-signify hegemonic constructions of Latina womanhood. A perfect example is the work of filmmakers like Lourdes Portillo (see Ramírez-Berg, 2002). But there are other, less known feminist Latinas making video and cinema that not only contest hegemonic Anglo images but also contest the oppressive representations of the Latina/o tradition. Ramón García argues that "while contesting the dominant culture's abject markings, the same cinematic reflections introduce a significant critique of gender, national, sexual, and cultural norms in contemporary Chicana/o culture" (García, 2002, p. 64). For example, in one of the videos that he analyzes, Rita Gonzalez's *The Assumption of Lupe Vélez,* the spitfire is re-signified as a subversive icon for queer politics. "Lupe Vélez is reconstructed as a legend of saintly proportions, an Evita Perón or Selena for a queer countercultural community," notes García (2002). While these profound challenges to hegemonic representations are very unlikely to directly reach working-class transnational teens, they have the potential to influence cultural workers like Salma Hayek, whose texts are more likely to reach this youth.

BLACK MEDIA AND POPULAR CULTURE TRADITION

Timothy Havens states that "the recognition that black youth culture, particularly African American youth culture holds an esteemed position among teenagers around the globe has become commonplace" (Havens, 2001, p. 57). Yet, the role that the black tradition plays in the development of subjectivities among Latina/o youth is a topic that deserves much more attention from scholars than it has to date received.[1] Juan Flores's exemplary book *From Bomba to Hip-Hop. Puerto Rican Culture and Latino Identity* (2000) is one of the few comprehensive studies on the topic. It illuminates the multiple crossovers and reciprocal influences between Latina/o, specifically Puerto Rican, and African American music.

In Chapter Four I show that both the Durham and the Carrboro Latina/o youth subcultures appropriated the music and style of black gangsta culture, and black media and popular culture were significant sources of cultural forms and meanings for the teens in my project. Most of them regularly watched Black Entertainment Television (BET), and all teens said they enjoy music originating in black culture, such as rap, hip-hop, and rhythm and blues (R&B). Black popular culture also reaches Latina/o teens through Anglo media outlets such as MTV, which airs many music videos featuring black artists and bands and was a preferred television option of most of the teens.

What does the black media and popular culture tradition offer to transnational Latina teens in general, and to Afro-Latina teens in particular? One may argue that because, in general, the imaginary of this tradition challenges white supremacist ideology, some black texts are likely to interpellate Latina teens, albeit in an oblique fashion, in potentially empowering ways. As women of color, all Latina teens may identify with the variegated representations of black womanhood that this tradition offers. Especially Afro-Latina teens may find the representations of black womanhood in this tradition more relevant for their social identity and subjectivity. Because African American youth culture signifies coolness among teens all over the world, in spite of internalized white supremacist ideology, transnational teens may draw on the tradition to make the transition into their new environs. Ana Ramos Zayas makes an interesting point regarding the appropriation of blackness by Latinas and Latinos as a means to become "American." In her ethnographic work in Newark, New Jersey, she found that

> For many Latin Americans and United States-born Latinos, "becoming American" was not equated with "becoming white," as has been the case for other (mainly European) migrants, but rather with "becoming Black." United States-born Latinos and Latin Americans migrants associated Blackness

with "Americaness," and exerted claims to an urban competency in their efforts to experiment with alternative forms of citizenship and belongingness. (Ramos Zayas, 2007, p. 86)

The use of black media by the teens indicates that they were indeed appropriating blackness in various ways. The specifics of such appropriation, unfortunately, is not an issue that I am prepared to address in the book. Even though I gathered very limited material on the issue, I found that the teens were routinely exposed to representations of black womanhood in many of their favorite music videos, many of which are produced by black artists, such as those of rap artist Ja Rule and bands like N*Sync. A considerable number of scholars have argued that women are often hypersexualized and objectified in rap and hip-hop music videos (Sharpley-Whiting, 2007). Authors like Tricia Rose, however, argue that sexism in rap has been gravely exaggerated by the mainstream press (2001, p. 233). A similar point is made by K. S. Jewell, who claims that despite the strong criticism of black texts that represent black women in stereotypical ways, the black media have contributed to positive representations of black womanhood (Jewell, 1992, p. 51). Other scholars point out that, through their creative agency, black women themselves have contributed to empowering representations of black womanhood. Gwendolyn D. Pough, for example, maintains that against the barrage of the bitches, hos, hoochies, chickenheads, and other stereotypes that many male rappers present, women rappers have put forth empowering representations of black womanhood. According to Pough, women artists like Queen Latifah, Salt-N-Pepa, Yo-Yo, and Roxane Shante, confront stereotypes with their skill, talent, popularity, and artistic persona, as well as with the women's issues that they articulate through their music: "Their physical presence as real women, not symbols," says Pough "helps to shake up notions of 'a woman's place.' The fact that they use their lyrics to bring women's issues to the forefront of rap music and hip-hop culture furthers disrupts the commonly held misconceptions and misrepresentations of black woman in hip-hop" (Pough, 2004, pp. 97–98). Equally important has been the work of black women behind the camera. In her critique of an extraordinary film by distinguished director Julie Dash, Jacqueline Bobo states that "in contrast to the limited depictions of black women formerly available in mainstream cultural forms, *Daughters of the Dust* presents the varieties within black womanhood" (Curren & Bobo, 1995, p. 77).

What is the impact that empowering representations of black womanhood may have on the development of self-affirming subjectivities among Latina teens? My guess is that such impact may be positive. In a very recent study of the relationship between television viewing and body-image development among Latina teens, Deborah Schooler (2008) found that "frequent viewing of black-oriented television

was associated with greater body satisfaction, specifically among those girls who were more acculturated. This finding is consistent with previous research documenting positive associations between viewing black-oriented television and the body image of African American women" (Schooler, 2008, p. 147). Although her findings are mixed, they offer some evidence that black television viewing may be empowering for some Latina teens.

The media and popular culture landscape of the New Latino South can be seen as contrapuntal because, as in Western contrapuntal music, it consists of different melodic lines. While observing this landscape, it is possible to hear harmonies and dissonances. I return to this point in Chapter Ten, but, given such rich availability, what are the specific media outlets, texts, and artifacts that particular groups of teens actually use? What are the individual and collective practices that they develop around such material culture? In the next chapter, I address these questions by meticulously describing the patterns of consumption and use that I found among the teens who participated in my project.

The Teens' Media AND Popular Culture Practices

In this chapter, I offer a comprehensive description of the teens' media and popular culture preferences and everyday practices at the time of the fieldwork. These included listening to music and watching the small screen. Also, I talk about their limited reading of magazines and books, and I discuss their use of computers and the Internet. The picture that emerges is quite intricate, but even though each teen's mode of consumption is unique, it is possible to distinguish patterns that go beyond individual experience. The descriptions given here provide the empirical grounds for the insights about general processes that the case study aims to illuminate. The differences between the case presented here, and a case of transnational Latina teens in comparable settings at the time of this writing, are likely to be differences "of degree not of kind" (Feagin et al., 1991, p. 5). Through my on-going volunteer work with Latina/o teens in producing a radio program, I have been able to observe their consumption and use of media and popular culture. Although there are important differences between these radio producers and the teens who participated in my project, in general the two groups' motivations for consumption and use appear to be similar. Regarding technologies, the most important difference is that teens now use social networking tools like MySpace and Facebook. Just as other teens (Lenhart & Madden, 2007), Latina/o teens now utilize on-line technologies more intensely than before for expressing their creativity and constructing their cyberidentities. Nonetheless,

their chief motivation for using these new tools is social networking, which, as I describe below, was the motivation of Latina teens for using e-mail at the time of my fieldwork.

The consumption patterns that I identify bring to mind Thomas Tufte's (2001) idea of the "multi-layeredness" of media consumption and use among transnational adolescents. Tufte investigated how thirteen transnational teens living in a working-class neighborhood in central Copenhagen use television to produce *locality* at several levels (local, national, international, transnational).[1] Tufte found that the teens' media consumption is "multi-layered," a term that he uses to mean that they attend to various media, which include U.S. productions, Danish national and local media, local "ethnic" media, and transnational media from the countries of origin (Tufte, 2001, p. 45). Tufte's idea advances a way of thinking about transnational consumption that goes beyond the usual West/the rest, modern/traditional, Spanish-language/English-language dichotomies.

THE PLEASURES AND MEANINGS OF MUSIC LISTENING

More than any other media, music is fundamental for the development of subjectivities and the positioning of social identities (McCarthy, 1999). Simon Frith notes that "music constructs our sense of identity through the direct experiences it offers to the body, time and sociability, experiences which enable us to place ourselves in imaginative cultural narratives" (Frith, 1996, p. 124). Not unlike other youth around the world (Christenson, Roberts, & Becker, 1998), listening to music was not only the most frequent media practice for the teens, but also a practice that had profound meanings. In response to my question about the technology that they used most often to listen to music, Daniela simply stated, "It doesn't matter as far as it's music." Although what mattered to them was the listening practice rather than the delivering technology, access to technology is an important factor in media use. When I conducted my fieldwork in Durham in the fall of 2003, the wide diffusion of technologies such as MP3s and iPods was taking off. These gadgets were beyond the teens' means and apparently even desires because I did not find any reference to them. By the summer of 2004, the gadgets were part of the desires of at least one teen, Paty, who pasted a cutout of an iPod in her collage (see Figure 1). Jennifer, Natalia, and Stephany said that they shared a CD player with other family members, and the rest of the teens said they owned a CD player. Regarding radio, only Gabriela, who was volunteering for a noncommercial black radio station, said that it was an important medium for her. The transcripts contain little mention of radio, but this is probably because I did not prompt them to talk about radio in the same way that I encouraged them to talk about other media. There are only a

few references to radio in their collages and media life calendars. Lidia put a radio and a CD player in her calendar as depictions of her favorite toys. Anabel, Alex, Carmen, and Gabriela also included radios in their collages. Carmen explained why she put the word "radio" by saying: "*me gusta escuchar la radio y ver que música hay*" (I like to listen to the radio and see what music is playing). Also, in a worksheet she pointed out that she would listen more often to the radio "if I had more time and the radio put [on] only my favorite songs." At the time of the fieldwork, there were no Spanish-language radio stations in either Durham or Carrboro. The strong preference for Latin artists and bands shown in Table 2 is even more noteworthy given the lack of Spanish-language radio.

Table 2 lists the artists and bands that seemed more salient for the majority of the teens. It combines data from calendars and worksheets asking for their top

Table 2. The Teens' Favorite Artists and Bands[a]

Individual Artists	Top 3 Artists/ Bands?	Top 3 Music Video?	Calendar
Shakira	Yes	Yes	Yes
Luis Miguel	Yes	Yes	Yes
Selena	Yes	No	Yes
Ricky Martin	Yes	Yes	No
Eminem	Yes	Yes	No
Enrique Iglesias	Yes	No	Yes
Nelly Furtado	Yes	Yes	No
Ja Rule	Yes	No	Yes
Sean Paul	Yes	Yes	No
Busta Rhymes	Yes	Yes	No
Ricardo Arjona	Yes	No	Yes
Gloria Trevi	No	Yes	Yes
Britney Spears	No	Yes	No
Bands			
Kumbia Kings	Yes	Yes	Yes
*N Sync	Yes	Yes	Yes
Aventura	Yes	Yes	No
Backstreet Boys	Yes	No	Yes

a The table combines data from media life calendars and two worksheets asking for the teens' favorite artists and music videos.

three favorite artists and top favorite music videos. First and foremost, the table shows the teens' fondness for pop female singers-songwriters Shakira, Selena, and to a lesser extent, Nelly Furtado. Selena is recognized as the Queen of Tejano music, a genre developed in Texas by Mexican Americans. Selena used lyrics in both English and Spanish, and she gained tremendous popularity among Mexican Americans in the late 1980s. She reached a substantial part of the Latin American market and successfully crossed over to the U.S. English-language mainstream culture. In 1995, when she was tragically slain at age 23, the Anglo media treated her death as a major event and *People Magazine* dedicated a commemorative issue in her honor. Then Texas Governor George W. Bush proclaimed her birthday as Texas' official "Selena Day." This kind of visibility and recognition for a Latina artist was unprecedented. The biographical film, *Selena,* which launched Jennifer López into stardom, spread Selena's celebrity status around the globe, and her popularity remains strong. In 2005, Univisión aired a special in her honor that broke audience records (Univisión, 2005b).

Shakira, likewise, is a global artist, but she epitomizes "reverse cultural imperialism," that is, the flow of culture products from the global South to the global North. Originally from Colombia, she gained huge popularity in the Spanish-language global market before crossing over to the English-language market and becoming a star on MTV. The latter launched her into international stardom.

The third female singer-songwriter mentioned by several teens is Nelly Furtado, a Canadian with close links to her parents' home country, Portugal. She sings in English, Portuguese, and Spanish; her innovative hybrid music borrows from many genres, combining, for example, hip-hop sounds with Portuguese *fado.* While she has not gained the stardom of Shakira or Selena, Nelly Furtado is a Grammy Award-winner with global reach.

Table 2 also shows that pop Latino artists such as Ricky Martin, Enrique Iglesias, and Luis Miguel were among the teens' favorites. However, they did not talk about male artists as often as they talked about female artists; for example, while there are thirty mentions of Selena and twenty-six mentions of Shakira in the transcripts, there are only seventeen for Luis Miguel, fourteen for Enrique Iglesias, and eleven for Ricky Martin. Like Shakira, pop vocalists Ricky Martin and Enrique Iglesias became celebrities in the Spanish-speaking world before crossing over to the English-language market. Martin is originally from Puerto Rico and Iglesias from Spain. Luis Miguel is from Mexico, and although he has won five Grammys, he sings only in Spanish and does not have the wide appeal of crossover artists. He began singing romantic ballads with subtle vocal nuances, and later started to perform traditional *boleros,* a romantic musical form that Cubans and Mexicans have enjoyed for many generations (Morales, 2003).

Latin bands that use Spanish and English lyrics and combine traditional genres with new sounds constitute the second major theme in the teens' preferences. The Kumbia Kings came from Texas, and one of the band's members is a brother of Selena. The band, now defunct, successfully crossed over to the English-language mainstream, mixing Colombian *cumbia* with rhythm and blues (R&B), hip-hop, and reggae music. The other band, Aventura, came from the Bronx, New York, and its music exemplifies the particular cultural hybridity that the recent immigration of Dominicans has created. The band combines Dominican *bachata* with R&B, hip-hop, and reggaeton. It produced the hit "Obsesión," which is very popular in Latin dance venues in the United States and beyond. Although to different degrees, all of these Latin bands crisscross musical boundaries and experiment with sounds and languages. The ongoing presence of Latin music in the teens' lives opens up various themes that I discuss in subsequent chapters, themes such as Latin music's central role in the local Latina/o youth subculture.

Then there are the rappers. The ones mentioned most often were Eminem and Ja Rule. An Anglo rapper, Eminem is considered to be the most commercially successful rapper of all time. He has been compared to Elvis for both his huge popularity and the anti-establishment critique within his lyrics. His semi-autobiographical film, *8 Mile*, was released at the time of my fieldwork in Durham, and the teens talked excitedly about the film. Black rapper Ja Rule was considered "the" rap artist of the early 2000s. His trademark was the juxtaposition of a thuggish style with soft female voices. In one of his famous duets, "I'm Real," his female chorus included Jennifer López. He acted in *The Fast and the Furious*, a film that was among the teens' favorites and to which I return in Chapter Eight. Two other famous black rappers on the teens' favorite list have Jamaican roots, and their music sounds owe much to reggae. Busta Rhymes was born in Brooklyn, New York, and he is of Jamaican and Puerto Rican descent. He mixes pop reggae with hip-hop. Sean Paul was born in Jamaica and he first gained recognition in the United States for his dance hall and reggae music.

Lastly, boy pop bands *N Sync and the Backstreet Boys, were also high on most teens' lists. Both bands, created by infamous U.S. mogul and conman Lou Pearlman, are composed of U.S. Anglo young men, but they had to gain their popularity in Europe before becoming successful in the United States. They have devoted audiences around the world, and the Backstreet Boys, which has sold over 60 million albums, has been called "the most famous boy band in music history" (VH1, 2007). The relative saliency of Anglo bands for most teens was, of course, related to global popularity and the skillful marketing of the bands. It is worthy of note, however, that only Beatriz, who was one of the less acculturated teens, pasted multiple signs of white male rockers. As shown in Figures 5 and 6, Beatriz's collage included indie rockers (e.g., The Pixies) and grunge bands, including the picture and name of Kurt Cobain, the singer/guitarist of Nirvana who committed

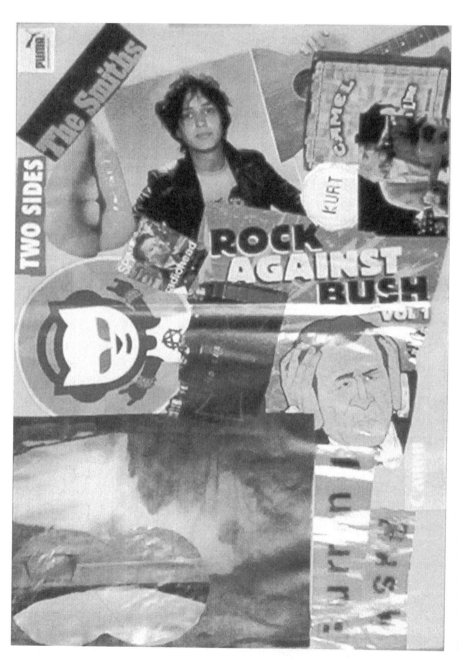

Figure 5. Collage by Beatriz (age 18), Panel A

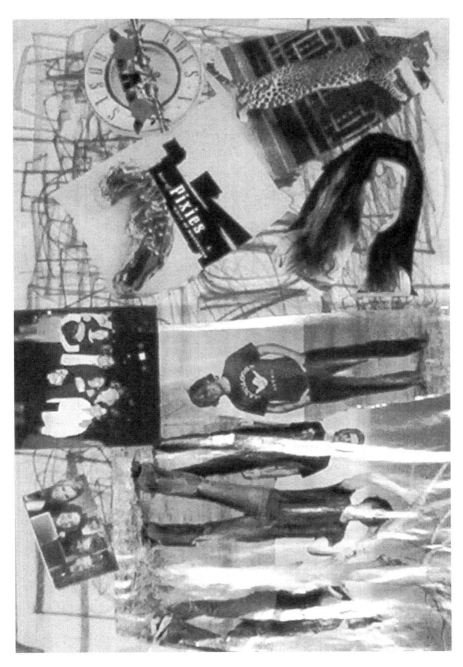

Figure 6. Collage by Beatriz (age 18), Panel B

suicide. Beatriz had come from Mexico City a few months before the fieldwork, but her music listening practices seem more in tune with the practices of the U.S. Generation X, which comprises people born between 1960 and 1980. Beatriz was born in 1985, but Generation X's anti-establishment listening practices confer cultural capital in some Mexican youth cultures. Moreover, Beatriz admired and had a strong connection with her aunts, who were a few years older than she. It is this family relationship that in part explains her media and popular culture practices. But the collage's angry antiestablishmentism is consistent with other Latina/o migrant youth's feelings of alienation.

The remaining artists and bands listed in Table 2 were less popular among the teens and, with the exception of Britney Spears, all are from Latin America. They include Guatemalan pop singer Ricardo Arjona and controversial Mexican pop artist Gloria Trevi, whose lyrics combine social critique, sexual innuendos, and a feminist standpoint. The saliency of music for the teens became apparent during the first meetings when I asked them to bring a sample of their favorite media to class. In the class that followed, most of them brought music:

Jennifer: I knew everybody was going to bring a CD! I knew it!

Lucila: *Vamos a hablar de esto.* (Let's talk about this.)

Stephany: I brought a copy of a CD of Selena because, I used to listen to her a lot when I was little, because, I was one of her number one fans.

Lucila: Really?

Stephany: Yeah, and I used, we used to sing her songs, and I got her Barbie doll.

Lucila: *Ok, qué lástima que no lo podamos tocar. ¿Alguien más?* (OK, what a shame that we can't listen to it. Someone else?)

Jennifer: I brought a CD, it's mixed but, it's because it's the first [that I had] and is, special.

This excerpt brings to light the importance of childhood media practices for the teens' subjectivity. Jennifer explained that she brought a CD that is "special" to her because it is the first CD that she owned, and Stephany says that she brought a CD of Selena because she was "one of her number one fans" when she was little. Stephany was born in the United States, but her childhood fondness for Selena was a common, borderless experience among both U.S.-born and foreign-born teens. The two groups shared many borderless media and popular culture experiences, but their shared experiences were more intense in regard to music, probably because music is the single most-often traded cultural good in the global market. The rapid intensification of the global circulation of cultural goods that characterizes globalization has been especially felt in music. The magnitude

of music goods that are traded globally, make up "one-quarter of all cultural imports and exports" (Croucher, 2004, p. 15).

Along with digital technologies, the economic and political forces that have propelled the global circulation of music goods help explain the popularity of black, especially African American, youth culture among teenagers around the globe. The appeal of African American youth culture among teens who seemingly share little with this culture, such as Middle Eastern teens, continues to perplex scholars (Havens, 2001). However, the popularity of African American youth culture among Latina/o teens is less obscure because there has been intense interaction between the two groups. Juan Flores, whose book documents the role of Puerto Ricans in the development of hip-hop, notes that "as neighbors and co-workers, African Americans and Puerto Ricans in New York had been partying together for many years. For decades they have been frequenting the same clubs, with black and Latin music bands, often sharing the bill" (Flores, 2000, p. 80). In the U.S. South too, African Americans are now sharing many spaces with Latinas and Latinos and it is likely that they share music and dance tastes. As Leticia pointed out, "some Latinos like black music, and some blacks like Latino music." The teens' gusto for black music was, of course, overdetermined by market and hegemonic cultural forces, but at the local level it was encouraged by their everyday interactions with black teens. When explaining the music preferences listed in her calendar, Natalia said: *"que por cierto, son todos morenitos ahí, la mayoría que yo oigo son morenos"* ("by the way, all [the musicians] that I put there are black, most of the ones I listen to are black"). And when I asked Stephany why she liked R&B, a genre developed by blacks that used to be called "race music," she said:

> Stephany: Um, I don't know. There's some R&B songs that just make you want to move. I mean, I like the Latin music too, but R&B, I don't know, I like R&B a lot. And Latin music too.
>
> Lucila: And now you say [in your calendar that] at thirteen and fourteen you also like rap. Tell me why you like it.
>
> Stephany: Um, I don't know. Well, see, sometimes there is, you know Eminem?...I like how he raps and because I like his rapping because he tells his life and it's interesting, you know? 'Cause mostly a lot of rappers don't do that. They just rap about them. And like in his CD, he talks about how he loves his daughter and everything and I mean that's nice you know? But I don't know, I like rap. There is some rap that is pretty...but then R&B, I like it too.

In her response to my question about R&B, Stephany related her predilection for Latin music, which had not been the topic at that moment. I believe that the association she makes has to do with dance, because both R&B and Latin music

"just make you want to move." Her answer also hints at the trouble she has (and that even music critics are likely to have) at disentangling both musical forms. Addressing my question about rap, she reveals her familiarity with the genre by pointing out the uniqueness of Eminem among rappers. Eminem is an excellent example of the commodification of authenticity, and authenticity was a quality much appreciated by the teens. Daniela, for example, included in her collage a symbol of authenticity by pasting a cutout of the word "real." (see Figure 18)

WATCHING THE SMALL SCREEN

Nielsen estimates that for 2004–2005, the average time spent watching television in Latina/o households per week was higher during both prime and day time, and slightly lower during night time than the average total U.S. households. But the only Latina/o age group that spent more time with television at night time was teenagers (ages 12–17). On average, Latina/o teens watched 12 hours and 15 minutes of television per week, which was much higher than the average total U.S. teen population (9 hours and 53 minutes), but much lower than the average for African-American teens (15 hours and 32 minutes) (Nielsen Media Research Inc., 2008). High levels of television watching have much more to do with class and the relative availability of other leisure choices than with racial/ethnic differences. The teens in my project had very limited access to other forms of leisure and, therefore, the amount of time they spent with television was much higher than the Nielsen national estimates. The Durham teens, who were attending school at the time of my fieldwork, estimated that they watched between 12 and 21 hours per week. Some Carrboro teens, who were on vacation when we held the class, estimated 28 hours per week; yet Beatriz and Paty, who had been in the United States for only a few months, estimated only between 7 and 14 hours.

In a worksheet asking for their access to television, all teens wrote that there was at least one television set in their homes and four teens indicated that they had their own television set.[2] Anabel talked about conflicts with her brother for the remote: "*En mi casa mi hermano y yo siempre nos estamos peleando por el televisor, aunque tenemos tres televisores en la casa, porque yo no puedo parar de ver televisión, ni tampoco mi hermano*" (at home my brother and I fight over the television set all the time, although we have three sets at home, because I cannot stop watching television, nor can my brother either). Most teens expressed guilt for spending too many hours with television, but guilt did not prevent them from watching the small screen even at odd hours. For instance, the habits of Leticia and Jennifer included watching television early

in the morning. During one session Jennifer talked about Univisión show *Qué Mujeres* and, when I asked her what channel was airing it, Leticia interrupted to say "in Univisión, a las seis de la mañana" (on Univisión at six in the morning). Likewise, the habits of others, like Carla, included watching late at night. "I have been watching *telenovelas*," she said, "two, two o'clock in the morning." Even Lidia, who insisted that she did not watch television, may have been watching at late night; she commented that Univisión's show *Otro Rollo,* which was a show that she recognized having watched sometimes (but "*sólo el monólogo*" [only the monologue]) was airing at 12:30 p.m. at the time of the fieldwork. Moreover, in a worksheet inquiring about television watching, nine teens indicated that they watched by themselves "most often."[3] Isabel, Lidia and Paty were the only teens who mentioned parental restrictions. Paty said that she hid from her older sister to watch a *telenovela* because her sister admonished her for watching "trash."

In one of the first classes with the Durham teens, I asked them if they watched more English-language programming or more Spanish-language programming. Stephany's comment illustrates their crisscrossing among media cultures: "Both—because after school I watch in English, but when it comes to the *novelas*, I watch the *novelas*." The answers on a worksheet inquiring about their top three most-watched channels, presented in Table 3, show the teens' participation in four traditions of television production.

In their responses to the worksheet, most teens indicated that Univisión was either their first or second most-often watched network. Anabel, Isabel, Lidia, and Paty did not list Univisión, but Paty and Lidia later revealed that they were routinely watching Univisión. Anabel mentioned that she was exposed to the network at home, but its programming seemed less relevant for her than for other teens. The only teen who consistently made few references to television, in either Spanish or English, was Isabel, who was living with her non-Latina foster mother. Twelve teens said they had access to basic or digital cable, and four mentioned access to satellite television. This means that, apart from Isabel (who refused to complete the worksheet), all teens were able to watch Univisión. Carmen, Leticia, Natalia, and Yvet, having access to satellite television, could watch other Spanish-language networks as well, such as Telemundo, Galavisión, and Mund2.

Their reasons for watching Spanish-language television varied. For teens like Beatriz, who had immigrated recently, it may have been the lack of English proficiency, but overall the reasons are much more complicated. An important reason is the family environment as the use of Spanish-language media is common among Latina/o transnational families; even U.S.-born teens, like Daniela and Sabrina, said that Univisión was one of their most-watched networks. Another

Table 3. The Teens' Responses to the Worksheet "Channels I Watch the Most."[a]

	Age	Time in U.S.	Language (Dominant)	First Choice	Second Choice	Third Choice
Anabel	12	3 years	Bilingual	Disney Channel	ABC Family	Nickelodeon
Carla	13	7 years	Bilingual	Disney Channel	MTV	Univisión
Leticia	13	6 years	Spanish	Univisión	Disney	HBO
Alex	14	4 years	English	Univisión	Disney Channel	ABC Family
Stephany	14	US-born	English	BET	Univisión	Cartoon Network
Jennifer	14	US-born	English	BET	Univisión	
Lidia	14	3 years	Spanish			
Paty	15	+1 year	Spanish	Disney Channel	Discovery Channel	ABC
Daniela	15	US-born	Bilingual	MTV	Univisión	BET
Sabrina	15	US-born	English	Univisión	Cartoon Network	USA
Susana	16	3 years	Spanish	Univisión	BET	USA
Yvet	16	9 years	Bilingual	Univisión	TBS	MTV
Natalia	17	2.5 years	Spanish	Cartoon Network	Univisión	MTV
Carmen	17	11 years	Bilingual	Univisión	Telemundo	Galavisión
Beatriz	18	+1 year	Spanish	Univisión		
Gabriela	18	3 years	Spanish	Univisión	MTV	Animal Planet
Isabel	20	4 years	Spanish			

a This table is based on a worksheet inquiring about the teens' top three most-watched television channels.

prominent reason has to do with psychological well-being because the practice becomes an everyday ritual for coping with the stressors brought about by migration. A further cause is related to the sense of cultural loss and the search for anchoring cultural identity. I fully address the last two reasons in subsequent chapters. Finally, the concerted effort made by Latin American media conglomerates in the 1990s to cater to youth, especially Venevisión and Televisa, should

be taken into account also. Consider the way Lidia explained how she acquired a taste for *telenovelas*:

Lidia: *Y luego hubo una telenovela para niños, empezaron las telenovelas para niños, y entonces a nosotros nos gustaba Carrusel de Rosas, de, no sé como se llama . . .*

Natalia: *De las Américas.*

Lidia: *De las Américas, empezó con esa, con esa telenovela y de ahí me empezaron a gustar las telenovelas después.*

Lidia: And then there was a *telenovela* for children, *telenovelas* for children began [to be aired], and so we used to like *Carrusel de Rosas*, of, I don't know what is it called . . .

Natalia: *De las Américas.*

Lidia: *De las Américas*, it began with that one, with that *telenovela* and from then on, later I started to watch *telenovelas*.

Carrusel de las Américas was the first juvenile *telenovela* produced by Televisa in 1989, when Lidia and Natalia were infants. A tremendous success, the program broke new ground and became the basis for a new sub-genre catering to children and adolescents that continues to reach both domestic and transnational publics. For example, Yvet and Paty said that some of their favorite shows at the time of the field-work were the juvenile *telenovelas Clap* and *Clase 406*. Because Televisa and Venevisión syndicate *telenovelas* to Univisión, Telemundo, and other U.S. Spanish-language networks, transnational youth has become an important market for them.

A large portion of the Anglo programming watched by many of the teens came from children's networks. Table 3 indicates that eight teens listed children's networks such as Nickelodeon and the Cartoon Network, as one, or even two, of their most-often watched networks. In addition, Sabrina, who did not list children networks on the worksheet, wrote in her calendar that children's programs were among her favorites at the time of the fieldwork.[4] The significance of children's media for the teens is a theme that I develop in Chapter Six. I was intrigued by the lack of familiarity of most Durham teens with such icons of Anglo, middle-class girl culture such as the twins Mary-Kate and Ashley Olsen. Only Leticia pasted a cutout with images of the celebrities' videos. Mary-Kate and Ashley gained popularity for their acting, as infants, in the television series *Full House*, which ran on ABC and became a hit in the late 1980s and 1990s. Later they had their own show, *The Adventures of Mary-Kate and Ashley*, and starred in two other ABC/ABC Family's series *Two of a Kind* and *So Little Time*. In addition, their films, videos, book series, video games, and merchandising have been hugely successful on the U.S. pre-teen market. Their products reach countries like Canada, France, Spain, the United

Kingdom, and New Zealand (Dualstar Entertainment Group, 2007). But these celebrities have not been exported to Latin American countries, a fact that may explain most of the teens' lack of familiarity with them. During a class with the Durham group, when I asked for examples of television dramas, Mary-Kate and Ashley were mentioned by Carmen:

Carmen: *Ah, ¿cómo se llama? La de las gemelas, ¿cómo se llama?*
Isabel: *¿Sisters, sisters?*
Natalia: *No, no, son otras, Ashley and Mary-Kate.*
Carmen: *Ashley and Mary-Kate.*
Carla: *Mary-Kate and Ashley.*
Leticia: *So Little Time.*
Carla: *So Little Time.*
Lucila: *Todas, ¿todas saben cuál es?*
Isabel: *Yo no.*
Carla: *Sí, sí es drama.*
Lucila: *¿Sí es drama? ¿Y cuánto dura?*
Lidia: *¿Dura una hora, no?*
Carla: *Media hora.*
Susana: *No, creo que dura una hora.*

Carmen: Ah, what's its name? About the twins, what's its name?
Isabel: *Sisters, sisters?*
Natalia: No, no, they're others, Ashley and Mary-Kate.
Carmen: Ashley and Mary-Kate.
Carla: Mary-Kate and Ashley.
Leticia: *So Little Time.*
Carla: *So Little Time.*
Lucila: Everybody, everybody knows which one is it?
Isabel: I don't.
Carla: Yes, yes, it's a drama.
Lucila: Is it a drama? And how long is it?
Lidia: It's an hour, no?
Carla: Half an hour.
Susana: No, I think it's an hour.

Compare the certainty of Carla and Leticia's interventions to the hesitation of Natalia, Lidia, Susana, and even Carmen, who was an avid television watcher.

Because these teens had been in the United States more than two years, their lack of familiarity with the series was not due to lack of language proficiency. Leticia and Carla were the youngest of the Durham group, and the less-behaviorally mature teens of the Carrboro group were also quite familiar with Mary-Kate and Ashley. Anabel and Alex wrote in a worksheet that they had watched the series *Full House* that week, and this is what they had to say when I further inquired about their familiarity with Mary-Kate and Ashley:

Alex: *Es como de Mary-Kate and Ashley, cuando eran pequeñas.*

Anabel: *Es cuando eran bebés, pero no las enseñan a las dos al mismo tiempo, pero las están cambiando.*

Lucila: *Ah, ¿cómo, Mary-Kate and Ashley?*

Alex: *Como ellas estaban pequeñas no podían andar todo el tiempo, entonces las cambiaron.*

Anabel: *Algunas veces divertido, otras veces triste.*

Lucila: *O sea, ¿les gustan los programas de Mary-Kate and Ashley?*

Anabel: *Ajá, a mí sí.*

Alex: *Yo sólo miro Fullhouse.*

Anabel: *Yo he visto bastante las películas de ellas.*

Lucila: *¿Tú has visto bastante las películas de ellas?*

Anabel: *Ajá*

Lucila: *¿Sí? ¿Las tienes?*

Anabel: *No, pero las he rentado y las he visto.*

Alex: It's like about Mary-Kate and Ashley, when they were little.

Anabel: It's when they were babies, but they don't show both at the same time, but they are switching them.

Lucila: Ah, like Mary-Kate and Ashley?

Alex: Like [when] they were little they couldn't be [working on the show] all the time, so they switched them.

Anabel: Sometimes funny, other times sad.

Lucila: So, do you like the shows of Mary-Kate and Ashley?

Anabel: Uh, uh, I like them.

Alex: I only watch *Full House.*

Anabel: I have seen many of their movies.

Lucila: You have seen many of their movies?

Anabel: Uh, uh.

Lucila: Yes, do you have them?

Anabel: No, but I have rented them and I have seen them.

The excerpt demonstrates Alex and Anabel's familiarity with the career of the teen celebrities. Alex, for example, alludes to the fact that the twin actors took turns playing one single character in *Full House*, thereby enabling the producers to comply with child labor laws. Because the teens who were familiar with these celebrities were also the less behaviorally mature, developmental stages in part explain some of their preferences. Nonetheless, developmental stages fail to explain the lack of references to these celebrities by U.S.-born teens and the lack of familiarity with the celebrities that teens like Carmen, Jackie, and Natalia showed, as they spent their pre-teen years in the United States.

Surprisingly, despite their fascination with music, MTV did not appear to be as popular with them as I had anticipated. Only five teens placed MTV among their top most-watched networks (see Table 3). Their calendars roughly confirm this finding. Thirteen teens did not have any reference to MTV in their calendars; only Natalia, Daniela, Carla, and Alex put MTV among their favorite television fare at the time of the fieldwork. Moreover, when I asked the Durham teens about their favorite music videos, only Carla, Gabriela, and Natalia mentioned MTV.

The only other network brought up by as many as nine teens was Black Entertainment Television (BET). As shown in Table 3, Stephany and Jennifer put BET as their top channel, Susana put it as her second, and Daniela put it as her third choice. Then, in their calendars, Alex included BET as one of her favorite television shows and Leticia wrote "BET Latino" under the column for favorite music. When I queried them about their favorite music videos, Stephany, Susana, Jennifer, and Sabrina listed shows that, according to them, aired on BET. During another session, Carla and Natalia also said that BET was among their favorite networks. This means that, despite my failure to specifically inquire about their use of BET, more than half of them brought it up.

The Durham teens were attending schools with many African American students, and thus peer influence helps explain their preference for BET. Yet peer influence does not explain the preference for BET of Carrboro teens like Alex, who was attending a predominantly white school. What may explain this preference is the concerted efforts made by BET to target Latina/o youth. In her calendar, Sabrina specified that, at the time of the fieldwork, her favorite show was *Cita's World*. Stephany also told me that it was a favorite of hers; she described it saying: "It's a lady 'cause, it's a cartoon girl, a digital girl, and she talks and she presents videos, but I like how she talks and everything, I like that show." The innovative BET show provides a clue concerning a possible important reason for the teens' relatively low mention of MTV. BET has incorporated music-video shows into its daily programming that have gained

popularity among Latina/o teens. Hence, the meanings flowing from the black tradition permeated the teens' media and popular culture landscape, and greatly contributed to the contrapuntal feeling of their media practices and preferences.

Anabel's comment in the above excerpt about renting the videos of Mary-Kate and Ashley illustrates the intricacy of media practices today, whereby content is delivered through various windows of distribution and transformed into slightly different commodities. The teens often used the small screen to watch films, and they were quite familiar with Hollywood blockbusters. All teens said they watched movies on video and DVD. Most indicated that they had access to a VCR at home and most said they also had access to a DVD.[5] Yet only Susana (video) and Natalia (DVD) stated that they used their own hardware. They did not talk about recording movies from television, but many made comments about owning their own movies. Natalia, for example, said: "*Yo tengo mis videos, como The Gift, ¿nadie ésa la ha visto? Es miedosa.*" (I have my own videos; such as *The Gift*. Has anybody seen it? It's scary.) And Carla revealed her fondness for having recordings of her favorite movies: "Have you all seen the *Jimmy Neutron* movie? [...] I got the movie, I wanted it!"

The teens talked about numerous movies, and I will come back to this discussion in the following chapters. At this point it is important to mention that, in all the material that I collected, there is only one mention of a Latin American film, *Como Agua para Chocolate (Like Water for Chocolate)*, which Carla brought up several times, saying that it was a favorite of both her and her mother. The teens talked more about recent releases, especially about their desire to watch the latest release. For example, Alex and Anabel talked at length about both their recent visits to the movie theater and they pasted cutouts of *Sleepover*, a recent release catering to the pre-teen and teen girl market that they were dying to see. Since I did the fieldwork with the Carrboro group during the summer—a time when marketers intensify their targeting to teens—marketing and availability in part explain Alex and Anabel's focus on movie-going. But movie-going was not a frequent practice for most teens. Carla said that movie-going took time from other media: "*A mí casi no me gusta ir porque, luego no puedo mirar mucho la tele*" (I don't like much going because then I cannot watch a lot of TV). Other comments point to the cost of tickets, lack of time, and, especially, parents' or guardians' concerns about the teens hanging out with friends. Lidia, for example, wrote in a worksheet that she would go to the movie theater more often if "*me dejaran salir más con mis amigos o a lo mejor si alguien que conozca [conociera] a mi mamá me lleve [llevara]*" (if I were allowed to go out with my friends or maybe if someone who knows my mother was going to take me). Talking about her reasons for not frequenting the movie theater, Carmen described a typical conversation with her parents:

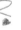

> *Y siempre me, me dicen que me quede, no puedo salir más antes de las seis y media, de las seis y media ya en adelante no me dejan salir, dicen que, que soy*

muy chiquita, y luego de aparte de allí, tengo que llegar antes de las nueve, tengo que estar ahí, a [en] la casa a esa hora que me dicen, o tengo que decirles, "voy a salir hasta tal hora," y me dicen "sí, sí, sí, ¡no!" Pues no voy. O decirles más temprano, pero ya "[a] qué horas vas a regresar," no, "como a las ocho," "OK, como a las ocho te quiero aquí." Si llegas un minuto, "¿por qué llegaste tarde?"

And they always tell, tell me to stay [at home], I can't go out before six thirty, from six thirty on they don't let me go out; they say that, that I'm very little, and then in addition to that, I have to arrive before nine o'clock. I have to be there, at home at the time they tell me, or I have to tell them "I'm going out until such and such time," and they tell me "yes, yes, yes, no!" So I don't go out. Or to tell them earlier, but "at what time you're going to be back?" no, "about eight o'clock," "OK, I want you here about eight o'clock." If you arrive a minute [late], "why did you get back late?"

In her dramatic and somewhat confusing account, Carmen explains that her parents' general rule is that she be at home before 6:30 p.m., and that in those special occasions when she is allowed to be out later, she has to return by nine o'clock. Given Durham's high level of violent crime (1.41 times the national average in 2003), her parents' restrictions may have been justified (CityRating.com). But another, perhaps more important factor, is the strict regulation of young women's mobility imposed by many families of Mexican origin. In her qualitative study on how Mexican American young women negotiate family cultural practices, Gallegos Castillo describes the highly asymmetrical gender expectations that govern family life. She found that the young women in her study felt oppressed by such expectations and resented the male privileges enjoyed by their brothers, especially their greater social freedoms. Among these young women, says Gallegos Castillo, "the most valued benefits of male privilege is the ability to hang out in public" (Denner & Guzmán, 2006, p. 49). Family restrictions, thus, help to elucidate most teens' avid small-screen viewing and low attendance to movie theaters. They do not, however, explain most teens' relatively low interest in magazine reading.

MAGAZINE READING

The teens' use of magazines was surprisingly low for a medium that has been touted as an essential resource for constructing gendered identity among young women. Since the pioneering work of A. McRobbie and J. Garber (1976), numerous researchers have investigated the content of magazines catering to young women. This research has consistently found that teen magazines promote a patriarchal ideology that constructs young women as concerned with beautification, pop music,

heterosexual romantic love, and the realm of the personal. While the bulk of this research has examined magazines catering to Anglo, middle-class young women, there is little reason to believe that publications targeting Latina teens espouse a different ideology (Osterman & Keller-Cohen, 1998). First, Latina magazines stick to general conventions of the genre that promote cultural imperatives, especially heterosexuality and the construction of women primarily as consumers. Second, the corporations producing these magazines have a strong interest in perpetuating such construction because they benefit from consumer capitalism; notably, the Mexican Editorial Televisa (often in agreements with other corporations, such as Hertz) produces the majority of Latina magazine titles (Johnson, 2000). And third, the emergent scholarship on the topic indicates that Latina magazines are quite similar to magazines catering to other populations. Johnson, for example, found that "more than one-fifth of the articles were personality features with another fifth devoted to beauty and fashion" (Johnson, 2000, p. 238).

Table 4 is based on the teen's responses on a worksheet asking for the "top three magazines that I read most often." All seventeen teens participated in this activity, but only eight[6] wrote down three different titles; four wrote only two,[7] one wrote only one,[8] and the remaining four[9] did not write any title at all. No one included a title of a black magazine such as *Ebony*, and while the teens put down the same number of Latina/o-oriented and Anglo-oriented titles, *Teen* was the only title mentioned by five different teens. In contrast, *Latina,* mentioned several times during other classes, was only named in the worksheet by three teens. In addition to the titles listed in Table 4, I identified seven other titles in their collages and the magazines and cutouts that they brought to the class: *Marie Claire, Mujer21, Photo Magazine, Teen People, Tiger Beat, Shape, Spin,* and *Home Magazine.* Their calendars confirm that most teens were not avid magazine readers. For example, even though it included a column for "favorite reading," only Carmen and Natalia put magazine titles.[10] Yet these responses should be viewed in conjunction with contradictory comments from other sessions. Most notably, Anabel put only two titles in her worksheet, but her collage had two cutouts from *Tiger Beat* (a teen magazine focusing on celebrities, music, and fashion), and during another session she mentioned that she was an avid reader of this magazine. When I asked her why she neglected to put this title in her worksheet, she shrugged her shoulders and said: "*Sé me olvidó*" (I forgot). Beatriz, who stated in the worksheet that she did not read any magazine, pasted an indexical sign of *Spin* magazine and at a later class was completely enthralled with a copy of *Cosmopolitan Hair and Beauty.* When I pointed out the apparent contradiction, she explained that that copy was "*un especial*" (a special issue) on hairstyle and that she was unhappy with her hair. I wondered whether or not "*especiales*" fall under the category of "magazines."

Table 4. The Teens' Response to the Worksheet "Top Three Magazines I Read Most Often."[a]

Latina/o-Oriented Titles	
Eres	Carmen, Lidia, Paty
Latina	Carla, Daniela, Leticia
Vanidades	Gabriela, Natalia, Susana
Tú	Lidia, Paty
Latina-Vogue	Natalia
Hispanic	Gabriela
Por Ti	Paty
People en Español	Carmen
TVyNovelas	Carmen
Anglo-Oriented Titles	
Teen	Daniela, Jennifer, Leticia, Stephany, Susana
Cosmopolitan	Daniela, Gabriela, Natalia
Seventeen	Natalia, Paty
M	Alex, Anabel
World Geography	Jennifer, Stephany
J 14	Carla
In Style	Carla
Nickelodeon Magazine	Anabel
People	Stephany

a Beatriz and Isabel did not complete the worksheet, and Yvet said that she did not read any magazines.

Still, the question remains why the teens seemed to have little interest in a medium that specifically targets young women. When I gave them directions for making the collages, Beatriz said, *"¡Ay, extraño mis revistas!"* (Oh, I miss my magazines!). She had limited English proficiency and thus, her comment implies that her answers to the worksheet had to do with the limited Spanish-language *choices* that she had in the United States. Yet, Sabrina and Yvet, who were perfectly fluent in English, also stated that they did not read any magazines. More than language proficiency, cost appeared to be the most important restrictive factor. When I prepared the worksheet I was already questioning my initial expectation that the teens would be avid magazine readers. Therefore, I included this sentence completion: "I would read more magazines if ..." Jennifer completed the sentence with "they were interesting and free!" Her response summarizes the overall findings.

The reason most often given for their infrequent magazine reading was cost,[11] followed by the content of magazines. Yvet gave the most articulate explanation:

Yvet: *Yo no gasto mi dinero [en revistas].*

Lucila: *¿Por qué no? ¿No te gustan?.*

Yvet: *Un artículo que me gusta, ahí lo leo en la tienda, pero gastar mi dinero, en revistas…Es que hay cuerpos tan bonitos, yo miro la ropa y termino asi como…*

Beatriz: *Oh, sí.*

Yvet: *"Bueno, algun día me quedaran." Pasan diez años, "bueno algun día me quedaran." No, mejor me compro lo que a mí me gusta, que veo en la tienda. ¿Para qué verlas a ellas más bonitas? No.*

Lucila: *¿No te gusta verlas?*

Yvet: *Me gusta sentirme bien de mí, o sea [se ríe].*

Lucila: *¿Y no te hacen sentir bien? ¿Cuáles revistas?*

Yvet: *No sé, como las de teenagers, algunas que venden en la tienda, a veces con modelos y todo eso. Y, like, ropa así como de cien dólares. Si voy a comprar [todas hablan a la vez]. No puedes comprarla, y te sientes mal porque no te puedes ver como la modelo, y te sientes mal porque [se ríe] nada.*

Lucila: *Pura frustración.*

Yvet: *Mejor me gusta ver ropa así que veo en la tienda y ya sé que me va a quedar, porque yo quiero mi size [todas se ríen]. Y que puedes comprar, no de cien dólares.*

Yvet: I don't spend my money [on magazines].

Lucila: Why not? Don't you like them?

Yvet: An article that I like, I read it there at the store, but to spend my money, on magazines…It's because there are very beautiful bodies, I look at the clothes and end up like…

Beatriz: Oh yeah.

Yvet: "Well, some day I will fit into them," then years go by, "Well, some day I will fit into them." No, I better buy what I like, what I see at the store. Why to look at them as prettier? No.

Lucila: You don't like to see them.

Yvet: I like to feel good about myself, I mean [giggles].

Lucila: And they make you feel bad? What magazines?

Yvet: I don't know, some for teenagers, some that are sold at the store, sometimes with models and all that. And like, clothes like a hundred

dollars if I go to buy [overlapping talk by group], you can't buy them, and you feel bad because you can't look like the model, and you feel bad because [giggles], nothing.

Lucila: Only frustration.

Yvet: I like better to look at clothes like, that I see at the store and that I know that they're going to fit, because I want my size [group laughs]. And that you can buy, not hundred-dollar stuff.

The most striking element in this excerpt is Yvet's awareness of magazines' class bias and unattainable beauty standards, as well as her self-awareness regarding the potentially harmful effect of the medium on working-class Latina teens like herself. Yvet's comment took me aback because none of the Durham teens articulated such an eloquent critique of magazines. Her comment, however, was somewhat contradicted by the cutout of a fashion model in her collage (see Figure 7). She presented the collage after she had made the comment above, and, at the time of the presentation, she seemed to become aware of the contradiction. She clarified that the cutout signified her desire to own a long skirt like the one the model was wearing, rather than her desire to look like the model. But to me, the contradiction suggests that her awareness was only a partial penetration of the contribution of teen magazines to the gender and class oppression of working-class Latina teens. According to Paul Willis (1981), a partial penetration is an impulse to comprehend the conditions of one's existence that have been kept in check by ideological forces.

The magazines most often mentioned by the teens *(Teen, Eres, Latina, Cosmopolitan,* and *Vanidades),* share a capitalist and patriarchal ideology that addresses young women merely as consumers. Note that Yvet says that she does not buy magazines, but that she does read articles at the store. Therefore, the cost of magazines may not prevent the teens from taking clues from that media. When I asked Anabel and Alex what they liked to read in magazines, they explained:

Anabel: *Bueno, en ellas tienen, dicen cosas de las personas famosas.*

Alex: *Que movies van a haber en el futuro.*

Anabel: *Sí.*

Alex: *Bueno, no en el futuro futuro.*

Anabel: *Pero que va a salir en el cine. Que están dando ahorita en la tele. Cosas así. Que está de moda, que no está de moda. Algo así.*

Anabel: Well, they have, they said things about celebrities.

Alex: What movies are going to be shown in the future.

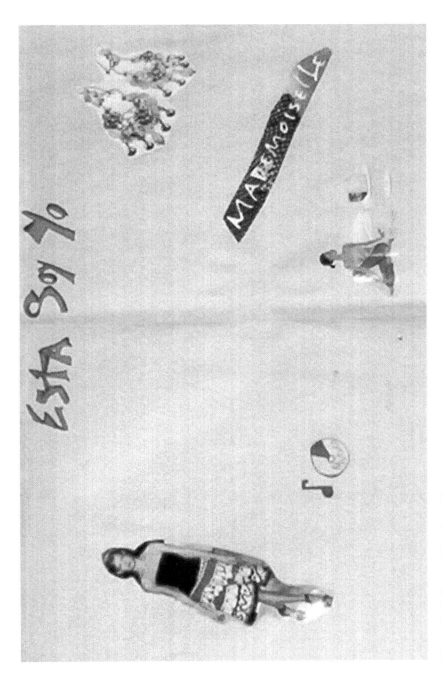

Figure 7. Collage by Yvet (age 16)

Anabel: Yeah.

Alex: Well, not in the future future.

Anabel: But what's going to be at the movies. What's showing now on TV. Things like that. What's trendy, what's not trendy. Something like that.

The excerpt suggests that magazines did play a significant role in the teens' development of adolescent subjectivities. By giving the teens access to "what's trendy" (like the skirt that Yvet wanted to buy and the hairstyle that Beatriz wanted to get), the magazines were teaching them overt lessons regarding gender and consumerism, as well as covert lessons about sexuality, race, and class. Because one of Anabel's favorites was *Nickelodeon Magazine*, an adjunct to the global children's television channel owned by Viacom, it is not surprising that she used magazines to inform her of the newest movie and television releases. Anabel's comment suggests that the medium was having a "rebound" ideological effect by directing the teens to other media that reinforced its teachings. To summarize, on the one hand, magazines seemed to be less significant for these transnational Latina teens than for the white middle-class teens studied by other researchers. On the other hand, in Willis's terms, despite the partial penetrations shown by teens like Yvet, magazines may be accomplishing disciplining functions over transnational Latina teens.

BOOK READING

The life media calendar inquired about preferences (e.g., favorite television show) rather than frequency of practices (e.g., most often, seldom), as some of the worksheets did. As shown in Table 5, even though the calendar included a column for "favorite reading," only Carmen and Natalia put magazine titles.[12] Aparently, most of the teens understood "reading" as referring to "book reading," probably due to the connotation given to the term at school. Yet Yvet and Beatriz were the only teens to put down titles that were probably required readings at school. Not even Sabrina and Susana, who were very diligent students, put any school readings in their calendars. This obviously suggests that school assignments were not among their "favorite readings."

Table 5 sums up the books that the teens said they read during their pre- and adolescent years. Note that Leticia and Paty were the only teens to cite what was probably the most popular book in the youth market at the time: *Harry Potter*. Only three teens included signs of book reading in their collages. Paty pasted five Harry Potter book covers (see Figure 1), Gabriela pasted an iconic sign connoting her reading (see Figure 17), and Leticia pasted an

Table 5. The Teens' Readings during Their Adolescence Years (10–20 Years Old)[a]

	Age	Time in the U.S.	Language (Dominant)	Signs of Book Reading in Collages	Favorite Readings
Anabel	12	3 years	Bilingual		Blank
Carla	13	7 years	Bilingual		None
Leticia	13	6 years	Spanish	Open book	*Harry Potter, Three Little Wishes, The Three Bears*
Alex	14	4 years	English		Any book
Stephany	14	US-born	English		Mystery
Jennifer	14	US-born	English		Poems
Lidia	14	3 years	Spanish		*Juventud en Extásis*, Mexican and Aztec History
Paty	15	+1 year	Spanish	5 book covers	*Harry Potter, El Valle de los Cucuyos, Manos*
Daniela	15	US-born	Bilingual		*Secret Garden*
Sabrina	15	US-born	English		
Susana	16	3 years	Spanish		
Yvet	16	9 years	Bilingual		*To Kill a Mockingbird, And Then There Were None, Things Fall Apart, Nectar in a Sieve*
Natalia	17	2.5 years	Spanish		Medicine books, *Tú Magazine*, planets, bible, *libros de terror*
Carmen	17	11 years	Bilingual		*Eres Magazine*
Beatriz	18	+1 year	Spanish		*El Juego del Apocalípsis, Aura, El Retrato de Dorian Gray, La Divina Comedia, El Lobo Estepario, La Tregua, Las Flores del Mal, Humano Demasiado Humano*
Gabriela	18	3 years	Spanish	Young woman reading	*Novelas, autoayuda, misterios*, aliens, *religión*, tarot, spiritual
Isabel	20	4 years	Spanish		U.S. History, *Tiger Eye*

a This table is based on the teens' collages and media life calendars.

unmistakable indexical sign of the salience that this practice had for her: a photo of an open book held by the hands of a child (see Figure 8). Several teens wrote titles of children's books in the years prior to their tenth birthday (which are not included in Table 5), but only Leticia, who was among the less behaviorally mature girls, put down children's titles during her early adolescent years.

Paty, the most avid reader of popular culture literature, wrote that what she liked to do the most was read, and she talked extensively about her fascination with Harry Potter; in addition, her collage had three cutouts of the character, the books, and one of the films. Another teen who may have been an avid reader was Beatriz. Although Yvet wrote down several titles, she indicated that what she liked to do the most was "hanging out with friends and dancing." But Beatriz, like Paty, noted that her favorite activities at ages 16 to 18 were reading and writing. To demonstrate her cultural capital, Beatriz put in many titles from ages 14 to 18, including masterpieces such as Baudelaire's *Flowers of Evil,* Dante's *Divine Comedy,* Nietzsche's *Humans, All Too Human,* and Wilde's *The Picture of Dorian Grey.* She also wrote the titles of novels of well-known authors such as Carlos Fuentes's gothic novella *Aura,* Patrick Suskind's *The Perfume,* and Hermann Hesse's *Steppenwolf.* In addition, Beatriz listed a popular book not exactly known for its literary merit but one that involves metaphysical themes, Jorge Volpi Escalante's *El Juego del Apocalípsis.* It is certainly hard to believe that she had actually read all of these difficult works, but what is plain is the social imperative that moved her to write down these titles. She thought that her media talk should incorporate titles considered hip in the Latin American bohemian teen circles that she identified with—which do not seem to have changed much since I was a teenager in Mexico more than a quarter of a century ago.

What did Beatriz, Paty, Leticia, and Yvet have in common? Leticia received an unusual amount of attention from her mother. Beatriz, Paty, and Yvet had strong mentoring relationships with young women a few years older than themselves. Paty had her older sister; Beatriz had her aunts, and Yvet had a student who became her mentor through a school-sponsored program. The influence of significant others on reading was also notable in Isabel, who wrote in her calendar that her favorite reading was *Tiger Eye.* I will return to Isabel and other teens' use of reading to cope with ambiguous loss in Chapter Six.

Finally, rather than recording specific titles, some of the teens indicated genres such as mystery, history, and poetry. Likewise, several teens indicated reading topics or subjects, such as medicine, self-help, and religion. Along with some of the titles they mentioned, these topics hint at a preference for mystery and the supernatural, and these show up in their other media choices as well. The topics and genres mentioned are closely connected to the distinguishable thread that runs

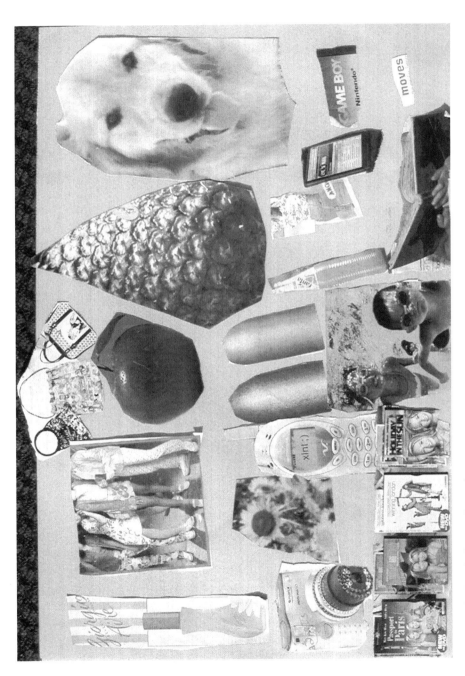

Figure 8. Collage by Leticia (age 13)

through each teen's media and popular culture practices. These threads are further developed in subsequent chapters.

USING COMPUTERS AND THE INTERNET

Despite the fact that access to computer technologies and the Internet is far more expensive than access to books and magazines, most teens did a great deal of reading and writing online. Latinas and Latinos have less Internet access than the Anglo population, but this situation is rapidly changing. Fairlie and London note that "there has been a dramatic rise in home computer access among all Latinos, and for Latina girls in particular, between 1998 and 2003." In six years, Latina girls' access went from 28 percent to 58 percent (Fairlie & London, 2006, p. 170). According to these authors, "Latina girls are more likely than other Latino groups to have a home computer and Internet access" (Fairlie & London, 2006, p. 171). The numbers, however, are very uneven among national subgroups and the percentage for teens of Mexican origin or ancestry is only 38 percent. Given that migrants of Mexican origin tend to be less educated and to have lower incomes than migrants from countries like Argentina and Colombia, class (rather than nationality) is likely to explain the differential access among national subgroups.

The access that the teens reported is somewhat different from the national trend. In a worksheet inquiring about media and communication hardware availability, only four teens wrote that they did not use a home computer. Ten indicated that that they shared a computer with their families, and three said that they used their own computers. In addition, all teens had access to the Internet at school; some, like Lidia, routinely accessed the Internet at the public library; and others, like Carla, accessed it at the community center.

The collages, which contain many signs of computer and Internet practices, provide further evidence of their familiarity with computers and the Internet. Table 6 indicates that nine teens included signs of Internet practices and computer technologies by adding indexical and iconic signs of computers and/or URLs. Also, Anabel and Alex pasted pictures downloaded from the Web. It is worth noting that Beatriz, Daniela, Isabel, and Susana, who indicated that they had no home access to computers, did not include any signs of Internet practices in their collages.

My sense is that searching for information on-line was not a frequent practice among the teens. Natalia seemed to be the only skillful on-line information seeker. For example, when Lidia was having trouble finding information for a class assignment, Natalia suggested that Lidia search the site of *Encarta:* "*te sale Encarta, www punto encarta punto com, está buenísima, te sale de todo*" (you get Encarta, www dot encarta dot com, it's really good, it has everything). Carla also mentioned that she used the Internet for seeking information but she stressed that she did not like to spend time at the computer: "*No me gusta estar en la computadora. No me gusta,*

Table 6. The Teens' Access and Use of Computers and the Internet

	Age	Grade	Time in U.S.	Language	Access to Computers at Home	Signs of Internet Use in Collages
Anabel	12	6	3 years	Bilingual	Yes	1
Carla	13	7	7 years	Bilingual	Yes	N/A[a]
Leticia	13	7	6 years	Spanish	Yes	1
Alex	14	9	4 years	English	Yes	1
Stephany	14	9	U.S.-born	English	Yes	0
Jennifer	14	9	U.S.-born	English	Yes	1
Lidia	14	10	3 years	Spanish	Yes	2
Paty	15	9	+1 year	Spanish	Yes	2
Daniela	15	10	U.S.-born	Bilingual	No	0
Sabrina	15	10	U.S.-born	English	Yes	1
Susana	16	12	3 years	Spanish	No	0
Yvet	16	11	9 years	Bilingual	Yes	0
Natalia	17	11	2.5 years	Spanish	Yes	1
Carmen	17	11	11	Bilingual	Yes	1
Beatriz	18	Graduate	+1 year	Spanish	No	0
Gabriela	18	Graduate	3 years	Spanish	Yes	5
Isabel	20	12	4 years	Spanish	No	0

[a]Note: Carla did not make a collage.

porque como no, no sé, no aguanto estar cerca de la computadora. Si sé muchas cosas sobre la computadora, ¿verdad? Pero no me gusta estar tanto, nomás cuando necesito buscar información sobre algo es cuando la uso, pero no, no me gusta tanto usarla" (I don't like to be at the computer. I don't like it, because like no, I don't know, I cannot stand to be close to the computer. I know many things about the computer, right? But I don't like to be so much, only when I need to search information about something it's when I use it, but I don't like to use it so much). Most remarkably, despite the teens' fascination with music, Lidia was the only teen who made a comment about downloading music from the Internet.

By and large, the teens' on-line reading and writing was for socializing and having fun. This finding predicts the intense use of Internet technologies for social networking by the transnational Latina teens that I observe now through my volunteer work with a nonprofit. Despite my failure to have a column in the calendar for practices involving computers and the Internet, five teens made use of other

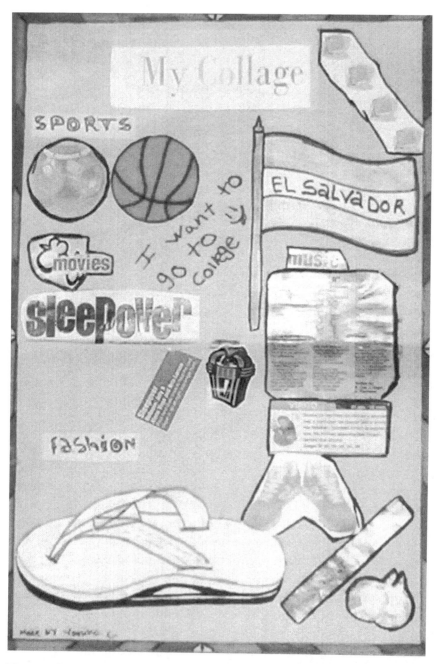

Figure 9. Collage by Alex (age 14)

columns to include such practices. Alex, Natalia, and Gabriela wrote "computer," Carmen put "chat," and Leticia put "going to the Internet." There are also other references to the Internet in some worksheets. Lidia, for example, stated that she watches her favorite music videos on the Internet. Alex, who said that she wanted to be a computer engineer, offered me a vivid description of her use of the Internet at different settings, a feature common to most U.S. adolescents' use of the Internet. First she said that at school she used computers to do projects, then when I asked her if she liked to surf the Web at home, she said:

Alex: *No mucho, el Internet, no sé [hay] cosas que si te ayudan mucho. Pero sólo a checar el e-mail, sólo a eso voy ahí.*

Lucila: *Sólo vas a checar tu e-mail.*

Alex: *Aunque sólo el Internet sólo lo uso así como para agarrar pictures, images. Y agarro fotos para poner en mi cuarto [...] Y a mi hermana le limpié el cuarto yo, porque sólo quería, y ¡ah! se lo decoré, y ahí pinté, a ella le gustan los monkeys. Y se las saqué [del Internet] y se las puse en la pared.*

Alex: Not much, the Internet, I don't know [there are] things that do help you a lot. But only to check the e-mail, I only go there for that.

Lucila: You only go to check your e-mail.

Alex: Although I only use the Internet like for getting pictures, images. And I get pictures to put in my room [...] And I cleaned my sister's room, because I only wanted, and, ah! I decorated it for her, and there I painted, she likes monkeys, and I took them [from the Internet] and I put them on the wall for her.

When I was giving directions for making collages to the Carrboro group, Alex observed that they could get pictures from the Internet, and indeed her (see Figure 9) and Anabel's collages (see Figure 10) have the same pictures downloaded from the Internet. Yet I could not identify any Internet materials in the other teens' collages. Alex also said that she accessed her e-mail at home in order to be in touch with friends. I have kept in touch with Alex, and I know that now she has a complex site at MySpace. Thus, it seems that the primary purpose of their use of computer technologies was, and is, for socializing. During a class session with the Durham group, we had this conversation about their Internet usage:

Lucila: *Te gusta meterte al Internet?* (Do you like going to the Internet?)

Sabrina: Yes. But I don't go on different like Web sites. I like just being on the Internet and going to chat rooms.

Stephany: Meet your friends.

Sabrina: And talking to people.

Susana: I know, right.

Lucila: *Lo haces en tu casa, o lo haces en tu escuela?* (Do you do it at home, or at school?)

Sabrina: At home and at school. 'Cause I have computer applications, fourth period and when we don't have anything to do we just get on the Internet.

Lucila: *Entonces lo que haces es irte a chatear.* (Then what you do is go to chat.)

Sabrina: Yeah, well in the Internet at school I can't get in the chat room, so I just go and check my e-mail.

Lucila: *O sea, ¿en la escuela no las dejan chatear?* (So, at school they don't allow you to chat?)

Group: No, no! Uh, uh.

Jennifer: They're mean.

Sabrina: Well, in Yahoo the messenger, it's the messenger, like you could get in and play games.

Susana: While you are talking to people. That's the only way to talk to people.

The excerpt shows their familiarity with instant messaging and e-mail. Chatting and playing games, often simultaneously, as the last comment by Sabrina states, were ways to "hang out" with other teens. While most U.S. teens use computer technologies for social networking purposes, to understand the actual significance of these practices for teens like Susana, one has to consider the limited opportunities to socialize with friends that they have. As Susana states, "that's the only way to talk to people" because transnational Latina/o parents tend to enforce strict restrictions on the time that their daughters spend hanging out with friends (Denner & Guzmán, 2006). Signs of the desire to socialize with friends away from home can be identified in several collages. For example, Lidia pasted a cutout with five girls literally hanging together in a swing (see Figure 2). Natalia put an indexical sign of hanging out (see Figure 11). And Alex's and Anabel's references to the film *Sleepover* (see Figures 9 and 10), may also be read as symbolic signs of a desire to participate in a social practice that is common among other U.S. teens but restricted for transnational Latina teens.

At least three teens said they used the Internet to keep up relationships across borders. Gabriela, for example, explained that she had written "love.dot.com" next to the picture of a friend in her collage because she kept in touch with him through the Internet: "*Porque esta persona vive lejos, entonces siempre estamos manteniéndonos en contacto por la computadora, el teléfono, las cartas*" (Because this person lives far

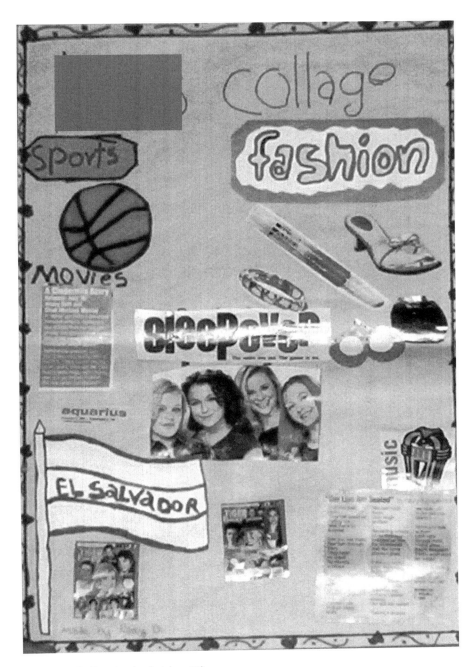

Figure 10. Collage by Anabel (age 12)

away, so we're always keeping in touch by computer, telephone, letters). Paty, who deeply missed the friends that she had left in Mexico, explained the meaning of the picture of a computer that she pasted in her collage in this way: *"Pues, en sí ahora mi vida está basada en la computadora porque es la única manera que tengo para comunicarme con mis amigos, es la computadora, entonces representé ahí una computadora"* (Well, in fact now my life is based on the computer because it's the only way that I have to communicate with my friends, it's the computer, so I represented there a computer). Paty became so unhappy that her family decided to send her back to Mexico a few months after I finished my fieldwork. The profound sense of migration loss that is involved in processes of transculturation is the topic of Chapter Six. But before moving into this crucial topic, in the next chapter I offer a few analytic reflections on the opportunities and challenges that the praxis of critical media literacy with transnational Latina youth presents to activists.

Teaching-Learning Transnational Critical Media Literacy

This chapter is dedicated to analytic reflections on the action component of my project. My principal intention here is to shed light on a path that may lead us to a pedagogical media literacy practice grounded on the concrete experience of transnational Latina teens. The action component involved several interrelated goals. The most immediate was to create a space where a small group of teens would empower themselves through the development of critical media literacy skills. Then, I sought to raise awareness among local Latina/o organizations of the importance of critical media literacy for Latina/o youth. Lastly, knowing that the popular culture experience of Latina/o youth is qualitatively different from the experience assumed in most theorizing on media literacy—that of white, middle-class youth—I wanted to explore, and later reflect on the potential of critical media literacy instruction for working-class transnational Latina/o youth.

The discussion that follows is mostly based on what I learned in the semester-long program with the Durham teens. In this chapter I refer to them as "students." Unfortunately, the Carrboro program was too short to provide enough material for the type of qualitative assessment that I present here. I argue that a number of the underlying assumptions of much of the theory and practice of media literacy are likely to lead the teacher of transnational Latina teens astray. I begin by explaining the theoretical grounding of what I call "transnational critical media literacy" (TCML). Then, I describe the course with the Durham teens. After that,

I move on to consider the myopia of my original curriculum, the class bias of media literacy, the potential of TCML for problematizing existential situations, and the teaching–learning of natural language that took place in my classroom. Finally, I discuss issues related to the cultural insight shown by the students and the ways in which their media practices may contribute to processes of social reproduction that work against their class interests. TCML calls for a demanding commitment on the part of the teacher: culturally sensitive media literacy programs for Latina/o transnational teens should be grounded on the specific experiences of the particular group of students with whom one is working. Given the scarcity of scholarship on the topic, one needs to start from scratch: by learning the students' actual media practices and preferences as well as the functions that media may serve in their lives. An analogy may be useful here. Students who grew up listening to Spanish at home but were schooled in English and thus are not fluent in their family's language do not benefit from Spanish-as-a-foreign-language classes designed for Anglo students. To build up their fluency they have to take Spanish for bilingual students classes, which are prepared with their particular needs in mind.

TRANSNATIONAL CRITICAL MEDIA LITERACY

According to the critical perspective on media literacy, this literacy entails a set of competencies that include production skills as well as critical thinking skills, such as the ability to apply analytical tools when examining one's own media practices; the ability to examine the connections between media practices and subjectivity; and the ability to understand the political economics of global media conglomerates, their power as socializing agents, and their role in the constitution of identities (Buckingham, 1998; Lewis & Jhally, 1998). What I call transnational critical media literacy is an approach grounded in the scholarship on globalization and transnationalism that I reviewed in Chapter One. This conceptual model offers a robust grounding for thinking of media literacy instruction in transnational terms, allowing us to highlight, for example, breakings of media boundaries and transgressions of conventional forms of consumption.

The foundation of TCML is Paulo Freire's (1994a; 1994b; 1999) method and philosophy, which foreground the relational and political aspects of literacy. TCML adheres to Freire's view of knowledge as co-produced in reflective dialogue and conceptualizes subjectivity as relational, constituted in intersubjectivity; it also assumes that the subjectivity of working-class transnational youth is (re)constituted in the Hegelian master-slave relationship. Consequently, they are particularly susceptible to the effects of media devaluing and stereotyping that characterize the treatment of people of color in general (Dates & Barlow, 1990;

Wilson et al., 2003) and of Latina/os in particular (see Chapter Three) by the Anglo tradition. Following Freire and other theorists of the subjective aspects of (post)colonization (e.g., Albert Memmi, Eric Fromm, and Frantz Fanon), TCML is concerned with the colonized mentality, and with finding ways to heal the psychological wounds inflicted by oppression. Freire referred to the ability to critically examine one's own existential reality as *conscientização,* or critical consciousness. *Conscientização* enables the oppressed to demystify inequality by examining its structural causes. TCML programs aim to be spaces in which students can pose problems about their own media practices and the relation of such practices to the subaltern public identities assigned to them by the dominant society.

TCML underscores the role of class by embracing Paul Willis's (1981) theory about the power of class culture to constitute subordinated subjectivities. TCML considers class in its intersection with other social distinctions (especially gender, race, ethnicity, nation, and transnational status), but it turns away from the focus on ethnicity that has distinguished Latina/o media studies. Whereas TCML recognizes the agency of working-class transnational teens to negotiate the meaning of mass-mediated messages, it assumes that they are less skillful than other oppressed teens whose cultural traditions and collective resistance identity (e.g., Chicanos, African Americans) may equip them to deal with, for example, media stereotyping. The incipient scholarship on media and transnational teens indicates that they make their own meanings of mainstream media texts and that often they use media products for their own purposes. Although this may be true, I posit that working-class transnational teens negotiate and resist the definitions of reality offered to them by the media only to a certain extent. With Paul Willis, I believe that oppression is deeply rooted in one's subjectivity and that transnational teens may experience their compliance with their own subordination as resistance. Lastly, like other critical approaches, TCML sees media literacy competencies as crucial for exercising democratic citizenship, but it differs in that it works with the notion of *cultural citizenship* advanced by Renato Rosaldo and other Chicano scholars that I discuss in Chapter One.

CUSTOMIZATION AND ITS LIMITS

The Freirean method calls for the teacher to develop a "culture circle" in which both students and teacher can discover, and later work together, on generative themes. Thus the teacher begins by learning about the reality of the students and by finding out which might be the generative themes of a particular group of students. Thus, I was prepared to make adjustments to the original curriculum according to my broadening understanding of student needs. I planned for early activities

that would help me to develop an overall sense of each teen's media practices, such as the collage and the life media calendar. Then, I used the material that I was gathering to inform the lesson planning (or "agenda," in Freirean terminology) for subsequent sessions. The most successful class activities were those that allowed us to discuss generative themes that have deep meanings in the students' quotidian lives. One such theme was dancing. Therefore, for an exercise, I combined basic principles of critical media literacy with a print advertisement for Liz Clairborne's perfume Mambo that I found in *Latina,* a magazine often mentioned by the students. An emerging research finding was the way in which Latin music and dancing serve as pivotal linkages to articulate Latina identity in media discourses as well as my students' self-concepts. The ad connected Latin music and dancing to metaphors of passion and to codes of heterosexual romance in a masterful way. Hence, it became an excellent instructional tool to problematize the dominant discourse on Latina femininity and to further explore students' views about dancing because, as Daniela put it when we were analyzing the ad: "the majority of Latinas dance."

But my curriculum had structural problems that went beyond the limits of customization. It reflected a common bias in media studies toward not seeing music as media, and it scheduled only one class for music and music videos. I incorporated exercises on music and music videos after the second session, but the course failed to fit the students' experience. The tremendous significance of music for adolescents has been noted by numerous scholars (McCarthy et al. 1999). Music was the axis around which many of my students' media practices revolved, and it had a profound connection to both cultural identity and cultural citizenship. Another of the curriculum's structural flaws was that it was unmindful of the salience of black media and black popular culture as sources of meanings for the students. As I pointed out in Chapter Two, they were attending schools with a high percentage of African Americans, and, most likely, their pupil culture influenced their media preferences. In Chapter Four, I explain that I found out that one of their favorite television choices was Black Entertainment Television (BET), and that their favorite films and music videos were populated by both black musicians and non-black musicians "performing black," such as Eminem. I was completely unprepared to deal with the maze of complexities that come with the crisscrossing of ethnic media boundaries. As I would figure well after I designed the course, the students' popular culture landscape was a site where four different popular culture traditions met.

MEDIA LITERACY AND CULTURAL CAPITAL

Much of the advice for media literacy suffers from a middle-class bias and overlooks the fact that working-class transnational parents are poorly equipped to guide their

children's use of media. These parents lack the cultural competencies needed to navigate their children's complex media world. For instance, two of the students who enjoyed spending time with media in the company of their mothers nonetheless dreaded their mothers' demands for translation when watching films:

Susana: *Mi mamá siempre, ella dice" "¿Qué?" "¿Qué dijo?" "¿Qué?"*

Lidia: *¡Ay sí! Es lo que no me gusta de verla [la película] con mi mamá porque le tengo que estar*

Natalia: *Traduciendo.*

Lidia: *Traduciendo.*

Natalia: *¡Ay no!*

Lidia: *Y está, está aquí [énfasis], al lado, y me dice: "¿Qué dijo?" Ni siquiera la puedo ver [la película.]*

Susana: My mother always, she says: "What?" "What did they say?" "What?"

Lidia: Oh gosh! That's what I don't like about watching [movies] with my mother because I have to be...

Natalia: Translating.

Lidia: Translating.

Natalia: Oh no!

Lidia: And she is right *here* [stress], next to me, and she says: "What did they say?" I can't even watch it [the movie].

This dialogue illustrates the typical reluctance of transnational youth to take on the onerous responsibility of translating for their parents, and it points to the special dynamics of the parent–child relation in working-class transnational families, where children typically develop cultural competency faster than their parents. Although in some cases it seems that media broadened the gap between a teen and her parents, media also help transnational teens satisfy deep socio-psychological needs brought out by the upsetting of the parent–child relation. Like most people, my students used media as emotional tools. Yet, I found that what was really distinctive among my students was their use of media to cope with the pain of separation. Numerous authors have reflected on the profound meaning of separation for the transnational experience. In Chapter Six, I explain how the "ambiguous loss" resulting from the multiple separations lived by transnational teens transformed seemingly trivial activities into profound healing rituals. TCML programs may do more harm than good if they are insensitive to the particular socio-psychological needs that students, and their families, may be satisfying with practices that may appear distressing to middle-class sensibilities. For example, even though many of the texts of Univisión are blatantly sexist, for some of my students, who were constantly Othered at school,

watching Univisión seemed to offer not only pleasure, but also a refuge, a nostalgic retreat to "home" and a comforting sense of belonging. Moreover, Spanish-language media and popular culture consumption practices may also help repair the erosion of parental authority, and they may ease inter-generational tension.

TCML AS A POTENTIAL SAFE SPACE FOR
PROBLEMATIZING EXISTENTIAL SITUATIONS

Freire's problem-posing method often led to moments in which students were problematizing their own "real, concrete, existential situations," as Freire would say. These moments provided opportunities for intervening in aspects of the students' lives that were not directly related to TCML. For instance, it was difficult for the students to find topics for their magazine writing assignments. After I explained that great authors often write about issues that they care deeply about, Carla announced that her article was going to be about why parents do not understand teens, and that she was going to interview teens at her school. The following week, I asked her if she was going to include parents as sources as well, and I reminded her of the basic guidelines of journalistic writing that we had studied. She did not answer, but later she announced to the class: "She [Lucila] just gave me an idea too, that we ask parents too, it's going to be the other way around, why we teens don't understand parents, that is, the other way around, then there are going to be two questions."

Some of the students' concern with inter-generational tension went beyond the typical adolescent preoccupation. As I mentioned above, some had complained about their mothers' inability to fathom the reality of Durham Latina teens; nevertheless, the class was very receptive to the idea of interviewing parents. I believe that their understanding of the journalistic imperative to account for different views contributed to their openness to consider the parents' perspective. Our classroom, therefore, became a site for exploring issues of extreme concern for the students such as gangs, Latina/o students "skipping school," and sexual taboos in the local Latina/o community, especially virginity.

MEDIA EDUCATION AND LANGUAGE LITERACY

When he talked about the importance of "regaining the power to speak" and the centrality of language in emancipatory struggles, Freire was talking about the development of communicative competencies, which is TCML's overarching goal. Much of the teaching–learning that took place in our classroom was about

natural, rather than media, language. Some students were fluent in both English and Spanish, but others had greater competence in one language than in the other. Initially, English as a Second Language (ESL) was not the purpose of the class, but it quickly took center stage. On the basis of my initial consultations with the Durham community organization's youth group, I prepared materials in English which became not only tools for the teaching–learning of media concepts but also instruments to study English. For example, students enjoyed practicing their English pronunciation by taking turns reading aloud. As Kellie, my research assistant, and I realized the potential of TCML for ESL, we began to think that the ESL classroom might be the ideal setting for TCML programs. Kellie developed the idea and implemented her own master's thesis project in a local school (Toon, 2003). Yet, in our classroom, amid the code-switching of the class, the learning of English was coupled with the learning of Spanish. U.S.-born students repeatedly expressed a desire to become more fluent in Spanish, and foreign-born students talked about their concern with losing their mother tongue. Such concern was exacerbated by the multiplicity of Spanish dialects spoken in Durham. We recorded numerous illustrations of joking interactions among the students about each other's Spanish dialect. This a perfect example of how transculturation works. Fernando Ortiz (1963) maintains that transculturation involves not only processes of acculturation, but also processes of partial deculturation and neoculturation. Our classroom became a site where the teens were not only acculturating by learning English, but also where they could express their anxieties about their partial deculturation and engage in a neoculturation practice: re-learning Spanish from the vantage point of both their familiarity with English and their newly-acquired appreciation of dialectical differences.

Most of the teens read few magazines and books and used the Internet mostly for e-mail and messaging (see Chapter Four). Carmen, one of the group's avid readers, grew up going back and forth between her home and host countries and seemed extremely aware of the lack of opportunities to read Spanish-language texts. An important reason for becoming less competent in written Spanish, she said, was that her interactions with teachers were in English. Her opportunities to read Spanish came from the Internet. When I asked her to explain the poem that she had pasted in her collage, she said:

Lucila: *Y luego tenías un poema, ¿te gusta mucho la poesía?*

Carmen: *Sí, me gusta mucho. Aunque casi a veces no me sale bien, yo escribirlo pero, me gusta mucho cuando mis amigos me escriben. Tengo unos amigos que me escriben a mí, de mi personalidad, y también porque me voy al Internet...*

Lucila: *¿En Internet lees poemas?*

Carmen: *Uh, uh. Y en parte porque a veces hay unos que se inspiran ellos solos, pero lo que vas viendo también es lo que hay de tu vida también, ahí vas leyendo, y te sale algo como un disfraz, así me paso a mí, o algo así.*

Lucila: *Uh, uh. ¿Tienes libros de poesía?*

Carmen: *Quiero comprar uno. Quiero comprar uno porque la verdad si me gustaría aprender a escribirlos bien.*

Lucila: *Pero más bien*

Carmen: *Me gusta más bien leerlos.*

Lucila: *Leerlos, pero más bien lees en, en Internet?*

Carmen: *Uh, uh, porque allí, donde allí ya sé donde están, las veo en Univisión [sitio], bajo "poemas" y allí es donde sale toda la lista.*

Lucila: *O sea, ¿en el sitio de Univisión?*

Carmen: *Allí en Univisión.*

Lucila: *Dice "poemas."*

Carmen: *Y nada más "publicable", "poemas", y luego te sale toda la página y hay de, uh, como, hay de hartas páginas. Y tiene, en cada página tiene diferentes poemas, de diferentes personas. Hay unos que, hay unos que son de escrituras de poema y escriben y escriben diferentes, hasta versos también escriben.*

Lucila: And then you had a poem. Do you like poetry a lot?

Carmen: Yes, I like it a lot. Although sometimes I cannot do it right, writing it, but, I like it a lot when my friends write [poems] for me. I have some friends who write for me, about my personality, and also I go to the Internet...

Lucila: Do you read poems on the Internet?

Carmen: Uh, uh. And in part because sometimes there are some that get inspiration by themselves, but also what you see is what it's there about your life too, and you find something like a custom, that's what happened to me, or something like that.

Lucila: Uh, uh. Do you have poetry books?

Carmen: I want to buy one. I want to buy one 'cause, the truth is that I would like to learn to write them well.

Lucila: But mostly...

Carmen: Mostly I like to read them.

Lucila: Read them, but mostly you read on, on the Internet?

Carmen: Uh, uh, 'cause there, there I already know where they are, I see them on Univisión [site] under *"poemas,"* and it's there where you get the whole list [of poems].

Lucila: That's to say, on Univisión's site?

Carmen: There, on Univisión.

Lucila: It says *"poemas."*

Carmen: That's it, *"publicable," "poemas,"* and then you get the whole page and there are, uh, like a bunch of pages. And it has, on each page it has different poems, from different people. There are some that, there are some that are poetry writing, and they write and write different [poems], they even write verses.

Carmen's avid use of the Univisión site to read poetry and the pleasure that she derived from it was unique among the Durham group, but other students shared her desire to improve her Spanish. The same desire appears to underlie Natalia's remarks about my language competency: *"¿Cómo le hace para que no se le olvide el español? ¡Y todas la palabras que sabe! ¿Cómo le hace?"* (How do you do it to not forget Spanish? And all the terms that you know! How do you do it?). The lack of both role models and formal educational opportunities to learn Spanish complicates the task of TCML and makes these programs even more urgent, because the void created by the schools heightens the importance that Spanish-language media may have on the lives of transnational Latina/o youth.

LEARNING, TRANSFORMATIONS, AND PENETRATIONS

How much did the students learn? Given the nature of the project, I did not ask them to do formal evaluations of the course. Except for levels of attrition and attendance, I have little information on how the entire class felt. I only have access to comments from the six students with the highest attendance; these comments are, of course, positive. Rather than testing students about specific content, I looked for evidence of student learning during data analysis. Most often, the evidence that I found showed students' understanding of specific concepts. Take for example the concept of corporate authorship. When we were examining a newspaper article, I pointed out that it did not have a byline and asked the class to tell me who the author was. Gabriela and Sabrina were quick to answer "the newspaper!" I also found evidence of their ability to apply the knowledge gained in class to new situations. For instance, as I explain in Chapter Two, in the second session we talked about collage-making as an art and I asked students to make *"who I am"* collages as homework. Then, in the fifth session, when we were examining the way in which a magazine article combined quotations from informants with statistics from a scientific report, Isabel noted: *"Es como hacer un collage"* (It's like making a collage).

The program's overall objective was that students would acquire analytical skills to examine media and popular culture practices, texts, and technologies, and

the connection between their selves and their own consumption and use of popular culture texts and artifacts. The six students who attended the class regularly became skillful in seeing such connections. For example, during the individual interview with Susana, we were talking about "Gybon," her favorite television show at ages 5–7. She said that it was a "robot that it was like a police" and then she explained: *"A mí siempre me han gustado las cosas de la ley, siempre me ha gustado la ley. Yo quería ser abogada y después detective…siempre me han gustado las pistolas y todo eso"* (I have always liked things about the law, I've always liked law. I wanted to be a lawyer, and later a detective…I have always liked guns and all of that). Then, when we were talking about her current favorite shows, she mentioned an "FBI drama," and interrupted herself to say: *"¡Todo de detectives, yo!"* (Everything about detectives, me!). Her words show that she was able to grasp the pattern in her media and popular culture practices and its connection with her own self. Susana also had another epiphany during a class in which we were discussing gendered media practices and I noted that there were few action television shows on their worksheets. My comment sparked a heated discussion about gender roles and the following remarks about cars:

Carmen: *A mí lo que, me gusta, normalmente, este, también de* low riders, *es de hombres, pero a mí me gustan los* low riders.

Lucila: *¿Te gustan?*

Carmen: *Me gustan mucho.*

Daniela: I like nice cars, I don't know, *no sé nada de carros pero me gustan mucho.*

Susana: *¡Exacto! Pero no sabemos nada, pero nos gusta*

Carmen: What I like, what I like, normally, it's also low riders, they are men's, but I like low riders.

Lucila: Do you like them?

Carmen: I like them a lot.

Daniela: I like nice cars, don't know, I don't know anything about cars but I like them a lot.

Susana: *Exactly!* But we don't know *anything*, but we like them.

Susana pointed out the contradiction between their liking of cars and their ignorance about them. In a similar fashion, Gabriela arrived at conclusions about her practices that show an impulse to grasp her position in U.S. society. The following excerpt comes from an individual interview in which we talked about her life media calendar:

Lucila: *Aquí pusiste "Friends," ¿es el show que te gusta más ahora?*

Gabriela: *Sí.*

Lucila: *¿Por qué te gusta?*

Gabriela: *Por super cómica. Aunque no tiene mucho, no tiene mucho, nada, no tiene nada que ver con mi vida pero me parece super cómica. Me (gusta), es una buena serie de entretenimiento, super cómica.*

Lucila: Here you put *Friends,* is this the show that you like the most now?

Gabriela: Yes.

Lucila: Why do you like it?

Gabriela: Because it's super-funny. Even though it doesn't have much, it doesn't have much, nothing, it doesn't have anything to do with my life but I think that it's super-funny. I like it, it's a good entertainment series, super-funny.

Gabriela's awareness of the social and cultural distance between her own life and the yuppie New York lifestyle depicted in the sitcom, shows a partial penetration, that is to say, a struggle between her cultural insight regarding her subordinated position as a transnational working-class Latina, and the ideological forces (e.g., the popularity of the sitcom) holding such insight back. The behavioral change of Leticia and Carla, two of the youngest students, was also quite revealing of their learning. Leticia had nearly perfect attendance and did her homework regularly. She had a shy personality and was an outsider to the group. For most of the semester she made sparse and brief comments in class, but by the end of the semester she opened up. Carla, who during the first classes was either withdrawn or disruptive, by the mid-term announced that she wanted to be called by her middle name from then on. After the class, Kellie and I rejoiced over the transformation that we had witnessed.

In one session I probed my finding about what I call "race-bending racism" in the Anglo media used by the students. It is a trend in media targeting the global adolescent market (e.g., MTV and Hollywood films), that deploys a deceptive combination of clearly racialized bodies and bodies that are ambiguously coded in terms of race. The result is the mystification of old racial stereotypes (e.g., Latino men as stupid, Asian men as cunning) inscribed in the text. A film that some students mentioned as one of their favorites, *The Fast and the Furious* illustrates the use of the race-bending technique racism well (I critique this film in Chapter Eight) and I used it to probe my idea. Lidia seemed aware of the lack of Latina/o representation in film; for example, she had written in a worksheet that she would go to the movies more often if the movies "*Tuvieran más hispanos*" (had more Hispanics), and she said that one of the reasons Latino/a teens liked *The Fast and the Furious* was that it included numerous Latina and Latino characters. However, when we analyzed the film in class, she seemed to realize its racist subtext. The

following excerpt shows the epiphany experienced by Lidia, who was emotionally invested in the film:

Lidia: *Lo que estaba viendo ahorita, es que el bueno, el detective, se veía más como americano, ¿verdad? Entonces él salió como el bueno de la historia.*

Lucila: *Es el bueno de la película.*

Lidia: *Es lo que yo no había notado, es que el* buuueeeno *[énfasis] de la historia fue un americano.*

Lidia: What I was noticing right now, is that the good [character], the detective, he looked more like American [meaning white], right? Then he played the story's good character.

Lucila: He's the movie's hero.

Lidia: That's what I hadn't noticed that the story's *gooood* [stress] one was an American.

Lidia had learned a storytelling technique that equates whiteness with moral superiority and she was able to read her favorite film critically. As transnational *mestizas*, my students had a vague sense of race, and it was difficult for them to understand the workings of racism in their favorite media texts. Nonetheless, during the semester, some began to demystify the media in their everyday lives. Natalia told the class that she was talking with Stephany about movies at school:

Natalia: *Estaba hablando con Stephany en la escuela y me dice, "mira que inteligentes son (los productores), en la música ponen blancos y negros cantando, y eso es bueno porque ellos atraen a los dos, blancos y negros." Es super inteligente.*

Leticia: Like in *8 Mile*

Lucila: Like what?

Leticia: The movie of Eminem.

Natalia: *Exacto, y tú ves también Christina Aguilera, ella también canta con hombres, está cantando, y ahí, todos, todas las razas, varias razas.*

Natalia: I was talking with Stephany at school and she says, "look how intelligent they are [media producers], in the music they put whites and blacks singing, and that's good because they attract both whites and blacks." It's super-intelligent.

Leticia: Like in *8 Mile*

Lucila: Like what?

Leticia: The movie of Eminem.

Natalia: Exactly, and you see also Christina Aguilera, she also sings with men, she's singing, and there, everybody, all the races, various races.

What Natalia relates here demonstrates that they had taken the critical examination of popular culture that took place in our classroom to other locales, which is evidence of high-level learning. And they were engaged in a more profound type of learning, what Paul Willis called *penetrations.* Developing a critical awareness about one's own practices and their effects on one's subjectivity can be seen as a form of penetration. When we studied advertising, I showed them a television commercial for a doll that is one of the merchandise products of the cartoon *Dora the Explorer.* The show was the top choice for one of the students, yet its significance stems not from its popularity among Latina/o audiences, but from its success among non-Latina/os. Amid the scarcity of Latina images in the Anglo tradition, Dora became a mainstream icon of Latina femininity. The cartoon character is bilingual and the doll says a few phrases in Spanish. When I screened the commercial, I was myself starting to fully realize the way dancing articulated Latina identity in the popular culture artifacts used by the students:

Lucila: *Lo que me parece es que en ese anuncio la feminidad Latina se asocia con la danza.* (What it seems to me is that, in that ad Latina femininity is associated with dance.)

Sabrina: With dancing.

Carmen: The first thing she said was "we dance." How come she couldn't say "we study," or something.

Jennifer: We read.

Daniela: We sing, something.

Group: We dance!

Daniela: OK, we can't talk because I love dancing, but I mean…

Bright and politically savvy, Daniela was often impatient with her classmates. Nonetheless, she shared the love of dancing with the rest of the class and being a good dancer of Latin music was central to her subjectivity. In her collage, for example, she wrote the word "*ritmo*" (rhythm) once and the word "dance" twice; she also drew three human figures that appear to be dancing. The excerpt suggests that, through the exercise, Daniela realized that the interplay between popular culture and self was much more complicated than she had previously thought. This type of cultural insight, or penetration, was the course's ultimate goal. I return to issues related to dancing as a culturally sanctioned activity for Latinas in Chapter Nine. In the following chapter, I focus on one aspect of the migration experience that I believe does not receive the attention it deserves in the scholarship on media/popular culture and mobility: migration loss; that is, the way in which people experience migration involves feelings of loss. Loss is an

important component of the processes of partial deculturation that, as I explain in Chapter One, Fernando Ortíz (1963) argues are part of transculturation. He insists that transculturation comprises processes not only of acculturation into another culture, but also processes of partial deculturation from the native culture, as well as processes of neoculturation. The next chapter is mostly dedicated to deculturation, but it also covers some of the new phenomena that emerge during neoculturation processes.

Dealing WITH Ambiguous Loss

Different social groups have distinct relationships to this anyway-differenti-ated mobility: some are more in charge of it than others; some initiate flows and movement, others don't; some are more on the receiving end of it than others; some are effectively imprisoned by it.

Doreen Massey (1993, p. 61)

Fernando Ortiz's (1963) theory emphasizes that transculturation involves not only processes of acculturation but also processes of deculturation or exculturation. Deculturation means the partial loss of one's native language and other sym-bolic systems, and the feeling of no longer having the small rituals that structure daily activities. It is precisely Ortiz's attention to the subjective experience of deculturation that makes his theory of transculturation particularly relevant for my argument about the centrality of the migration experience in the consumption of popular culture among transnational youth. The teens' subjective experience of deculturation is the focus of this chapter. Following the lead of Celia Jaes Falicov (1998; 2001/2), who has used the notion of *ambiguous loss* to explore the meaning of migration loss for transnational Latina/os, I explore the teens' use of media and popular culture to cope with the chaos and disjunctions that come with migration. The notion of *ambiguous loss* was developed by Pauline Boss (1993; 1999; 2006), and it refers to a distinctive kind of loss that defies closure,

such as the uncertainty and sadness felt by the families of missing persons, by the children of Alzheimer's patients, or by immigrants who crave what they left behind (Boss, 1999). Although I draw on Roger Silverstone's (1993) argument that media provide ontological security in the postmodern world by occupying the transitional space between self and other, my argument is primarily built on Boss's notion of ambiguous loss. Boss cites migration as a situation that can bring about ambiguous loss. In addition, Falicov (2001/2) casts light on the meaning of migration loss for transnational Latina/o families by examining the functions of migrant family rituals and their potential for helping migrants live with ambiguous loss. Following a discussion of theoretical considerations, I talk about the multiple journeys of the transnational teen by presenting a self-description of one teen's crossings, which illustrates how migration traverses the adolescence of these teens. Then, because toys are popular culture artifacts increasingly tied to media, I discuss toys and playfulness. After that, I illustrate the way most teens used children's media and popular culture to cope with anxieties produced by the separation that is part and parcel of the immigrant experience. In addition, I discuss the teens' use of media and popular culture to maintain a sense of continuity and to develop resiliency. To conclude, I highlight the most salient uses of media and popular culture that I found.

AMBIGUOUS LOSS AND MEDIA AND POPULAR CULTURE RITUALS

Boss combines insights from her own clinical practice with a broad theoretical foundation that draws on phenomenology, symbolic interactionism, and social constructivism. Her social psychological perspective on family stress puts social and contextual factors in the foreground. It assumes that the psychological construction of family, which may overlap or be at odds with the physical family, plays a vital role in loss and trauma as well as in health and resiliency. Along with its emphasis on the grief and mourning brought up by loss, Boss's theory underscores that ambiguity and uncertainty also entail hope and openings. "In the confusion and lack of rigidity lie opportunities for creativity and new ways of being," argues Boss (1999).

Her view of identity posits that social relationships shape our perception of who we are and what roles we are supposed to play in the family and in the community. This perception is fluid and entails frequent reconstruction. "Who we are," says Boss, "reflects back to us through interactions with significant others. Each person, however, has differing social relationships and experiences, so each

person's 'truth' about who he or she is in the world differs. Furthermore, based on diverse couple, family, and community contexts, each person's identity requires reconstruction over time as social relationships shift and mature" (Boss, 2006, p. 122). She points out that people need to reconstruct their own perceptions of who they are to successfully navigate through life stages and other changes that bring losses of various kinds. All cultures have created rituals to help people cope with clear-cut losses such as death, observes Boss (1999), and most societies have rituals that mark life-cycle changes, such as the funeral and the wedding. Still, most cultures lack rituals for ambiguous losses.

Boss distinguishes two types of ambiguous loss. The first type is "perceiving loved ones as present when they are physically gone," such as when persons are missing due to war or natural disasters, kidnapping, or incarceration. More common situations include divorce, adoption, and relocation. The second type is perceiving loved ones "as gone when they are physically present" (Boss, 1999, p. 7), such as due to Alzheimer's disease, addictions, and chronic mental illness or homesickness or extreme preoccupation with work (Boss, 2006, p. 9). Migration involves features of both types. For example, parents may be physically present, but psychologically, they may stay behind in the home country and thus be emotionally unavailable; grandparents may be physically far away but still be the predominant members of a child's psychological family.

In her application of this theory to clinical work with migrant Latina/o families, Falicov (2001/2) has stressed the function of rituals and their significance for helping families cope with the numerous ambiguous losses that come with migration while, at the same time, helping them to gradually incorporate aspects of the new culture into their everyday lives. Among the various types of rituals described by Falicov, "spontaneous rituals" performed by migrant families illuminate the use of media and popular culture to cope with migration loss. These include rituals of memory (e.g., telling stories about the home country), rituals of re-creation of public spaces and ethnic networks (e.g., little Italy), rituals of connection (e.g., sending money back home), and traditional cultural rituals that deal with the life cycle, religion, healing, and daily life. It is possible to argue that these rituals are part of the process of deculturation.

Although Boss and Falicov are interested in family therapy rather than in media and popular culture practices, ethnographies of the media consumption of diasporic groups (Adoni, Caspi, & Cohen, 2006; Durham, 1999; Durham, 2004; Geourgio, 2006; Naficy, 1993) have documented that media are thoroughly implicated in many of the rituals that Falicov identifies. Falicov includes telephoning home among the rituals of connection, and she points out that watching television is one of the everyday rituals that may help families gradually incorporate elements of the host culture. Falicov's ideas find ample support in the

extensive scholarship on media rituals (see Couldry, 2003). Boss seems less optimistic regarding media, however, when she mentions the "obsession with computer games, Internet, TV" as a situation that may result in the psychological absence of someone (Boss, 2006, p. 9).

MEDIA AND POPULAR CULTURE AND THE
SENSE OF ONTOLOGICAL SECURITY

To frame my interpretation of the teens' talk about their media and popular culture practices, I complement Boss's theory with Roger Silverstone's interpretation of ontological security and media as *transitional objects*. Drawing on Anthony Giddens' (1984) theory of the structuration of everyday life, Silverstone suggests that media (television, in particular), with their "veritable dailiness" and structuring relation to daily routines, help people manage the threat of chaos and keep a sense of ontological security. In Giddens' definition, ontological security is "the confidence that most human beings have in the continuity of their self-identity and in the constancy of the surrounding social and material environments of action" (cited by Silverstone, 1993, p. 577). To Giddens's argument that ontological security is based on the experience of basic trust, Silverstone adds that such development also requires the experience of the symbolic. Therefore, he incorporates a key insight from Donald W. Winnicott's (1971) reformulation of psychoanalytic theory: the *transitional object*. Winnicott hypothesizes that during the developmental stage he calls the "transitional experience," the infant begins to separate from her or his mother and to distinguish between inner and outer worlds. In this liminal, potential space, the child encounters the paradox of having to keep "inner and outer reality separate yet interrelated" (Winnicott, 1971, p. 2). This space is where play, creativity, and the symbolic emerge, but it is also the source of much anxiety. The mother's breast, which the child perceives as neither internal nor external, alleviates anxiety and is later replaced by other *transitional objects*. Silverstone suggests that people use media to deal with *transitional phenomena*. His compelling argument, which is part of an elaborate theory of the place of television in everyday life, has been widely discussed in research on media consumption, and it finds support in empirical research on "ethnic media" and diasporic audiences.

THE MULTIPLE JOURNEYS OF TRANSNATIONAL TEENS

A perceptive teen who had been in the United States only a few months at the time of the fieldwork, Paty, composed an eloquent narrative of her ongoing passage to

womanhood. In it, she described the multiple transitions implicated in the adolescence of the transnational teen. Her narrative emerged first in the collage in Figure 1, and it subsequently took an oral form during class. Like many of the teens in my study, Paty has lived long periods separated from family members, and she developed strong attachments to those who acted as surrogate family. The following excerpt comes from the "show-and-tell" session in which Paty explained her collage to the class:

Paty: *Cuando ella [mi hermana] se fue, se vino para acá más bien, y yo me quedé en México. Y todo esto representa mi vida de cuando ya se fue, amigos, novio [...] Entonces, aquí le pongo, represento que me vine para acá. [...] a Estados Unidos. [...] y éste es el camino [se ríe]: Aquí es cuando estoy aquí, en Estados Unidos.*

Lucila: *O sea, cuando eras niña, cuando se vino tu hermana, entonces te quedaste con tus amigos y tu novio, ¿verdad? Ya no tenías a tu hermana.*

Paty: *Ajá. Entonces toda mi vida [...], toda mi vida lo que valía eran mis amigos. O sea, ya había encontrado algo con que ser feliz.*

Lucila: *¿Y luego te viniste para acá?*

Paty: *O sea, me volvieron a dar a mi hermana, pero, como que, mmm... [...]*

Lucila: *Y luego, acá [apuntando al lado inferior derecho del collage], o sea, como que hay mucha tristeza ¿no?*

Paty: *Esto es todo Estados Unidos. Aquí ya se supone, bueno, lo represento eso, aquí y cuando, por ejemplo, se me han acercado gente y, y tal vez en un momento estuve como que encerrada en mi caparazón, este, y no quería tener amistades.*

Lucila: *¿Y esta niña acá?*

Paty: *Entonces, este ya no es, estoy sola, pero, ahí puse "wait" como, como que, estoy sola, pero al menos ya me resigné que me voy a esperar a regresarme.*

Paty: When she [my sister] left, better said [when she] came here, and I stayed in Mexico. And all this represents my life when she left, friends, boyfriend [...] then here I put, represent, that I came [...] to the United States [...] and this is the path [giggles]. Here is when I'm here, in the United States.

Lucila: That means, when you were a child, when your sister left, then you made friends and your boyfriend, that's right? You didn't have your sister anymore.

Paty: Uh, uh. Then all my life [...] everything that was worth anything were my friends. I have found something that made me happy.

Lucila: And then you came here?

Paty: I mean, they gave me my sister back, but, like, mmm... [...]

Lucila: And then here [pointing toward the lower right side of the collage], it seems like there's a lot of sadness, no?

Paty: All of this is the United States. Here this is supposed to be, I mean, I represent here, when for example people have tried to be close to me, and perhaps for a while I was inside my shell, and, I mean, I didn't want to make friends. […]

Lucila: And this girl here?

Paty: Then, this is not anymore, I'm alone but, I put there "wait," like, like I'm alone but at least I'm resigned that I'm going to wait to come back.

The dialogue and Paty's visual narrative movingly show that transnational teens go through adolescence while also navigating many other difficult transitions. Paty first had to adjust to living without the sister who left for the United States ahead of her, and then she herself had to leave behind familiar surroundings and relationships and adapt to another culture and new relationships. Paty had lived through the numerous separations that characterize the migration experience, and she was coping with ambiguous loss. That the teens were intensively dealing with migration loss became apparent to me when I screened *Almost a Woman* a docudrama that describes the adolescence of Puerto Rican writer Esmeralda Santiago who moved to Brooklyn, New York, at age 13. I noted that the teens were nodding and showing other expressions of agreement when young Esmeralda talked about her migration losses. During a scene when Esmeralda is longing for her father who stayed in Puerto Rico, Leticia, the Puerto Rican teen in the program, commented: *"Está como todas nosotras"* (She's like all of us). Leticia's volunteered comment was remarkable because up to that point, she had seldom spoken in class. At the time of the fieldwork, only two of the teens were not living with their mothers, but seven had spent long periods away from them. Susana, Carla, and Natalia, for example, lived several years with their grandmothers while their mothers worked in the United States.

For transnational families, kin networks are extremely important because migration typically depends on their support. In many cases, children are left behind with relatives until the parents establish themselves in the host country. When the children join their parents, the joy of reunion is mixed with the ambiguous loss resulting from the separation of the kin left behind. Susana, for example, left the grandmother who kept her for most of her childhood; Lidia left her father and grandmother; and Natalia's migration was precipitated by the death of the grandparents who raised her. Peers left behind represented painful losses, too. In her calendar, Carmen put "cousin" as her closest relationship the year before her migration; Gabriela included her cousins as one of her closest relationships during the entire decade prior to her migration; and Carla, who only put names of friends and "cousins" as her closest relationships, expressed her yearning for the life she lived in Mexico with her "more than ten" cousins. As Paty notes in the

excerpt above, leaving her friends was difficult because they were "everything that was worth anything."

Migration, however, also meant that new rituals of connection were created. Like other girls, the teens were avid users of the telephone and most used the Internet to chat. Yet their engagement with these media was different in the sense that it was also a migrant ritual of connection. For example, on describing her collage to the class, Paty said about the cutout of a computer: *"En realidad mi vida está basada en la computadora porque es la única manera que tengo para comunicame con mis amigos, es la computadora"* (Actually my life is based on the computer because it's the only way I have to communicate with my friends, it's the computer). Yet Carmen explained her collage by saying: *"Latinchat.com es porque, no es, chateo con otras gentes de diferentes países, conocerlos, y ya todos me conocen ahí"* (Latinchat.com is because, it's not, I chat with other people from different countries, get to know them, and everybody knows me there). These are new rituals of connection that the teens had created, but while Gabriela and Paty talked about keeping old relationships, Carmen spoke of making new ones.

PLAY, PLAYFULNESS, AND MATERIAL CULTURE

Because teens spend large amounts of time with media and because many of their leisure activities are tied to media, the ending of media rituals—especially those that they performed with other children—may be significantly disruptive of their play and playfulness. Asked why they listened to certain music or watched certain television shows, the teens often responded that it was because friends, siblings, or cousins did. Because many of the teens spent years with their extended families before migrating, in many cases cousins became as important as siblings. Lidia said that she and her cousin were *"como hermanas"* (like sisters). Gabriela explained watching *He-Man* at ages 11 through 12, saying: *"Y el* He-Man *era por mis primos, porque el superhéroe, el que todo lo puede, ésa era la fiebre entonces, el, el* He-Man *y los* Power Rangers" (And *He-Man* was for my cousins, because the super hero, the one who can do anything, then that was the fad at the time, the, *He-Man* and the *Power Rangers). He-Man* was one of the first cartoons based on a toy (Mattel's *Masters of the Universe* series). Because the pervasive merchandising that exists in children's media has blurred the line between media and artifacts such as dolls, I included a column for "favorite toy" in the calendar. I found that leaving toys behind seems to accentuate the loss of childhood that adolescents typically suffer. Most of the teens mentioned Barbie as one of their favorite toys as children, but for Carmen, who said that she used to have a "huge" collection of Barbies, the doll seemed to have had special significance. Carmen had also talked at length about

her devotion to Selena, the famous Texan singer, but when I asked her if she had the Selena Barbie, she complained bitterly that her parents did not allow her to buy it: "*Yo quería, pero, mis papás casi no me dejaban, así de que comprar muchas cosas y siempre me decían que no, que como voy a llevar todo eso*" (I wanted to, but my parents didn't let me, like buying many things, they used to tell me all the time, no, that "*how was I going to take all that*" [my emphasis]). This means that her parents did not want to spend money on artifacts that would have to be left behind. Working-class families cannot carry much with them when they emigrate. For the children, having to separate from toys that often become transitional objects can be quite distressing and can jeopardize their sense of ontological security. Boss claims that "the process of reconstructing identity after loss requires embracing change while maintaining some historical continuity" (Boss, 2006, p. 127). Reflecting on Susana's media life narrative, I came to the conclusion that she felt great confusion at the time of her migration, which coincided with her early adolescence. Because she was lively and assertive and wrote in her collage the words "*Soy feliz*" (I'm happy), I was puzzled by her confusion and memory lapses about the time of her migration. Then I noticed that her favorite toy from ages 4 to 11 was "a tiger," but that she had left blank the space for favorite toy at the time of her migration. At age *fourteen*, when Susana mastered English and returned to participating in extracurricular activities, she wrote in her calendar: "I bought a new tiger." Like Linus's blanket in Schultz's cartoons, the tiger served as a transitional object. The loss of self that adolescents typically experience was exacerbated by migration, but Susana was able to regain a sense of ontological security, recover her playfulness, and thrive in her new environment. By buying a new tiger, she established continuity while constructing a new identity. Susana appeared to develop resilience and regain her strong sense of self at least in part through her family media rituals. For instance, Susana was one of only two teens who marked in their worksheets that they watch television with their families "most often." During a class when we were discussing movie watching, she said: "*En mi casa, mi mamy renta un montón de DVDs y todos en la casa, todos ahí, todos en la sala, viendo, todas las películas, nos pasamos horas ahí y hasta la medianoche [viendo]*" (In my home my mom rents a bunch of DVDs and everybody at home, everybody there, everybody in the living room, watching, all the movies, we spend hours there and until midnight [watching]). By renting "a bunch of DVDs" Susana's mother encouraged a family ritual that kept "everybody in the living room."

Everyday media and popular culture rituals in the private and familiar space of Susana's home helped her to successfully cope with ambiguous loss. By contrast, when Natalia was about to migrate and join her mother after many years of

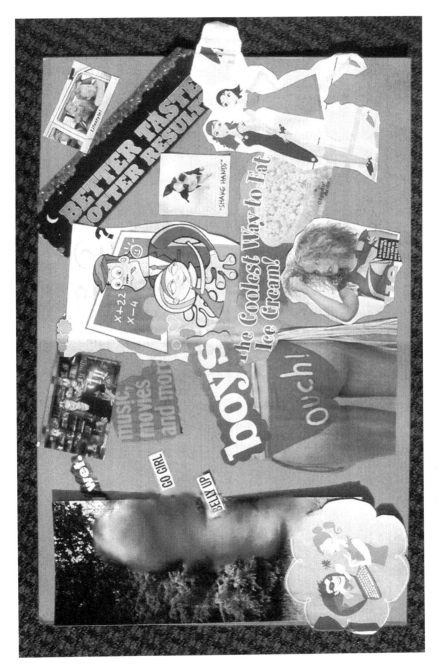

Figure 11. Collage by Natalia (age 17)

separation, she developed a strange illness that, according to her, the doctors could not explain. Most likely, it was a somatization of her anxiety, but Natalia had another explanation. She had been an avid consumer of horror media until the traditional healer who cured her of her illness recommended that she cease consuming this content. She said:

> *Por eso dejé de leer libros de terror. Porque aquí el curandero según me dijo que esos eran super malas energías para mí, y como yo toda mi vida estuve metida tan en eso, es que yo no sé, me fascinaba, quería averiguar más del, del otro mundo, pero nunca encontré nada, no, algo así, quería saber como eran las brujas, como si, si el diablo existía, si no [existía], todo eso.*

> That's why I stopped reading horror books. Because the healer told me that those were super-bad energies for me, and since I have been into that all my life, because, I don't know, I was fascinated [by horror content], I wanted to find out more about the, the after-world, but I never found anything, I wanted to know how the witches were, how they, whether the devil existed or not, all of that.

The healer's advice may well have helped her overcome her distress. The research on mood management suggests that horror content aggravates anxiety and depression (Zillmann, 1991). What is fascinating is the cultural syncretism embedded in her story of illness and media use. Natalia went on to channel her curiosity into astronomy and medicine, but at the time of the fieldwork she did not engage in family media and popular culture rituals that may have helped her keep a sense of ontological security. Natalia was the teen who most consistently reported watching television alone and never talking about media and popular culture texts with her mother or other family members.

READING AND COPING WITH AMBIGUOUS LOSS

Reading was an important strategy used by some of the teens to cope with ambiguous loss. Gabriela left blank the cells corresponding to favorite reading during her childhood and put "None" at ages *11 to 14*, but she wrote "novels" at age 15, the year she left Venezuela. This is how she explained her new reading habit:

> *Era una etapa de transición. ¿Me entiende? Estaba creciendo, o sea estaba en la así, de desarrollo, dejé amigos en Venezuela, pero me muevo para los Estado Unidos, cortaron así esa, esa, esa relación de amigos que estaba en Venezuela. Entonces vengo para acá, no conozco a nadie, y luego era una etapa de transición, toda, aparte de la juventud, que ya de por sí es difícil, vienes y te mudas a otro país, no sabes el idioma, ya, ya se hace más complicado de lo que, normalmente es, ¿me entiende?*

That was a transition stage. Do you understand me? I was growing up, I mean I was in a, development [stage], I left friends in Venezuela, then I moved to the United States, they cut that, that, those relationships that I had in Venezuela. Then I come here, I don't know anybody, and then it was a transition stage, everything, apart from adolescence, that it's difficult in itself, you come and move to another country, you don't know the language, then, then it becomes more complicated than it's normally, do you understand me?

Gabriela explains that going through adolescence while migrating "becomes more complicated" as one is cut off from relationships. Gabriela specifically talks about the loss of friends and how her newly acquired reading ritual helped her to cope. Likewise, Carmen developed a ritual of poetry reading in Univisión's website to satisfy her cravings for the friends that she left in Mexico and, in a broader sense, her nostalgia for Spanish language and Mexican culture. And Paty, who was an avid reader of *Harry Potter* novels before migrating, told me that she was reading in English the same novels that she had read in Spanish. Paty's reading was helping her to acculturate, serving as a bridge between two languages, but it was also providing a sense of continuity in the midst of change.

The most extreme case of separation was Isabel. When she presented her collage to the class, which is shown in Figure 12, she clarified that she had pasted a picture of a street girl because that was the way she felt when she was a child in Mexico. Isabel wrote in her calendar that her favorite reading at age 19 was the book *Tiger Eye*. When I asked her what the book was about, she said:

Es acerca de, la hija, y la mamá y el papá, y que ellos están viviendo en una parte, en tal parte, y se están cambiando de, se mueven a diferentes, muchas veces, el caso que, no le gusta, al final del caso, no le gusta meterse a una escuela, porque piensa que si se mete a una escuela va a hacer bastantes amistades y va a dejar sus amistades ahí, y se va a volver a mover a otra parte y va a estar así con, continuamente, va a estar dejando bastantes amistades y todo eso.

[It's] about, the daughter, and the mother and the father, and that they were living in one place, in such and such place, and they are moving from, they move to different, many times, what happens, she didn't like it, at the end, she didn't like to go to a school, because she thinks that if she goes to a school, because she thinks that if she goes to a school she is going to make many friends and then she's going to leave her friends there, and she's going to move to another place and she's going to be like that, continuously, she's going to be leaving friends and all that.

In her description of the book's plot, Isabel highlights the fear of repeatedly leaving relationships behind: "she thinks that if she goes to a school she is going to make many friends and then she's going to leave her friends there," she says. At

Figure 12. Collage by Isabel (age 20)

the time of the fieldwork Isabel was in ninth grade and she expressed, time and again, her (socially acceptable) desire to graduate. However, having missed school from ages 12 to 15, she had a checkered school history. Even before her international migration, Isabel was a migrant; she had lived in three different cities and had changed schools frequently. In Isabel's recounting of the character's life, the repeated loss of school friends resonated with her own life. Isabel's collage reinforces the dominant motif of her narrative of self. In addition to the picture of the street girl, Isabel included a sign of family in her collage by pasting a large picture of an idyllic portrayal of family: A man playing with three children on the beach, which she said represented a trip she took with her family. She also codified home by pasting the picture of a white house; she explained that it represented her surrogate family's house where, she said, she was living very happily.

Other popular culture practices may help the teens to build up resiliency. Most notably, music—by far their favorite media—seems to serve such purposes. In Chapter Nine, I describe the teens' preference for Latin American and Caribbean music and the way this music seems to act as the glue of the local Latino youth subculture. Listening to this music and sharing CDs are rituals that sustain the local Latina/o youth subculture, which becomes a safe haven for collective healing and re-creation; in this sense, it resembles the ethnic communities that, as Falicov remarks, collectively and ritualistically recreate cultural spaces. In her ethnographic work with Mexican American teens in San Antonio, Texas, Vicky Mayer (2003a; 2003b) does not say much about this practice. This city has been a Mexican settlement for centuries, so transnational teens may not need these rituals to reconstruct their identities. In contrast, my findings suggest that transnational working-class teens in new settlement areas, who are likely to encounter a deleterious context that discriminates against their families' class and culture, may have a dire need for them. The local Latina/o subculture that I observed is also quite different from the youth subcultures described by Cynthia L. Bejarano (2005) in her ethnography of teens living in "the greater Borderlands." Bejarano describes two distinct formations among teens of Mexican origin or descent. She says that "Chicana/o" teens (born in the United States) used language, music, clothes, and other popular culture artifacts to differentiate themselves from teens born in Mexico, or "Mexicana/os." The borderlands are very different from the New Latino South, and while I found evidence of differentiation among Latina/o teens in Durham and Carrboro, it was far more related to class and race than to nativity.

TRANSNATIONAL USES OF CHILDREN'S MEDIA

In his thoughtful examination of Disney's films, Henry Giroux (1995) argues that children's media are far from being ideologically innocent. To the contrary, they convey racialized representations that contribute to naturalize inequality in the social

world. The ways in which Latina/o youth respond to such representations is yet to be understood. Mayer has made the most substantive contribution to the study of the media practices of working-class Latina/o youth. In her ethnographic study with girls, she briefly mentions some children's media (e.g., the movie *Cinderella*) and notes that one of the teens said she enjoyed reading a children's book series *(The Baby-Sitters Club)* and that the Disney channel was among her favorites (Mayer, 2003a, pp. 120–124). Yet Mayer does not explore the function of children's media. Most of the teens in my project had a strong preference for cartoons; for example, animated Disney movies such as *Cinderella, Sleeping Beauty, The Little Mermaid,* and *Beauty and the Beast* were among their favorites. In a worksheet asking for the three television shows that they watched most often, several indicated cartoon shows; Carla put *Blue's Clues,* Stephany put *Cita's World,* Susana put *Dora the Explorer,* Natalia put *Sponge Bob Square Pants,* and Gabriela put *Scooby Doo.* In another worksheet asking for the three channels they watched the most, Natalia gave the Cartoon Network as her first choice, Sabrina listed it as her second choice, and Stephany as her third one. Anabel and Paty mentioned the Disney Channel as their first choice, and Leticia and Alex listed it as their second. In addition, Anabel also listed Nickelodeon as her third choice, and Isabel, who had repeatedly indicated that she did not watch television, mentioned Bugs Bunny's foe, the Tasmanian Devil, as something that she liked to watch *"a veces"* (sometimes). Such strong preference for children's media finds an explanation in Silverstone's theory of media as transitional objects, but it can be further explicated by making use of the notion of ambiguous loss. The following excerpt comes from the individual interview with Carla, in which I asked her to elaborate on her calendar:

Lucila: *¿Y Nickelodeon por qué?*

Carla: *Porque tiene que, caricaturas y los caricaturas como mi hermano ahorita no está viviendo conmigo. Las que, él, él los miraba ¿no? Entonces a mí me recuerdan de él, por eso.*

Lucila: *¿Te recuerdan a tu hermanito?*

Carla: *Sí.*

Lucila: *¿Dónde está tu hermanito?*

Carla: *Está en México con su papá.*

Lucila: *Uh, uh. ¿Y cuánto hace que se fue?*

Carla: *Uh, ya tiene, creo que tres o dos años.*

Lucila: *Y lo extrañas mucho. ¿Cuántos años tiene, cinco?*

Carla: *El tiene cinco.*

Lucila: *O sea se fue cuando tenía ¿dos?*

Carla: *Se fue a los dos, dos y medio,* yeah.

Lucila: *Y tú lo quieres mucho ¿no? ¿Y no lo ves?*

Carla: *Le llamo. No traje mi cartera, ahí tengo su foto.*

Lucila: *Y por eso ves la televisión porque te hace acordarte de él?*

Carla: *Sí. Me gusta mucho ese programa, con él.*

Lucila: *¿Hay algún programa en especial que te gusta?*

Carla: *Ah! Los de Aventuras en Pañales. Como, son de bebés, entonces me recuerda mucho a él, como él es un bebé todavía, por eso.*

Lucila: And Nickelodeon, why?

Carla: Because it has cartoons, and cartoons, like my brother right now, he isn't living with me. The ones he used to watch, no? So, they remind me of him, that's why.

Lucila: Do they remind you of him?

Carla: Yeah.

Lucila: Where is your brother?

Carla: In Mexico, with his father.

Lucila: Uh, uh. And when did he leave?

Carla: Uh, it has been, I guess three or two years.

Lucila: And you miss him a lot. How old is he, five?

Carla: He's five.

Lucila: That means that he left when he was two years old?

Carla: He left when he was two and a half, yeah.

Lucila: And you love him a lot, no? Don't you see him?

Carla: I call him. I didn't bring my wallet, I have his picture there.

Lucila: And that's why you watch TV, because it reminds you of him?

Carla: Yeah. I like that program a lot, with him.

Lucila: Is there any program in particular? That you like?

Carla: Ah! *Aventuras en Pañales (Rugrats)* 'Cause, it's about babies, so it reminds me of him, 'cause he's still a baby, that's why.

The poignancy of this dialogue shows that Carla's cartoon watching was a healing ritual. The fact that she describes her brother as a baby—the way she remembers him—rather than as a five-year-old—the age he was at the time of the interview—tells of her way of keeping him present through a television ritual. "In mobile cultures," says Boss, "the people important to us may or may not be the people we live with physically" (Boss, 2006, p. 30). The excerpt also shows that Carla engaged in what Falicov calls "rituals of connection" by calling her brother and by keeping his picture in her wallet. Further, Carla was creating real and imaginary rituals involving music to cope with the physical absence of her brother.

She described one of her favorite songs *"La hoja en blanco"* ("The blank page") as being about *"una muchacha a la que la dejaron sola"* (a girl who was left by herself), and she expressed her desire to publicly perform her rendering of Selena's song "Missing My Baby." Looking to heal not only herself, but also her psychologically absent mother, she wanted to dedicate her performance to her mother.

DEVELOPING RESILIENCY THROUGH
MEDIA AND POPULAR CULTURE

Resiliency is one of key concepts in the theory of ambiguous loss, and it takes into account both individual and family coping skills. Boss says that resiliency is "the ability to stretch (like elastic) or flex (like a suspension bridge) in response to the pressures and strains of life. When crises occur (as opposed to just pressure, stress, or strain) resiliency is defined as the ability to bounce back to a level of functioning equal to or greater than before the crises" (Boss, 2006, p. 40). Rituals serve to strengthen resiliency. Falicov describes the rituals that migrant Latina/o families perform to cope with ambiguous loss. The research on Latina/o audiences indicates that *telenovela* watching is a prevalent media ritual (Barrera & Bielby, 2001; Rojas, 2004). Apart from Lidia and Isabel, the teens have access to Univisión, the largest Spanish-language network in the United States. When I inquired about the channels they watched the most, both foreign- and native-born teens mentioned Univisión. *Telenovelas* are the network's staple, and the genre is widely popular among both U.S. Latina/o audiences and Latin American and Caribbean audiences. For example, in her reception study with Latina adult women, Rojas found that most of her twenty-seven respondents raised criticisms of Spanish-language television, but "surprisingly, newscasts and soap operas…were almost exempt from respondents' criticism" (Rojas, 2004, p. 132). As in the studies by Mayer (2003b) and Moran (2003), watching *telenovelas* was a ritualistic practice carried out by the teens' caregivers. Talking about her *telenovela*-watching at age 9, the year before she emigrated, Alex said: "It is because my babysitter, when I was little, she used to sit me with her, and she liked the *novelas*, so I used to sit with her and I watch them too." Paty also made the same point: *"Bueno, de hecho cuando era chiquita veía todas las novelas con mi abuela, porque me pasaba todos los días con mi abuela. Entonces miraba todas las novelas y me sabía los nombres y sus [se ríe]."* (Well, as a matter of fact, when I was little I used to watch all the *novelas* with my grandmother, because I would spend every day with my grandmother. Then I used to watch all the *novelas*, and I knew their titles and their [giggles]). Paty giggled because *telenovela* watching is a clearly gendered and classed practice and thus the object of much public derision. *Telenovelas* are often a

guilty pleasure, which may explain why only eight teens put *telenovelas* as one of their favorite television shows in their calendars.[1] However, in my interactions with them, it became clear that all teens were quite familiar with the genre. For example, when I asked the Durham group if they had seen *Salomé*, a *telenovela* that had just ended at the time, Carla jumped up to say: "*¡Yo la miré completita y me encantó!*" (I watched it in its entirety, and I loved it!). Her comment was unexpected to me because she had not indicated in the calendar or worksheets her preference for the genre.

The pleasure associated with *telenovela* watching is apparent in Yvet's explanation of the magazine cutout that she pasted in her collage (see Figure 7). It is a drawing of a dark-skinned young woman practicing yoga in front of a television set. "*Puse una muchacha viendo la tele and haciendo ejercicio, porque me gusta hacer eso, no lo hago mucho* [todas se ríen], *y tenía una de éstas, una novela, porque me gusta ver las novelas, me gusta relajarme cuando estoy viendo mis novelas*" (I put a girl watching TV and exercising because I like to do that, I don't do it very often [group giggles], and I had one of these, a *novela*, and 'cause I like to watch *novelas*, and I like to relax when I'm watching my *novelas*). The pleasure described by Yvet seems to emanate from the ontological security that one's own cultural dwellings can provide, an idea that resonates with Barrera and Bielby's finding that, through *telenovelas*, unrooted Latinas and Latinos re-create familiar experiences (Barrera & Bielby, 2001, p. 6). Furthermore, *telenovelas* seem to also sustain rituals of connection. Mayer found that *telenovelas* "were a way to connect to women of all ages on both sides of the border" (Mayer, 2003a). She notes that the Mexican American teens in her study exchange news about *telenovelas* and other popular culture fare with their extended kin across the border. In the following excerpt from Mayer's book, Lupe, one of the teens in her study, describes a typical conversation with a cousin who lives in Mexico:

> A lot of them, they'll be like, "Well, this *novela* came out over here." And I will be like, "Oh, it just started over here." And they will be like, "It just started over there? That was a good one!" And they know what's going to happen, and we won't see that happening until maybe a few more weeks. Like maybe three weeks later, we'll be like, oh, OK, that's what she was talking about. There's a lot of communication. (Mayer, 2003a, p. 132)

In describing her conversation, Lupe concludes that "there is a lot of communication" with the extended family across the border. The quotation shows that *telenovela* watching is a ritual through which Lupe reproduces her relationship with her Mexican cousin; the practice not only provides her with a current topic for telephone conversation, but it also re-creates a familiar space in which her cousin is psychologically present. As such, *telenovela* watching is a ritual of

connection as well as a ritual of re-creation. Boss underlines that when people suffer an ambiguous loss "resiliency erodes as rituals and celebrations are canceled." She recommends adjusting old rituals to the new situation and creating other innovative rituals (Boss, 2006, p. 40). Gabriela, Paty, and Lidia indicated in their calendars that, upon their arrival to the United States, they were avid *telenovela* watchers. In the following excerpt, Paty responds to my question regarding why she liked to watch *Clap*, a teen *telenovela*:

> *Entonces como es el único programa que, o sea, cuando llegué aquí, no he visto nada de tele, y ya cuando prendí esa, y vi que estaba Clap, que era la que estaba empezando a ver allá, dije "¡La tengo que terminar de ver!" porque ya la había empezado a ver alla. Entonces la estoy viendo. No es que sea muy buena, ni que sea mi favorita, sino que es lo único que veo.*

Because it's the only choice here, I mean, when I arrived here, I haven't seen TV, and then when I turned [it] on and I saw that *Clap* was showing, which was what I was starting to watch there, I said "I have to finish it!" because I have started to watch it there. So, I'm watching it. It's not that it's very good, or that it's my favorite, but rather that it's the only thing I watch.

Paty's limited English was, most likely, one of the reasons for her *telenovela* watching, but the practice cannot be explained just in terms of language proficiency. It has to do with the need to re-create rituals that were broken by migration. Watching "ethnic media" like *telenovelas* may well be a practice that boosts resiliency. However, these functions may not be unique to "ethnic media," because given the market dominance of U.S.-based transnational media abroad, foreign-born teens were familiar with much of the U.S. popular culture that they would encounter across the border. Susana, for example, said that her favorite show at age ten was *Mellizas y Rivales (Sweet Valley High)*, and that she still watches a police drama that she used to watch in Honduras. These practices, as Falicov observes, may help the teens to incorporate elements of the new culture in the safety of known media and popular culture rituals.

In sum, this chapter offers further empirical evidence for Silverstone's argument about the way in which people use media and popular culture to cope with *transitional phenomena*. But what I wish to highlight are four uses that clearly reveal how postcolonial migrant teens utilize media and popular culture to cope with deculturation. The first use is related to the need to preserve a sense of historical continuity by reinventing old rituals. This use gives a glimpse of the potentially beneficial effect of popular culture available in several geographic locations. A directly related, second use is bringing into play one's previous familiarity with global popular-culture fare as a means to bridge two worlds. These first two uses underscore that the practices of transnational Latina teens occur within the larger

social consumption of global popular culture. The third use is to create a space of complete belonging; *telenovela* watching illustrates this use well. Finally, the last use is a practice performed to bring about the subjective experience of co-presence with someone who is far away. In the concluding chapter of the book, I return to these four uses and elaborate on their implications for research on media and mobility. In the next three chapters, I focus on the axes of identity that seemed more crucial for the teens: gender, race, and nation. I deal first with gender, by drawing on Judith Butler's (1990) theory of performativity.

Gendered Selves

This chapter is grounded in Judith Butler's (1990; 1993) notion of identity as *performativity*. According to this theory, when performing an action we are not only expressing and reaffirming our identity, we also are "doing" identity. In other words, we constitute our identities by repetitive acts, by everyday practices. The chapter also illustrates limitations of the theory in the case of Latina transnational teens. The possibilities that working-class transnational Latinas have for "doing" gender are restricted by the identity as "Latinas" ascribed to them in the United States. In their daily lives, racial and class distinctions often take precedence over gender difference. Living in the margins, these teens cannot ignore powerful axes of difference that the theory of *performativity* neglects. Thus, I also draw on Linda Martín Alcoff's (2006) account of Latina/o identity and subjectivity, as well as on the contrapuntal approaches that I review in Chapter One. As I describe in Chapter Three, transnational teens (re)construct their gendered selves against the backdrop of the contrasting representations of Latina womanhood that emanate from the four traditions of their media and popular culture landscape.

Because the analysis places the data collected through "who I am" collages in the foreground, this chapter is organized according to the five techniques used by the teens to compose a gendered identity in these visual narratives of self. Accordingly, I first introduce the five techniques, and briefly discuss two of them, which are: (1) encoding femininity through images of girls and young women, and

(2) using few or no signs of masculinity in their collages. I then talk about how the teens alluded to media practices in their collages that they viewed as either feminine or gender-neutral, while shying away from practices clearly gendered as masculine, such as video game-playing. Next I dedicate entire sections to the remaining techniques including references to romantic heterosexual relations and encoding a desire to beautify themselves through fashion and beauty-product imagery. Finally, to illustrate how media and popular culture are implicated in the construction of individual, unique gender configurations, I present three cases that show differing degrees of defiance and accommodation to the often-conflicting regulatory frameworks that coexist in the transnational Latina/o milieu. I hope to demonstrate that the teens drew on two competing discourses on womanhood and femininity. One was the traditional discourse on Latina womanhood and the other was the alternative discourse articulated by the women's movement. Because the latter discourse is far less vibrant in Latin America than in the United States, these competing discourses become associated with cultural geographies and entangled with the politics of belonging that I discuss in Chapter Nine. But, are there really only two discourses? Am I falling into the traditional/modern binarism trap? Perhaps, but in my view there are clearly two contrasting discourses, although both of them contain dialectical variations. To ground the analysis in the teens' cultural milieu, in the next section I talk about the limited options for producing a gendered identity that are available in Latin American and Caribbean as well as in U.S. Latina/o communities.

GENDER IN LATIN AMERICAN AND U.S. LATINO PATRIARCHIES

Most research on gender in Latin America and U.S. Latina/o communities has relied on the notions of *machismo* and its counterpart, *marianismo*.[1] Likewise, the dichotomous categories of "virgin/madonna" and "whore" have guided much theorizing on *mestiza's* sexuality (Chant & Craske, 2003, pp. 134–138). *Machismo* and *marianismo* refer to Mexican conventional gender roles. While the former is characterized by hypervirility, aggression, and self-centeredness, the latter is distinguished by the "virtues" of the Virgin Mary, especially virginity and self-sacrifice. The essentialism implied in these notions has been challenged by authors who argue that each particular locale develops its own distinct form of patriarchy. Moreover, increasing numbers of Latin American women are now attending school, joining the labor market, having fewer children, taking up political positions, and living in nontraditional household arrangements. These changes suggest that conventional gender constructions are being shattered and that the possibilities for

producing new gendered identities are widening (Chant & Craske, 2003). Although gender has become a highly contested terrain, the time-honored discourse on femininity is quite alive and the variegated forms of patriarchy in Latin America are still very oppressive. For example, the brutality of mechanisms deployed to police women is evidence of the region's continued gender violence and sexual harassment. The hundreds of feminicides that go unpunished along the U.S.–Mexico border are emblematic of the viciousness of this policing. One of the most influential feminist scholars in Latin America, anthropologist Marcela Lagarde (1993), has proposed a typology of gendered identities available to Mexican women that includes five basic types: *madresposa, monja, puta, presa,* and *loca* (motherwife, nun, whore, prisoner, and madwoman). In her extensive fieldwork with women in Mexico, Lagarde found that women are hard-pressed to construct their gendered and sexual identities within the boundaries of the house, the convent, the brothel, the prison, and the asylum (1993). She argues that all Mexican women perform, at least partially, one or two of the stereotypical identities of these figurative spaces; those who reject the house and the convent most forcefully are perceived as "bad women, sick, incapable, weird, madwomen" (my translation) (Lagarde, 1993, p. 41). Rooted in Catholicism as manifest in the folklore of working-class male migrants (Peña, 1991) and constantly reproduced by media texts like *telenovelas* (Dávila, 2001; Rojas, 2004), the traditional Latin American discourse on gender and sexuality permeates working-class U.S. Latina/o settings (Crenshaw, 2003; González López, 2005). The frequent contact that women migrants have with relatives back home reinforces its internalization. Latin American women migrants tend to visit their home countries and keep in touch with relatives there more than men do. Also, women migrants all over the world send a larger share of their income home than men (Chant & Craske, 2003, p. 252).

The literature on migration suggests that gender roles are reworked upon migration in ways that favor expanded freedoms for women (Hirsh, 1999; Hondagneu-Sotelo, 2002). However, the limited choices for producing identity that are available to Latin American and Caribbean women find their way into *El norte.* In his anthology about Latino manhood, Ray González argues that, as opposed to many white men who have been reconsidering gender roles, many Latino men are still *"muy macho"* (very macho). "Cultural traditions," he says, "have made it easy for many Latino men to stand still without change" (González, 1996, p. xv). In the same anthology, Rudolfo Anaya points out that many Latinas take an active part in the reproduction of macho ideology and behavior, a point that he mentions has been made before by Latina writers like Ana Castillo and Denise Chávez (Anaya, 1996, p. 68). As Vicky L. Ruíz says of Chicanas, women have been expected to be the "guardians of 'traditional culture'" (Ruíz, 1996, p. 132). For Chicanas, says poet Gloria Anzaldúa, their

culture is a *cultura que traiciona* [culture that betrays], one that subjects women to the enduring mandates of a "cultural tyranny" and puts the burden of "tradition" on their shoulders:

> The culture expects women to show greater acceptance of, and commitment to the value system than men. The culture and the Church insist that women are subservient to males. If a woman rebels she is a *mujer mala*. If a woman doesn't renounce herself in favor of the male, she is selfish. If a woman remains a *virgen* until she marries, she is a good woman. For a woman of my culture, there used to be only three directions she could turn: to the Church as a nun, to the streets as a prostitute, or to the home as a mother. Today some of us have a fourth choice: entering the world by way of education and career and becoming a self-autonomous person. A very few of us. (Anzaldúa, 1987/1999, p. 37).

The teens aspired to pursue the fourth choice; they wanted to further their education and have a career, but many complained about extreme policing from their mothers. For Carmen and Lidia, traditional beliefs about women's sexuality—especially about virginity until marriage—were the cause of much conflict at home. As I describe in the remaining part of the chapter, all teens "did" gender against the backdrop of *culturas que traicionan*.

"DOING" GENDER THROUGH COLLAGE-MAKING AND MEDIA AND POPULAR CULTURE TALK

Making and talking about "*who I am*" collages demand intense "doing" of gender. Each of the teens constructed an identity that reflected a unique gender configuration, yet it is possible to identify a few general patterns in the sixteen collages. The five main techniques employed by the teens to produce a gendered visual narrative of self include the following: (1) encoding femininity by pasting images of feminine-looking girls and young women; (2) using few or no signs of masculinity; (3) alluding to media practices they viewed as either feminine or gender-neutral, while staying away from practices clearly gendered as masculine; (4) including references to romantic heterosexual relations; and (5) encoding a desire to beautify themselves through fashion and beauty product imagery.

The first technique includes both indexical and iconic signs.[2] Three teens used photographs of themselves in the collage and most used signifiers that resembled the collage-maker in some way. The technique was used in thirteen of the sixteen collages. Only Alex, Sabrina and Carmen did not include representations alluding to girls and women, and Carmen was the only teen to use a picture of a young man to represent herself—in this case, showing her desire to graduate (see Figure 13).

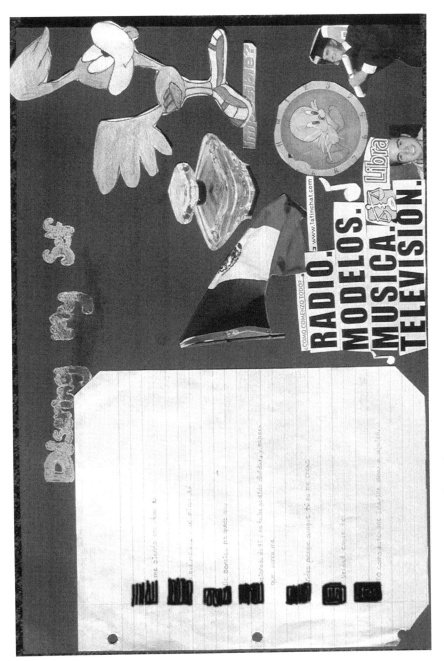

Figure 13. Collage by Carmen (age 17)

The nearly ubiquitous presence of imagery representing girls and young women was also a means of signifying the teens' sense of belonging to girls' groups. This technique is the most obvious means of (re)producing a gendered self in and through discourse, that is to say, in and through the signifying images and words used in the collage to compose a narrative. By pasting cutouts of girls laughing with their mouths wide open and wearing makeup and sexy attire, they "cite" media conventions and constitute their own identities according to "the highly regulatory framework" governing gender performances and pervading teens' media.

The second technique, using few or no signs of masculinity, complements the first one. As do many other feminist authors, Butler argues that the structures and institutions that regulate gender are grounded in a conceptual episteme (or paradigm) based on the male–female binarism. Hence, performing a feminine identity involves the double act of appearing feminine while at the same time not appearing masculine. In the collages, while representations of girls and women are either indexical or iconic signs of femininity, representations of boys and men are not signs of masculinity but rather symbolic signs of heterosexual romance. Most often, the teens alluded to the objects of their desires rather than to actual romantic relationships. For example, Lidia superimposed the word "love" onto a picture of pop star Enrique Iglesias and Paty drew a red heart around the picture of soccer celebrity David Beckham (see Figures 1 and 2). Many of the collages contain a handful of signs of masculinity that have been contested by the women's movement and are therefore now ambiguous. For instance, Paty's collage has references to sports; Daniela's has references to competence, and Sabrina has references to career, but, as I discuss later in the chapter, only in Isabel's collage do traditional signs of masculinity take an unequivocal masculine meaning. The remaining three techniques require a more elaborate discussion than the first two, and I therefore dedicate a section to each of them.

PRODUCING FEMININE SELVES THROUGH THE SIGNIFICATION OF MEDIA PRACTICES

The teens' collages include signs of media texts, practices, and artifacts that construct a gendered identity. Before I discuss this third technique, let me talk about an in-class exercise that casts light on the gender meaning the teens attached to signs of media. The exercise asked students to color-code media artifacts using pink for women's media and blue for men's media.[3] When I asked about the telephone, the nine teens who worked on the activity said "pink!" But when I asked them about the video cassette recorder, no one said "pink." Three said that they

had used both colors, and six said they had used blue.[4] In the following conversation, the teens are explaining their answers regarding the VCR:

Lucila: *Masculino, ¿por qué es masculino?*

Jennifer: Girls will be watching *novelas* and boys will be watching the movie.

Sabrina: The movie.

Daniela: It requires some work.

Susana: *Yo puse los dos.*

Isabel: Me too.

Daniela: Most VCRs don't work, properly […]

Lidia: *Yo lo puse masculino pero yo, yo no sé en mi casa, en mi casa también lo ocupamos los dos pero el que tiene más la iniciativa siempre es mi hermano, yo por eso le puse masculino.*

Daniela: *En mi casa, no sé porque el único hombre es mi hermanito, pero en [la] sociedad es el hombre porque,* like most, *yo tengo como casi todas las cosas que necesitan un poco de trabajo,* or programming or some type of function, *como que lo arregla mi hermanito, como que él puede programar el VCR, él puede,* you know, connect the stereo, TV, go together, and he plays the Nintendo and…

Lucila: *¿Y cuántos años tiene tu hermanito?*

Daniela: *Tiene once y ya desde chiquito empezó ha travezear con eso.*

Lucila: Masculine, why is it masculine?

Jennifer: Girls will be watching *novelas* and boys will be watching the movie.

Sabrina: The movie.

Daniela: It requires some work.

Susana: I put both.

Isabel: Me too.

Daniela: Most VCRs don't work, properly […]

Lidia: I put masculine but I, I don't know, at my home, at my home we both use it, but the one who has more initiative is always my brother, that's why I put masculine […]

Daniela: In my home I don't know, because the only man is my little brother, but in society it's men because like most, I have, like almost all things that need a little work, or programming or some type of function, like it's my little brother who sets them, like he can program the VCR, he can, you know, connect the stereo, TV, go together, and he plays Nintendo and…

Lucila: And how old is your little brother?

Daniela: He's eleven, and he began to mess with that when he was very little.

Both Lidia's and Daniela's comments about their brothers' ingenuity regarding media technology that "requires some work," echo a truism in media studies and show that the teens perceived media technologies in similar gendered ways. The excerpt also helps to further interpret how they "do" gender through their use of imagery of media technology and practices. None of the collages, for example, has images of VCR or DVD hardware.[5] Other media that require great technical competence, for example, musical instruments, were conspicuously absent from both the collages and the teens' memories and desires. The persistent references to music in the collages reflect the centrality that music had for (re)constructing their ethnicity; there were twenty-nine signs of music in the collages and only Isabel's collage has no signs of music. However, only Beatriz' collage (see Figure 6) has an image of an instrument (a guitar), and she was the only teen who talked about her desire to play an instrument. Therefore, nearly all references to music "cite" practices that observe gender norms articulated by the dominant discourse on femininity—one that limits women's possibilities for performing music. The signifying absence of musical instruments is even more significant when one considers that ethnicized practices around Latin American and Caribbean music were rituals that helped sustain their local Latina/o youth subculture, a point to which I return in Chapter Eight. The persistent references to music signs in the collages reflect the centrality that music had for (re)constructing ethnicity at the local level. The references also illustrate the way in which the teens "did" a gendered and racialized identity.

Another practice that has been clearly gendered—and marketed—as masculine, video game playing, was conspicuously absent in the collages as well as in data gathered by other methods. Alex and Leticia reported owning a Nintendo, but only Leticia included an iconic sign of video gaming in her collage. In addition, Anabel noted in her life media calendar that Nintendo was her favorite toy at the time of the fieldwork, yet she said that she used her brother's player. What is remarkable about this signifying absence is that in the two exercises where the teens were specifically asked to compose a narrative of self, only the youngest teens (Leticia and Anabel) chose to include video games. Further, eight of the nine teens who participated in the color-coding exercise identified Nintendo as a man's technology; even Leticia colored the Nintendo blue.[6] Susana said: *"Yo le puse 'el hombre' porque ... mi hermano juega* Nintendo *y siempre trae a los amigos a jugar con él, siempre puros amigos ... y las amigas,* I mean, *las hermanas de los amigos siempre andan jugando, viendo caricaturas"* (I put "man" because, men, because, my brother plays Nintendo, and always, he brings his friends home to play with him, always only boy friends, and the girl friends, I mean, his friends' sisters are always playing, watching cartoons).

This comment, however, does not mean that video-game playing was not among the teen girls' practices. Even Gabriela, who often gave socially desirable answers to my questions, admitted to playing video games "sometimes." During other sessions, Stephany admitted to playing "a lot," and Sabrina and Susana disclosed that they did play at school by using Yahoo Messenger. Merging video games with new technologies for interpersonal communication, computer applications such as Yahoo Messenger may be de-gendering video game playing. Nonetheless, the teens clearly identified it as a man's activity and did not use signs of video games in their visual narratives of self.

Sabrina and Susana's comments also offer clues for interpreting the gender meaning of other computer technologies for the teens. In the exercise, seven teens designated the computer as gender neutral, Daniela indicated that it was feminine, but only Carla coded it as masculine. In the collages, the number of computer practice signs (16) is only surpassed by the number of music listening signs (29). Traditional women's practices, such as letter writing and telephone talking, have been transformed by the Internet. These new Internet practices, in turn, may have contributed to the de-gendering of the computer, which a few years ago was seen as a man's technology. The teens made no clear-cut distinctions between computers and the Internet and ten collages contain signs of practices involving these technologies. This high number of images is remarkable when compared to the number of signs alluding to practices traditionally seen as women's; for example, there are only two collages with signs of telephone talking (Paty's and Stephany's), two with signs of magazine reading (Anabel's and Beatriz's), and one with signs of both practices (Susana's).

The teens had mixed opinions about movie and television watching. They saw specific genres, texts, and the practice of attending to them as gendered. Alex and Anabel, for instance, pasted cutouts of advertisements for the contemporary release of *SleepOver*, a Hollywood film about the slumber party of four Anglo teenage girls. In the color-coding exercise, six teens coded the television set as gender neutral, but Susana, Daniela, and Carla coded it as feminine. Lidia articulated the majority view: *"Porque las mujeres son muy telenoveleras y los hombres son, les gusta ser deportistas"* (Because women are very much *telenovela* watchers than men are, they like to play sports). The minority maintained that the television set was feminine because *"la mujer pasa más [tiempo] en casa que, que el hombre, el hombre siempre pasa, trabajando, o afuera con los amigos"* (women spend more time at home than men, men always are working, or outside with friends), said Susana. Note how, despite the fact that her mother was a daring and independent woman, Susana articulated the traditional discourse that confines women to the house. Other comments suggest that the traditional Latin American discourse on femininity was at odds with the teens' lived experience. In Chapter Two, I noted that at the time of the fieldwork, ten teens were living in female-headed households. During a conversation about cars,

Lidia made a telling remark about her mother: "*Yo a veces le digo a mi mama, 'tú eres la, la muy moderna,' porque maneja de todo, maneja de carrerras porque mi hermano tiene un carro de carreras*" (Sometimes I tell my mother "you're very modern," because she drives everything, she drives sports cars because my brother has a street racing car). Lidia's choice of the word "*moderna*" to describe her mother hints at the teens' awareness that "new *braceras*" like her mother were challenging Latin American traditions.

DESIRES FOR BEAUTIFICATION AND COMMODITIES

The teens talked about the desire for beautification that is presented in advertising and teens magazines targeting Latinas (Johnson, 2000; Johnson et al., 2003) as universal and natural among young women. Fourteen collages contain signs of this desire in references to fashion and beauty practices. When Sabrina presented her collage to the class, she said:

Sabrina: OK, umm, I have shampoo. I don't know. Because, I put it because you know it makes your hair smell good.

Stephany: Girls like to smell good. Girls like to smell good. All of them do.

Sabrina: And girls like to smell good. [. . .] I put got curl, because you know I got curly hair. My favorite time of the year is spring, so I wrote 'spring.' I'm skilled. I love Fridays. Umm, I am sort of like an adventurous [sic]. My favorite shampoo is Pantene Pro V. I am a student. Mmm, I like getting shoes. I like taking pictures, and I like putting on make up!

Sabrina and Stephany seem to be "citing" an apparently natural law mandating that "girls like to smell good." Other data suggest that perfume was the single most desired beauty product by the teens (e.g., some carried perfume bottles in their purses; Carmen's and Leticia's collages had images of perfume; and Leticia's also had the brand name [Adidas Moves]). In and through her narrative, Sabrina produces a feminine identity in accordance with conventional regulations of the female body. She says that she likes wearing makeup and mentions her favorite shampoo. Hair and hair products are recurrent elements in the collages. Like Sabrina, Gabriela pasted a cutout of Pantene Pro V shampoo; Jennifer pasted an image of a girl blow drying her hair; Beatriz and Paty pasted cutouts of hair; Paty put on a tiny box of L'Oreal hair coloring product; and Natalia said that she had pasted a prominent image of a girl pulling her hair because she was always "fighting" with her hair. Finally, Sabrina stated that she likes shoes—a feminine artifact with

fetish status in many cultures. Cutouts of shoes figured in Anabel's, Alex's, and Leticia's collages as well. Other teens also indicated a similar compliance with customary gender rules by including images of clothes and jewelry, and words like "beauty," "fashion," and "looks." Femininity, thus, was encoded in most collages by cutouts of commodities, and in the case of some teens, by unmistakably branded commodities. In describing her collage, Alex underlined New Balance as her favorite brand of tennis shoes, and she indicated a desire for Rainbow sandals. Similarly, when Isabel asked Sabrina to clarify the meaning of a tennis shoe pasted on her collage, Sabrina replied: "Because I like Nike shoes. And I like Nike, Nike, Nike! Nike is the best!" Her enthusiasm confirms both the impact of branding and advertising, as well as the significance of commodities in the construction of youth-gendered identities, two points that have been repeatedly made in research with other youth. It also suggests a desire to belong to a certain class or lifestyle. Teresa Brennan (1992) makes a similar point to Silverstone's (2007) argument about the relationship between media use and ontological security (see Chapter One). Brennan argues that we have a psychic need for points of reference for the self. Grounded in psychoanalysis, her argument posits that commodities provide us not only with points of reference, but with *fixed* points of reference. According to Brennan, it is their fixity that makes commodities such nifty reference points for the self. Her insightful comment illuminates the meaning of the numerous pictures of commodities that the teens pasted in their collages.

THE HETEROSEXUAL MATRIX

Another technique used to construct the teens' identities was their inclusion in the collages of references to romantic love. Once again, rather than signifying their actual experiences, most teens signified their desires. Apart from Paty and Gabriela, who pasted pictures signifying actual relationships, what was most often expressed was a desire for romantic love. In eight of the thirteen collages using this technique, the desire was clearly presented as heteroerotic.[7] See, for example the signs in the lower left corner of Jennifer's collage in Figure 14. Of course, expressing their desires as heteroerotic was the only socially acceptable way to present themselves within the context of the project. In Chapter One, I mention that although Butler theorizes gender and sexuality together, I do not discuss sexuality in the book because, in part, I do not have enough data to venture into interpretations of the teens' sexual subjectivities, and, in part, because I feel that the teens would not have liked me to write about aspects of their selves that they unintentionally disclosed to me.

The ties between media and desires for romantic love were apparent in many collages: four teens pasted pictures of male celebrities, obvious objects of their

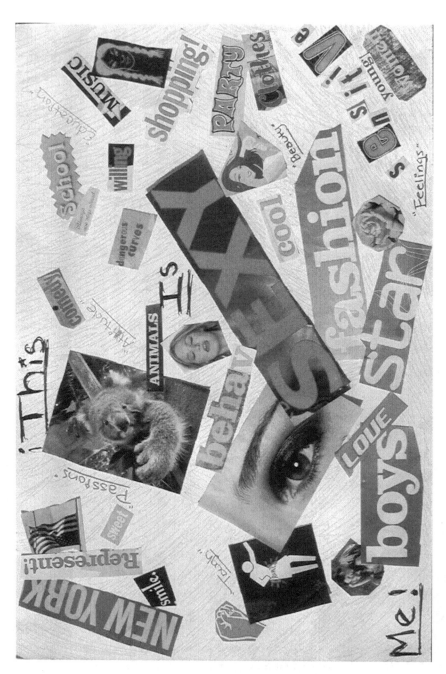

Figure 14. Collage by Jennifer (age 14)

romantic desires (Carmen pasted the picture of singer Luis Fonsi or "Alfonsín"; Gabriela used the picture of singer Luis Miguel; Paty pasted pictures of actor Ewan McGregor and soccer celebrity David Beckham; and Lidia also pasted the picture of Beckham in addition to a picture of pop teen artist Enrique Iglesias). Anabel pasted a description of the contemporary movie release, *A Cinderella Story*; Alex pasted the lyrics of a song that unambiguously talks about heterosexual relations;[8] and Natalia pasted a cartoon portraying a boy coming out of a computer screen to offer a flower to a delighted girl.

Like Natalia, Gabriela and Paty included iconic signs of heterosexual couples. It is surprising that only Gabriela encoded her desire for heteroerotic relationships through marriage imagery. In responding to my question about the picture of a bride and a groom in her collage, she said: "*¡Oh, porque, no sé, yo como mujer, me gusta, me, como siempre he tenido la ilusión de tener una familia, de casarme, pero eso va a ser mucho después*" (Oh, because, I don't know, I as a woman, I like, I, I have always dreamed of having a family, of getting married, but that it's going to be much later). Gabriela talked of her dream of having a family as a natural desire emanating from her womanliness, "*yo como mujer*," she says. In this way, she "cites" the injunction of the *madresposa*, which expects women to fulfill themselves through marriage and family. However, she adds that "*eso va a ser mucho después*," postponing, thus, the duty to comply with the mandate. In the following sections, I present three cases that illustrate, more specifically, the way media and popular culture are implicated in the construction of unique gender configurations.

"ALL AMERICAN" LATINA IDENTITY AND SUBJECTIVITY

Stephany was one of the four teens who had been born in the United States. Her collage, which is shown in Figure 3, reveals the centrality that race and nation had for these teens' construction of gendered identities. It has recurrent signs of Anglo, middle-class girlhood, including lively but sugary colors; words like "sweet," "angel," "happy," and "romantic," and cutouts of two cell phones, which signify the indispensable girl practice of phone talking. Stephany was unambiguous regarding her love of commodities and shopping. In addition to cutouts of feminine-looking pants and a sports suit prominently displaying the brand Nike, she carefully composed the word "shopping" by altering a cutout of another word with a marker. When I probed the teens' understanding of the gendered nature of shopping by asking them if men like shopping, they responded with an emphatic "No!" and Sabrina added: "A guy shopping is real weird, you see a guy shopping, you go, 'OK'!"

Stephany constructed her femininity as that of a U.S. young woman. At the center of the collage, she pasted a U.S. flag and, and at the top right side, she put

an iconic sign of Anglo girlhood: the picture of a blonde teenage girl laughing with an open mouth. Nonetheless, she acknowledged her ancestry by the phrase "Latin American gURL." She went to some trouble to compose the word "Latin" by cutting and pasting letters; but, within the overpowering Anglo girlishness of her visual narrative, the word's small size hints at the peripheral nature of her *Latinidad*. In Chapter Eight, I describe how Stephany and her sister Jennifer talked about their struggle to define themselves at school as both Americans and *not* Mexicans. As in other regions of the United States, in North Carolina "Mexican" is not only a signifier of nation but also a signifier of a lower race and a working-class status.[9] Stephany's collage, thus, shows how gendered identity concerns were inextricably linked to an anxiety about being racialized.

CAUTIOUS DEFIANCE OF CONVENTIONAL LATIN AMERICAN FEMININITY

Susana's collage, which is shown in Figure 15, is remarkable because its motif is a gender configuration that differs from the more conventional one represented in Stephany's. At the center of the collage, there is a large cutout of the familiar sign for "women" with the word *"femenina"* superimposed and written with a red marker. In addition, there are seven different images of women, plus references to fashion and beauty. At the time of the fieldwork, Susana had been in the United States for three years, and she impressed me as being very mature and well adjusted. She was one of the best students in my class and she had taken leadership roles at school. Despite her pleasant personality, feminine appearance, and demeanor, her collage and her media memories and practices suggest that she was caught between the traditional injunctions of her native Honduran culture and her desire to perform an alternative femininity. In describing her collage to the class, she said:

> OK, *me describo femenina, con mucho poder, me gusta trabajar en muchas fotos, por eso puse la cámara aquí, me gusta ir a la playa, escuchar música, ir de compras, y el reloj porque siempre ando de prisa, siempre a veces llego tarde y [...] me gusta hablar por teléfono, y hacer ejercicio y siempre estar en, en forma, me gusta leer, por eso la revista aquí, me gusta el deporte, me gusta el soccer.*

> OK, I describe myself as feminine, with a lot of power, I like working on many photos, that's why I put the camera here, I like to go the beach, listen to music, go shopping, and the clock because I'm always in a hurry, always, sometimes I arrive late and [...] I like to talk on the phone, and exercise and always be in, in shape, I like to read, that's why the magazine here, I like sports, I like soccer.

As demonstrated in her collage, Susana encodes a conventional femininity in this narrative while at the same time asserting her power. She refers to practices unambiguously associated with women, such as listening to music, going shopping, talking on the phone, and reading magazines. But her references to power, sports, and being in shape allude to a resistant stance regarding traditional Latin American gender norms. Underneath her feminist concerns and her compelling claim to femininity, there seems to lie an apprehensive awareness of gender transgression. Susana constructs a femininity that challenges the submissive femininity of the *madresposa*, and it looks as if she knew that she had to do so very prudently to avoid being labeled as *loca*. In the collage she conveyed her interest in fashion by a cutout with the words "fashion consultant" and a picture of a young woman. The picture implies that, for her, shopping for the right garments is a serious matter. The young woman in the picture is sexy but looks professional; she wears a form-fitting jacket, no jewelry, and a reserved ponytail. She has a pensive posture, plus a notebook and a pen in her hand; she is not just shopping for fashionable clothes. Is Susana carefully considering the best attire to create a credible performance of femininity that does not require forfeiture of desires for power and independence?

Susana's collage also shows other ways in which media and popular culture are implicated in the performance of her different femininity. Note that she pasted the cover of the magazine *Shape* between the word "sport" and a large cutout of a young woman lifting weights. Her concern with beautification, which is evident in the collage in the phrases "a beautiful" and "lose weight," is inextricably tied to her desire for power and independence; it is a desire for a femininity that embraces physical prowess. She chose a magazine that adheres to nontraditional ideals of beauty. What is remarkable about the collage's cautious defiance of traditional femininity is that such a wary challenge seems to be a characteristic trait of Susana's media practices. In her calendar, for example, she wrote "*novelas*" (soaps) as her favorite television show at the time of the fieldwork and said that her favorite movies included the romantic tale *Titanic*, the story of the ultimate girl hero *Cinderella*, and the romantic comedy *Mr. Deeds*. Her preference for *telenovelas* and romantic stories matches those of most other teens. Yet Susana is the only teen who stated that police dramas were among her favorite media texts. She said that she liked to watch "a series about the FBI" and *Expedientes Secretos (The X Files)*, and added: "*Desde que yo estaba, desde Honduras, yo la he venido viendo*" (I've been watching it since I was in Honduras). Watching police dramas—a rather masculine practice—was one of her television rituals. Also, in her calendar Susana did not put Barbie as her favorite toy, as many of the teens did. The following excerpt comes from the

individual interview with her, in which I inquired about her memories of Barbie:

Lucila: *¿No jugaste con Barbies?*

Susana: *Sí, jugué con Barbies, pero no sé, más me gustaba, ¿qué era? Jugué con Barbies con mis hermanas. Pero, no sé.*

Lucila: *¿No era tu [juguete] favorito?*

Susana: *No, no era mi favorito, de Barbie.*

Lucila: *Y luego,* the television show, *tienes los Power Rangers... ¿los veías en Honduras?*

Susana: *Sí, se me olvidó poner Gybón que me gustaba más que los Power Rangers.*

Lucila: *¿Qué era Gybón?*

Susana: *Gybón era un robote, que era como policía, sí, es que a mí me gustaba, hoy estoy, agarré unas clases de* police explorer.

Lucila: *También.*

Susana: *También. Me ha gustado siempre lo de la ley, la ley siempre me ha gustado. Quería ser abogada y despues detective.*

Lucila: *Sí, habías dicho que querías ser detective.*

Susana: *Detective, y me ha gustado siempre, pistolas y todo eso.*

Lucila: Didn't you play with Barbies?

Susana: Yes, I played with Barbies, but I don't know, I liked more...What was it? I played Barbies with my sisters but I don't know.

Lucila: It wasn't your favorite [toy]?

Susana: No, Barbie wasn't my favorite.

Lucila: And later you have the *Power Rangers*...did you watch it in Honduras?

Susana: Yes, I forgot to put that I liked *Gybon* more than I liked *Power Rangers.*

Lucila: What was *Gybon?*

Susana: *Gybon* was a robot that was like a police officer, yes and I liked it, and today I am taking some police explorer classes.

Lucila: Also.

Susana: Also. I have always liked things having to do with the law, I have always liked the law. I wanted to be a lawyer and then a detective.

Lucila: Yes, you had told me that you wanted to be a detective.

Susana: Detective, and I always like guns and all that.

The characteristic trait of Susana's media practices is illustrated by this dialogue. She replies that she did play with Barbies as a child because of her sisters, but that what she always liked were *"pistolas y todo eso"* (pistols and all that). Her favorite cartoons match her desire to have a career in the traditionally male-dominated area of law enforcement. As in her favorite television series *The X Files*, some of the main characters in the cartoon *Power Rangers* are attractive and intelligent policewomen. It is not easy for a 16-year-old Latina like Susana to perform the femininity embodied by *The X Files'* protagonist Special Agent Dana Scully, played by Gillian Anderson.[10] Scully personifies an alternative femininity that is distinctively Anglo, yet Susana seems to have bridged the contradiction between, on the one hand, her Catholic upbringing and Honduran origin, which come with injunctions banning women from entering many career fields, and, on the other hand, her desire to become a detective and her admiration for characters like Scully. It is very revealing to contrast Susana's popular culture practices and preferences with the care that she took to construct a feminine identity in her collage; she was the only teen to include two practices associated with femininity: talking on the phone and reading women's magazines.

In her collage there are no signs of nation, and the women represent various racialized ethnicities, including Latina, Anglo, and Asian American. Susana performs a femininity that seems to transcend nationality and ethnicity and relates to a nearly universal struggle for women's rights. About the middle of the term, I asked the teens to bring a magazine article to analyze in class. Susana brought a well-researched feature about women's status entitled *"¿Mandan las mujeres?"* (Do women rule?). In another class, when the conversation shifted into issues of sexual harassment, she said: *"¡Imagínense si no cambiamos, imagínense la siguiente generación como va a ser! ¿Cómo? Ser peor. Van a decir que nosotros somos como los de antes. ¿Se imaginan?"* (Imagine if we don't change, imagine how the next generation is going to be! How? It'll be worse. They're going to say that we're like those who came before us). Susana's indignant comment hints at some sort of personal experience with the issue. Perhaps this is the consequence of seeing the struggle of women like her mother, who achieved more independence after migrating to the United States (Hirsh, 1999; Hondagneu-Sotelo, 2002). In choosing an article about women's oppression and expressing indignation about possibly reproducing the status quo, Susana reveals a way of being transnational that cautiously, but assertively, crosses many borders. Most of the other teens also aspired to take the fourth option that Anzaldúa says is now available to Latinas— to gain independence through education. However, it seems that they did so in a way cognizant of the old popular proverb, pointed out by Mexican writer Rosario Castellanos, that reveals out the indictment hanging over women who dare to

enter forbidden spaces: *"Mujer que sabe Latín, ni encuentra marido ni tiene buen fin"* (woman who knows Latin, neither finds a husband nor has a good end) (Castellanos, 1973).

MARGINAL, TRANSGRESSIVE FEMININITY

"Yo soy una mujer y yo soy bien tough" (I'm a woman and I'm very tough) said Isabel, who constructed her identity in a decisively transgressive fashion for a 20-year-old transnational Latina. At the time of the fieldwork, she had been in the United States for over five years, was living with a foster mother, and working as a carpenter and electrician. She also said that she had left home at fifteen and had been on her own since. Although she was the oldest of the group, she was attending the last year of high school.[11] Her demeanor was rough and her behavior sometimes rude. She often wore baggy pants and T-shirts, and twice she attended classes wearing a soccer uniform. Like Natalia said, she "tried to look different." She had a tattoo, and throughout the semester she changed her hair color from bleached, to bleached with blue streaks, and then to green. In Lagarde's typology, Isabel would fit the profile of the *loca* who is at risk of becoming a *presa*. Some of her comments suggest that her uncompromising performance of an alternative gendered identity had not been well received at school, where, she said, she had been ostracized by peers and penalized by teachers and administrators. Her arresting collage, which is shown in Figure 12, suggests her transgressive identity. In explaining it to the class, she said:

¡Ay, que feo! Lo mío no es, demasiado, pero esto más o menos me representa a mí, no que andara así, eso que andar en la calle asi allá en México, y, más que nada cuando ya me salí de la casa de mis papases, ¡ah! y luego aquí es cuando, cuando estaba con toda mi familia allá en México, y fuimos a Puerto Peñasco, al mar de Puerto Peñasco [...] y, esto porque siempre he querido comprar un carro de esos y, y, aquí [apuntando a Chucky] a pesar de que he pasado por muchas cosas malas no le tengo miedo a las cosas [...] Chucky, es una persona que asusta a la gente, representa mucho miedo [...] entonces, a pesar de que he pasado por muchas cosas, ah, no tengo miedo, y, y aquí porque estoy contenta, aquí porque es como, cuando llegué a la casa de la señora con la que vivo ahorita y la casa está muy grande [...] Y esto, porque antes cuando llegué aquí no tenía nada de dinero y ahorita como voy trabajando y sacando dinero y lo he puesto en el banco. [...] Y ésta, [pelota] porque es mi juego favorito, es mi adoración, el fútbol, y luego el volibol, porque es el segundo lugar de fútbol.

Oh how ugly! Mine isn't too much, but this more or less represents me, not that I would be like that, to be on the street like that over there in Mexico, and above all when I've left my parents' house, ah! And then here it was when,

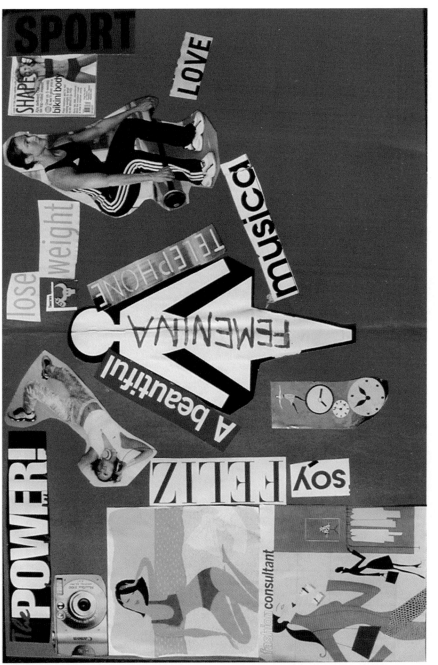

Figure 15. Collage by Susana (age 16)

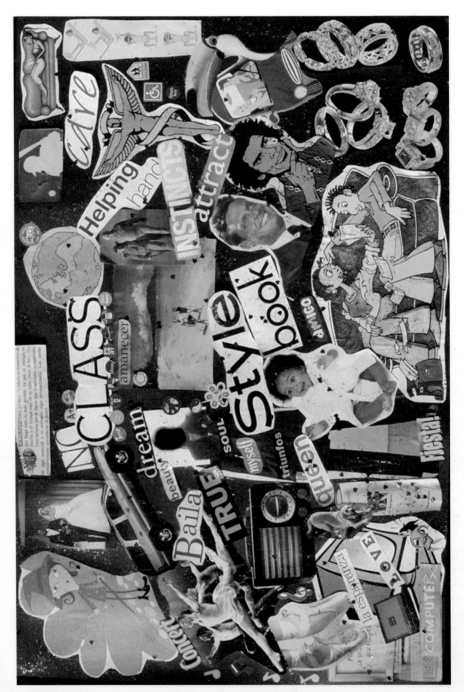

Figure 16. Collage by Gabriela (age 18), Panel A

when I was with all my family over there in Mexico, and we went to Puerto Peñasco, the beach at Puerto Peñasco [...] and this because I always wanted to buy one of those cars and, and, here, [pointing to the Chucky doll] in spite of having gone through a lot of bad things I am not afraid of anything [...] Chucky is a person who frightens people, he represents a lot of fear [...] so, in spite of having gone through many things, ah, I am not afraid, and here because I am happy, here because it's like, when I arrived at the home of the lady I live with now and the house is very big [...] And this, because when I arrived here I had no money, and right now because I'm working and making money and I've put it in the bank.[...] And this [ball] because it's my favorite game, it's my adoration, soccer, and then volleyball, because it's in second place to soccer.

When presenting her collage Isabel seemed to realize the striking power of the grotesque imagery she had chosen, and she gave a somewhat apologetic explanation. Hers is a tale of survival. First she recounts the difficult childhood that made her become like Chucky, unafraid and frightening looking, but then she goes on to state that she is happy now. Also, Isabel explains that the picture of a man and three children at the beach stands for the cherished memory of a trip she took with her family. The collage defies acceptable expressions of Latina femininity by both including imagery that clearly evokes masculinity and by excluding femininity signifiers. The collage has no signs of beauty or fashion, no signs of feminine media practices, no signs of romantic love, and no signs of body (e.g., there are no sensual lips, eyes, or buttocks as in other collages). The gender of the child with the pacifier is somewhat ambiguous and Chucky is a male doll. The collage has other traditional signs of masculinity: money, sports, and a Range Rover SUV. Further, in the picture she chose to represent the memory of her family, there is no image of a woman. Might this absence hint at a rejection of what Monique Wittig (1986) calls "compulsory heterosexuality"?

Isabel's media and popular culture memories and preferences reveal her identification with characters that endure painful situations such as her own (e.g., losing her parents and struggling at school). She shared some of the other teens' preferences, especially their gusto for traditional Latin music and dance, but many of Isabel's preferences seem more typical of boys than of girls. For example, when we were talking about reading, she said "I like to read mystery things, like, ah! Scary things!" Also, the heavy metal band *Metallica* was her second choice for top three artists, and among the films that she brought out were *Blood in Blood Out* (a Hollywood thriller gangster melodrama about three East Los Angeles Chicano boys) and *The Mummy Returns* (a Hollywood horror film catering to adolescent boys). She repeatedly said that she did not watch television at all; in one occasion

when I asked the teens to fill up a log sheet of their weekly television watching, Isabel refused to do so. She did, however, have some familiarity with *telenovelas* and admitted to watching the Tasmanian Devil, too: "*Ya no miro mucho, solamente, a Tasmanian*" (I don't watch much anymore, only, Tasmanian). The Tasmanian Devil, from the Warner Brothers' series *Looney Tunes*, seemed to have a special significance for her. It was one of the few characters that she could remember watching as a child, and rather than putting Barbie as her favorite toy in her calendar, as most other teens did, Isabel wrote "Tasmanian."

The alternative gender configuration suggested by Isabel's collage, in addition to some of her media memories and present practices, matches her defiant stance regarding statements about appropriate feminine behavior made by other teens. For example, during a class when the conversation turned to issues of appearance, Natalia argued that, as young women, they were coquettish and liked to be seen as pretty. Isabel interrupted her with a question: "*¿Coqueta yo? ¡No!*" (Me, coquettish? No!). Likewise, in another class, Jennifer said, "Like the boys will always be active and the girls will be just ..." Isabel jumped to say: "Not always!" And, more significantly, when we were talking about gender norms that oppress women, Isabel underlined the complicity of some women with such norms. "*Pero muchas mujeres quieren pensar así*" (But many women want to think that way), she said. Isabel's frequent argumentative stance is evident in the following excerpt. The conversation was triggered by my questions about the extremely sexualized representation of women in the clip of Univisión's *telenovela Salomé* that we had just watched:

Susana: *La forma de vestirse también tiene que ver mucho en la persona.*

Lucila: *¿Por qué?*

Susana: *Porque, digamos así como ellas [en la telenovela], que se dice, con vestido corto, pasa por la calle, por supuesto que cualquier hombre la volteará a ver y va a querer hacer, intentar hacer algo.*

Isabel: *Pero es que por eso somos libres de hacer cualquier, de vestirnos como quieramos. Susana: Sí, pero...*

Natalia: *Pero es lo que estamos causando, es lo que nosotros causamos, si queremos hacer...*

Carla: *Sí pero en el mero momento...*

Natalia: *Lo que estamos causando. ¿Y para qué nos vestimos lindas? ¿Para qué nos vestimos así? ¡Para que nos miren! ¿Para qué otra cosa te vistes así?*

Carla: *Para que nos estén echando el ojo.*

Isabel: *¡Pero no para que te violen!*

Carla: *Sí, pero tú los estas provocando.*

Natalia: *Los provocamos.*

Carla: *Nosotros los provocamos.*

Isabel: *¡Ellos se provocan solos! Porque no les estamos [diciendo], no les estamos, así: "Ven tócame aquí" ¡Ay! Y luego al ratito, ¡pásatelas!*

Susana: The way you dress yourself has a lot to do with a person.

Lucila: Why?

Susana: Because let's say like the women [in the soap opera], let's say, with a short dress, walks down the street, almost certainly any man would turn around and stare, and would intend to do something to her.

Isabel: But that's why we are free to do whatever, to dress like anyway we want.

Susana: Yes but…

Natalia: But this is what we are provoking, this is what we provoke, if we want to do it…

Carla: Yes, but in that very moment…

Natalia: What we are provoking. And why do we dress pretty? Why do we dress that way? So they look at us! Why else would you dress that way?

Carla: So that they stare at us.

Isabel: But not so that they can rape you!

Carla: Yes, but you are provoking them.

Natalia: We provoke them.

Carla: We provoke them.

Isabel: They provoke themselves! Because we are not [saying], we're not like, "Hey come over and touch me here," oh! And later after a little while, quit that!

In her characteristic blunt manner, Isabel first unabashedly asserts a woman's right to play with her own style, "We're free to do any, to dress anyway we want." Then she makes a case against sexist assumptions that justify sexual harassment. While Natalia and Carla call upon the patriarchal argument that women provoke men when they dress revealingly, Isabel contests the argument claiming that men decide by themselves how to respond to the assumed provocation. Also quite telling in the excerpt is the muted voice of Susana, who timidly agrees with Isabel that women are free to choose their attire but does not voice further opinions. She seems to be more aware than Isabel of the highly regulatory structure that governs

gender in the transnational Latina/o milieu—and of the dreaded consequences of defying it.

Whereas only Isabel was fearless in her resistance, most of the teens were resisting conventional femininity. Proof of their resistance is that motherhood did not seem to define them. There is a conspicuous absence of imagery of motherhood in the collages, and there are remarkably few expressions of desire to become a mother in the teens' talk. Within the oppressive framework of the conventional Latin American gender discourse, the mother enjoys a special status that provides authority and enables some personal and political claims. This status also affords women the possibility of challenging authoritarian structures. The best documented struggle is that of the *madres de la plaza de mayo* who took to the streets to denounce atrocities of the Argentinean military at a time when conditions of state terrorism prevented men from expressing dissent (Kaiser, 2005). Only the most mature teen, Gabriela, expressed her desire to become a *madresposa*. Age may explain this prominent silence in the case of younger teens, but it does not in the case of older ones. At least four other factors seem to play a crucial part in their apparent rejection of the *madresposa*: (1) many of the teens were children of *new braceras*, women who have challenged the gender mandates of their home countries; (2) the teens' school culture emphasized education as a means of personal fulfillment; (3) they participated in popular culture traditions that present alternative ways of producing a gendered identity, such as the Anglo and the black traditions; and (4) Gabriela's family had enjoyed solid middle-class status in their home country, a clear indication of the significance of class ideologies.

COUNTERPOINT, PERFORMATIVITY, AND DIFFERENCE

In what ways are media and popular culture implicated in the dynamics of producing gendered, classed, and raced identities and subjectivities among working-class, transnational Latina teens living in the New Latino South? First, using Butler's notion of performativity, I argue that the teens' collages as well as their media talk are *performatives*; they are acts in and through which the teens constitute their identities. In other words, when "talking" about themselves and their media memories, actual practices, and desires, the teens were in fact "doing" gender. Second, drawing on contrapuntal approaches I posit that the gendered identities that they constructed have a contrapuntal texture. As in contrapuntal music, contesting gender discourses continuously play against one another to produce a given identity. Belonging to marginalized communities, the teens cannot overlook the centrality of axes of difference, such as race and class. They

compose gendered-classed-raced identities in the space produced in and through the dialogue of two discourses. I also argue that the dialogical counterpoints that create the space in which the teens compose their gendered identities were first, the dominant Latin American gender discourse, which permeates the transnational, working-class milieu; and second, the alternative discourse encountered by the teens in Anglo media representations such as Dana Scully, in the U.S. schools in which girls excel, and in the daring acts that *new braceras* perform in their everyday lives. While these three manifestations of the alternative discourse may seem to be different discourses, I view them as dialectical variations. Again, this is not to say that the two discourses do not manifest themselves in various registers on both sides of the border, but rather that they correspond to different cultural geographies.

As the above analysis shows, various degrees of resistance to dominant gender norms are discernible in the teens' talk. While observing conventional definitions of femininity and heterosexual relations, most constructed gendered identities also incorporated elements of the alternative femininity discourse. In the cases of Susana and Isabel, concerns about cultural and national identity appear buried under concerns about gender and sexuality, which confirms Butler's claims regarding the centrality of gender in identity construction processes. But in Stephany's case, anxieties about cultural identity overshadow gender concerns. Because Stephany was born in the United States, but Susana and Isabel were not, one might see their contrasting anxieties as a consequence of their citizenship status. While there is some merit to such an explanation, the fact that cultural and national identity were also prominent concerns of foreign-born teens like Lidia, Carmen, Gabriela, Alex, and Anabel indicates that factors other than being the immigrant generation operate in this complicated dynamic. Stephany's manner of incorporating Anglo femininity reminds me of Frantz Fanon's "white mask," the narcissistic identification with the colonizer that constitutes the colonized subject (Fanon, 1967). However, following Butler I have assumed that there is "no doer behind the deed," therefore there cannot be a "black skin" behind the mask. The partial incorporation of alternative Anglo femininity that Stephany's collage suggests opens up complex and fascinating questions for further research concerning mimicry. At times the invocation to the alternative gender discourse seems to be a strategy for challenging the gender oppression that characterizes Latin American and Caribbean societies and permeates the transnational Latina/o milieu. It resembles the concept of mimicry proposed by Homi Bhabha, who posits mimicry as "the sign of a double articulation, a complex strategy of reform, regulation and discipline, which 'appropriates' the Other as it visualizes power" (Bhabha, 1994, p. 86). A Latina teen constructing her identity in the interstices of two cultural geographies may find it empowering to mimic a femininity

associated with the dominant Anglo culture in order to resist both the domination of the hegemonic group and the gender oppression of the transnational Latina/o milieu.

Then again, in the New Latino South, very strict mechanisms are kept in place to ensure that racial boundaries are difficult to cross. In the next chapter, I look at another of the axes of difference that structure the possibilities for constructing identity and developing subjectivity that are available to working-class, transnational Latina teens: race. As I discuss in Chapter One, Linda Martín Alcoff convincingly argues that Butler's theory is insufficient to explain "the Latino particularity" because it ignores the fact that, just like gender, race is also visible. Martín Alcoff contends that "racialized identities affect not only one's public status but one's experienced selfhood as well" (Martín Alcoff, 2006). The historical fact of the racialization of postcolonial migrants makes race a crucial axis of difference that we cannot afford to ignore when exploring the *problematique* of migrancy, identity, subjectivity, and popular culture.

Racialized Identities, Racialized Subjectivities

A chief component of the "culture clash" that transnational Latina/o families experience when they migrate is a tough awakening to race, first, because we are racialized, and second, because we come to a society that is much more race-conscious than Latin American and Caribbean societies. In the local settings of the New Latino South, the Latina/o "difference" is the reason for assigning a lower status to the entire group. In line with Linda Martín Alcoff's (2006) claim regarding the persistent racialization of most Latina/os in the United States, the identity assigned to transnational teens is not ethnic but racial. While the official racial status of Latinas and Latinos in the United States has been ambiguous, on the basis of lived experience, we have been classified according to wealth and phenotype. Michael Omi documents that after the annexation of California, light-skinned Mexicans with wealth and European features were treated as white, but working-class, dark-skinned Mexicans with Indian features were not (Omi & Winant, 1986). I believe that something similar has been happening in the New Latino South. Hence, along with other processes of identity construction, the teens were rejecting, resisting, accommodating, and accepting various means of racialization, not the least of which were the media and popular culture representations of *Latinidad* and Latina womanhood discussed in Chapter Three. At the same time, having entered a race-conscious society, the teens and their families were in the midst of a race awakening that involved an exploration of their own prejudices.

Within the dominant social structure, racialization of Latina/o transnational youth is necessary to ensure conformity to the needs of the global economy and the global division of labor. While numerous institutions of the dominant society act in tandem to transform transnational Latinas and Latinos into a lower race, media and popular culture play a fundamental role as well. In a broader sense, in this chapter I am concerned with Paul Willis's question regarding working-class youths' continued replication of their social status by moving into working-class jobs. More specifically, I am concerned with the role popular culture plays in the construction of a subaltern Latina social identity and a subaltern subjectivity, that is, the way in which the four traditions of popular culture contribute to a Latina subjectivity in accord with the working-class occupations that the dominant society expects of these young women. In Chapter Three I pointed out that hegemonic constructions of Latinas are limited to two types of representations: maid-like figures and hypersexual women. The latter, of course, is more seductive for young women. The hypersexualization of dark bodies is a crucial weapon of the European colonial project, and sexualizing the dark body has been simultaneously a means to racialize it (Gilman, 1985; Pieterse, 1992). In the "erotics of Aryanism," argues Thomas, sexualization and racialization are one and the same process:

> Critically, if we define "racialization" as the cultural-historical process by which "race" is conferred, at both individual and collective levels, then we must define "sexualization" as the cultural-historical process by which "sex" is conferred, both individually and collectively, as if this social identification is "natural" and not in fact normative; as if social processes of "racialization" and "sexualization" are not in fact one and the same. (Thomas, 2003, pp. 239–240)

Following this line of thought, in this chapter I argue that the various techniques deployed in media and popular culture to sexualize the Latina body simultaneously and systematically racialize Latina womanhood, in particular dark-skinned, working-class Latina womanhood. In addition to media and popular culture representations, there were at least two other factors that were shaping the development of new subjectivities among the teens: one was the social identity assigned to them in their everyday settings, especially at school, and a second was the identities and subjectivities that they and/or their families brought from their original country. I begin the chapter by addressing this latter topic.

WHAT TRANSNATIONAL FAMILIES BRING FROM "HOME"

Migration scholars like Sylvia Pedraza note that what a group brings from home is one of the factors that determine the group's outcome in the host society

(Pedraza, 1998, p. 3). Latino migrant families to the New Latino South bring identities that were forged within the remains of a glorious pre-Columbian past mixed with the wounds inflicted by defeat and colonization, first by European powers, and then by the very country that they enter. The colonial relationship with the United States is one of those pivotal historical facts that has made Latin American and Caribbean countries what they are. Some theorists of Latin American national identities, like Samuel Ramos, have underscored that the prominent feature of such identities is what in Albert Memmi's terms would be called the colonized mentality. Ramos (1951), a Mexican philosopher, uses Alfred Adler's psychoanalytic theory to interpret Mexican collective identity and argues that the inferiority complex proposed by Adler explains Mexican character at the level of both individual and collective action. The inferiority complex, says Ramos, is rooted in the experience of Spanish conquest and colonization, and it is a constitutive element of the national identity that emerged after the independence of 1810. Ramos was put in jail when his first essay on the issue was published in the early 1950s. Such a violent response suggests that there must be some truth in his theory. Latin American and Caribbean countries have been lands of intense miscegenation, and creolization, *mestizaje*, and *mulataje* have been salient motifs of their art, literature, religion, and folklore. These motifs have also been prominent in Latin American and Caribbean scientific explorations and philosophical thinking. Fernando Ortiz's (1963) theory of transculturation, described in Chapter One, is but one example of the profound need to explain the character of our national identities. José Vasconcelos (1976) is another remarkable example. A pioneer of the idea of *Latinidad*, Vasconcelos posited that Latin Americans are a *raza cósmica* (cosmic race) because they have emerged from the mixing of all races. His argument, which has been celebrated especially by Chicano artists and activists as a challenge to the ideology of white supremacy and racial purity, in fact privileges European ancestry. In Chapter One I mention that Silvia Spitta (1997) uncovers the contempt for women that is poorly veiled in Ortiz's work. Vasconcellos's work is plagued with misogyny (Vargas, 1982).

Working-class families also bring with them a class identity constituted within the framework of the rigid social stratification of Latin American and Caribbean societies. Authors like Julie Bettie (2003) talk about this identity as a "caste orientation." Other authors point to the fact that the region's social stratification is governed by the color hierarchy established by the European colonial powers. Tracing the roots of the color hierarchy through colonial times, Frank F. Montalvo explains that:

> A skin color hierarchy that stressed White lineage became recognized as a proper way to control the dark other in the Spanish colonies, which were governed by

race and privilege. Throughout colonial history the social policy of "whitening," or *"blanqueamiento,"* served as an incentive for dark people to gain social advantage for themselves and their children by striving to look and act like Spaniards through social unions and marriages. (Montalvo, 2004, pp. 28–29)

The desire for *blanqueamiento* (literally, whitening) has been both retained and obscured in the post-colonial identities that migrant Latinos bring with them. Montalvo and other Latino scholars have borrowed the term *colorism* from the scholarship on African Americans to talk about this phenomenon in Latina/o communities. Colorism refers to an "ingroup social preference for light-skinned over dark-skinned members in many aspects of family, work, and community life" (Montalvo, 2004, p. 27). As postcolonial societies, Latin American and Caribbean countries continue to respect the color hierarchy implemented by the colonizers while simultaneously denying its currency. Thus, half-concealed in the social imaginary, this hierarchy regulates every aspect of social life, and it is (re)produced by all kinds of cultural expressions, not least of which are media and popular culture artifacts (Dzidzienyo & Oboler, 2005; Mindiola, Niemann, & Rodriguez, 2002). Given that negative connotations associated with dark skin are a major component of the hegemonic ideology in the teens' home countries as well as in their new local communities, they could not avoid being influenced, "spoken" by it, as Althusser (1971) would say. Paty, for example, stated during a conversation about the stigmatization of Latina/o youth at local schools: *"Ya nos tienen caracterizados a los hispanos así como, feitos, morenitos, y no sé, ignorantes"* (They have already characterized us Hispanics as ugly, dark-skinned, and I don't know, ignorant). Even when criticizing the stereotyping of Latinos, she could not avoid revealing the colorism underneath her own association of dark skin with ugliness and ignorance because such associations are the staples of everyday talk in her native Mexico.

In their home countries, the teens (or their parents in the case of U.S.-born teens) were full-fledged members of the dominant Spanish-speaking society. Apart from Gabriela, whose case I explain below, the teens were *mestizas. Mestizos* have a vague sense of the workings of systems of racial inequality and the teens seemed to be negotiating two different understandings of race, one stemming from the social locations of their families while in the home countries, and the second from their families' social locations in the New Latino South. When I asked the Durham group to assign the characters of a Mexican *telenovela* into Latin American dominant racial categories, they were perplexed. However, when they talked about their current lives, they used four distinct categories: *"Americana/o," "Hispana/o or Latina/o," "China/o,"* and *"Africana/o"* or *"Morena/o."* By *"China/o,"* which literally means "Chinese," they referred to Asians and Asian Americans; by "Morena/o," meaning "dark-skinned," they meant black. In accordance with the common usage in many Latin American and Caribbean countries, the teens often used the

Spanish term *"negra/o,"* as well. Yet, aware of the public repudiation of the term in the United States, they often corrected themselves in mid-sentence. Such hesitation reveals a neoculturation linguistic practice and discloses the conflicting impulses they felt with respect to race matters.

AFRO-LATINIDAD

Gabriela was the only teen who saw herself as Afro-Latina. She had been born in Venezuela, a country with complicated racial politics and an enduring myth of racial equality. Like Gabriela, the majority of Venezuelans are *pardos,* or light-skinned mulattos, but they are not considered *negros*, *africanos*, or *afrovenezolanos*. Only those with very dark skin are considered so. *Afrovenezolanos* constitute at least 15 percent of the population and historically have been subjected to racial prejudice and discrimination. In the last few decades, the *Red de Organizaciones Afrovenezolanas* and the *Unión de Mujeres Negras*, among others, have been denouncing discriminatory practices including demeaning media portrayals, and have been attempting to claim their rightful place in the history of the country. Unfortunately, *Afrovenezolanos* are still a stigmatized minority (García, 2005). While living in Venezuela, Gabriela was not *negra, africana,* or *afrovenezolana;* she was *parda*. Because she came to the United States when she was fifteen, Gabriela's social identity as a *parda* probably had strong roots in her subjectivity. In Durham, Gabriela identified herself as Latina while fully acknowledging the black blood of her heritage. Her dual identification comes across in her two-panel collage, shown in Figures 16 and 17.

Although Gabriela's collage contains pictures of light-skinned and blonde women that represent diverse aspects of Gabriela's self and/or her desires, the collage also has three iconic signs of Gabriela's black subjectivity: drawings of young women reading, doing yoga, and teaching about sexually transmitted diseases, the latter one of her community service activities at the time. Moreover, to codify her desires for marriage and children, she pasted cutouts of a black baby and of a black couple in wedding attire. And, she pasted a drawing of a black young man and even codified her interest in health care by using a drawing of a caduceus-like symbol with a black man.

Gabriela's volunteer service with a local, non-profit black radio station at the time of the fieldwork makes plain her attachment to the black community. Her popular culture consumption practices, however, do not show a marked preference for black media. Her favorite music included a variety of genres, but she did say that her favorite artist was Luis Miguel, who sings only in Spanish and whose picture she pasted in the collage. Her fandom for Luis Miguel was an important constant in her life; she indicated in her calendar that the singer was her favorite

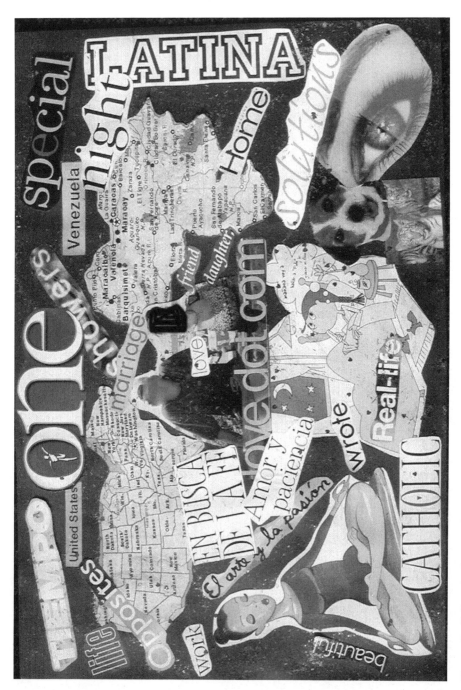

Figure 17. Collage by Gabriela (age 18), Panel B

since age seven. Gabriela's most-watched network was Univisión, and in a worksheet asking for "the TV shows that I like the most," she wrote *Friends* and *Despierta América*. The latter is Univisión's morning show and the former is the globally successful sitcom that features a group of young white yuppies living in Manhattan, New York City. Gabriela frequently pointed out what she saw as contradictions in her behavior; for example, she explained the word "opposites" that she pasted in her collages by saying: "*significa que siempre tengo diferentes opinions, o sea soy muy mente abierta pero es contradictorio, yo soy muy contradictoria, por eso puse 'opposites'*" (it means that I have always different opinions, I mean, that I'm very open minded but it's contradictory, I'm very contradictory, that's why I put "opposites"). I had the impression that Gabriela was experiencing herself as a very disjointed subject, which is, of course not uncommon among transnationals. Granted, this feeling is related to the numerous changes that come with migration, but I also think that the change in racial membership has much to do with her sense of a deeply fragmented self.

The manifest signs of blackness in her collage may signify not only an identification with blackness but also a response to a cultural imperative that, most likely, she found confusing. The large cutout with the word "Latina" in her collage indicates that Gabriela clearly identified herself as Latina, yet the rigid dichotomous racial regime of the United States did not give her, a light-skinned mulatta, the choice of not identifying herself as also black. Apparently, Gabriela was not only struggling to experience herself as "Latina," as the rest of the teens were; she was simultaneously struggling to experience herself as "black," rather than as *parda*. In the difficult task of developing a new subjectivity, Afro-Latina/o youth like Gabriela face the additional burden of the unwritten U.S. "one-drop rule" that stipulates that one single drop of black blood makes a person black.

RESISTANCE AND ACCOMMODATION TO THE
U.S. RACIAL REGIME

Renato Rosaldo and William V. Flores note that "Mexican *mestizos* who cross the border into the United States move not only from one nation-state to another, but also from one side of the color line to the other" (Rosaldo. & Flores, 1997, p. 94). This experience is as true for *mestizos* from all Latin American and Caribbean countries as it is for Mexicans. Being *mestizas*, how did the teens make sense of the minute everyday mechanisms at work to racialize them? How did they respond to them? And how were media and popular culture implicated in both processes of racialization and resistance to it? No doubt, the teens were overtly resisting racialization. Overt resistance to racialization was evident in the

refusal of U.S.-born teens like Jennifer to be labeled "Mexican," a term that in North Carolina schools and other settings of their everyday lives has an unambiguously racist connotation. Overt resistance to racialization was also apparent in the refusal of teens like Paty to be classified on the basis of race/ethnicity at school:

> *No sé por qué ese afán de dividir a la gente por razas. Igual a mí me choca que ponen, en los exámenes, a mí todavía no me cae el veinte, que digan en los exámenes y la primera pregunta, este, "qué raza eres?" Y ya pusieron "hispana, blanco, negra, o asiático, o otro." Así como que, y ¿para qué quieren? Yo nunca contesto. Y este, una vez me dijo, por ejemplo, la maestra de álgebra, me dijo "tienes que ponerle" y ¿por qué le voy a poner? Y le digo "en todo caso le voy a poner blanco ¿por qué voy a poner que hispano? Por que me tienen que clasificar así?" Y me dice "No, así tienes que poner."*

I don't know why that insistence of dividing people according to race. Like I hate that they put, on the exams, still it doesn't dawn on me, that, they say on the exams and the first questions is "what's your race?" And they already put "Hispanic, white, black, Asian, or other." That's like, and what do they want it for? I never answer. And once, once she told me, the algebra teacher told me "you have to put it" and why am I going to put it? And I tell her "in any case I'm going to put white, why am I going to put Hispanic? Why do they have to classify me like that?" And she tells me "No, you have to put it like that."

Paty's defiant attitude to be "Hispanized," and her reluctant preference for the category white suggests, first, that she was aware that in U.S. culture, whiteness signifies the absence of race. Second, it suggests that she realized that her claims to power as "Hispanic" would be much less valid than the claims that she felt entitled to make in her native Mexico. Her public identification as "Hispanic," thus, was clashing with the lived sense of self that she had just a few months before. Paty had very light skin and in Mexico her family was middle class, a privileged class for whom it was possible to ignore the racial hierarchy that organized her home country's socio-economic stratification. Having crossed the color line when she crossed the border, Paty was overtly resisting the state's power to racialize her. Her explicit resistance notwithstanding, Paty's somewhat veiled desire to be classified as white exposes contradictory feelings and desires. Natalia revealed a similar desire to be seen as white when she came to class with a new hair color with light highlights, and she explained that her mother wanted her to be blonde for their upcoming trip to Colombia. Because both Paty and Natalia had light skin, it was possible for them to pass as white in some public settings. At moments like these, I could not help but think of Frantz Fanon's point about the desire of the colonized black man to speak French like a Frenchman (1967).

STRATEGIES OF ACCOMMODATION

In their study of migrant Latina/o youth living in North Carolina, Krista Pereira and her colleagues found that discrimination was a concern for both teens and their caregivers. Moreover, Latina teens "reported higher levels of discrimination from school peers" than Latino boys (2008, p. 2). For the teens in my project, school peer relationships that sustained racial divisions were extremely difficult and probably painful to resist. When I asked some of the Durham teens if they socialized with white girls, Susana and Carla hinted at the manner in which they made sense of the racial segregation that I observed in local schools and that authors like María Palmer Unger (2003) have thoroughly documented:

Lucila: *¿Ustedes tienen amigas americanas, blancas americanas?*

Susana: *Sí.*

Natalia: *Morenitas.*

Carla: *Yo no, yo tengo africanas, no me llevo mucho con las americanas, tengo una cosa que no me llevo mucho con las americanas, no me puedo llevar con ellas.*

Lucila: *¿Por qué?*

Carla: *No sé, no me puedo llevar con ellas por, no sé, a mí me gusta ser muy divertida y, ellas como que a la vez estudian, y estudian, estudian, y yo estudio y me divierto y a ellas no les gusta estarse divirtiendo.*

Susana: *Siempre les gusta la contraria, aunque digas que el color es, aunque el color es negro y digan que es blanco, tiene que ser blanco, así son ellos, la mayoría pues, los que yo conozco.*

Carla: *Se creen mucho nomás porque son americanos pero la verdad, para mí no.*

Lucila: Do you have American girl friends, white Americans?

Susana: Yes.

Natalia: *Morenitas.*

Carla: I don't, I have Africans, I don't get along well with white girls, it's my own thing, but I don't get along well with white girls, I can't get along with them.

Lucila: Why?

Carla: I don't know, I can't get along with them because, I don't know, I like to have fun and they like to study, and study, study, and I study and have fun, and they don't like to have fun.

Susana: They always like to be arguing, even if you say that the color is, even though the color is black and they say it is white, it has to be white, that's the way they are, I mean most, those that I know.

Carla: They're full of themselves, just because they're white, but really, not for me.

Susana explains her strained relations with white girls by attributing a belligerent character to them; Carla straightforwardly talks about the air of superiority that she perceives about them, and Natalia says that she has not white but black girl friends. The segregation at school, and thus the existence of several peer cultures, helps explain the teens' use of black popular culture that I describe in Chapter Four. In turn, this use sheds light on the effects that the public identification of transnational Latina/o youth in the New Latino South had in the teens' subjectivities. It was becoming very hard for them not to experience themselves as "youth of color," as racialized subjects. Martín Alcoff contends that, "one cannot have a subjectivity that can transcend the effects of public identification" (Martín Alcoff, 2006). The public identity of the teens at their schools was, to a large extent, (re)produced by the stereotypical constructions of Latino youth that circulate in the Anglo media and popular culture tradition.

Carla's comment in the excerpt about white girls resonates with dominant presuppositions about white girls as studious and boring and Latina girls as fun. "They like," she says, "[to]study, and study, study, and I study and have fun, and they don't like to have fun." In the U.S. social imaginary, student achievement has been linked to whiteness, and youths of color often fail in school because they fear that their peers would ostracize them for "acting white" (Kao, 2000). This fear, and more precisely for a migrant context, the fear of assimilation, are core to Carla's explanation of her trouble getting along with white girls. Yet Carla is not saying (at least in my presence) that she does not study; rather, she is saying that she studies and also has fun, arguing that one can be both studious and Latina, although a difficult option according to the hegemonic imaginary. Ramírez-Berg summarizes the "master assimilation narrative" told by films like *Bordertown*, in which the protagonist is an Other from the ghetto or the *barrio*. After achieving success in the Anglo world, "protagonists realize that American success is incompatible with 'the best human values,' namely those espoused by their root culture" (Ramírez-Berg, 2002). In simple terms, to be successful in the mainstream U.S. society, one has to assimilate.

Going against the hegemonic imaginary, the teens repeatedly expressed explicit desires for school achievement and career success. These are recurrent themes in their talk and their collages. Carmen's collage (see Figure 13) has an indexical sign of school achievement: the picture of a young man in graduation regalia. Stephany's collage (see Figure 3) has two symbolic signs of the same desire: the word "education" and the word "school" overlapping the phrase "always one step ahead." She explained that the meaning of the composition was "be one step

ahead of school at school." Alex and Sabrina made their desire even more explicit. Alex wrote "I want to go to college" (see Figure 9) and Sabrina put "I want to go to medical school and become a family physician" (see Figure 4). The teens' aspirations are congruent with the findings or a large-scale study on Latina/o youth in North Carolina. Pereira and her colleagues found that "immigrant Latino youth were highly motivated to succeed academically" (2008, p. 2).

Tied to the teens' desire for school achievement is their more general desire to be powerful and successful. Daniela (see Figure 18) and Gabriela (see Figures 16 and 17) coded this profound desire in single words like "power," "success," and "*triunfos*" (triumphs), but Lidia was unequivocal (see Figure 2). She pasted three cutouts: One read, "Be the star," another stated the same command in Spanish, "*Sé la estrella*" (be the star), and the third cutout read, "The sun is 93 million miles from earth." When she presented her collage to the class, Lidia said this about these signs:

> *Sé la estrella, porque pienso que para todo, aunque sea para cualquier cosa que tú quieras hacer, tienes que ser como una estrella. Y el sol es alguien, tú entre miles de gentes, tienes que sobresalir tú y ser como reluciente, como una estrella... nosotros, uh, yo para mi persona yo lo puse así, que el sol está muy lejos de mí. Pero, como, está como a 93 millones de distancia. Pero yo sé que si yo me propongo hacer algo, yo, aunque esté muy muy lejos de mí, de mi alcance, yo lo voy a alcanzar.*

> Be the star, because I think that for everything, even if it's for anything that you want to do, you have to be like a star. And the sun is someone, you, among thousands of people, have to stand out and be like sparkling, like a star...we, uh, I for my own person I put it like that, that the sun is very far away from me. But, like, it's like 93 million away. But I know that if I set my mind on doing something, I, even if it's very, very far away from me, from my reach, I'm going to reach it.

Lidia's moving explanation of the metaphor in her collage clarified that the enigmatic statement about the sun signified her determination to overcome any obstacles. She did not express a desire for school achievement or for specific career goals like some of the other teens. Rather, Lidia articulated a duty to be outstanding. She chose the imperative mode to convey her feelings about being a star, and she underscored the importance of these feelings by putting the command in both Spanish and English. The sun metaphor also revealed her complex feelings about being a star, like the sun, while living in social and economic conditions that make such aspiration seem like being "93 million miles" from her reach. Lidia's poignant expressions of resolve and purpose make a powerful statement about the resiliency and optimism of teens like her. This powerful statement, as well as other teens' expressions of profound desire to

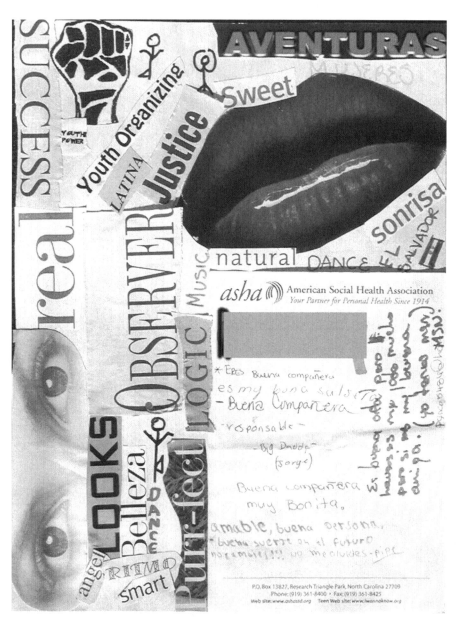

Figure 18. Collage by Daniela (age 15)

graduate and to go to college, contrast with prevailing stereotypes of "the troubled Latina girl" that authors like Jill Denner and Bianca Guzmán (2006) maintain is prevalent in most of the research on Latina girls. The stereotypical representations of Latina/o youth that circulate in the hegemonic culture were a huge obstacle for the teens to overcome. In the remaining sections of this chapter, I focus on the ways in which the teens accommodated, rejected, and resisted such representations.

COMPLIANCE, RESISTANCE, OR STRATEGIC ACCOMMODATION?

The stereotypical representations of Latinas found their way into the teens' subjectivity. The most palpable example of the teens' readiness to "naturally" conform to stereotypical representations of Latina womanhood was the desire that several teens expressed to be sexy. While many white teens also have this desire, in the case of Latina teens, such a desire matches the normative expectations about Latina womanhood that are relentlessly (re)produced in the Anglo tradition of media and popular culture; as women of color, by being sexy, young Latinas comply with the logic of postcolonial sexual politics, and become the exotic object of desire. I discuss this issue in Chapter Seven, but here it is relevant to look at how some of the teens expressed their desire to be sexy in their collages. Daniela, for example, signified her desire by using pictures of sensuous lips and eyes (see Figure 18). She made the meaning of these signs clear by saying "*los labios porque creo que es una parte, la parte [que] es más, sexy, de las partes que hay en el cuerpo… los ojos también, los ojos también creo que son bien, sensuales*" (the lips because I think that it's a part, the part [that] is most, sexy, of the body parts… the eyes too, the eyes too I think that are quite sensual). Lidia and Jennifer also used pictures of eyes or lips in their collages to signify the same desire (see Figures 2 and 14). In Lidia's collage the expression of this desire is small and simple, but in Jennifer's the expression is complex: overlapping the eye, and at the center of the collage, she pasted the word "sexy" in big, red letters. Moreover, overlapping the last two pictures she put the word "behav" (i.e., behave); and as she clarified during her collage presentation to the class, the overlapping creates the sentence "behave sexy." The imperative mode of this composition indicates its normative character. She then put "dangerous curves" above the word "sexy." When I asked what she meant, the class laughed and made me understand, without saying it directly, that the phrase had sexual overtones.

The power of images of hypersexual Latinas, specifically Selena and Jennifer López, is easy to see on Natalia's collage (see Figure 11). She expressed her desire for being sexy and having a "J Lo butt" by using explicit signs. First, she used a large indexical sign of a girl's butt wearing red panties with the word "ouch!" Second, she also pasted a full-body picture of herself crossed by the words "sexy

wet." Third, she used a drawing of two girls with one of them accidentally showing her butt. In her explanation of this drawing, she said *"Es que yo siempro ando así, a mí siempre me anda pasando eso"* (It's 'cause I'm always like that, that is always happening to me). Finally, the word "boys" superimposed on the picture of the girls' butts suggests that the latter sign is an end and the former a means. This interpretation finds support in the two iconic signs of heterosexual desire that Natalia used, one of a young man coming out of a computer to offer a flower to a delighted young woman, and another of a girl declaring her love to a discombobulated teacher. It is interesting to note that as hypersexuality, Natalia's collage is marked by excess; note for example that the cutouts overflow the poster.

These examples suggest that teens like Daniela, Lidia, Jennifer, and Natalia may have been unconsciously complying with the hegemonic forces at work in their racialization. Stereotyping and objectification are forms of psychological oppression and, as feminist theorists like Lee Bartky point out, "they are some of the ways in which the terrible message of inferiority can be delivered even to those who may enjoy certain material benefits" (Bartky, 1990, p. 23). But there are other explanations. One is that as young women of color, they may have been—somewhat instinctively but nonetheless strategically—accommodating to the identity that would allow them to make the greatest claims to power. By making themselves the exotic Other, and thus the object of desire of the ultimate holder of power, the white man, working-class Latina teens may attain a relatively advantageous position. Another explanation is that their desire to be sexy is actually an affirmation of cultural belonging. Frances Negrón-Muntaner advances this argument in her critique of the film *Selena*, in which Jennifer López plays Selena:

> In gendered terms, the big rear end acts both as an identification site for Latinas to reclaim their beauty and a "compensatory fantasy" for a whole community. Insisting to write or talk about big butts is ultimately a response to the pain of being ignored, thought of as ugly, treated as low, yet surviving—even thriving—through a belly-down epistemology.... Through Jennifer's butt, the rear end becomes a more ample trope for cultural belonging. (Negrón-Mutaner, 1997, p. 192)

Drawing on Bakhtin et al., Negrón-Muntaner argues that hyper-sexualization of the Latina body is, in this case, affirmative at both the individual and the collective level. In a similar vein, Mary Beltrán posits that "it is possible to see Jennifer López...as empowered and empowering through asserting qualities such as intelligence, assertiveness, and power—while also proudly displaying her non-normative body and declaring it beautiful" (Beltrán, 2002, p. 82). That the teens were using Selena to create a sense of belonging and to affirm themselves as Latinas is one of the most evident findings of my project. Their use of Selena/Jennifer López's butt

and other signs of sexiness is a more complex matter. Bakhtin's (1994) notion of heteroglossia, which underscores the primacy of context over text, reminds us that to read the teens' expressions of desire to be sexy, one must take into account the ideological positioning of the author. I do believe that the signs of such desire in the collages are affirmations of cultural belonging, but at the same time, the backsides of women of color are debasing signs of patriarchal and colonial grammars. The desire to be sexy seems to be linked to contestatory impulses in the case of Daniela, and probably of Lidia, too; yet in the case of Natalia, and perhaps of Jennifer, the same desire appears to respond more to impulses to conform rather than to resist the relentless representation of Latina womanhood as hypersexual and thus racialized. As Frances R. Aparicio argues, "one cannot dismiss the sedimented patriarchal and racialized values that Selena and Jennifer López's butts still trigger for many non-Latino viewers as icons of cultural subalternity" (Aparicio, 2003, p. 99).

PARTIAL PENETRATIONS

Grasping how many of their media and popular culture practices work to guarantee that they fit the racial category assigned to them was a much more difficult task for the teens. *The Fast and the Furious*, a gang film targeting adolescents, was released on video during the time of my fieldwork, and some of the students kept mentioning it. I used this film to probe the teens about Hollywood cinematic constructions of Latinos. It is a tremendously successful B-grade film and it has sprung a sequel *(2 Fast 2 Furious)*. It tries to market to youth of color without offending Anglo audiences. The film has many black, Asian American and Latino characters, but it simultaneously reproduces the Anglo media stereotypes of youth subcultures and their resistant identities. In her critique of this and other films that exemplify this recent trend in Hollywood to produce "raceless" texts for global youth audiences, Beltrán says that "ideologies of white superiority and nonwhite subordination continue to have powerful influence, even while the casting, production design, and other manifest components of the film promote a multicultural aesthetic" (Beltrán, 2005, p. 63).

The film is about the drag racing subcultures of Los Angeles, and it caters to adolescent boys with its theme (on-street racing), its fast action scenes, its sound track and special effects, its stars, and its male gaze (the camera often pans on scantly clad female bodies). It is also an excellent example of an intriguing trend in the current media construction of race in the dominant culture's texts in which racial ambiguity is mixed with traditional racial stereotypes. The main characters are an undercover detective (played by Paul Walker) and a leading racer, Dominic Toretto (played by Vin Diesel). The detective is an extremely flat character and

his race seems equally obvious, with his blond hair and blue eyes functioning as unequivocal signs of his whiteness. Toretto is a bit more complex as a character and his race is ambiguous. His name identifies him as Italian or white ethnic, but his looks may confuse viewers. The looks of Toretto's sister (played by Jordana Brewster), who becomes the detective's love interest, are less racially ambiguous, but she could pass for Latina. When I asked my students to identify the race/ethnicity of the characters, their answers strengthened my sense of the racial ambiguity in the film. Natalia said, "*¿De qué raza era Diesel?* (What race was Diesel?) and Lidia thought that many characters "*se veían como hispanos*" (looked like Hispanic). She said: "*Algunos se veían como hispanos, este, la mayoría, la mayoría se veían como hispanos... las dos muchachas se veían como hispanas, su esposa o algo así... su novia, ellos era como hispanos*" (Some [characters] looked like Hispanic, I mean, most, most looked like, the bold one [Diesel] looked like Hispanic... Both girls looked like Hispanic, his wife or something like that... his girlfriend, they were like Hispanic).

As I mentioned above, Toretto and his sister are ethnic white (Italian American), but Toretto's girlfriend, Letty, is clearly marked as Latina by her name, her Indian phenotype, and her makeup and clothing style. Played by Michelle Rodríguez, a dark-skinned Latina, Letty comes across as a tough gang girl involved in an abusive relationship with Toreto, who seems to cheat on her at every opportunity. Although hers is a secondary role, it is nonetheless important as she is the only woman who races in the film (which some teens pointed out), and she therefore complicates the film's androcentric story (Beltrán, 2004). Moreover, Rodríguez is the only Latina/o actor whose name appears in the credits. Other minor Latina characters are clearly depicted as sexually available, and Hector, the leader of the Latino gang, is portrayed as stupid. In one scene, Toretto asks Hector to watch over the money for a bet. Someone asks, "Why Hector?" and Toretto replies: "Because he is too slow to run away with the money." Hector looks puzzled, but says nothing. The large number of racialized bodies shown on the screen may make the film's denigration of Latinos (and indeed of other groups, especially Asian Americans) difficult to see. Here is what one reviewer thought about the film's ethnic diversity:

We also see the marketing of the film in how it is cast, portraying ethnic diversity. Lance Nguyen and Johnny Tran lead a polished but ruthless Asian motorcycle gang, called a "wolfpack," that is in competition with Dominic. Not only has a business deal gone sour but Dominic slept with Tran's sister. In one of the drag race sequences, Ja Rule, as Edwin, an African American driver, has a cameo scene. Add to the mix Michelle Rodríguez and an

uncredited Latino actor as Hector, and we have a politically correct movie ...
(Singleton, 2000)

Like this reviewer, the teens seemed to have missed the denigration of youth
of color. They said that the film was quite popular among Durham Latina/o youth
and talked about how their male Latino friends imitated the races depicted in the
film on the Durham highways. The students explained that they liked the film
because it caters to youth and because it is about cars and racing. They also said
that they like it because it has Latina/o characters. Lidia put it this way: "*Representan
a los hispanos, bueno, no los representan tan mal*" (They represent Hispanics, I mean,
they do not represent them so badly). The relative abundance of clearly racialized
but nonetheless racially ambiguous characters in music videos and films targeting
youth may work to obscure the contribution of the hegemonic media to the racial-
ization of Latina/os. Transnational Latina/o youth may feel that the inclusion of
Latina/os in Hollywood youth films are a sign of progress, even when they are
stereotypically portrayed and Latina/o actors are not even credited.

As the semester progressed, the Durham teens demonstrated further awareness
of the stereotyping of Latina/os in the texts of the Anglo tradition. In Chapter
Five I discuss the realizations that teens like Lidia had about the representation
of *Latinidad* in *The Fast and the Furious*, but here it is important to stress that some
of the teens were able to grasp the way Anglo popular culture texts racialize
Latina/os. Natalia, for example, said: "*Nosotros los colombianos, Colombia ¡drogas!
En todas las películas que he visto que son de drogas sale Colombia...y los mexicanos
también, todos de pandilleros, con drogas*" (We Colombians, Colombia drugs! All the
movies about drugs that I have seen show Colombia...and Mexicans too, all are
gang members, with drugs). Lidia made a perceptive comment about the repre-
sentation of Latinas in reality shows:

> *En los* reality shows pasan, *este, parte de la realidad de los* reality shows, *y pasan
> a las mujeres Latinas, pero así de lo peor, se van con todos los tipos, y hacen ahí sus
> enajenantes cosas, este, entonces ya las clasifican así como que, por no decir otra
> palabra, fáciles.*

> On reality shows they show, uh, part of the reality of reality shows, and they
> show Latina women, but like the worst [kind], they hang on with all guys,
> and they do their alienating things, uh, so they already classify them like,
> not to say other word, easy.

Lidia seems to be saying that reality shows include Latinas because Latinas
are part of the world that these shows profess to mirror, which is the multiracial

everyday life that is lived in urban working-class settings in the United States. Yet she argues that reality shows selectively choose the "worst" Latinas and that they end up classifying Latinas as "easy." Her discerning remarks show awareness of the stereotypical representation of Latinas in the Anglo tradition as hypersexual and morally lacking. This representation reveals a crucial mechanism of racialization because, as Stephen Cornell and Douglas Hartmann state, the inferiority implied by racial designations is "most importantly and almost invariably an inferiority in moral worth" (Cornell & Hartmann, 1998, p. 28).

(RE)INTERNALIZING COLORISM

Because white supremacy permeates many of the texts of both the Latina/o and the global Spanish-language traditions, they play a significant role in the racialization of working-class, transnational Latina/o youth. *Telenovelas* indeed contribute to processes of racialization and I talk about these texts in other chapters. At this point, it is relevant to look at what the teens had to say about *El Show de Cristina*, a popular talk show produced by Univisión. Hosted by Cuban exile Cristina Saralegui, the show is somewhat similar to *Rosie* and *The Oprah Show*, but, as Viviana Rojas mentions, Spanish-language shows like *Cristina* and Telemundo's *Laura in América*, have "a declared philosophy of service" and Univisión and Telemundo overtly advertised these shows as a space for empowering Latinos (Rojas, 2004, p. 129). The shows mix sensational entertainment with discussion of serious topics, including issues of discrimination against Latina/os. In her study exploring how Latina adult women respond to *Cristina* and to *Laura in América*, Rojas found that, in general, the interviewees disputed the networks' claims of service to their audiences and strongly disapproved of the oversexualized representations of Latinas (Rojas, 2004, p. 145–47). According to Rojas, "the majority of the interviewees strongly criticized the scanty dresses of the models in Univisión's variety shows such as *Sábado Gigante (Gigantic Saturday)*, *El Gordo y la Flaca (The Fat and the Skinny)*, and *Los Metiches (The Busybodies)*, and the sexual overtones of some talk shows such as *El Show de Cristina* (Rojas, 2004, p. 114). Arlene Dávila offers another example of the disgust that many Latina/os feel regarding the sexualization of Latina/os. She recounts how Dominicans living in New York City have organized themselves to denounce the damaging representation of Dominicans in *El Show de Cristina*: "In 1998, they condemned the talk show *Cristina* for oversexualizing and ridiculing Dominicans and 'staining' their image through what they regarded as its selection of *chusma Dominicana* (lowlifes) as guest for the show" (Dávila, 2002, p. 170). By contrast, some of the teens in my

project hold very different views regarding *Cristina*. During a class with the Durham group, I asked them what they liked about the show:

Lucila: *Habían dicho que les gustaba Cristina, ¿Me podrían decir por qué?*

Carla: *Porque, mmm, no sé porque como hay veces, como hay veces muestra cosas buenas, y hay veces muestra cosas malas ¿verdad? Pero, hay veces te enseña algo.*

Lidia: *Yo creo que es como todo ¿no? Tiene sus partes buenas y sus partes malas... Muestran algo que es, para ti es, es algo bueno, pero es algo malo. O sea, lo malo por la forma en que están viviendo pero te lo muestra a la realidad, algunas veces.*

Carla: *Uh, uh.*

Lidia: *Algunas veces te muestra otras cosas.*

Natalia: *Muchas veces te deja muchas monalisas [moralejas], muchas enseñanzas.*

Lidia: *Uh, uh.*

Natalia: *No hacer eso, no hacer esto otro.*

Lucila: You have said that you liked *Cristina,* can you tell me why?

Carla: Because, mmm, I don't know, because sometimes, sometimes they show good things, and sometimes they show bad things, but sometimes they teach you something.

Lidia: I think that it's like everything else, no? It has its good parts and its bad parts.

Carla: Uh, uh.

Lidia: They show something that is, that for you it's, it's something good, but it's something bad. I mean, it's bad because of the way they are living but it's shown as it really happens, sometimes.

Natalia: Uh, uh.

Lidia: Sometimes it shows you other things.

Natalia: Many times it leaves you with many lessons, many teachings.

Lidia: Uh, uh.

Natalia: Not to do this, not to do that.

What Lidia means is that, even though the show presents crude language and disturbing situations, it teaches something important: In *Cristina,* social life "is shown as it really happens." She recognizes that the show presents "bad things,"

but, contradictorily, she seems to be arguing that her exposure to the show is a positive learning experience. It is telling to compare Lidia's response to *Cristina* in the above excerpt to her previous critical response to reality shows like *Cops*. While she is able to demystify the latter, she does not seem to have the same insight about the former. Why not? Naturally, the answer is related to the conventions of each genre, which frame the presentation of negative images of Latina/os in different ways, but what I want to highlight here is Lidia's relationship with *Cristina*, because it sheds light on the teens' overall relationship with both the Latina/os and the global Spanish-language traditions. Paul Willis pointed out the saliency of ideas and values that arise from cultural relationships internal to the group, and he argued that such ideologies are more easily internalized because they come from inside one's culture (Willis, 1981, p. 60). *Cristina* is a text that presents itself as part of the culture of transnational working-class Latinas, that it directly speaks to them, and that it alleges to faithfully represent the social life of our communities. Furthermore, *Cristina* claims to provide a public service for Latina/os. In the excerpt, Natalia articulates her unsuspecting view of the show by arguing that "many times it leaves you with many lessons, many teachings." Her claim, corroborated by Carla, may be more an effect of the network's advertising of talk shows as spaces for Latina/o empowerment than Natalia's own insight, but in any case, it seems that these teens were especially susceptible to the talk show's lessons regarding race, class, gender, and sexuality. As in other texts of both the Latina/o and the Spanish-language global traditions, one of the crucial teachings of *Cristina* is the naturalness of white supremacy and colorism.

CONSUMPTION AND RACIAL MEMBERSHIP

Subtle mechanisms of racialization were very hard for the teens to understand, much less to challenge. Such was the case of the association of media and popular culture practices with racial/ethnic membership. I explained in Chapter Four the strong preference of the teens for the artifacts of the Latina/o and the global Spanish-language traditions. During a class, when I pointed out that nearly all of them had indicated on the worksheets that they regularly watched Univisión, Stephany and Lidia explained:

> Stephany: [It's] because we're Hispanics, but if there was different people, different races, they probably put different, you know? Because you know, a lot of Latinas like Univisión, you know, different races like different things, because they want to buy things that are their race, do you know what I mean?

Lidia: *Yo pienso que es porque es el único canal hispano en el cable, cuando pones el cable es el único.* (I think that it's because it's the only Hispanic channel on cable, when you turn on cable it's the only one.)

Stephany had been born in the United States and her explanation is quite at home with the prevailing naturalization of racial categories that exists in this country. Her stance is in sharp contrast to Paty's contestatory stance toward the U.S. racial regime that I presented earlier in this chapter. Lidia introduces the question of availability, but like Stephany, she assumes that it is natural for Latinas to watch Univisión. In concert with Martín Alcoff's (2006) nonessentialist account of the formation of the subject discussed in Chapter One, watching Univisión is a cultural practice that does not serve to recognize racial differences but actually to produce them. What it is fascinating in the excerpt is that Stephany extends her argument about television watching to consumption in general. "Different races," she matter-of-factly says, "want to buy things that are their race." Talking about the connection between identity and consumption, Teresa Brennan (1992) argues that commodities are especial sources of ontological security because they provide us with fixed points of reference for the self. The naturalization of race-based consumption is a powerful mechanism for the racialization of young people who are needed by the transnational economy. It is one of the means by which transnational labor is made cheap. The racialization of Latina/o transnational youth, through their consumption of popular culture, lays the groundwork for the development of subaltern subjectivities. Then, racialized mass-mediated representations support as well as confirm such subjectivities. At the same time, the same representations validate the authenticity of racialized public identities. The racialization of most Latina/os in the United States is intertwined with the dominant society's refusal to grant them full citizenship status. In the following chapter, I turn to the thorny issues of national and cultural identity.

CHAPTER NINE

The Politics OF Belonging

To approach the overlapping questions of national and cultural identity, I make use of the broad analytical category proposed by Sheila L. Croucher: the politics of belonging. She defines the term as "the processes of individuals, groups, societies, and polities defining, negotiating, promoting, rejecting, violating, and transcending the boundaries of identities and belonging. These politics and processes are highly contextual, and although belonging and its fluid nature are as old as history, the context in which belonging is negotiated changes" (Croucher, 2004, p. 41). Thus, the category highlights the multiplicity, fluidity, and constructedness of belonging, without disregarding the constraints that context and conditions put on the options that specific people or polities have available for claiming membership in social and political formations. Croucher posits that ontologically, belonging is an "achievement." In my reading of Croucher, belonging is a performative in the sense that Butler uses the term, because we "do" belonging within the structural constraints of our own situation.

The shrinking of the nation-state's power and the emergence of other forms of "polis" above, below, and across the level of the nation, have destabilized the traditional notion of citizenship, which stresses a tie to a state that comes with rights and obligations. Croucher points out that citizenship has become "soft," malleable, and that it now entails different formations of political belonging

(Croucher, 2004, pp. 80–81). Examples of new political practices include customs that have emerged in subnational communities like Catalonia, as well in supranational political formations like the European Union. According to Croucher, however, the relationship between the individual and the nation state is still central to any discussion of the politics of belonging (Croucher, 2004, p. 45). To talk about issues of citizenship, therefore, I must discuss the teens' most direct relationship to the U.S. state, which is their legal citizenship status. I purposely restrained myself from inquiring about the legal status of the foreign-born teens, but in Latina/o settings people often disclose their legal status during the course of conversation. The group included several legal citizens, some by birth and some by naturalization, and several foreign nationals. Among the latter were legal permanent residents, legal nonpermanent residents, and undocumented individuals. To complicate matters further, one of the legal citizens was born in Puerto Rico, which is a territory (commonwealth) of the United States. Although Puerto Ricans are U.S. citizens by birth, their status is close to that of denizens; in everyday life, many people think of them as foreigners. These institutional categorizations played an important part in the teens' attachments to nation, culture, and territory. The subjectivity of each of the teens, as Michel Foucault would argue, could not but be the effect of these categorizations.

SENSE OF INCLUSION OR EXCLUSION IN THE U.S. POLITY

Renato Rosaldo argues that citizenship entails various degrees of belonging and entitlement that are not accounted for in the legal dichotomous division between being a citizen or not being one. His concept of cultural citizenship assumes that, in addition to their political, social, and civil rights, people are entitled to cultural rights (Rosaldo and Flores, 1997, p. 57). The near invisibility of *Latinidad* in the hegemonic culture thus implies that we are not an integral part of the U.S. polity. I wanted to explore the relationship between such near-invisibility in the Anglo tradition and the teens' sense of symbolic inclusion or exclusion in the United States. During a class in which we studied the representation of *Latinidad* in Anglo television, we had the following dialogue:

Lucila: *¿Cuáles son las imágenes de Latinas, piensen, o Latinos en general, en la televisión en inglés, que recuerden?*

Grupo: *No.*

Lidia: *Yo no he visto ni uno.*

Natalia: *Yo nunca, la verdad yo nunca, cuando veo televisión en inglés, nunca veo Latinos.*

Lidia: *La verdad los que yo he visto en la televisión, y si hay, no, la verdad, si hay [es] cuatro por ciento [...] yo he visto unos Latinos pero como público, asi como MTV, ahí sacan pero son, desde diez personas que hay solamente un Latino.*

Carla: *Como hace dos, fueron, hace, creo que tres semanas tuvieron el* awards *para el rock, estuvo El Tri, estuvo Mana, estuvo Motolov.*

Natalia: *Shakira.*

Carla: *Shakira, Paulina Rubio, Enrique Iglesias.*

Lucila: *Los músicos.*

Natalia: *Sí, hay muchos ahora, hay muchos, se está llenando ahora mucho de Latinos en la música Americana.*

Carla: *Pero imagínate que salió El Tri, y cantó.*

Natalia: *¡Cantó!*

Lucila: What are the images of Latinas, think, or Latinos in general, on English-language television that you remember?

The Group: None.

Lidia: I haven't seen any.

Natalia: I never, really I never, when I watch English-language television, I never see Latinos.

Lidia: Really those that I have seen on television, and if there is, no, really there is four percent [...] I have seen some Latinos but as public, like in MTV, there they are, but they are, only one Latino for every ten persons.

Carla: About two, they went, about three weeks ago, they showed the rock awards, it was El Tri, it was Mana, it was Motolov.

Natalia: Shakira.

Carla: Shakira, Paulina Rubio, Enrique Iglesias.

Lucila: Musicians.

Natalia: Yes, there are many now, there are many, it's getting full of Latinos in American music now.

Carla: But imagine that El Tri was there, and he sang.

Natalia: They sung!

Lidia's guess of four percent is accurate because numerous studies have shown that the number of Latina/os in both news and entertainment has fluctuated between two and four percent (Subervi Vélez, 2004). In the above excerpt the teens at first say that they cannot remember any Latina/os on television because they were thinking of characters in entertainment programming, such

as sitcoms and dramas. This was the framework of the discussion that we had been holding. But the teens quickly steer the discussion into music and MTV, and Natalia asserts, "It's getting full of Latinos in American music now." In her choice of tense and adverb, she communicates her awareness of both the overall exclusion of Latina/os in the Anglo media and the significance of the change that she perceives. Her own and Carla's absolute delight about the performance of Latin American musicians on MTV confirms how significant the visibility of *Latinidad* seems to be for them. Lidia also notes that there are Latinas and Latinos among the live audience in MTV shows. This is an important issue for the racialization of Latina/os because, even in the most participatory shows, live-studio audience members have an extremely limited agency. The increasing presence of Latina/os in this role has important implications for Latina/o identity and subjectivity. Live audiences add a third group to the presence of *Latinidad* on television, which includes meager numbers of Latino actors and more sizable numbers of "real" Latina/os in reality shows such as *Cops*. In general, of course, all three groups occupy subordinate positions; Latina and Latino actors often play secondary or nonspeaking-roles, most Latina/os in reality shows are criminals or victims, and live-studio audiences follow the lead of hosts and producers. On the one hand, by reinforcing the symbolic subordination of Latina/os, the live-studio audience is likely to strengthen the dominant ideology that upholds the subordination of Latina/os in U.S. society. On the other hand, it is also likely that this growing visibility will lend credibility to marketers' claims about the burgeoning "Hispanic market."

PLACES OF BELONGING AND IDENTITY

Along with the destabilization of the notion of citizenship, the notion of place has been contested. Dorren Massey challenges us to think of place in terms of time. She argues that places are not bounded portions of space but fluid points of intersections or "articulated moments in networks of social relations and understandings" (Massey, 1993, p. 66). Asking the reader to imagine seeing the earth from a satellite, crisscrossed by the moving lines of social relations, Massey says that the point where two or more of these paths cross each other constitutes a unique "place" (Massey, 1993, p. 66).

The teens deployed all kinds of signs to convey their sense of place and belonging. Some signs signify belongingness to youth formations or lifestyles. For example, the multiple pictures of rockers in Beatriz's collage indicate her attachment to a subculture; the pictures of Nike products in Stephany's collage signify her desire to take part in a lifestyle. But what I want to focus on here is on the signs

of nation that are in half of the collages: Jennifer's, Lidia's, and Stephany's col-
lages have images of the American flag; Carmen's has the Mexican flag; Daniela's,
Anabel's and Alex's have the Salvadoran flag; and Gabriela's has the maps of both
the United States and Venezuela with the names of both countries above. In addi-
tion, Stephany has the words "Latin American gURL" (a reference to gURL.org);
Daniela's and Gabriela's have the word "Latina"; and Jennifer's has the phrase
"New York Represents!" In our directions for collage making, we explained: "you
can put anything that represents you." Therefore, what Jennifer's means is that
New York represents her. When presenting their collages to the class, Lidia said
that she included the U.S. flag because *"estoy viviendo aquí"* (I'm living here), and
Carmen said that she pasted the Mexican flag *"porque representa mi cultura"*
(because it represents my culture). Gabriela talked about the juxtaposition of the
maps and names of Venezuela and the United States in terms of her dual attach-
ment. These teens were talking about "home" in the sense of a space of belonging
and identity, but while Lidia gave preference to the local, Carmen privileged the
national, and Gabriela the transnational. The signs of nation in Stephany's collage
triggered a heated discussion about belonging, national identity, and citizenship
among the Durham group. The following excerpt is from the session in which
Stephany presented to the class the collage shown in Figure 3, which has a picture
of the U.S. flag near the center and the phrase "Latin American gURL on the
lower right side," but it does not have any codes of Salvadoran an ancestry.

Daniela: What about the "Latin American gURL"?

Isabel: Didn't you say that you're American?

Daniela: Do you consider yourself American and Latin American?

Stephany: Yeah, because my mom is, you know. [...]

Sabrina: We are Americans, and we were born in America. So we're Americans.

Isabel: I don't know if I am wrong but I read in, read in a book that wher-
ever your father or mother are from, you are from that country. Not
just because you was born over here you are from here, you know
what I mean? [...]

Natalia: *Sólo si eres, de acá, pero son de los países de sus padres.* (Only if you're,
from here, but they're from their parents' countries.)

Isabel: *Exactamente, de donde [eres].* (Exactly, where you're from.)

Natalia: *Sí, ellas son de acá, pero son de allá.* (Yes, they're from here, but
they're from there.) [...]

Stephany: That's why I put both cause...

Sabrina: Well, I consider myself as an American.

Susana: *¿Por qué?* (Why?)

Sabrina: Because, I mean, if I was not born in another, if, I was not born in another country so why would I want to say, "hey, I am from El Salvador," am I? I am not! And then is, like, why? Because, my parents are from there, I wasn't born there, you know.

Lucila: Where were you born?

Stephany: New York.

Sabrina: We are *Salvadoreñas,* at the same time *pero* (but)

Susana: *¿Pero como te consideras más? Quiero decir, la cultura que tienes.* (But how do you consider yourself more? I mean, the culture that you have.) [....]

Stephany: But I don't consider myself American 'cause people ask me where are you from and I say El Salvador.

Jennifer: At school when people say "What are you?" That's when I'll say Salvadoran, but when they say where you from, I'll say New York.

This poignant discussion reveals the anxiety felt by the teens in connection to belonging and citizenship, and shows that they dealt with the politics of belonging not just by claiming a bond to a territory or a polity but also by claiming membership in a community and attachment to a culture. In the excerpt, there are several views regarding belonging, citizenship, national and cultural identity, and the meaning of being an "American." First, Isabel's confusion about birthright citizenship mirrors the mystification of the citizenship status of the U.S.-born children of immigrants that prevails in the New Latino South. In the United States, the law grants automatic citizenship through *jus soli* (right of the land) and/or through *jus sanguinis* (right of the blood). Since the passing of the Civil Rights Law of 1866, children born within the U.S. territory are automatically citizens, regardless of the legal status of their parents; also, the laws understand citizenship as a dichotomous category, that is, either one is or is not a citizen. However, as Rosaldo and his colleagues have documented, the popular understanding of citizenship diverges from the legal one, and people's talk and behavior reveal that in everyday interactions there are various degrees, or classes, of citizenship in the U.S. polity. The social identity assigned to U.S.-born Latina/os, and in many cases their own subjectivities, frequently fails to match their legal status. For example, even though Stephany was born in the United States and thus she is a legal citizen, she describes herself as Salvadoran and as from New York City, yet she does not describe herself as "American."

Questions of identity and belonging are complicated even more by the processes of racialization that the teens were undergoing. Sabrina's assertiveness in the previous excerpt and the passion in her voice suggest that this was not the first time she had faced a situation in which she needed to assert her cultural

identity as *Salvadoreña*, without giving away her "American" national identity and her right to full U.S. citizenship status. Aware that in the New Latino South there are several degrees of citizenship, Sabrina and her sisters were resisting the social forces that diminished their birthright citizenship. In Chaper Eight, I talk about issues of racialization and describe how in other conversations it became clear that their claim to a Salvadoran identity was in part due to their reluctance to being labeled "Mexican," a term that they complained was assigned to them at school and has a racist connotation in the South and other areas of the United States.

Another significant issue in the excerpt is the weight that Susana gives to subjectivity and to culture. The question that she poses to Stephany, "*¿Pero cómo te consideras más? Quiero decir, la cultura que tienes,*" is her own way of asking Stephany about her lived subjectivity, the way she understands herself to be in relationship to a culture. As it is in the broader Latina/o discourse on rights, culture is a recurrent theme in the teens' talk about the politics of belonging. Blanca G. Silvestrini explains that, in the Latina/o discourse on rights, culture and rights are linked because culture provides "a sense of belonging to a community, a feeling of entitlement, the energy to face everyday adversities, and a rationale for resistance to a larger world in which members of minority groups feel like aliens in spite of being citizens" (Silvestrini, 1997, p. 43).

Going back to the excerpt, there is also Sabrina's unambiguous claim to being American, along with her claim that she and her sisters "are *Salvadoreñas*, at the same time." Feelings of transnational or dual belongings also were expressed by foreign-born teens. As an example, in their collage presentation to the class, Lidia and Gabriela stated both their belonging to the United States and their belonging to their countries of origin. Another foreign-born teen, Carmen, clarified the nuances of her feelings of dual belonging. She said that she pasted a Mexican, but not an American flag in her collage, because "*más me considero mexicana porque es mi origen, es, este, donde yo nací, aunque estaba [estoy] hablando un poco más inglés, porque el español, porque como que el español me hago bolas ya*" (I consider myself more Mexican because it's my origin, it's, um, where I was born, even though I speak a bit more English, because Spanish, like I get mixed up in Spanish).

Like Susana does in the above excerpt, Carmen talks about belonging and citizenship in relationship to language and culture. She was the teen who most frequently expressed fears of assimilation, and the fact that she pasted a beautiful iconic sign of the Mexican flag at the center of her collage, next to four Spanish words referring to media and popular culture, does not strike me as a coincidence (see Figure 13). These signs point to a thread that runs through Carmen's media and popular culture practices. This thread is her attachment to her cultural roots combined with a deep fear of assimilation. At the time of the fieldwork she was 17

and had been living in Durham for 11 years. Despite her fluency in English, she had an intense engagement with Latina/o as well as Spanish-language global media. Of all the teens, she was the most avid reader of Spanish-language and bilingual magazines (see Table 4). Carmen was also the only teen who listed three different Spanish-language television networks as her most-often watched channels (see Table 3), and she was the only one to mention a fourth Spanish-language/bilingual channel, Mun2. She used the Internet abundantly, especially Univisión's Web site, to create a space of belonging and cultural identity. Further, her favorite artists and bands were all Latina/os or Latin Americans (Kumbia Kings, Elefante, Aventura, and Thalia), and she was passionate about dancing to Latin music. (Below, I discuss the way Daniela engaged in dancing to Latin music as a means of claiming her cultural citizenship.) More than any other, Carmen's case illustrates the teens' use of media to produce locality and a sense of home in a similar way to that of the diasporic people living in Norway who were interviewed by Dag Slettemeås. Media technologies and content, he says, provided these people "a gateway to travel home (to cultural roots), hence being crucial in the complex task of producing locality and a sense of home" (Slettemeås, 2006, p. 2). Carmen's use of Spanish-language media and Latin music to deal with her fears of integration need not be interpreted as detrimental to her participation in U.S. society and culture. On the contrary, as I posit below, her intense engagement with Spanish-language media and popular culture was a means to actively participate in the public hegemonic sphere. But let me make a final point about the excerpt above before I move on to discuss dancing. The excerpt also reveals Stephany's ingenious way of keeping what is near and dear. She says she is both "Salvadoran" and "from New York." Bypassing the national level with respect to the United States, she claims both her parents' culture and her belonging to a local place. Thus she talks about home on different geographical scales. Likewise, Lidia and Beatriz claim their identity as *Chilangas* or Mexico City natives. Their attachment to global cities resonates with Saskia Sassen's (1998) argument about the new spatial sources of identity that have replaced the nation, and it seems particularly germane to Kevin Robbins' (2001) suggestion that we think "through the city" and "against the nation" when investigating questions of belonging and identity formation. Still, in the case of the teens, the city is a significant source of identity only for those born in global cities. For the remaining teens, nation is the most powerful source of identification and belonging.

Beatriz codified her belonging to Mexico City in a complex way. In the upper left corner of the collage shown in Figure 5, Beatriz pasted a picture of a landscape with a camping tent. She explained that she had shaped the cut-out as a double-circle to signify that her home was far away because the landscape was seen through binoculars. The tent is an iconic sign that connotes "home." But the relationship between the tranquil landscape and Mexico City is arbitrary. When I asked her

how a peaceful landscape could represent a megacity, she explained: "*Porque está bien chévere, muy en paz, era para mí lo que representaba, así yo me quedaba en mi país... Es que era super chido, así como bien relax, como se ve aquí, y tu casita, así bien relax todo*" (Because it's cool, very peaceful, that's what it represented to me, I was like that in my country... It was super cool, like quite relaxed, as one can see here, and your little house, everything quite relaxed). In the nostalgic rendering of her belonging to a place, Beatriz opened up the meaning of "home" to represent both a place and a state of mind, an experience. For her, Mexico City was not so much a physical location, but a safe, relaxed space. She seemed to be thinking of Mexico City not as a physical area with boundaries, but as a significant point of intersection in her personal network of social relations. That is, Beatriz appeared to be thinking of "place" in the way proposed by Massey (1993). Her sense of Mexico City, the place, was for her clearly relational.

DOING CULTURAL CITIZENSHIP THROUGH DANCING

As defined by Rosaldo and Flores, cultural citizenship "refers to the right to be different (in terms of race, ethnicity, or native language) with respect to the norms of the dominant community, without compromising one's right to belong, in the sense of participating in the nation-state democratic processes" (Rosaldo and Flores, 1997, p. 57). William B. Flores and Rina Benmayor state that cultural citizenship is expressed (and therefore constituted, I would add) through practices that range from quotidian activities to the broadest scenes. The teens engaged in cultural practices that were self-affirming at both the individual and the collective levels, and this served them in developing a sense of belonging to various spaces, including the local and the transnational. Although the teens' agency was vital in the development of their cultural practices, they did not develop them at will. Ahiwa Ong proposes a different view of cultural citizenship, which goes beyond Rosaldo's articulation of the concept and serves to explain important elements of the teens' cultural practices. Ong argues that, as articulated by Rosaldo, cultural citizenship implies "that immigrant or minority groups can escape the cultural inscriptions of state power and other forms of regulations that define the different modalities of belonging" (Ong, 1996, p. 738). Ong views cultural citizenship in Foucauldian terms, as a process of "self-making and being made by power relations that produce consent through schemes of surveillance, discipline, control, and administration" (Ong, 1996, p. 737). Her argument illuminates many of the teens' cultural practices, but it is particularly germane to the most public of them—music and dance. By reading their listening and dancing practices through the lens of Edward Said's (1994)

metaphor of the counterpoint, I found that in the polyphony of the teens' practices, one could hear voices of the four media and popular culture traditions in interaction, but the predominant voice was Latin.

A teen who demonstrated unusual insight regarding the low citizenship status assigned to Latina/os in the New Latino South was Daniela. She often took a resistant, almost rejectionist stance toward the mainstream society and its hegemonic culture. Daniela was very active in the community center and she aspired to go to law school. Her collage, shown in Figure 18, contains iconic and symbolic signs of resistance and political savvy. She pasted cut-outs of a black raised fist and of the words "justice," "youth organizing," and "youth power." The upper-right corner of her collage, in which she juxtaposed these signs of resistance to the words "success" and "Latina," suggests that she saw herself as a Latina leader and as a Latina youth organizer; and, that for her, the meaning of success is connected to the collective Latina/o struggle for justice. Moreover, Daniela expressed her resistance by rejecting the term "American." In the following excerpt she talks about her stance:

> I think it's weird because before attending the Centro [community center], I used to say that I was American, because I was born here. But, afterwards, like now, I'm like "I'm Salvadoran." If they ask "Where were you born?" I'll say "California," but I'm Salvadoran. So I think, living with, interacting with Hispanics makes you feel more Latina, you take more pride. [...]
>
> *Porque hace como dos años yo, si me preguntaban de dónde era, yo decía* "I'm from L.A. I'm American." But now when you ask me, "I'm Salvadoran." *Entonces ahora, aunque mis padres son nacidos allá, yo soy nacida aquí, ahora yo soy Salvadoreña.* (Because about two years ago I, if they asked me where I was from, I used to say "I'm from L.A. I'm American." But now when you asked me "I'm Salvadoran." So now, even though my parents were born there, I was born here, now I'm Salvadoran.)

Daniela's use of code-switching in this excerpt is fascinating. She begins talking of her transformation in English, the language that she used before becoming *Salvadoreña.* Then she alternates between the two languages in the same sentence. And she finishes the comment with a complete sentence in Spanish, as if to emphasize, with the rhythm of her codeswitching, the change in her subjectivity. Daniela talks about her relatively recent choice of identifying herself not as American, but rather as *Salvadoreña* as indeed an achievement, as Croucher (2004) would argue. When she asserts that she is *Salvadoreña* she is not so much talking about her bond to El Salvador's territory or polity but rather about her membership in the Salvadoran diasporic community and her attachment to the Salvadoran culture. In other words, Daniela claims her cultural rights and her cultural citizenship. Flores and Benmayor equate cultural citizenship to empowerment (Flores & Benmayor, 1997, p. 12). The

affirmation of *Latinidad* is empowering for Daniela because acknowledging her Salvadoran heritage is a self-affirming act that brings about a sense of dignity and self-esteem: "you take more pride," she says.

Daniela describes her transformation as a result of "interacting with Hispanics," by which she means her recent circle of politicized friends at the community center. As she did in her collage, Daniel demonstrates in the excerpt her awareness of the role of the Other in the development of her own subjectivity. Yet there is another element that most likely played a part in her transformation: the local context. Her family moved to Durham from Los Angeles, California, a city where 46.5 percent of the population is classified as "Hispanic," and where Latina/o culture is deeply seated (U.S. Census Bureau, 2008a). In Durham, Daniela probably began to experience herself as a member of a minority group in a very different way. According to her media life calendar, she came to Durham at age 11, a time when she said that she did not have any close relationships, when what she liked the most was "being by myself," and her only media practice was reading the book *Secret Garden*. By age 14, Daniela had discovered a new and exciting meaning for her racial status. She developed a close relationship with her activist cousin, a politically savvy college student. The emergence of Daniela's new subjectivity as a politicized Latina is apparent in her calendar where she indicated that she went from listening to "hip-hop" and "watching TV" at age 13 to listening to "Latin" music and "dancing " at ages 14 and 15.

The thread that runs through Daniela's media and popular practices is the "doing" of identity and belonging through music and dance. In Butler's terms, Daniela's listening and dancing were *performatives,* that is, repetitive acts that constituted her identity and her membership in the Latina/o community. Likewise, and perhaps most significant for media studies, is that her repetitive assertions regarding her love of music and dancing were performative utterances that enacted the identity she claimed. In the exercise mentioned earlier that explored the teens' favorite media, Daniela brought a salsa CD to the class, illustrating the performativity of her media and popular culture talk: "*Yo traje un CD de salsa porque me gusta la salsa, me gusta bailar la salsa*" (I brought a salsa CD because I like salsa, I like dancing salsa). Then, during a later class in which we were examining an advertisement that showed a Latina dancing, she drew attention to the "fact" that "*a la mayoría de las Latinas les gusta bailar*" (most Latinas like dancing). Daniela constructed her cultural identity in her collage through music and dance as well. She wrote the words "music" and "dance" (twice), pasted a cut-out of the word "ritmo" (rhythm), and drew three small figures dancing. She explained the meaning of these signs:

Daniela: *Estos [señalando las figuras bailando] porque me encanta bailar, es mi cosa favorita, es una de mis, mi cosa, es mi pasión.*

Lucila: *Y también tienes* "dance."

Daniela: Yes, yes.

Natalia: *¿Por qué?*

Daniela: *Es mi cosa favorita.*

Lucila: *¿Qué bailas?*

Daniela: *De todo, pero me gusta, me encanta bailar la música Latina.*

Daniela: These [pointing to the dancing figures] because I love dancing, it's my favorite thing, it's one of my, my thing, it's my passion.

Lucila: And you have "dance" too.

Daniela: Yes, yes.

Natalia: Why?

Daniela: It's my favorite thing.

Lucila: What do you dance?

Daniela: Everything, but I like, I love to dance Latin music.

Her explanation shows that listening and dancing to Latin music were practices through which she performed an identity that was manifestly gendered. Daniela's case poignantly illustrates that practices such as listening and dancing not only constitute a gendered identity but simultaneously produce a racialized identity as well, because for Latinas, dancing is a normative expectation. The teens' processes of identity construction did not occur in an autonomous place; they occurred in a place structured by hegemonic relations that designate a subaltern place for Latinas. The love of dancing was not unique to Daniela among the teens, but I think that for her it was especially significant as an avenue to take center stage in public spaces. At the time of the fieldwork, she and Carmen were rehearsing for a school performance in which they had major roles as dancers. Such performances are important public affairs at schools. Gwendolyn D. Pough, in a study of black womanhood and hip-hop culture, notes the importance of spectacle for marginalized people: "The show, the spectacle, is the first step toward change—the first part of being heard. For a historically marginalized group, the spectacle is what allows them a point of entry into a public space that has proven to be violent and exclusionary" (Pough, 2004, p. 19).

Daniela impressed me as a political leader in the making. Given that the local schools offer few opportunities for young women like Daniela to take leadership positions, I think that she opted for taking the only role available to her. Through dancing she used her Latina identity to claim the right to "speak" in the public sphere. Yet her speech was scripted and scripts come with both narrative, and normative expectations. I believe that dancing was empowering for Daniela but,

according to Pierre Bourdieu's theory of social reproduction, Daniela's art as a dancer, as well as her consumption and use of music, plays a role in social reproduction: "art and cultural consumption are predisposed, consciously and deliberately or not, to fulfill a social function of legitimating social differences (Bourdieu, 1984, p. 7). Hence, I have mixed feelings about practices that open up opportunities for young people to participate in the wider society, while at the same time restricting them to culturally sanctioned activities. Does dancing function for Latina girls in a similar way that basketball works for black boys? Perhaps the analogy is flawed, but as researchers and activists, we need to ask these difficult questions. No doubt, dancing to Latin music allows teens like Daniela and Carmen the rare opportunity to actively participate in mainstream society's public spaces and to exercise a form of citizenship, albeit limited. It is also an activity through which they develop public performance skills that are extremely useful for active participation in public settings. But cultural practices cannot be outside the broader power relations that discipline Latina/o youth, and dancing in particular casts light into the workings of subjectification, that is, into the ways in which teens like Daniela turn themselves into particular kinds of subjects (Foucault, 1980). Seemingly a genuine individual choice, dancing to Latin music may serve to make teens like Daniela subaltern subjects.

LATIN MUSIC, NEOCULTURATION, AND THE
PRODUCTION OF LOCALITY

Daniela's case shows the role of Latin music in the development of subjectivity and the production of "home" at the individual level. Similarly, at the collective level, Latin music played a pivotal role in the construction of a public identity as well as in the production of place and locality. By "locality" authors like Thomas Tufte and Arjun Appadurai refer to a phenomenological experience in which the relativity of contexts, the interactivity of technologies, and the sense of social immediacy merge. It is a process of constructing place and belonging in late modernity (Appadurai, 1996, p. 178). Tufte's (2001) study on the multilayered use of television to produce locality at several social–spatial levels by transnational teens living in central Copenhagen seems particularly illuminating here. He found that these working-class teens used television to produce locality at several levels, including the transnational, the national, and the local. The power of music to create community, to generate a sense of intimacy and connectedness is almost a truism in the extensive scholarship on music fandom and in the related theorizing on the social functions of music. Simon Frith (1996), for instance, points out that music serves to create a social context and to produce a sense of place. Larry Grossberg

(1992) argues that because of the affective relation that fans have with music, fandom exceeds consumption; it is productive and can be empowering.

In the everyday settings of the teens in my project, there are people from many countries and consequently, upon their arrival in the New Latino South, the teens were exposed to music traditions from Latin America and the Caribbean that were new to them. Hence, in the course of their migration, many teens experienced a drastic change in musical tastes. The direction of such change was not so much toward the dominant Anglo music catering to adolescents, but toward Latin music. Several teens indicated in their calendars that it was upon their arrival in the U.S. South that they discovered the rich musical traditions of their own countries as well as the traditions of other Latin American and Caribbean countries. Here, for example, is how Isabel clarified her experience:

Lucila: *Pusiste [en tu calendario] que cambiaste, que a los 16 te empezó a gustar la punta.*

Isabel: *No la conocía, ni el merengue, ni la bachata, Ni regaee. En mi casa, casi nunca la escuchaba.*

Lucila: *O sea, ¿aquí conociste más música? [. . .] ¿Cómo?*

Isabel: *Porque, hay varias culturas aquí, y diferentes, este, gente, traen sus tradiciones, su música y todo eso. Entonces por eso es que conocí punta de Honduras.*

Lucila: You put [in your calendar] that you changed, that when you were 16 you began to like *punta.*

Isabel: I wasn't familiar with it, nor *merengue,* nor *bachata,* or reggae. At home I seldom listened to it.

Lucila: So, you became acquainted with more music here? [. . .] How come?

Isabel: Because, there are several cultures here, and different, uh, people, they bring their traditions, their music, and all of that. That's how I became acquainted with *punta* from Honduras.

The experience that Isabel describes was shared by many other teens in both the Durham and the Carrboro groups. In fact, one of the themes that I explored further with the Carrboro group was this newly acquired taste for numerous Latin music genres, and I found plenty of confirming evidence. It was obvious that through these cultural practices Latina/o teens were carving out places that were distinctly Latina/o. Their own places were not bounded physical spaces but rather, as Massey would put it, the unique articulated moments where the youth's paths in the network of social relations intersected (Massey, 1993). In some of the

literature on diasporic communities, there are descriptions of "frozen" cultural settings where exiles gather to socialize. When I first arrived in San Antonio, Texas in the early 1980s, I was invited to one of those settings. I was shocked by what, to me, appeared to be a 1940s scene in a dancing hall. By contrast, the scenes of the places/moments created by the teens are anything but "frozen." What the teen do seems like improvisation and not like mechanical reproduction. Susana described the traditional songs that she and other teens like as *"canciones que son de aquí pero que antes eran antiguas"* (songs that are from here but that they were old before), suggesting that traditional songs are no longer "old" in the New Latino South. Naturally, there are many forces operating in this phenomenon, including the popularity of world music and the ethnic cultural resurgence that has taken place around the globe. Yet, the teens did not talk about the music of indigenous peoples such as Honduras' *Mizkito* or Mexico's *Purépechas*. They talked about *mestizo* genres, some of which have been used by the state as national symbols. In the following excerpt, Lidia, a native of Mexico City, says that she has recently acquired both a taste for the music of other countries as well as a taste for the music of Northern Mexico:

> *Todos mis amigos eran como muy de pop, muy fresas, y todo eso y, o sea no les gustaba así la cumbia ni nada de eso, y entonces cuando llegué aquí pos yo también llegué así, pero después ya me empezó a gustar de cualquier música que escuchaba, y empecé a experimentar más música. Bueno me empecé a juntar con amigos que son, son de otras partes, no de México, de la ciudad, sino de, otras partes [de México], porque tengo varios amigos de otras partes, no, y me empezaron a regalar CDs de norteña.*

> All my friends were like very pop, very preppy, and all that, I mean they didn't like *cumbia* or anything like that, and then, when I arrived here, I arrived like them too, but later I started to like any music that I listened to, and I started to experiment with more music. Well, I started to hang out with friends that are from other places, not from Mexico City but from other parts [in Mexico] because I have several friends from other parts, no, and they started to give me CDs of *norteña*.

Lidia talks about the expansion of her music taste as the result of "experimenting" with more music. Her sampling of music such as *norteña* is an experience that has to do with newness rather than nostalgia. The genre originated in Northern New Spain (which included Texas) and its development owes much to the cultural boom that took place in the San Antonio area at the time of the Mexican revolution of 1920. Its distinctive accordion and *bajo sexto* (the Mexican 12-string guitar) sounds evolved into the unique *conjunto* music that characterizes the Mexican American popular culture of Texas. *Norteña* is a border music;

its constant revitalization is due to the incessant flows of people and cultural products that have crisscrossed the U.S.–Mexico border for over a century. Today, *norteña* enjoys great popularity among the rural and urban working classes on both sides of the border. However, for Mexico City teens like Lidia, whose identity is tied to *rock en español, norteña* had little appeal before she came to the United States. That is why Lidia talks about her newly acquired taste of *norteña* as experimenting, as going beyond the parameters of her identity as a rocker. In Lidia's collage (see Figure 2) such identity is placed in the foreground through the deployment of unambiguous symbolic signs. She pasted the word "rock" near the center and put the complete sentence "I like rock" at the lower right corner of the collage. No doubt Lidia was still a fan of *rock en español,* but she had developed a strong affective relationship to other Latin music.

Lidia's description of the processes that she was undergoing nicely illustrates Fernando Ortiz's theory of transculturacion. As explained in Chapter One, Ortiz (1963) argues that tranculturation involves acculturation, or acquiring a different culture, a partial *desculturación,* or the loss of the preceding culture. In the excerpt from Lidia above, the various phases of the process of moving from one culture to another are displayed. Lidia says she is no longer a *fresa.* She has not lost her previous identification with rock (and perhaps that is why she highlighted her identity as a rocker), but she is no longer the Mexico City rocker who did not like *norteña.* Hers is a partial loss, which is precisely what Ortiz says occurs during processes of deculturation. Transculturation also implies *neoculturación* or the ensuing creation of new cultural phenomena (Ortiz, 1963, p. 103). Lidia's consumption of *rock en español,* along with her newly acquired taste for *norteña,* exemplifies processes of neoculturation at the individual level. The collective consumption and use of traditional Latin American and Caribbean music make visible the same processes at the level of the social formation.

When I described the teens' media availability in Chapter Four, I noted that at the time of the fieldwork there were no Spanish-language radio stations in the area. Therefore, the teens' discovery of Latin genres was not the result of their exposure to local radio. Another medium, however, was deeply implicated in the development of their new music taste: television. The Latin music boom of the last few years has given Latin artists and bands a place in mainstream Anglo media, especially in MTV, but even a conservative network like CBS risked airing the first Latin Grammies in 2000 (it moved to Univisión afterward). An equivalent to the Oscars for Latin music in the United States, the Latin Grammy Awards was the first program ever to be broadcast entirely in Spanish on mainstream television. Likewise, BET has made concerted efforts to attract Latina/o youth, particularly with BET Latino, and by airing music videos by many Latina/o and Latin American artists. Last but not least, Univisión very seriously promotes Latin music. In 2001,

Univisión went into the music recording business by acquiring 50 percent of Mexico-based Disa Records and signing a distribution and worldwide licensing agreement with Universal Music Group. The former was then the world's second-largest independent Spanish-language record label, and the latter was part of Vivendi Universal, which owns the largest catalog of music in the world. With the launching of Univisión Music Group, Univisión became the leader of Spanish-language music in the U.S. market (Univisión, 2005a). Hence, television in general and Univisión in particular were important sources of exposure to Latin music and dance for the teens. Yvet talked about this role of television:

Lucila:	*Pero dices que bailabas bachata y cumbia. ¿Ustedes son de México, no? ¿Dónde conociste la bachata y la cumbia?*
Yvet:	*Mi primo Emilio, me gustaba como él bailaba. Íbamos a fiestas y él bailaba y todo, y me gustaba, y miraba la tele y ponían bachata y merengue, y los music videos, y 'pos me gustaba el ritmo. Y yo no sabía moverme pa' nada, y mi primo me trató de enseñarme a bailar, pero no, no pude. Y entonces empecé [a aprender] con las mujeres y sí pude.*
Lucila:	*Y dices que mirabas la tele ¿Qué programas?*
Yvet:	*Ah, music videos como de, MTV, BET.*
Lucila:	But you say that you used to dance *bachata* and *cumbia*. Your family is from Mexico, no? Where did you learn about *bachata* and *cumbia*?
Yvet:	My cousin Emilio, I liked the way he danced. We used to go to parties and he danced and everything, and I liked it, and I watched TV and they had *bachata* and *merengue*, and the music videos, and so I liked the rhythm. I didn't know how to move at all, and my cousin tried to teach me to dance, but no, I couldn't. And then I began [learning] with women and I was able to do it.
Lucila:	And you say that you used to watch TV, what shows?
Yvet:	Ah, music videos like those of, MTV, BET.

One can see in Yvet's description how media and peer group, two forces that operate at very different levels, come together in shared teen popular culture practices. One can also see in the excerpt the power of the media to teach Latina teens to perform not only *Latinidad*, but *panlatinidad*. Even though Yvet does not mention Univisión in this excerpt, the network was one of her favorite television choices; in its efforts to sell Latina/o audiences to national advertisers, this network has been instrumental in the production of *panlatinidad* (Rodriguez, 1999). I mentioned in Chapter Two that in the last few years, I have had the opportunity

of observing many other teens during my volunteer work with a youth organization that now produces a radio show. By the time of this writing, local teens are almost obsessed with a new genre, reggaeton, but they use Latin music to create their own places and group solidarity in the same way that the teens in my project did. I keep hearing teens talk about Latin music and seeing them exchange CDs of their favorite Latin artists and bands who perform recent compositions as well as recent renderings of traditional songs. As it was for the Durham teens, in their world, becoming a *connoisseur* of these traditions is a prerequisite for gaining membership in a community and for becoming a Latina or Latino. Listening to Latin music and dancing to its rhythms are practices that hold together their individual as well as their group identities.

Counterpoint AND
Contrapunteo

For all its triviality and frivolity, the messages of popular culture circulate in a network of production and reception that is quite serious. At their worst, they perform the dirty work of the economy and the state. At their best, they retain memories of the past and contain hopes for the future that rebuke the injustices and inequalities of the present.

George Lipsitz (1990, p. 21)

The broad question that I have explored in this book is the relationship among the self, migrancy, and the consumption and use of media and popular culture. I have delved into this question by describing and interpreting the vernacular ways in which a small group of working-class, transnational Latina teens talk about their selves in relation to their popular culture practices. The book highlights the power dynamics involved in mobility because, as Doreen Massey (1993) points out, while the elites control what moves around the globe and how they themselves move, refugees and economic migrants are forced to move by those very flows, "imprisoned" by them. The flows that force most Latin American and Caribbean peoples to move to *El norte* are configured by the labor needs of global capital. Therefore, my central concern has been the relationship between youth culture practices and what Paul Willis calls penetrations and limitations. Penetrations are lived cultural insights about the economic and political conditions of one's life; they involve the grasping of "dominating ideologies and enclosing technologies of

control and domination" (Willis, 1981, p. 59). Limitations are mystifications of such conditions, technologies, and ideologies. My goal was to find the extent to which particular cultural practices, such as a preference for *telenovelas*, were penetrations and thus acts of resistance that may advance transnational youth's citizenship potential. Or, conversely, I wanted to learn if their practices were only partial penetrations or even mystifications of the real determinants of their incorporation into U.S. society that would end up validating processes of racialization and class reproduction.

When I began my project I was naively interested in learning about the teens' actual practices, but during the course of my fieldwork, I became more concerned with their imagination. I realized that it was impossible to approach issues of subjectivity without paying attention to the two dimensions of the imagination, memory and desire. Reflecting on what was going on in the after-school programs on media literacy that I implemented, I also realized that when "talking" about themselves and their media memories, actual practices, and desires, the teens were in fact "doing" gender, race, class, and *Latinidad* in the particular context of my project. Thus, drawing on Judith Butler's (1993) notion of *performativity*, I came to the conclusion that the teens' collages as well as their popular culture "talk" were *performatives*. They were acts *in and through which* the teens constituted their subjectivities.

The risks that the notion of *panlatinidad* presents for the research have been the topic of debate among Latina/o studies scholars (see Aparicio, 2003). In media communication studies, Mayer, for example, has called for "retheorizing the map of *panlatinidad*," and for producing studies that include groups other than the usual Mexican, Cuban, or Puerto Rican participants (Mayer, 2004). While I appreciate her point, I argue that nationality is not necessarily the most important vector of difference among Latina/os. In addition to nationality and the basic demographic variables, there are three other vectors—class, race, and migration—that play a critical role in the popular culture practices of Latina/o audiences. Bourdieu (1984) demonstrates that class is paramount in shaping taste and consumption, and there is plenty of evidence showing that race is associated with patterns of media consumption. A major argument of this book is that, for Latina/os, migration is another commanding vector. By focusing the analytic lens on migration and transnationality, I hoped that this book would demonstrate the critical need for a thorough consideration of the migration experience, or lack thereof, when investigating the consumption and use of popular culture by different groups of Latina/os. Migration has a powerful bearing on everyday life, especially family life, which is the primary sphere where media and popular culture are consumed and used. If residence in a particular zip code predicts, with some accuracy, our consumption patterns, must not membership (or nonmembership) in a transnational community profoundly affect our use of media and popular culture?

Russell King and Nancy Wood (2001) suggest three main roles for the media in the migration process. One is the potential for the global hegemonic media, rich in images of Northern wealth, to stimulate a desire to migrate in people from the South. Another is the effect that the host country's media constructions of immigrants have on immigrants' *own* experiences of inclusion or exclusion. The third role, played by media such as the world wide web and satellite television originating in the home country, is influencing the politics and cultural identity of immigrant individuals and communities (King & Wood, 2001, pp. 1–2). The comment is insightful, but it has an embedded dichotomy that ends up obscuring the roles of media and popular culture in the lives of transnational Latina/os, and, most likely, in the lives of other transnational peoples. The dichotomy is the home/host, global/native, modern/tradition, metropolitan center/postcolonial dichotomy lying beneath much scholarship on migration and media.

I hope to have demonstrated in this book that the Latina/o and the black traditions were essential to the particular character of the mediated landscape that the teens inhabited. These traditions have significant contradictions, such colorism and oversexualization of women of color, but at the same time, as products of subaltern creative energy, they offer "minor" narratives, rich in images of Northern oppression and struggles for social justice. Such rival narratives, imagery, and discourses stimulate desires in people from the South; the influence that the U.S. civil rights movement had on the struggle to end apartheid in South Africa is but one example of such stimulation. Media constructions of immigrants produced by Latina/os and blacks have an effect on immigrants' experiences; these images shape not only their experiences of inclusion or exclusion in the U.S. polity at large, but also their sense of belonging to communities based on race/ethnicity or on common experiences of oppression. Further, globalization has made it possible for subaltern mediascapes originating in the South to reach Northern spaces with much more frequency than ever before (Keck & Sikkink, 1998). Women and indigenous peoples' advocacy networks crisscross the world, carrying media texts and even popular culture artifacts produced by local movements; Mexico's Zapatistas, of course, are the best example of these minor global flows from the South (Cleaver, 1998). Subaltern media and popular culture flows originating in both the South and the North connect disenfranchised peoples across national borders (Melucci, 1996). These minor flows are as integral to the transnational movement as are the hegemonic mediascapes. The numerous and fascinating question posed by minor flows and their interconnections with hegemonic ones demand to be put high on the agenda for research not only on media and migration but on also in media communication studies in general. Said cannot be more insightful about these issues in *Culture and Imperialism*. "The point of my book is that such populations and voices have been there for some time, thanks to the globalized

processes set in motion by modern imperialism; to ignore or otherwise discount the overlapping experiences of Westerners and Orientals, the interdependence of cultural terrains in which colonizer and colonized co-existed and battled each other through projections as well as rival geographies, narratives, and histories, is to miss what is essential about the world in the last century" (Said, 1994, p. xx).

Subaltern popular culture traditions operate within their own social–spatial and cultural–geographical coordinates. Somewhat similar to the concept of artistic field, my notion of a "tradition of popular culture" (or tradition of media and popular culture) assumes that a tradition has its own grammar, capable of governing both production and consumption. For example, the mode of production of *El Mariachi*, a film by Robert Rodríguez, corresponds to a sort of tongue-in-cheek, critical mode of consumption that asks viewers to take pleasure in improvised settings, low-cost video editing, and subversion of the intrinsic conservatism of the Hollywood warrior-adventure narrative (Ramírez-Berg, 2002, p. 227). As Bourdieu explains, a particular mode of consumption requires a particular aesthetic disposition, and it comes with particular normative expectations about consumer behavior. Bourdieu gives the example of post-impressionist painting, which "demands categorically an attention to form which previous art only demanded conditionally" (1984, p. 267). Yet, as happens in artistic fields, the norms governing a tradition are not all-powerful, and although the mode of production shapes the mode of consumption, it does not determine it. Consumption is not an autonomous sphere; it has its own possibilities, its fissures. Authors like James C. Scott (1990), Michel de Certeau (1984), and Jesús Martín Barbero (1987) have shown how the subalterns creatively exploit the elite culture's crevices to bring into play their own cultural histories and their own culturally bounded desires.

In the passage quoted in the epigraph, George Lipsitz reminds us that popular culture messages "perform the dirty work of the economy and the state," but he also reminds us that media messages "retain memories of the past and contain hopes for the future that rebuke the injustices and inequalities of the present" (Lipsitz, 1990, p. 20). The ethnographic descriptions that I offer in this book suggest that the teens' use of media and popular culture entailed precious memories and huge hopes. They profusely used texts and artifacts from the four traditions to cope with the ambiguous losses that are part and parcel of the migration experience. Their strong relationship with both the Latina/o and global Spanish-language traditions seemed to be anchored in a need to recreate cultural spaces and sustain a sense of historical continuity. They strongly asserted their right to be different by consuming texts produced by the two traditions of their families' cultures. They were engaged in numerous cultural practices that were self-affirming, including, for example, their pleasurable watching of *telenovelas* to feel at home, their collective use of Latin music to produce locality, and their lack of interest or

even expressed rejection of Anglo teens' magazines. In this sense the teens were struggling to affirm a form of cultural citizenship *a là* Rosaldo.

In general, I have argued that the Anglo media and popular culture tradition discipline working-class Latina/o transnational youth to accept the inferior status assigned to them. By so doing, it contributes greatly to the emergence of racialized subjectivities. While offering variegated constructions of *Latinidad*, the prevailing colorism of both the Latina/o and global Spanish-language traditions act in tandem with the white supremacist assumptions of the hegemonic U.S. culture. Yet, albeit to very different extent, all traditions are sites of struggle for competing constructions of womanhood and *Latinidad*. Some texts coming from the black and the Latina/o traditions propose dignified representations of dark-skinned people that challenge hegemonic constructions; as such, they may be key resources for transnational Latina teens to resist racialization and develop a resilient, healthy sense of self. This is not to say, of course, that we should not hold culture industries accountable. I return to this issue at the end of the chapter. The role that the Anglo media and popular culture play in the stereotyping of Latina/os has been studied by numerous scholars. However, the role that both the Latina/o and global Spanish-language traditions play in the racialization and subsequent subordination of Latina/o youth is a relatively new topic that is awaiting critical scrutiny.

Before moving into a discussion of the notions of counterpoint and *contrapuntero*, I mention as an aside a very intriguing but still undeveloped finding: the "threads" that run through each individual teen's media and popular practices. Threads became evident in the narratives of the teens that I came to know the best. For Susana, who was the only teen who said she liked police dramas, the thread was closely related to her desire to have a career in law enforcement. For Carla, who liked to watch the cartoon *Rugrats*, the thread was linked to her use of media to cope with ambiguous loss. For Natalia, who was obsessed with horror content, the thread was death and mystery; it is revealing that hers was the only collage (see Figure 11) with a specific reference to television shows about teen witches. I suspect that these threads may not be unique to transnational youth and I hope that other researchers will pick up this lead.

CONTRAPUNTEO AND COUNTERPOINT

At the ground level of ethnographic work, to what extent do Edward Said's counterpoint and Fernando Ortiz's *contrapunteo* serve us for exploring the relationship among the self, migrancy, and the consumption and use of popular culture? I noted in Chapter One that Ortiz's *contrapunteo* and Said's counterpoint

metaphors are deceptively similar. Therefore, the first step is conceptual clarity. The counterpoint is part of the Western canon of classical music. The term designates a polyphonic quality of sound, a musical texture with two or more melodic lines, each with its own rhythm and pitch, playing simultaneously "against" one another. Ortiz's *contrapunteo Cubano,* on the other hand, is a folk performance that demands great wit and a carnivalesque sense of humor. It is a playful, improvised musical and poetic dispute practiced by *campesinos* (white and black peasants) and urban blacks in Cuba. Given that *contrapunteo* means an action, I argue that it is useful to understand *contrapunteo* more as a verb than as a noun. Like most verbs, the essence of *contrapuntear* is to express action and movement. In his anthropological exploration of Cuban culture, Ortíz wanted to convey the sense of playfulness, mockery, and improvisation of Cuban *clases populares.* He emphasized such a sense in the literary, rather than scientific, form that he chose for his *Contrapunteo Cubano del tabaco y del azúcar* (1963). Roberto González Echeverría states that the text is "a witticism, a *jeu d'espirit*…a long, detailed Joycean game of words and concepts [...], its irreverent tone, mockery, frequent jokes, and predictability of the contrasts, place the text within that which it wishes to define" (González Echeverría, 2005, p. 212). I argue that *contrapunteo's* dynamic nature presents some clear advantages over the counterpoint metaphor for grasping the meaning of popular practices that, although ideologically and structurally constrained, are nonetheless improvised. *Contrapunteo* is dynamic but not dialectic; there is no resolution of the dispute, no synthesis. Hence, albeit not completely, the *contrapunteo* metaphor avoids the essentializing risks of the tropes of *mestizaje* and hybridity noted by Antonio Cornejo Polar (1996) and Roger Silverstone (2007).

As handy as Said's and Ortíz's metaphors are for beginning to understand phenomena related to transnational youth's uses of popular culture, these metaphors come with dangers. As all metaphors do, both counterpoint and *contrapunteo* overlook differences among various kinds of phenomena. Let me begin with the way in which the teens selectively consumed texts and artifacts offered by the popular culture landscape of their environs. Said's counterpoint is a convenient heuristic to account for a landscape whose overall texture is, indeed, polyphonic because it consisted of various independent, but nonetheless intertwined, streams.

Said's metaphor is also evocative of the teens' mode of consumption. However, he states that in the counterpoint, there is "only a provisional privilege being given" to the various themes (Said, 1994, p. 59). Such was not the case for the Latina/o and the global Spanish-language traditions, which tended to eclipse the black and the Anglo traditions in the teens' mode of consumption. For example, most teens watched Black Entertainment Television, but their favorite network was Univisión;

they listened to all kinds of music, but most had a strong preference for Latin music. Moreover, although they were avid users of Anglo popular culture, most did not pay much attention to products that directly target young women, such as magazines like *Seventeen* and Anglo icons of girlhood Mary-Kate and Ashley Olsen. Rather than imagining the teens' consumption as "layered," as Thomas Tufte (2001) suggests, I propose we envisage likely scenarios of this mode of consumption by considering the way individual teens attend to, and often appropriate, more or less, elements of each of the four media and popular culture traditions available to them. This idea is illustrated in Figure 19.

The relative space that each of the traditions occupies in the consumption matrix of a particular teen changes to accommodate the local context, her peer culture, and her family and personal history. I found, for example, that the black tradition was more salient for the Durham than for the Carrboro teens and for some individuals than for others. An intriguing question opened by this project is the relative weight of black media culture in the media practices of Latina/o youth. The salience of black media for the Durham teens points out a blind spot in media communication research. Future studies, however, should not take lightly the fact that practices are always situated. The popular culture landscape of a particular group of transnational teens, at a particular place, is contingent to the group's position *vis à vis* its local surroundings and global connections. Whereas scholars like Juan Flores (2000) have analyzed the multiple exchanges between black and Latina/o music, the exchanges in other media have been largely understudied.

With respect to the heuristic value of the counterpoint and *contrapunteo* metaphors to understand the subjectivity of transnational youth, Said's counterpoint served me well in making sense of the teens' gendered identities. As it is in contrapuntal music, the teens' identities and subjectivities reveal two competing gender discourses that act as dialogical counterpoints. The teens composed gendered identities in the space produced in and through the dialogue of two gender discourses in a way reminiscent of the negotiations between the peer and the parental cultures of the Punjabi Londoner teens studied by Marie Gillespie (1995) and the subjective movement between "the West" and "the Arabs" described by the young Maronites interviewed by Marwan M. Kraidy (2005, pp. 129–140). I recognize that my interpretation implies a binarism, yet authors like Alberto Moreiras (2001) argue that we should not rush to try to eliminate all explanations that rely on binarisms. In some cases, social and cultural phenomena may indeed be composed of binary elements. I suggest that the dialogical counterpoints that created the space in which the teens constructed their gendered identities are, on one side, the deeply entrenched, rooted in Catholicism, patriarchal gender discourse that permeates cultural and social life in both Latin America and U.S. Latina/o places (i.e., networks of social relations); and on the other side, the

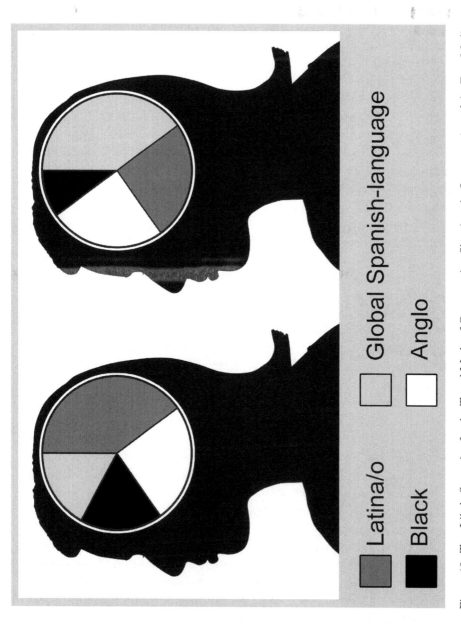

Figure 19. Two Likely Scenarios for the Teens' Mode of Consumption Showing the Incorporation of the Four Media and Popular Culture Traditions.

feminist discourse that transnational Latina youth encounter in such Anglo media representations as Dana Scully, in the U.S. schools in which girls excel, and in the daring acts that *new braceras* perform in their everyday lives. Although both discourses exist on both sides of the border, they do correspond to different cultural geographies.

But there is a problem in using Said's counterpoint to grasp the development of gendered subjectivity: The resulting gender compositions were not always harmonious, with great tension between the two discourses. In the polyphonic selves that the teens were developing there was not always the "concert and order" that, according to Said, exists in the counterpoint of Western classical music. There were many factors producing disorder, contradiction, anxiety, and apprehension in the teens' lives that are not easily explained by a literal deployment of the counterpoint metaphor. Firstly, migration is a long and confusing process for everyone, but it is especially demanding for young people who go through adolescence while simultaneously facing the numerous challenges that come with migration. National statistics regarding the high incidence of depression and suicide among Latina teens, as well as evidence of their high levels of emotional vulnerability (Hovey & King, 1996; Koss-Chioino & Vargas, 1999; Zayas, Lester, & Fortuna, 2005), indicate that navigating multiple transitions is extremely challenging. In a a large-scale study of immigrant Latina/o families in North Carolina, Krista Pereira and her colleagues found that "North Carolina Latino immigrant youth were engaged in fewer risky behaviors (e.g., alcohol consumption) than other adolescents in the U.S., but depression (8%), PTSD [post-traumatic stress disorder] (6%) and anxiety (30%) affected many. Females reported mental health concerns more frequently than males" (Pereira et al., 2008, p. 3).

In the exploration of the impact of migration in the psychic life of the teens discussed in Chapter Six, I show that the foreign-born teens especially were struggling to keep a sense of ontological security. The sense of continuity in their own selves had been threatened by the experience of having been uprooted from familiar social and material environments.

Ortiz's work is particularly valuable here because he emphasized deculturation and the subjective experience of transculturation. While Ortiz argues that transculturation involves the creation of new cultural phenomena in processes of neoculturation, his vivid language also conveys the trauma brought about by unrootedness and partial deculturation (Ortiz, 1963, p. 260). The theory, therefore, seems appropriate for grasping the meanings of transnational youth's consumption and use of popular culture because it allows us to incorporate Pauline Boss's notion of ambiguous loss. In Chapter Six I described how the teens were dealing with the two types of ambiguous loss that, according to Boss, are involved in migration loss (Boss, 1999, p. 7). The teens' psychological family comprised friends and family

members who were not physically present; many were across a political border always stressful to cross, even if you have immigration papers and look middle-class. Some of the teens' parents were physically with them but were emotionally unavailable because they were intensely preoccupied by discrimination and what they had left in the home country. While Boss's theory of ambiguous loss helps us grasp the migrant psychic life at the levels of the individual and the family, Ortiz's theory of transculturation helps us grasp the same life at the level of the transnational formation.

Ortiz's theory of transculturation, with its neat distinction between processes of acculturation, deculturation, and neoculturation, can save us from the mistaken paths of one-directional theories of acculturation. Transculturation is far more useful than the assumptions beneath much of the empirical audience research on both Latina/o and transnational communities. Going back to Franz Boas in the 1880s, anthropological theories have recognized that cultural exchanges are always mutual, but the term "acculturation" came to be used synonymously with assimilation of minorities or immigrants into the hegemonic culture. In media communication research, "acculturation" has generally meant assimilation into the Anglo society, incorporation of Anglo cultural traits, and adoption of Anglo values and behaviors. It is common to find references to "levels of acculturation," in studies of Latina/os and the media, especially in marketing research (Palumbo, 2005). In its common usage, I find the concept of acculturation more of a hindrance than a handy tool for several reasons. First, in many studies, along with language use and other cultural practices, media use is itself considered an indicator of assimilation (Ayala, Mickens, Galindo, & Elder, 2007). Second, the notion is used in research that studies entirely different populations, including groups comprised of only international migrants, groups comprised of nonmigrant minorities (e.g., African Americans and Native Americans), and mixed groups such as Asian Americans. And third, the notion assumes a binary distinction that is not only inaccurate but also misleading. In the case of Latina/os, the binary is supposed to be Spanish-language media versus English-language media; in the case of other transnational peoples, the binary has been expressed as "home media/culture" versus "Western media/culture" (see Adoni et al., 2006; Geourgio, 2006; Gillespie, 1995; Kraidy, 2005; Ogan, 2001).

Its explanatory power notwithstanding, the theory of transculturation entails a naïve view of gender and race relations, as Silvia Spitta (1997) persuasively argues. Furthermore, a literal deployment of the *contrapunteo* metaphor would fail to account for the ruthlessness of the racialization processes that the teens were experiencing. Like the United States, Latin American and Caribbean societies are structured by racism. There is rampant discrimination against blacks and indigenous peoples in the region, and colorist behavior is the staple of social,

cultural, and economic life. However, the United States is a very race-conscious society. In Latin America and the Caribbean, most members of the dominant society fail to view even barefaced racial discrimination and colorist behavior as manifestations of entrenched racist attitudes. Thus, because in their home countries, the teens' families were full-fledged members of the dominant society, most likely they were unaware of their own racial prejudices. In the New Latino South, these families have a ruthless awakening to racism. They are not accepted as full-fledged members of the mainstream and become new subjects: "Latinas" and "Latinos," "immigrants of color." As members of a stigmatized group, the teens and their families were learning the workings of racial systems of inequality, and they were enduring the psychological race injuries that Frantz Fanon (1967) describes so eloquently. Teens like Paty were angrily resisting state mechanisms of racialization that operate through the public school system, and teens like Stephany were rejecting their identification as "Mexicans" because in the settings of their everyday lives, the category is not only a national identification but a racial one. But standing firm against the more subtle racializing that was accomplished through popular culture proved far more difficult for them. In Chapter Three I described the representational backdrop against which the teens were developing their subjectivities. Such a backdrop included the near symbolic annihilation of *Latinidad* in the Anglo tradition, its pervasive stereotyping of Latinas as spitfires or maids, and its racialized (and racializing) representations of Latina/o youth. Most importantly, the teens were also developing their subjectivities against the overly sexualized construction of Latina womanhood offered not only by the Anglo, but also by the Latina/o and the global Spanish-language traditions.

One cannot develop a subjectivity that ignores one's visible identities, as Martín Alcoff correctly argues. The possibilities for "doing" identity that were available to the teens were far from endless. They were rigidly structured by the harsh mechanisms that ensure that these working-class kids would end up, as Paul Willis (1981) puts it, "letting themselves get working-class jobs." I can discern shifts in the polyphony of representations of Latina womanhood in the various traditions, but I also perceive quite discernable representational patterns that converge to construct working-class, dark-skinned Latinas as the subaltern female Other. In line with patriarchal and white-supremacist representations of women of color, the most recurrent images of working-class Latina women in the teens' media landscape were maids and hypersexual women. In Chapter Seven I showed that resisting regimes of representation that simultaneously sexualize and racialize working-class Latina womanhood was complicated for teens like Susana and Isabel. Susana seemed to be aware that to break dominant gender imperatives, she needed to exercise extreme caution; Isabel resorted to performing a defiant, sometimes threatening, identity that got her into trouble at school. Moreover,

although the sexualization of the Latina body may serve Latinas like Jennifer López to attain visibility, celebrity, and thus considerable power, as authors like Mary C. Beltrán (2002) and Frances Negrón-Muntaner (1997) maintain, the techniques deployed in popular culture to sexualize the Latina body are simultaneously a systematic way to racialize dark-skinned, working-class Latina womanhood, a point rightly made by Angharad Valdivia (2007). At the ground level of consumption and use that I studied, sexualized representations of Latina womanhood did not seem to be benefiting teens like Natalia, who were adopting such representations to construct their own identities. It is important to keep in mind that, by contrast to other marginalized groups such as Chicanos in California and African Americans, Latinas and Latinos in the New Latino South have not yet built up cultural traditions and collective resistance identities that may help our youth to deal with media stereotyping.

The politics of belonging that I explored in Chapter Nine are not the harmonious interweaving of different voices that Said's metaphor of the counterpoint implies. With its long history of white supremacy, the New Latino South is an arid ground for working-class, Latina/o youth to negotiate belonging. The saliency of the politics of belonging for the teens reveals their apprehension about citizenship. Even the native-born teens *who* were struggling to transcend the hegemonic boundaries of belonging that dictate that all Latinas and Latinos are foreigners, or at best, denizens of the U.S. polity. Many of the teens' popular culture practices reinforced the cultural inscriptions of state and other forms of power that enforce the local hegemonic boundaries of belonging. Teens like Daniela were responding by publicly asserting their cultural citizenship. No doubt the teens' cultural citizenship involved processes of self-making but, as Aiwa Ong astutely argues, cultural citizenship also involves processes of being made. Not unlike other postcolonial migrants, the teens were "being made by power relations that produce consent through schemes of surveillance, discipline, control, and administration" (Ong, 1996, p. 737). Thinking that the teens' repetitive practices were performative utterances that enacted the identity that they claimed, in Chapter Nine I suggested that the teens' listening and dancing to Latin music were not only affirmative practices of cultural citizenship, but that, simultaneously, they produced a racialized public identity, and most likely a racialized subjectivity, because for Latina young women these practices are normative expectations. I do not mean to say that such collective practices do not fulfill important functions for the social and psychological well-being of certain individuals, families, and specific communities. I strongly believe they do, but with Willis, I maintain that oppression is deeply rooted in identity and that people often experience their compliance with their own subordination as resistance (Willis, 1981). As activists and scholars we must not refrain from asking thorny questions that might stimulate

debate about cultural practices that, in my view, even Willis in some of his later work (1990) celebrated as contestatory. A secure place can be a refuge, but it can also be a place of confinement.

In many of the teens' cultural practices, it is possible to see their consent to the same forces that were transforming their working-class families into even more subordinate subjects than before migrating. Such consent is visible, for example, in the teens' "raced" consumption of popular culture as well as in their inability to make connections between their own subaltern public identity at school and the disparaging representations of *Latinidad* and Latina womanhood that many of their favorite media texts (re)produce. Even perceptive teens like Lidia, who was able to unpack the stereotypes of Anglo television's reality shows like *Cops*, was deceived by the techniques to attract youth of color deployed in popular culture texts catering to youth, like the blockbuster movie *The Fast and the Furious*. The film is typical of a trend in the Anglo tradition to attract subaltern youth formations in the global market, without undermining white supremacy, that I call "race-bending racism." It is a deceptive technique of racialization that deploys the mixing of clearly racialized bodies and bodies ambiguously coded in terms of race, to mystify the traditional racial stereotypes inscribed in the text. It was not until the last classes of the Durham critical media literacy course that Lidia and other teens were able to notice the stereotypical representation of Latino young men as "slow," and of Latina young women as sexually available or abused. Before taking the class, the mere inclusion of Latina/o youth in the film appeared to be a sign of progress for them.

This is not to say that there was never contrapuntal tension in the teens' engagement with the hegemonic Anglo tradition. *Some* teens, like Lidia and Yvet, were reading *some* of its texts contrapuntally. Stuart Hall says that Africa is "the secret code with which every Western text was 're-read'" in the Caribbean (Hall, 1990, p. 236). In the case of Latina/os, the secret code seems to be what Juan Flores calls the Latino imaginary: "the shared memory and desire...the congruent histories of misery and struggle, and intertwining utopias" (Flores, 2000, p. 198). Both Said's and Ortiz's contrapuntal approaches are valuable heuristics for investigating transnational subaltern youth's engagement with hegemonic cultures, but Said's articulation presents clear advantages here. Spitta (1997) makes use of Hall's idea of Africa as a subtext in Caribbean cultural life to argue that *contrapunteo* can be understood as subtextual tension. In the theory of transculturation, she argues, *contrapunteo* "does not actually allude to the 'note against note' structure of contrapuntal musical compositions, but rather to an African subtext and rhythm in a more general contrapuntal relationship to all of western music and culture" (Spitta, 1997, p. 163). While Spitta's interpretation of Ortiz's theory is robust, it is Said who explicitly deploys the counterpoint as a method.

He writes: "As we look back to the cultural archive, we begin to reread it not univocally, but *contrapuntally*, with a simultaneous awareness both of the metropolitan history that is narrated and of those histories against which (and altogether with which) the dominating discourse acts" (Said, 1994, p. 59).

Developing a subjectivity that "although polyphonic had concert and order" (Said, 1994, p. 59) was a tremendous feat for the teens. It required not only an ability to balance messages coming from often contradictory discourses, but also a remarkable resiliency to the relentless microaggressions that Latina/o young people endure both through the media and through their everyday interactions in the New Latino South. Amazingly, most of the teens seemed to be accomplishing such a feat. They seemed, as poet Mario Benedetti encourages, to be determined to *defender la alegría* (defend happiness) in the mist of quotidian humiliations. Their cultural practices were rituals of bereavement, but they were also rituals of reincarnation, practices that helped them bridge gaps between the familiar and the foreign. As such, these practices appeared to be essential not only to successfully cope with ambiguous loss but also to develop resiliency and to construct whole, harmonious subjectivities. In spite of the compounded forces driving the teens to become docile laborers, they had high expectations for themselves; desires for professional careers and school achievement were recurrent themes in their narratives of self. As Lidia vividly put it, their goals were as far away as the sun is from earth, "93 million miles away," but the enormity of the task that they faced did not encroach in the realm of their desires.

What are we to do to enable teens like Lidia to *defender la alegría* and fulfill their dreams? The question begs the answer: media and popular culture literacy for Latina/o transnational youth is an urgent field of intervention. Creating programs that enable these teens to skillfully read media texts contrapuntally is a basic step for assisting them in the difficult task of building healthy subjectivities and what Manuel Castells (2004) calls "project identities." But teaching–learning this kind of literacy is easier said than done. The challenges that it poses for both students and teachers are complicated. The dynamics of the parent–child relationship in working-class transnational Latina/o families are quite different from the dynamics assumed by much of the writing on media literacy. In these families, children typically develop cultural competency in the Anglo hegemonic culture sooner than their parents and other migrant adults in their social networks. Consequently, most of these children become cultural brokers for their parents and other relatives. In Chapter Six, I explained that many of the teens were using popular culture to satisfy deep sociopsychological needs related to the disruption of the parent-child relationship. I also explained that for teens like Carla, seemingly trivial leisure activities like watching cartoons were actually healing rituals. Parallel to what happens

in the parent–child relationship, the relationship of migrant children with their teachers in the New Latino South is also complicated. Most teachers are not fluent in Spanish and lack the cultural competence necessary to effectively assist these children. As a result, children also become cultural brokers for teachers and the school system. They are actually helping the adults who are supposed to be helping them. Given that this book is the outcome of an action-research project, in Chapter Five I presented the lessons learned in my after-school program with the Durham teens. I hope that such reflections will assist those committed to the time-consuming and creatively demanding praxis of critical media literacy with working-class, transnational Latina/o youth. A word of warning, however, is in order: Teaching–learning critical media literacy to this youth is extremely challenging. Hasty programs may do more harm than good if they are insensitive to the particular sociopsychological needs that students, and their families, may be satisfying with practices that may appear distressing to middle-class sensibilities.

Because one of the principal contradictions that Latina teens confront is the sexualization of Latina womanhood in the same media in which they seek refuge, it is imperative that teens learn to read texts from both the Latina/o and the global Spanish-language traditions contrapuntally. In this case, however, the subtext is not *Latinidad*, but woman, Africa, indigenous *América,* the working class—and a more daring attempt than mine would add alternative sexualities to this list. The history of women's resistance to our *culturas que traicionan* (cultures that betray) is one of the subaltern histories "against which (and altogether with which) the dominating discourse acts" (Said, 1994, p. 59). Other concurrent, subaltern histories are those of the centuries-long struggles of both indigenous peoples and peoples of African descent, which have been intertwined with labor and peasant movements.

In addition to critical media literacy, another urgently needed, concurrent strategy has been suggested by scholars like Rosa Linda Fregoso (1993), Arlene Dávila (2001), and Viviana Rojas (2004): We must critically engage, at both the level of scholarship and the level of advocacy and policy making, with the sexualization of Latina womanhood in the Latina/o and the Spanish-language traditions. The great value of some women's practices anchored in what I called the Latin American discourse on gender, such as those of the Argentinean mothers of the *plaza de mayo* (Kaiser, 2005), must not deter us from denouncing a discourse that is inherently oppressive and thus, morally wrong. The Latina/o as well as the global Spanish-language traditions re(produce) a meta-discourse that sustains not only sexism, but other systems of inequality such as racism simultaneously. Certainly the culture industries producing such misogynist texts are not products of race-conscious societies, but this historical fact does not absolve them from their

responsibility, as one of the most influential institutions in the socialization of Latina/o youth, to stop reproducing and naturalizing the superiority of the white elites. The national political struggle for Latina/o rights is necessarily linked to the success of concurrent struggles to change those cultures that betray our youth.[1]

Epilogue: The Present Political Moment

The economic and political muscle of Latina/os in the United States has been growing during a time of profound change in geopolitics. When I did my fieldwork in 2002 and 2003, the country was dominated by the feelings of outrage that arose after September 11 and that demonized Islam and the Arab world. Five years later, the country is hurting in quite a different way: the Iraq war debacle, the deep troubles of the economy, and the disenchantment with free-market ideologies, among other recent national tragedies and regrets, have politically energized large numbers of people. Many are seeking to transform electoral politics, but others have grown or revitalized xenophobic sentiments. Muslims and people of Arab origin or descent are, of course, the main targets of many hate groups, but Latina/os are the target of anti-immigrant groups that have grown more militant in recent years and that have embittered the heated immigration debate. For example, according to the Southern Poverty Law Center, in 2007 there were 888 documented hate groups in the country; the states with the most groups were the traditional recipients of Latina/o immigrant streams: California (80), Texas (67), and Florida (49). Granted, these are very large states, but they were followed by smaller states that experienced unprecedented Latina/o population growth: South Carolina (45), Georgia (42), Tennessee (38), Virginia (34), and New Jersey (34). North Carolina, the state where the settings of my fieldwork are located, had 28 groups (Southern Poverty Law Center, 2007). Xenophobic fears centered on the

"Latino cultural difference" combined with local struggles for jobs and public resources, creating a harsh environment where the public identities for Latina/o youth, as well as the modes of citizenship available to this youth, are shaped. This ruthless environment encroaches on the sorts of selfhoods that Latina/o youth may develop. Thus, grasping the meanings of their popular culture practices becomes an even more urgent concern in the current moment of political and economic insecurity.

I have kept in touch with four of the teens, who from time to time tell me what the rest of the teens are doing. Paty went back to Mexico. The youngest teens are now attending high school. Four other teens are attending college, and a fifth will be attending next year. The remaining teens have found clerical or other jobs in the lower rung of the service sector, including construction. Some of the latter say that they would like to go to college some day; others say that they prefer to earn money and become independent, but the truth is that their families cannot afford to send them to college. Especially for undocumented teens, going to college remains a dream. Undocumented young people are required to pay exorbitant out-of-state tuition fees, and they are not eligible for the subsidies that enable some working-class U.S. students to earn a college degree (e.g., government grants and loans, and most private scholarships). All hopes are now put in the passage of the "Dream Act" (Development, Relief, and Education for Alien Minors), which would facilitate access to college for undocumented youth. There is stiff opposition to the Dream Act from anti-immigrant groups, but, if passed, the law would enable teens like some of those who participated in my study to reach a goal that now seems to be "93 million miles away," as Lidia put it.

Notes

1 MEMORY AND DESIRE

1 For a discussion on the theories of popular culture, see Strinati (Strinati, 1995).

2 My use of the term "transnational" corresponds to the term "foreign stock," as used by the U.S. Census Bureau (Schmidley, 2001, p. 22). Thus I employ the term "Latino/a transnational youth" to talk about both foreign-born individuals and natives of foreign-born or mixed parentage (one parent native and one parent foreign-born). It is important to distinguish between the terms "Latin American" and "Hispanic/Latina/o." The former denotes inhabitants of Latin America, but the latter designates persons who reside in the United States (both natives and foreign-born) and who trace their origins to Latin America and the Caribbean.

3 In this sense, the term *cultura popular* is similar to the traditional sense of "folk culture."

4 As García Canclini describes, *lo culto* is generally studied by literary critics and art historians, *lo masivo* by media communication scholars, and *lo popular* by folklorists and anthropologists (García Canclini, 1989).

5 Bakhtin, Morris, Voloshinov, and Medvedev (1994) also talk about a type of hybridity in which internal opposition and contestation are not central ("organic hybrids"), but their interest is in the intentional hybrid.

6 Reminiscent of Anzaldúa's description of "the juncture where the *mestiza* stands" (Anzaldúa, 1987/1999), Bhabha describes hybridity as the place "where cultural differences 'contingently' and conflictually touch" (Bhabha, 1994). Similarly, what Bhabha calls the *liminal* is clearly reminiscent of the borderlands as a trope. But Bhabha is particularly

interested in debunking the notion of pure cultures and authentic identities. He argues against the idea that hybrid cultures are created from the mixture of pure cultures. His emphasis is on the continual, unending nature of hybridization. For Bhabha, cultures are official endeavors to fix what is inherently in flux.

7 Cynthia H. Enloe (2004) has proposed the use of the phrase "labor made cheap" instead of the phrase "cheap labor," which essentializes what in fact is a condition resulting from unequal economic relations.

8 The term "imaginary" come from the French authors, who use *imaginaire* to refer to a collective set of beliefs, ideas, and aspirations.

9 The most extreme public manifestation of such sentiment that occurred about the time of my fieldwork took place in Siler City, a small rural city near the settings of my project. In 2000, local anti-Latino groups organized a well-attended demonstration and invited David Duke, a former leader of the infamous white supremacist Ku Klux Klan, to be the guest speaker.

10 In most of the research on the media consumption of Latinos, the category "English-language media" refers to the hegemonic Anglo media. The consumption of other English-language media is seldom considered.

11 I borrow this approach from Martín Alcoff (2006).

2 THE STORY OF THE PROJECT

1 The events and interactions that I describe in the book were shaped by the teens' awareness that the classes were part of a research project. My university's Academic Affairs Institutional Review Board required me to prepare letters of introduction as well as parental consent and teen assent forms in both English and Spanish. During the recruiting process, I made every effort to explain to potential participants that the program had a dual purpose, one of which was to investigate their media and popular culture practices. I dedicated half of the first class to ensuring that the teens understood that I would be studying their behavior and that I intended to write a book about it. Lastly, throughout the duration of the programs, I reminded them that the classes were also a research endeavor. I offered the Durham teens a $50 gift certificate plus an official certificate of completion (from my university department) of the course for their participation. To the Carrboro teens I only offered a $40 gift certificate.

2 Lutrell's book was published in 2003, but I was fortunate enough to hear her talk about her ongoing research years previously.

3 I have successfully used this method in a previous ethnographic study to gather data on the work trajectories of the employees of a network of Mexican radio stations (Vargas, 1995).

3 REPRESENTATIONS OF *LATINIDAD* AND LATINA WOMANHOOD

1 A comprehensive search on the coverage of Latina/os in the black media yielded only one study, by Susan Weill (Weill & Castañeda, 2004), focusing on black newspapers in the U.S. South.

4 THE TEENS' MEDIA AND POPULAR CULTURE PRACTICES

1. According to Appadurai, locality is "a complex phenomenological quality, constituted by a series of links between the sense of social immediacy, the technologies of interactivity, and the relativity of contexts" (Appadurai, 2001, p. 178).
2. Natalia, Yvet, Susana, and Alex.
3. Natalia, Alex, Carla, Sabrina, Stephany, Jennifer, Carmen, Daniela, and Anabel.
4. Alex and Carla also wrote the names of children's channels on their calendars at the time of the field work.
5. The exceptions were Daniela, Isabel, and Leticia.
6. Carla, Carmen, Daniela, Leticia, Natalia, Paty, and Stephany.
7. Anabel, Jennifer, Lidia, and Susana.
8. Alex.
9. Beatriz, Isabel, Sabrina, and Yvet.
10. Natalia put *Tú* at ages 12 and 14–15, and *Seventeen* at 16; and Carmen put *Seventeen* at ages 15–17.
11. Daniela, Jennifer, Natalia, Sabrina, Susana, and Yvet.
12. Natalia put *Tú* at ages 12 and 14–15, and *Seventeen* at 16; and Carmen put *Seventeen* at ages 15–17.

6 DEALING WITH AMBIGUOUS LOSS

1. Sabrina (15), Gabriela (19), Alex (14), Paty (15), Yvet (16), Jennifer (14), Lidia (14), and Susana (16).

7 GENDERED SELVES

1. For a critique of the notions of *machismo* and *marianismo*, see Chant and Craske (2003).
2. I am referring here to classic distinctions introduced by semiotician Charles Peirce: An iconic sign is perceived as resembling in some way the object it represents, for example a photograph of a child is iconic. An indexic sign has a direct connection to its object, for example the fingerprints of the child are indexic signs of her. By contrast, the relation between the word "child" and the child is totally arbitrary, and thus the former is a symbolic sign, a convention (Sturken & Cartwright, 2001, p. 140).
3. For this activity, I used a handout copyrighted by the Center for Media and Values (1990). The handout does not acknowledge the author.
4. Carla, Daniela, Lidia, Jennifer, and Sabrina.
5. Only Leticia pasted a cutout with eight DVD recordings; these recordings, however, featured films by Mary-Kate and Ashley Olsen—two popular culture icons of Anglo girlhood that were seldom mentioned by other teens.
6. Nintendo: Blue, Susana, Daniela, Sabrina, Gabriela, Jennifer, Leticia, Natalia, Lidia, Carla; both, Carmen; Pink, none.

7 The four teens who did not include references to romantic love in their collages were Isabel, Leticia, Daniela, and Yvet.

8 "Confessions Part II" by R&B singer Usher.

9 See Valdivia (2006) for a discussion on the politics of *salsa* and identity among Latina/os in the U.S. Midwest.

10 Gillian Anderson became an icon in U.S. lesbian circles. Of course, Susana did not know about this cult. I mention it because it sheds light into the oppositional signification of Anderson's identity.

11 The pacifier used by the child in Isabel's collage suggests that the child is not only materially but also affectively deprived.

10 COUNTERPOINT AND *CONTRAPUNTEO*

1 On a practical note, like in any struggle for social justice, the overall strategy to change the Latina/o and the global Spanish-language media should be manyfold. But tactically, it would be more effective to target the Latina/o media first because the U.S regulatory framework and judicial system give an advantage to activists in this country.

References

Acosta-Alzuru, C. (2003). Tackling the issues: Making meaning in a telenovela. *Popular Communication, 1*(4), 193–215.

Adoni, H., Caspi, D., & Cohen, A. A. (2006). *Media, minorities, and hybrid identities: The Arab and Russian communities in Israel.* Cresskill, NJ: Hampton.

AIM TV Group. (2008). *Home page.* Retrieved May 6, 2008, from http://www.aimtvgroup.com/.

Althusser, L. (1971). *Lenin and philosophy, and other essays.* London: New Left.

Anaya, R. (1996). "I'm the king": The macho image. In R. González (Ed.), *Muy macho: Latino men confront their manhood.* New York: Anchor Books (pp. 57–74).

Anderson, B. (1983). *Imagined communities: Reflections on the origin and spread of nationalism.* New York: Verso.

Anzaldúa, G. (1987/1999). *Borderlands: The new mestiza = la frontera* (2nd ed.). San Francisco: Aunt Lute.

Aparicio, F. R. (2003). Jennifer as Selena: Rethinking Latinidad in media and popular culture. *Latino Studies, 1*, 90–105.

Aparicio, F. R., & Chávez-Silverman (Eds.). (1997). *Tropicalizations: Transcultural representations of Latinidad.* Hanover, NH: Dartmouth College Press, University Press of New England.

Appadurai, A. (Ed.). (2001). *Globalization.* Durham, NC: Duke University Press.

Appadurai, A. (1996). *Modernity at large.* Minneapolis: University of Minnesota Press.

Austin, J. L. (1975). *How to do things with words.* Cambridge, MA: Harvard University Press.

Ayala, G. X., Mickens, L., Galindo, P., & Elder, J. P. (2007). Acculturation and body image perception among Latino youth. *Ethnicity & Health, 12*(1), 21–41.

Bakhtin, M. M., Morris, P., Voloshinov, V. N., & Medvedev, P. N. (1994). *The Bakhtin reader: Selected writings of Bakhtin, Medvedev, and Voloshinov.* New York: Arnold.

Barnard, I. (1997). Gloria Anzaldúa's queer mestizaje. *Melus, 22*(1), 35–53.

Barney, C. (2007, March 27). Hispanic viewers embrace show's positive role model. [Electronic version]. *Pittsburgh Post-Gazette,* p. W37. Retrieved April 24, 2007 from http://www.post-gazette.com/pg/07088/773285-237.stm

Barrera, V., & Bielby, D. D. (2001). Places, faces, and other familiar things: The cultural experience of telenovela viewing among Latinos in the United States. *The Journal of Popular Culture, 34,* 1–18.

Bartky, L. (1990). *Femininity and domination: Studies in the phenomenology of oppression.* New York: Routledge.

Bejarano, Cynthia, L. (2005). *Que onda? Urban youth culture and border identity.* Tucson, AZ: University of California Press.

Beltrán, M. C. (2005). The new Hollywood racelessness: Only the fast, furious (and multiracial) will survive. *Cinema Journal, 44*(2), 51.

Beltrán, M. C. (2004). Más macha: The new Latina action hero. In Y. Tasker (Ed.), *Action and adventure cinema.* London: Routledge (pp. 186–200).

Beltrán, M. C. (2002). The Hollywood Latina body as site of social struggle: Media constructions of stardom and Jennifer Lopez's "cross-over butt." *Quarterly Review of Film and Video, 19*(1), 71–86.

Berger, P. (1972). *Ways of seeing.* London: British Broadcasting Corp.

Bettie, J. (2003). *Women without class.* Berkeley, CA: University of California Press.

Bhabha, H. K. (1994). *The location of culture.* New York: Routledge.

Boas, F. (1940). *Race, language and culture.* New York: Macmillan.

Bobo, J. (1995). *Black women as cultural readers.* New York: Columbia University Press.

Boss, P. (2006). *Loss, trauma, and resilience. Therapeutic work with ambiguous loss.* New York: Norton.

Boss, P. (1999). *Ambiguous loss: Learning to live with unresolved grief.* Cambridge, MA: Harvard University Press.

Boss, P. (1993). The experience of immigration for the mother left behind: The use of qualitative feminist strategies to analyze letters from my Swiss grandmother to my father. *Marriage & Family Review, 19*(34), 365–378.

Bourdieu, P. (1984). *Distinction: A social critique of the judgment of taste.* Cambridge, MA: Harvard University Press.

Brake, M. (1985). *Comparative youth culture.* New York: Routledge.

Brennan, T. (1992). *The interpretation of the flesh: Freud and femininity.* London: Routledge.

Buckingham, D. (Ed.). (1998). *Teaching popular culture: Beyond radical pedagogy.* London: University of London Press.

Butler, J. (1993). *Bodies that matter: On the discursive limits of "sex."* New York: Routledge.

Butler, J. (1990). *Gender trouble: Feminism and the subversion of identity.* New York: Routledge.

Castellanos, R. (1973). *Mujer que sabe Latín.* México: SepSetentas.

Castells, M. (2004). *The power of identity* (2nd ed.). Malden, MA: Blackwell.

Center for Media and Values (1990). Handout.

Chant, S., & Craske, N. (Eds.). (2003). *Gender in Latin America.* New Brunswick, NJ: Rutgers University Press.

Children Now; National Hispanic Foundation for the Arts (2001). *Prime time for Latinos: Report II: 2000–2001 prime time television season.*

Christenson, P. G., Roberts, D. F., & Becker, L. (1998). *It's not only rock'n'roll: Popular music in the lives of adolescents.* Cresskill, NJ: Hampton.

CityRating.com. (2008). *Durham crime statistics (NC).* Retrieved May 6, 2008, from http://www.cityrating.com/citycrime.asp?city=Durham&state=NC.

Cleaver, H. M. (1998). The Zapatista effect: The Internet and the rise of an alternative political fabric. *Journal of International Affairs 51*(2), 621.

Clemens, L. (2005, May 1). Hooked on telenovelas. *Marketing y Medios.* Retrieved March 21, 2008 from http://www.marketingymedios.com/marketingymedios/search/article_display.jsp?vnu_content_id=1000902246.

Cooper, H., Charlton, K., Valentine, J. C., & Muhlenbruck, L. (2000). Making the most of summer school: A meta-analysis and narrative review. *Monographs of the Society for Research and Child Development, 65*(1), 1–117.

Cornejo Polar, A. (1996). Una heterogeneidad no diálectica: Sujeto y discurso migrantes en el Perú moderno. *Revista Iberoamericana, LXII* (176–177), 837–844.

Cornell, S., & Hartmann, D. (1998). *Ethnicity and race.* Thousand Oaks, CA: Sage.

Cortés, C. E. (1997). Chicanas in films: History of an image. In C. E. Rodríguez (Ed.), *Latin looks: Images of Latinas and Latinos in the U.S. media.* Boulder, CO: Westview (pp. 121–141).

Couldry, N. (2003). *Media rituals: A critical approach.* New York: Routledge.

Crenshaw, K. (2003). Mapping the margins: Intersectionality, identity politics, and violence against women of color. In E. Mendieta (Ed.), *Identities: Race, class, gender, and nationality.* Malden, MA: Blackwell (pp. 175–201).

Cross, B. (1993). *It's not about a salary … rap, race, and resistance in Los Angeles.* London: Verso.

Croucher, S. L. (2004). *Globalization and belonging.* New York: Rowman & Littlefield.

Dates, J. L., & Barlow, W. (1990). *Split image: African Americans in the mass media.* Washington, DC: Howard University Press.

Dávila, A. (2002). Talking back. Latino media and U.S. Latinidad. In M. Habell-Pallán, & M. Romero (Eds.), *Latino/a popular culture.* New York: New York University Press (pp. 25–37).

Dávila, A. (2001). *Latinos Inc.* Berkeley, CA: University of California Press.

de Beauvoir, S. (1968). *The second sex.* New York: Modern Library.

de Certeau, M. (1984). *The practice of everyday life.* Berkeley: University of California Press.

de Santis, A. D. (2001). Caught between two words: Bakhtin's dialogism in the exile experience. *Journal of Refugee Studies, 14*(1), 1–19.

Denner, J., & Guzmán, B. L. (Eds.). (2006). *Latína girls: Voices of adolescent strength in the United States*. New York: New York University Press.

Derrida, J. (1982). Signature event context. In A. Bass (Ed.), *Margins of philosophy* (pp. 309–330). Chicago: Chicago University Press.

Dick, B. (2002). Action research: Action and research. [Southern Cross University, Graduate College of Management Web site, from Southern Cross University, Action Research Resources Web site] Retrieved November. 16, 2002 from http://www.scu.edu.au/schools/gcm/ar/arp/aandr.htm

Dualstar Entertainment Group. (2007). *Dualstar Entertainment Group corporate Web site*. Retrieved February 5, 2006, from http://dualstarentertainmentgroup.com/

Durham, M. G. (2004). Constructing the "new ethnicities": Media, sexuality, and diaspora identity in the lives of South Asian immigrant girls. *Critical Studies in Media Communication, 21*(2), 140–161.

Durham, M. G. (1999). Out of the Indian diaspora: Mass media, myths of femininity, and the negotiation of adolescence between two cultures. In S. R. Mazzarella, & N. O. Pecora (Eds.), *Growing up girls: Popular culture and the construction of identities*. New York: Peter Lang (pp. 193–208).

Durham Public Schools. (2002). *Durham public schools' plan for closing the achievement gap*. Retrieved February 24, 2004 from www.dpsnc.net

Dzidzienyo, A., & Oboler, S. (Eds.). (2005). *Neither enemies nor friends: Latinos, Blacks, Afro-Latinos*. New York: Palgrave Macmillan.

EFE. (November. 26, 2007). Censuran a Montéz de Durango en EU. [electronic version]. *El Siglo de Torreón*. Retrieved January. 18, 2008 from http://www.elsiglodetorreon.com.mx/noticia/313797.censuran-a-montez-de-durango-en-eu.html

El Pueblo Inc. (2003). *N.C. Latino community*. El Pueblo Inc. Retrieved November. 12, 2004 from http://capwiz.com/elpueblo/index_frame.dbq?url=http://capwiz.com/elpueblo/officials/state/?state=NC

Emerson, R. M., Fretz, R. I., & Shaw, L. L. (1995). *Writing ethnographic field notes*. Chicago: University of Chicago Press.

Enloe, C. H. (2004). *The curious feminist: Searching for women in a new age of empire*. Berkeley: University of California Press.

Escobedo, E. (2007). The *Pachuca* panic: Sexual and cultural battlegrounds in World War II Los Angeles. *Western Historical Quarterly* 38, 133–156.

Espin, O. M. (1997). *Latina realities: Essays on healing, migration, and sexuality*. Boulder, CO: Westview.

Fairlie, R. W., & London, R. A. (2006). Getting connected: The expanding use of technology by Latina girls. In J. Denner, & B. L. Guzmán (Eds.), *Latina girls: Voices of adolescent strength in the United States*. New York: New York University Press (pp. 168–186).

Falicov, C. J. (2001/2). Migración, pérdida ambigua y rituales. Retrieved September. 28, 2005 from http://www.redsistemica.com.ar.libproxy.lib.unc.edu/migracion2.htm

Falicov, C. J. (1998). *Working with Latino families*. New York: Guiford.

Fanon, F. (1967). *Black skin, white masks*. New York: Grove.

Feagin, J. R., Orum, A. M., & Sjoberg, G. (1991). *A case for the case study.* Chapel Hill: University of North Carolina Press.

Fernandez-Kelly, M. P., & Schauffler, R. (1996). *Divided fates: Immigrant children and the new assimilation.* In A. Portes (Ed.), *The new second generation.* New York: Russell Sage Foundation (pp. 30–53).

Flores, J. (2000). *From bomba to hip-hop.* New York: Columbia University Press.

Flores, J. (1997). The Latino imaginary: Dimensions of community and identity. In F. R. Aparicio, & S. Chávez Silverman (Eds.), *Tropicalizations: Transcultural representations of Latinidad.* Hanover, NH: University Press of New England (pp. 183–193).

Flores, W., & Benmayor, R. (Eds.). (1997). *Latino Cultural Citizenship: Claiming Identity, Space, and Rights, Boston: Beacon.*

Foucault, M. (1980). *Power/knowledge: Selected interviews and other writings, 1972–1977.* New York: Pantheon.

Foucault, M. (1978). *The history of sexuality, volume I: An introduction.* New York: Vintage Books.

Fregoso, R. L. (1995). Homegirls, cholas, and pachucas in cinema: Taking over the public sphere. *California History, 74*(3), 316–327.

Fregoso, R. L. (1993). *The bronze screen: Chicana and Chicano film culture.* Minneapolis: University of Minnesota Press.

Freire, P. (1999). *Pedagogy of the oppressed.* New York: Continuum.

Freire, P. (1994a). Education as the practice of freedom. In P. Freire (Ed.), *Education for critical consciousness.* New York: Continuum (pp. 63–84).

Freire, P. (1994b). *Education for critical consciousness.* New York: Continuum.

Frith, S. (1996). Music and identity. In S. Hall, & P. du Gay (Eds.), *Questions of cultural identity.* Thousand Oaks, CA: Sage (pp. 63–84).

Gabrilos, D. (2006). *U.S. news magazine coverage of Latinos: 2006 report.* Washington, DC: National Association of Hispanic Journalists.

García, J. (2005). *Afrovenezolanidad e inclusión en el proceso bolivariano venezolano.* Caracas: Ministerio de Comunicación e Información.

García Canclini, N. (1995). *Consumidores y ciudadanos.* México DF: Grijalbo.

García Canclini, N. (1989). *Culturas híbridas: Estrategias para entrar y salir de la modernidad.* México DF: Grijalbo.

García, R. (2002). New iconographies: Film culture in Chicano cultural production. In N. Quiñonez H. (Ed.), *Decolonial voices.* Bloomington, IN: Indiana University Press (pp. 64–75).

Geourgio, M. (2006). *Diaspora, identity and the media: Diasporic transnationalism and mediated spacialities.* Cresskill, NJ: Hampton.

Giddens, A. (1984). *The constitution of society: Outline of the theory of structuration.* Berkeley: University of California Press.

Gillespie, M. (1995). *Television, ethnicity and cultural change.* New York: Routledge.

Gilman, S. L. (1985). Black bodies, white bodies: towards an iconography of female sexuality in late nineteenth-century art, medicine, and literature. *Critical Inquiry 12*(1), 204–242.

Gilroy, P. (1993). *The Black Atlantic: Modernity and double consciousness.* New York: Verso.

Giroux, H. A. (2000). Disposable youth/disposable futures: The crisis of politics and public life. In Campbell (ed.), *The radiant hour. Versions of youth in American culture*. Exeter, Devon: University of Exeter Press (pp. 71–87).

Giroux, H. A. (1995). 'White panic'. *Z Magazine, 8*(5), 12–14.

Giroux, H. A. (1995). Innocence and pedagogy in Disney's world. In E. Bell, L. Hass, & L. Sells (Eds.), *From mouse to mermaid: The politics of film, gender, and culture*. Bloomington, IN: Indiana University Press (pp. 43–61).

Gómez Peña, G. (2000). *Dangerous border crossers: The artist talks back*. London; New York: Routledge.

González Echeverría, R. (2005). The counterpoint and literature. In M. A. Font, & A. W. Quiroz (Eds.), *Cuban counterpoints: The legacy of Fernando Ortíz*. New York: Lexington (pp. 209–216).

González Hernández, D. (2008). Watching over the border: A case study of the Mexico-U.S. television and youth audience. In A. N. Valdivia (Ed.), *Latina/o communication studies today*. New York: Peter Lang (pp. 219–236).

González, J. A. (1994). *Más(+) cultura(s): Ensayos sobre realidades plurales*. México: Gustavo Gili.

González López, G. (2005). *Erotic journeys. Mexican immigrants and their sex lives*. Berkeley/Los Angeles: University of California Press.

González McPerson, J. (September 2001). Targeting teens. *Hispanic*, 33–36.

González, R. (Ed.). (1996). *Muy macho: Latino men confront their manhood*. New York: Anchor Books.

Gramsci, A. (1994). *Letters from prison*. New York: Columbia University Press.

Grossberg, L. (1992). Is there a fan in the house? The affective sensibility of fandom. In L. Lewis (Ed.), *The adoring audience: Fan culture and popular media*. London: Routledge (pp. 50–67).

Hall, S. (2000). The multi-cultural question. In B. Hesse (Ed.), *Un/settled Multiculturalism: Diasporas, entanglements, transruptions*. London: Zed Books, (pp. 209–241).

Hall, S. (1990). Cultural identity and diaspora. In J. Rutherford (Ed.), *Identity, community, culture, difference*. London: Lawrence and Wishart (pp. 222–237).

Hall, S. (1988). New ethnicities. In K. Mercer (Ed.), *Black film, British cinema*. London: Institute for Contemporary Arts (pp. 50–67).

Hall, S., & du Gay, P. (1996). *Questions of cultural identity*. Thousand Oaks, CA: Sage.

Havens, T. (2001). Subtitling rap. *Gazette, 63*(1), 57–72.

Hirsh, J. S. (1999). *En el norte la mujer manda*: Gender, generation and geography in a Mexican transnational community. *American Behavioral Scientist, 42*(9), 1332–1349.

Holtzman, J. (2002). *Immigrant access to public benefits in North Carolina*. Raleigh, NC: North Carolina Justice and Community Development Center.

Hondagneu-Sotelo, P. (2002). Families in the frontier: From braceros in the fields to braceras in the home. In M. M. Suárez-Orozco, & M. M. Páez (Eds.), *Latinos remaking America*. Berkeley, CA: University of California Press (pp. 259–263).

Hovey, J. D., & King, C. A. (1996). Acculturative stress. Depression, and suicidal ideation among immigrant and second-generation Latino adolescents. *Journal of the American Academy of Child and Adolescent Psychiatry, 35*, 1183–1192.

Huaco-Nuzum, C. (1996). (Re)constructing Chicana, mestiza representation: Frances Salomé España's *Spitfire* (1991). In C. Noriega, & A. A. López (Eds.), *The ethnic eye: Latino media arts*. Minneapolis: University of Minnesota Press (pp. 260–274).

Jewell, K. S. (1992). *From mammy to Miss America and beyond: Cultural images and the shaping of U.S. social policy*. New York: Routledge.

Johnson, M. A. (2000). How ethnic are U.S. ethnic media: The case of Latina magazines. *Mass Communication & Society, 3*(2 & 3), 229–248.

Johnson, M. A., David, P., & Huey, D. (2003). Beauty in brown: Skin color in Latina magazines. In D. I. Ríos, & A. N. Mohamed (Eds.), *Brown and black communication: Latino and African American conflict and convergence in mass media*. Westport, CT: Praeger (pp. 159–174).

Johnson-Webb, K. D. (2002). Employer recruitment and Hispanic labor migration: North Carolina urban areas at the end of the millennium. *The Professional Geographer, 54*(3), 406–421.

Johnson-Webb, K. D., & Johnson, J. H. (1996). North Carolina communities in transition: The Hispanic influx. *North Carolina Geographer, 5*, 21–40.

Jones, A. (Ed.). (2003). *The feminism and visual culture reader*. New York: Routledge.

Kaiser, S. (2005). *Postmemories of terror*. New York: Palgrave Macmillan.

Kao, G. (2000). Group images and possible selves among adolescents: Linking stereotypes to expectations by race and ethnicity. *Sociological Forum, 15*(3), 407–430.

Keck, M. E., & Sikkink, K. (1998). *Activists beyond borders: Advocacy networks in international politics*. Ithaca, NY: Cornell University Press.

King, R., & Wood, N. (Eds.). (2001). *Media and migration. Constructions of mobility and difference*. New York: Routledge.

Kochhar, R., Suro, R., & Tafoya, S. (2005). *The New Latino South: The context and consequences of rapid population growth*. Pew Hispanic Center.

Korzenny, F., & Korzenny, B. A. (2005). *Hispanic marketing: A cultural perspective*. Burlington, MA: Elsevier/Butterworth-Heinemann.

Koss-Chioino, J. D., & Vargas, L. A. (1999). *Working with Latino youth*. San Francisco: Jossey-Bass.

Kraidy, M. M. (2005). *Hybridity or the cultural logic of globalization*. Philadelphia, PA: Temple University Press.

La Ferle, C., Li, H., & Edwards, S. M. (2001). An overview of teenagers and television advertising in the United States. *Gazette: The International Journal for Communication Studies, 63*(1), 7–24.

Lagarde, M. (1993). *Los cautiverios de las mujeres: Madresposas, monjas, presas, putas y locas*. México: Universidad Nacional Autónoma de México.

Larsen, N. (1929). *Passing*. New York: Knopf.

Lenhart, A., & Madden, M. (2007). *Teens, privacy, and on-line social network*. Pew Internet and American Life Project.

Lewis, J., & Jhally, S. (1998). The struggle over media literacy. *Journal of Communication, 48*(1), 109–120.

Lipsitz, G. (1990). *Time passages: Collective memory and American popular culture*. Minneapolis: University of Minnesota Press.

López A. A. (1991). Are all Latins from Manhattan? Hollywood, ethnography, and cultural colonialism. In L. D. Friedman (Ed.), *Unspeakable images: Ethnicity and the American cinema.* Urbana, IL: University of Illinois Press (pp. 404–424).

Lucas, T. (1998). Youth gangs and moral panics in Santa Cruz, California. In T. Skelton, & G. Valentine (Eds.), *Cool places: Geographies of youth subcultures.* New York: Routledge (pp. 145–161).

Lutrell, W. (2003). *Pregnant bodies, fertile minds.* New York: Routledge.

Malinowski, B. (1963). Introduction. In F. Ortíz (Ed.), *El contrapunteo cubano del tabaco y del azúcar* (pp. i–ixx). Universidad Central de las Villas.

Marshall, T. H. (1964). *Citizenship and social class and other essays.* Cambridge: Cambridge University Press.

Martín Alcoff, L. (2006). *Visible identities: Race, gender, and the self.* Oxford: Oxford University Press.

Martín Barbero, J. (1987). *De los medios a las mediaciones: Comunicación, cultura y hegemonía.* México: Gustavo Gili.

Massey, D. (1993). Power-geometry and a progressive sense of place. In J. Bird, B. Curtis, T. Putman & G. Roberson (Eds.), *Mapping the futures: Local cultures, global change.* London: Routledge (pp. 59–69).

Massey, D. S., Durand, J., & Malone, N. (2000). *Beyond smoke and mirrors: Mexican immigration in an era of economic integration.* New York: Russell Sage Foundation.

Mato, D. (2003). On the making of transnational identities in the age of globalization: The U.S. Latina/o-"Latin" American case. In E. Mendieta (Ed.), *Identities: Race, class, gender, and nationality.* Malden, MA: Blackwell (pp. 281–294).

Mayer, V. (2004). Please pan the pan: Retheorizing the map of pan Latinidad in communication research. *The Communication Review, 7,* 113–124.

Mayer, V. (2003a). *Producing dreams, consuming youth: Mexican Americans and mass media.* Piscataway, NJ: Rutgers University Press.

Mayer, V. (2003b). Living telenovelas/telenovelizing life: Mexican American girls' identities and transnational telenovelas. *Journal of Communication, 53*(3), 479–495.

McAnany, E., & LaPastina, A. (1994). Telenovela audiences: A review and methodological critique of Latin American research. *Communication Research, 21*(6), 828–849.

McCarthy, C. Hudak, G., Miklaucic, S., & Saukko, P. (Eds.) (1999). *Sound identities: Popular music and the cultural politics of education.* New York: Peter Lang.

McRobbie, A., & Garber, J. (1976). Girls and subcultures. In S. Hall, & T. Jefferson (Eds.), *Resistance through rituals: Youth subcultures in post-war Britain.* London: Hutchinson (pp. 209–222).

McWilliams, C. (1949). *North from Mexico.* New York: Greenwood.

Melucci, A. (1996). *Challenging codes: Collective action in the information age.* Cambridge: Cambridge University Press.

Mills, G. E. (2000). *Action research: A guide for the teacher researcher.* New York: Merrill.

Mindiola, T., Niemann, Y. F., & Rodriguez, N. (2002). *Black-brown relations and stereotypes.* Austin, TX: University of Texas Press.

Mirandé, A. (1997). *Hombres y machos: Masculinity and Latino culture.* Boulder, CO: Westview.

Molina Guzmán, I. (2007). Salma's Frida: Latinas as transnational bodies in U.S. popular culture. *From bananas to buttocks: The Latina in popular film and culture*. Austin: University of Texas Press.

Montalvo, F. F. (2004). Surviving race: Skin color and the socialization and acculturation of Latinas. *Journal of Ethnic & Cultural Diversity, 13*(3), 25–43.

Montero-Sieburth, M., & Villarruel, F. A. (2000). *Making invisible Latino adolescents visible*. New York: Falmer.

Moore, J. M. (1991). *Going down to the barrio: Homeboys and homegirls in change*. Philadelphia, PA: Temple University Press.

Moore, Z. (1999). Postcolonial influences in Spanish diaspora: Christian doctrine and the depiction of women in Tejano border songs and calypso. In C. McCarthy, G. Hudak, S. Miklaucic, & P. Saukko (Eds.), *Sound identities. Popular music and the cultural politics of education*. New York: Peter Lang (pp. 215–234).

Morales, E. (2003). *The Latin beat: The rhythms and roots of Latin music*. New York: Da Capo Press.

Moran, K. (2003). A reception analysis: Latina teenagers talk about telenovelas. *Global Media Journal, 2*(2).

Moreiras, A. (2001). *The exhaustion of difference: The politics of Latin American cultural studies*. Durham: Duke University Press.

Mosco, V., & Schiller, D. (2001). *Continental order?: Integrating North America for cybercapitalism*. Lanham, MD: Rowman & Littlefield.

Naficy, H. (1993). *The making of exile cultures: Iranian television in Los Angeles*. Minneapolis: University of Minnesota Press.

Narváez Gutiérrez, Juan Carlos. (2007). *Ruta transnacional: A San Salvador por Los Angeles*. México: Universidad Autónoma de Zacatecas.

National Hispanic Media Coalition. (2008). About us. Retrieved March 6, 2008 from http://www.nhmc.org/about/

Navarrete, L., & Kamasaki, C. (1994). *Out of the picture: Hispanics in the media*. Washington, DC: National Council of La Raza.

Negrón-Muntaner, F. (1997). Jennifer's butt. *Aztlán: A Journal of Chicano Studies, 22*, 181–194.

Nielsen Media Research Inc. (2008). *Hispanic-American television audience*. Retrieved February 20, 2008, from http://www.nielsenmedia.com/ethnicmeasure/hispanic-american/indexHisp.html

North Carolina Institute of Medicine (2003). *NC Latino health*. Durham, NC: North Carolina Institute of Medicine.

Oboler, S. (1995). *Ethnic labels, Latino lives*. Minneapolis: University of Minnesota Press.

Obregón Pagán, E. (2007). *Murder in the Sleepy Lagoon: Zoot Suits, race, and riots in wartime L. A.* Chapel Hill: University of North Carolina.

Ogan, C. (2001). *Communication and identity in the diaspora*. Lanham, MD: Lexington.

Omi, M., & Winant, H. (1986). *Racial formation in the United States: From the 1960s to the 1980s*. New York: Routledge & Kegan Paul.

Ong, A. (1996). Cultural citizenship as subject-making. *Current Anthropology* 37(5), 737–762.

Ong, A., & Nonini , D. M. (1997). *Ungrounded empires: The cultural politics of modern Chinese transnationalism*. New York: Routledge.

Orozco, G. (1996). *Televisión y audiencias: Un enfoque cualitativo.* México: Universidad Iberoamericana y Ediciones de la Torre.

Ortiz, F. (1963). *Contrapunteo cubano del tabaco y el azúcar: Advertencia de sus contrastes agrarios, económicos, históricos y sociales, su etnografía y su transculturación* (2nd ed.). Santa Clara: Universidad Central de las Villas, Dirección de Publicaciones.

Osterman, A. C., & Keller-Cohen, D. (1998). "Good girls go to heaven; bad girls … " learn to be good: Quizzes in American and Brazilian teenage girls' magazines. *Discourse & Society, 9*(4), 531–558.

Palmer Unger, M. T. (2003). The schooling experience of Latina immigrant high school students. Ph.D. Dissertation, University of North Carolina at Chapel Hill.

Palumbo, F. A. (2005). Segmenting the U.S. Hispanic market based on level of acculturation. *Journal of Promotion Management, 12*(1), 151.

Paulin, L. (2007). *Newspaper discourses of Latino labor and Latino rights in the new U.S. South.* Ph.D. dissertation. The University of North Carolina at Chapel Hill.

Paxman, A., & Saragoza, A. M. (2007). Globalization and Latin media powers: The case of Mexico's Televisa. In V. Mosco, & D. Schiller (Eds.), *Continental order? Integrating North America for cybercapitalism.* Oxford: Rowman & Littlefield Publishers (pp. 64–85).

Pedraza, S. (1998). *Contribution of Latino studies to social science research on immigration* (JSRI Occasional Paper No. 36). Michigan State University: The Julian Samora Research Institute.

Peña, M. (1991). Class, gender and machismo: "Treacherous woman" folklore of Mexican male workers. *Gender and Society, 5*(1), 30–46.

Pereira, K. Chapman, M., Potoshnick, S., & Smith, T. (2008). Latino youth and mental health: Latino youth and parents adapting to life in the American South. Carolina Population Center, University of North Carolina at Chapel Hill. Retrieved September. 14, 2008 from https://www.cpc.unc.edu/projects/lamha/publications/LAMHA_School_Report_Final_v2.pdf

Pieterse, J. N. (1992). *White on black: Images of Africa and blacks in Western popular culture.* New Haven, CT: Yale University Press.

Portes, A., & Rumbaut, R. G. (1996). *Immigrant America: A portrait.* Los Angeles: University of California Press.

Pough, G. D. (2004). *Check it while I wreck it: Black womanhood, hip-hop culture, and the public sphere.* Boston: Northeastern University Press.

Pratt, M. L. (1992). *Imperial eyes: Travel writing and transculturation.* London: Routledge.

La Prensa (2008, May 16). Bush signs legislation for national museum of the American Latino. *La Prensa.* Retrieved from http://www.laprensa-sandiego.org/current/Museum051608.htm

Project 2050. (2008). *What is project 2050?* Retrieved April 20 2008 from http://www.p2050.com/WhatProColon.htm

Prosser, J. (Ed.). (1998). *Image-based research: A sourcebook for qualitative researchers.* London: Routledge Falmer.

Public School Review. (2008). *Chapel Hill.* Retrieved February 26, 2008 from www.publicschoolreview.com/school_ov/school_id/59130

Rama, A. (1985). *La crítica de la cultura en América Latina*. Caracas, Venezuela: Biblioteca Ayacucho.

Ramírez-Berg, C. (2002). *Latino images in film: Stereotypes, subversion, and resistance*. Austin, TX: University of Texas Press.

Ramírez-Berg, C. (1997). Stereotyping in films in general and of the Hispanic in particular. In C. E. Rodríguez (Ed.), *Latin looks: Images of Latinas and Latinos in the U.S. media*. Boulder, CO: Westview (pp. 104–120).

Ramos, S. (1951). *El perfil del hombre y la cultura en México*. Buenos Aires: Espasa-Calpe.

Ramos-Zayas, A. (2007). Becoming American, becoming Black? Urban competency, racialized spaces, and the politics of citizenship among Brazilian and Puerto Rican youth in Newark. *Identities: Global Studies in Power and Culture, 14*(1–2), 85–190.

Robbins, K. (2001). Becoming anybody: Thinking against the nation and through the city. *City, 5*(1), 77–90.

Rocco, R. (1997). Citizenship, culture, and community: Restructuring in southeast Los Angeles. In W. Flores, & R. Benmayor (Eds.), *Latino cultural citizenship claiming identity, space, and rights*. Boston, MA: Beacon (pp. 97–123).

Rodríguez, A. (1999). *Making Latino news: Race, language, class*. Thousand Oaks, CA: Sage.

Rodríguez, A. (1996). Objectivity and ethnicity in the production of the "Noticiero Univisión." *Critical Studies in Media Communication, 13*(1), 59–81.

Rojas, V. (2004). The gender of Latinidad: Latinas speak about Hispanic television. *The Communication Review, 7*, 125–153.

Rosaldo, R., & Flores, W. V. (1997). Identity, conflict, and evolving Latino communities: Cultural citizenship in San Jose, California. In W. Flores, & R. Benmayor (Eds.), *Latino cultural citizenship: Claiming identity, space, and rights*. Boston: Beacon (pp. 57–96).

Rose, G. (2001). *Visual methodologies*. London: Sage.

Rose, T. (2001). Never trust a big butt and a smile. In R. Curren & J. Bobo (Ed.), *Black feminist cultural criticism*. Malden, MA: Blackwell (pp. 232–254).

Rouse, R. (1995). Thinking through transnationalism: Notes on the cultural politics of class relations in the contemporary United States. *Public Culture, 7*, 353–402.

Rubin, H. J., & Rubin, I. (2004). *Qualitative interviewing: The art of hearing data*. Thousand Oaks, CA: Sage.

Ruiz, M. V. (2002). Border narratives, HIV/AIDS, and Latina/o health in the United States: A cultural analysis. *Feminist Media Studies, 2*(1), 37–62.

Ruíz, V. L. (1996). "Star struck": Acculturation, adolescence, and the Mexican-American woman. In D. Gutiérrez (Ed.), *Between two words: Mexican immigrants in the United States* Wilmington, DE: Scholarly Resources (pp. 125–148).

Rumbault, R. G. (1997). Paradoxes (and orthodoxies) of assimilation. *Sociological Perspectives 40*(3), 483–511.

Said, E. (1994). *Culture and imperialism*. New York: Knopf.

Salih, S. (2002). *Judith Butler*. London: Routledge.

Santa Ana, O. (2002). *Brown tide rising: Metaphors of Latinos in contemporary American public discourse*. Austin, TX: University of Texas Press.

Sassen, S. (1998). *Globalization and its discontents: Essays on the new mobility of people and money*.

New York: New Press.

Schmidley, D. A. (2001). *Current population reports: Profile of the foreign-born population in the United States: 2000.* Washington, DC: U.S. Census Bureau.

Schooler, D. (2008). Real women have curves: A longitudinal investigation of TV and the body image development of Latina adolescents. *Journal of Adolescent Research, 23*(2), 132.

Scott, J. C. (1990). *Domination and the arts of resistance. Hidden transcripts.* New Haven: Yale University Press.

Sharpley-Whiting, T. D. (2007). *Pims up ho's down: Hip Hop's hold on young black women.* New York: New York University Press.

Silverstone, R. (2007). *Media and morality: The rise of the mediapolis.* Malden, MA: Polity.

Silverstone, R. (1993). Television, ontological security and the transitional object. *Media, Culture, and Society, 4,* 573–598.

Silverstone, R., & Hirsch, E. (Eds.). (1992). *Consuming technologies: Media and information in domestic spaces.* London: Routledge.

Silvestrini, B. G. (1997). The world we enter when claiming rights: Latinos and their quest for culture. In W. Flores, & R. Benmayor (Eds.), *Latino cultural citizenship.* Boston, MA: Beacon (pp. 39–53).

Singleton, G. O. (2000). *Superb action carries weak plot and pedestrian acting* Reel Movie Critic. Retrieved August. 16, 2003 from ReelMovieCritic.com

SiTV. (2008). *About SiTV.* Retrieved April 30, 2008 from http://www.sitv.com/aboutSiTV.

SiTV. (2007). *SiTV tags into Latino trends with two new online blogs.* Retrieved June 11, 2008 from http://www.pr.com/company-profile/press-releases/3104

Sletterneås, D. (2006). Identity formation and the construction of home in diasporic households: the impact of media technologies. Retrieved February. 5, 2008 from www.itu.dk/people/barkhuus/chi2006workshop/slettemeas.pdf

Smith-Nonini, S. (2005). Federally sponsored Mexican migrants in the transnational South. In J. Peacock, H. L. Watson, & C. R. Matthews (Eds.), *The American South in a global world* (pp. 59–82). Chapel Hill, NC: University of North Carolina at Chapel Hill.

Southern Cross University. (2001). *Action research resources.* Southern Cross University, Graduate College of Management Web site. Retrieved October. 11, 2002 from http://www.scu.edu.au/schools/gcm/ar/arhome.html

Southern Poverty Law Center Web page. (2007). Retrieved April 20, 2008 from http://www.splcenter.org/intel/map/hate.jsp

Spitta, S. (1997). Transculturation, the Caribbean, and the Cuban-American imaginary. In F. R. Aparicio, & S. Chávez Silverman (Eds.), *Tropicalizations: Transcultural representations of Latinidad.* Hanover, NH: University Press of New England (pp. 160–180).

Spradley, J. P. (1980). *Participant observation.* New York: Holt, Rinehart, and Winston.

Spradley, J. P. (1979). *The ethnographic interview.* New York: Holt, Rinehart, and Winston.

Squire, C. (1997). Who's white? television talk shows and representation of whiteness. In M. Fine, L. Weiss, L. Powell, & M. Wong (Eds.), *Off white: Readings on race, power, and society.* London: Routledge (pp. 242–250).

Stake, R. (1995). *The art of case study research.* Thousand Oaks: Sage.

Strauss, A., & Corbin, J. M. (1998). *Basics of qualitative research: Techniques and procedures for*

developing grounded theory (2nd ed.). Thousand Oaks, CA: Sage Publications.

Strinati, D. (1995). *An introduction to theories of popular culture.* London: Routledge.

Stringer, E. (1999). *Action research.* Thousand Oaks, CA: Sage.

Sturken, M., & Cartwright, L. (2001). *Practices of looking: An introduction to visual culture.* Oxford: Oxford University Press.

Suárez-Orozco, M. M., & Páez, M. M. (2002). Introduction. In M. M. Suárez-Orozco, & M. M. Páez (Eds.), *Latinos. Remaking America.* Berkeley: University of California Press (pp. 1–38).

Subervi Vélez, F. (2006). Los medios de comunicación Latinos en Estados Unidos: Categorías y funciones. In D. González Casanova (Ed.), *Los mexicanos de aquí y de allá: Problemas comunes.* Memoria del Segundo Foro de Reflexión Binacional. México: Fundación Solidaridad Mexicano Americana (pp. 199–216).

Subervi Vélez, F. (2004). *Network brownout 2004: The portrayal of Latinos & Latino issues in network television news, 2003* (NAHJ report. Washington, DC: National Association of Hispanic Journalists). Retrieved March 18, 2008 from www.freepress.net/docs/network-brownout-2005.pdf

Suro, R. (2005) *Changing channels and crisscrossing cultures: A survey of Latinos and the news media.* Pew Hispanic Center. Retrieved August. 19, 2005 from http://pewhispanic.org/files/reports/27.pdf

Szarek, L. (2008). Putting the accent on opinión: A textual analysis of Latino immigration discourse on the editorial and opposite-editorial pages of North Carolina community newspapers. University of North Carolina at Chapel Hill, NC.

Task Force on Latino Issues. (1994). *Willful neglect: The Smithsonian Institution and U.S. Latinos.* Washington, DC: Smithsonian Institution.

Tate, J. (2007). The good and bad women of telenovelas: How to tell them apart using a simple maternity test. *Studies in Latin American Pop Culture, 26*, 97–111.

Thomas, G. (2003). Erotics of Aryanism/Histories of empire. *CR: The New Centennial Review, 3*(3), 235–255.

Toon, K. L. (2003). *Media literacy in the language learning classroom.* Unpublished M.A. thesis, University of North Carolina at Chapel Hill, Chapel Hill, NC.

Tovares, R. D. (2002). *Manufacturing the gang: Mexican American youth gangs on local television news.* Westport, CT: Greenwood.

Tufte, T. (2001). Minority youth, media uses and identity struggle: The role of the media in the production of locality. In K. Ross, & P. Playdon (Eds.), *Black marks: Minority ethnic audiences and media.* Aldershot, England: Ashgate (pp. 33–48).

United States Census Bureau. (2008a). *Los Angeles (city) QuickFacts from the US census bureau.* Retrieved April 3, 2008 from http://quickfacts.census.gov/qfd/states/06/0644000.html

United States Census Bureau. (2008b). *North Carolina QuickFacts from the U.S. census bureau.* Retrieved May 1, 2008 from http://quickfacts.census.gov/qfd/states/37000.html

United States Census Bureau. (May 1, 2008). *U.S. Hispanic population surpasses 45 million; now 15 percent of total.* Retrieved May 6, 2008 from http://www.census.gov.libproxy.lib.unc.edu/Press-Release/www/releases/archives/population/011910.html

United States Census Bureau. (June 18, 2003). *Hispanic population reaches all-time high of 38.8*

million. Retrieved April 8, 2007 from http://www.census.gov/Press-Release/www/2003/cb03-100.html

United States Census Bureau. (2000). *Census data for the state of North Carolina.*

Univisión. (2005a). *Univision music group completes acquisition of Fonovisa creating a leading Latin music company in the U.S., Mexico and Puerto Rico.* Retrieved February 16, 2008 from http://corporate.Univision.com/corp/en/pr/Los_Angeles_19042002–1.html

Univisión. (2005b). *Univisión's "Selena vive!" breaks audience records.* Retrieved February 13, 2008 from http://www.Univision.net/corp/en/pr/Houston_11042005–2.html

Valdivia, A. N. (2008). Popular culture and recognition: Narratives of youth and Latinidad. In N. Dolby & F. Rizvi (Eds.), *Youth moves: Identities and education in global perspective.* New York: Routledge (pp. 101–114).

Valdivia, A. N. (2007). Is Penélope to J. Lo as culture is to nature? Eurocentric approaches to "Latin" beauties. In M. Mendible (Ed.), *From bananas to buttocks: The Latina body in popular film and culture.* Austin, TX: University of Texas Press.

Valdivia, A. N. (2006). Salsa as popular culture: Ethnic audiences constructing an identity. In A. N. Valdivia (Ed.), *A companion to media studies.* Malden, MA: Blackwell (pp. 399–418).

Valdivia, A. (1998). Stereotype or transgression: Rosie Perez in Hollywood film. *Sociological Quarterly, 39*(3), 393–408.

Valdivia, A. N., & Bettivia, R. S. (1999). Gender, generation, space, and popular music. In C. McCarthy, G. Hudak, S. Miklaucic, & P. Saukko (Eds.), *Sound identities: Popular Music and the cultural politics of education.* New York: Peter Lang (pp. 429–446).

Vargas, L. (2000). Genderizing Latino news: An analysis of a local newspaper's coverage of Latino current affairs. *Critical Studies in Media Communication, 17*(3), 261–293.

Vargas, L. (1995). *Social uses and radio practices: The use of participatory radio by ethnic minorities in Mexico.* Boulder, CO: Westview.

Vargas, L. (1982). *Lo femenino en la filosofía mexicana.* Unpublished thesis, Universidad Autónoma de Chihuahua, México.

Vasconcellos, J. (1976). *La raza cósmica.* México: Espasa-Calpe.

Vertovec, S. (1999). Conceiving and researching transnationalism. *Ethnic and Racial Studies, 22*(2), 447–462.

VH1, (2007). *Behind the music: Backstreet Boys.* Retrieved February 13, 2007 from http://www.vh1.com/shows/dyn/behind_the_music/88747/episode_about.jhtml

Weill, S., & Castañeda, L. (2004). "Emphathetic rejectionism" and inter-ethnic agenda setting: Coverage of Latinos by the Black press in the American South. *Journalism Studies, 5*(4), 537–550.

Wible, S (2004). Media advocates, Latino citizens and niche cable: The limits of "no limits" TV. *Cultural Studies 18*(1), 34–66.

Willis, P. (1981). *Learning to labor.* New York: Columbia University Press.

Willis, P., Jones, S., Canaan, S., & Hurd, G. (1990). *Common culture. Symbolic work at play in the everyday culture of the youth.* Boulder, CO: Westview.

Wilson, C. C., Gutiérrez, F., & Chao, L. M. (2003). *Racism, sexism, and the media: The rise of class communication in multicultural America* (3rd ed.). Thousand Oaks, CA: Sage.

Wimberley, R. C., & Morris, L. V. (1997). *The southern Black belt*. Lexington, KY: TVA Rural Studies, The University of Kentucky.

Winnicott, D. W. (1971). *Playing and reality*. New York: Routledge.

Wittig, M. (1992). *The straight mind and other essays*. Boston: Beacon Press.

Wortham, S., Murillo, E., & Hamann, E. T. (Eds.). (2001). *Education in the new Latino diaspora: Policy and the politics of identity*. Westport, CT: Ablex Publishing.

Yosso, T. J. (2002). Challenging deficit discourse about Chicanas/os. *Journal of Popular Film and Television*, Spring, 52–62.

Yzaguirre, R. (2002). *Help save the Showtime drama series* National Council of La Raza. Retrieved June 10, 2003 from http//:nclr.policy.net/proactive/newsroom/release. vtml?id=17540.

Zayas, L. H., Lester, L. J., & Fortuna, L. R. (2005). Why do so many Latina teens attempt suicide? A conceptual model for research. *American Journal of Orthopsychiatry, 75*(2), 275–287.

Zazueta Martínez, K. (2004). Latina magazines and the invocation of a panethnic family: Latino identity as it is informed by celebrities and papis chulos. *The Communication Review, 7*, 155–174.

Zea, L. (1990). *Descubrimiento e identidad Latinoamericana* (1st ed.). México: Universidad Nacional Autónoma de México, Coordinación de Humanidades, Centro Coordinador y Difusor de Estudios Latinoamericanos.

Zillmann, D. (1991). The logic of suspense and mystery. In J. Bryant, & D. Zillmann (Eds.) *Responding to the screen: Reception and reaction processes*. Hillsdale, NJ: Lawrence Erlbaum (pp. 281–303).

Index